Music and the Myth of Wholeness

Music and the Myth of Wholeness

Toward a New Aesthetic Paradigm

Tim Hodgkinson

The MIT Press
Cambridge, Massachusetts
London, England

This book was set in Stone by the MIT Press. Printed and bound in the United States of America.

Library of Congress Cataloging-in-Publication Data

Names: Hodgkinson, Tim.
Title: Music and the myth of wholeness : toward a new aesthetic paradigm / Tim Hodgkinson.
Description: Cambridge, MA : The MIT Press, [2015] | Includes bibliographical references and index.
Identifiers: LCCN 2015038318 | ISBN 9780262034067 (hardcover : alk. paper)
Subjects: LCSH: Music--Philosophy and aesthetics. | Aesthetics. | Aesthetics--Social aspects.
Classification: LCC ML3845 .H62 2015 | DDC 781.1/7--dc23 LC record available at http://lccn.loc.gov/2015038318

10 9 8 7 6 5 4 3 2 1

For Micol

Contents

Acknowledgments

This is a book that has come together gradually over a long period. Phases of writing have been scattered through the working life of a musician. Countless people over years have therefore unwittingly contributed to it: chance remarks, turns of conversation, mentions of musics, films, books, and a new connection is made. I cannot name them all, but here are a few.

Micol Vacca, who introduced me to a whole tradition of Italian aesthetic thought—Pareyson, Vattimo, Perniola—made numerous criticisms, interventions, and suggestions; provided material on psychology, critical theory, and linguistics; gave me working space; and goaded me along. I tried out ideas, argued, or corresponded with David Connearn, Harry Gilonis, Keith Howard, Kersten Glandien, Chris Cutler, Valentina Suzukey, Chris Frith, Tom Lubbock, Carole Pegg, Ben Piekut, and Malise Ruthven, all of whom gave me encouragement. Ben Piekut deserves a medal for reading and criticizing an entire early draft that was more or less unreadable; Malise Ruthven also; Tiggy and Malise for much hospitality; Ken Hyder for several helpful reads and rereads at various stages; Iancu Dumitrescu and Ana-Maria Avram for day-long discussions about music, phenomenology, and much else; Lu Edmonds, Phil Minton, Odile Jacquin, and Robert Worby for various helps; Peter Hodgkinson and Noele Bellier and Bella the dog for inspiration; Robert Reigle for his encyclopedic knowledge of contemporary music and discussions on ethnomusicology and spectralism; and Doug Sery at the MIT Press for warm support for this project.

Ken Hyder and Gendos Chamzyryn, whom I joined in the K-Space project, and many friends and acquaintances in Tuva and throughout Siberia and Russia, including Boris Podkosov, Anatoly Kokov, Spartak Chernish, Tania Jamatshuk, Boris Tomilov, Tamara, Boris Tolstobokov, Valentina Ponomareva, Konstantin Gogunsky, Sainkho Namtchylak, Chai-Su, Ai-Churek, Vladimir Rezitsky, Eugene and Olga Kolbashev, Nicolai Michailov, Yeremi Hagayev, Kunga-Boo Tash-Ool, Mongush Kenin-Lopsan, Doptchun

Kara-Ool Tyulyushevich, Bolot Biryshev, Vlail Kaznacheev, Alexander Tro-
fimov, the Barnaul Healthy Living Association, Kolya and Lyuda Dmitriev,
Sergei and Marfa Rastarguev, Albert Kuvezin, Alexei Sayaa, Sasha Mezdrikov,
Grigori Valov, Sergei Dykhov, Kongar-Ool, Sayan Bapa, Radik Tulush, Ste-
pan Manzyrykchy, Alexei Kagai-Ool, Sergei Tumat, Alexander-Sat Nemo,
and Sergei Ondar.

All uncredited references to shamans, Tuvan or otherwise, are from my
field recordings and notebooks.

Parts of this book have previously appeared in print in earlier stages.
John Zorn has given permission to reprint parts of *Holy Ghost* published by
Hips Road in *ARCANA V, 2010* (appearing in revised form as part of chapter
1). I also draw on the following:

"Musicians, Carvers, Shamans,"*Cambridge Anthropology* 25, no. 3 (2005–
 2006): 1–16.

"Transcultural Collisions; Music and Shamanism in Siberia," essay pub-
 lished online by the School of Oriental and African Studies, London
 (September 2007), http://www.soas.ac.uk/musicanddance/projects/
 project6/essays/file45913.pdf.

"On Listening,"*Perspectives of New Music* 48, no. 2 (summer 2010): 152–179.

I was in the final stages of writing when news came that Gendos
Chamzyryn had died in Kyzyl, Tuva. He was a great musician and friend,
and will be sorely missed. He had written to me that he thought people all
around the world would be interested in this book.

Tim Hodgkinson
London, June 2015

I Word and Body

1 Prelude

Summer 1996, Ust-Ordinsk, west of Lake Baikal, Siberia: percussionist Ken Hyder and I are on stage; everything's ready, we're about to play. I raise my saxophone to my lips. Suddenly I hear a voice. Someone is speaking—not in a hushed way but out loud, addressing everyone in the room, asking a public question: the question is: "How did you begin playing music?"

NOW? You want to know that NOW? Before even a note? "I started to hear certain music," I said, "as if it were a window opening into another world, a world that was more vivid than the one I lived in at home with my parents. And that intensity is something I've always gone after ever since. To lift people up out of where they are, to bring a sense of limitlessness, of possibility, a reminder that that also IS."

These improvised words, part artistic manifesto, part autobiography, bring forward straight away the question of an aesthetics that wishes to concern itself with being. Such an aesthetics can distill itself only out of subjective experience. To unfold this aesthetics is to describe a network of relationships between the accidents and histories of a life and a mind developing and testing its thought in relation to it.

If I had to give that thinking a rough birthdate, I would recall a few weeks in summer 1967 when I lived above the burning ghats on the bank of the Ganges in Varanasi, India, reading, in a hashish haze, books from the Theosophical Library, puzzling over the thought-pictures, and, most of all, the ones in which language was represented by a horizontal line and spirituality by a vertical one. An intriguing separation between communication and consciousness hovered in these diagrams. This way of depicting the sacred seemed to bear in some way on the organization of art. Was music horizontal and communicative like language, or was it vertical and concerned with changes of consciousness like spirituality? At school I had started on clarinet and then switched to saxophone. I was already a big

John Coltrane fan, and hearing the *Africa Brass* LP had been a life-changing moment. Could I think this out in a way that did justice to both the richness of language and the explosive effect this new music was having on me?

That autumn I came back to England and Cambridge University. I was soon involved in playing group music in the band Henry Cow. At the start, there was no theory about this, just the pragmatics of dealing with who we were and what we thought we wanted to do. The sounds we imagined and listened to, what we thought and felt and talked about, somehow, by a long and sometimes arduous process of trying out, jelled into music. Gradually I realized that music was, in some mysterious way, "of itself"—not isolated from life but not entirely continuous with it: always turning whatever it absorbed into something subtly but deeply its own.

At this time I was studying social anthropology, reading, absorbing, and synthesizing. But suppose there were no unified system into which everything we learned about our human identity could be fitted? Suppose human beings were not integrated wholes, but dynamic fields in which different forces collide? British social anthropology in the 1960s assumed a basic continuity between nature and culture; societies were like organisms, bodies with every part having its "function." I was, of course, being taught by people who had known a colonial world whose social hierarchies had been taken for granted. Other postcolonial anthropologies would soon emerge that no longer subscribed to an overtly organic model of society. Nevertheless, an underlying integration of the human being is still the bedrock assumption, and the aim of intellectual work is to make sense of data by showing how they fit together. The object of description is magically assembled into a unity by the process of developing a coherent description of it.

It was the glossed-over boundary between nature and culture within the human being that became for me the core variable—in fact more than a variable, a gap, a leap older than faith, a profound aporia against which, and across which, the preaching insistence of culture is generated. The culture of a society is, among other things, a propaganda directed at its incoming members, its children, in the form of how they will be closed in to the world as that culture imagines it. As a young self-styled rebel, I felt this as an immediate pressure in my surroundings. Every culture generates to its own ends the subjects that inhabit it. In each individual psyche is installed the fracture between the embodied intelligence of immediate sensation and the conceptual language-based representations that string together the obligatory narrative of a person—as conceived and constructed in that culture's notion of personhood. I felt that anthropology wanted to assimilate me into a set of beliefs about society, just as society did.

Detour into human cybernetics. Pain is an image, sound is an image, this page an image. I mean that they appear to us. These images are finely collated out of tiny informations rising in the afferent nervous system. They are transitory patterns of neuronal activity, momentary states of a plastic and holistic medium. Therefore, quite rightly, they seem to us alive, in a state of becoming, and likely to change from one moment to the next. This, if you like, is the quality of experience itself. It is life manifesting itself into subjectivity. Language, on the other hand, is for communicating across the space between us: the vibrancy of sense broken down to be squeezed into a narrow stream or stutter of audible sounds or visible marks—an external paraphernalia whose connections, isomorphisms, and resonances with inner life are far from evident.

My first proposition is this: the projection of the sacred is the human response to the untranslatability between the two informational modes that above all other factors define the condition of that being's being. Spiritual practice iterates a wresting movement across the raw divide of this untranslatability. It is the shared but innermost secret of our species. The conversation with the gods is the conversation with ourselves we could never have.

You might guess that I am then going to argue that art goes on from this to attempt the translation itself, to fire off a kind of utterance that does what language can't, and spill out what religion ultimately blurs and conceals. After all, as a musician, I work with the intelligence of sound: music seems to plunge directly into the house of the spirit, eliciting complex inner motions that dart away from language. Is music then the expressive projection into sound of the images that are passing states or patterns of embodied intelligence itself—representations for which we can find no equivalents in language? The idea is tempting. After all, we have no direct access to our own embodied intelligence, only to what that intelligence brings before us, namely, the world as it livingly seems, as we hear, see, smell, taste, and touch it—the image of the world as our senses sift and collate it from what comes forward to them. This world is already talking to itself, and our attempts to join that talk, to talk that talk, can be thought of as attempts to cross the cybernetic divide that splits us. And a "word" in the language of the world would be something we could experience with our senses, like a song or a painting.

Clifford Geertz wrote that people move "very frequently between radically contrasting ways of looking at the world, ways which are not continuous with one another, but separated by cultural gaps."[1] He was talking about an improvisational lucidity in human negotiation. But there is equally a

definite marking apart of certain cultural spaces to which these radically contrasting ways of looking at the world correspond. This is where ritual or spiritual actions occur. Some of this difference carries over into the quality of the objects that we recognize as art and as set apart from other made things. The extent of this carrying over from ritual to art will be an issue here. Art is what I want to get at; art is what I do.

Music making was, and still is in many places, thought of as a spiritual activity. But as a highly skeptical twenty-first-century Westerner, I think of music as aesthetically organized rather than shaped by beliefs concerning transcendent beings. Nonetheless, around 1990, in the course of a series of conversations about improvisational technique with fellow musician Ken Hyder, I remembered shamanism from my anthropology days and began to sketch possible connections between shamanic practice and musical improvisation. Shamanic performances had a large element of improvisation as compared with the fixed rituals and liturgies of other religions. And shamans took trouble to prepare for their performances, which might suggest that improvising musicians should do the same. These ideas were stimulated further by a major performing tour of Siberia in that year, the first by a British group, they said, since the revolution. With the thaw of communism, many indigenous Siberian cultures were just starting to remember shamanism as an integral part of their national identities. Shamans at this point, having been arrested, imprisoned, and forbidden to practice under the Soviet system, were still working in secret and in outlying districts. Out in Siberia, the locals were not convinced that *glasnost* would not turn out to be just another Party line, likely to be reversed like all the others. But gradually, over a number of trips, it became possible to meet shamans and observe and participate in their rituals. The focus started to settle on the Republic of Tuva on the Mongolian border, where, in 2005, I investigated the complex cultural boundary between the sacred and the aesthetic. Being ready by now to share certain kinds of experiences, not only of music but also of dreams and visions, with my "informants" (a word ethnographers use that I still can't quite detach from a notion of policing), allowed me into certain kinds of discussion that would not have been possible otherwise.

Back in Europe, it became increasingly clear to me that the articles I was publishing on this and other musical topics were underwritten by a theoretical position that had never before been articulated, by me or anyone else. What was particularly terrifying was that to do this, I had to bring together ideas from diverse and specialized sources. I do not see this as a question of my lack of academic qualifications, but rather of the structure of knowledge itself. How much freedom can one have in selecting and interpreting the

work of others who have been deeply into their fields? Everything comes down to how much sense is made of the ideas in the new context. Does the division of knowledge among disciplines reflect the organization of reality? Disciplines are highly political entities, competing for access to resources, but they are also communities of scholars. If sometimes these communities act in defense of boundaries that seem conventional and overconcerned with legitimacy, they also reflect and generate a collective creativity. A transdisciplinary approach must lack the benefits of membership of a specific community of scholars. It's a solo act.

But the idea of a solo act is hard to square with how I actually feel. I feel rather more immersed in a general collective endeavor that underlies all the specializations, perhaps forming their unconscious, seizing on the kinds of iconic or isomorphic similarities often ascribed to the unobserved life of the mind. It is absolutely in the nature of aesthetics to concern itself with these connections. On one level, aesthetic thought grasps everything that comes toward it as form. The connection between, say, Durkheim's theory of ritual and the theory of art occurs in the first place as a similarity of form. Ideas have shapes, and these shapes transpose and appear in other contexts. The aesthetic attitude is for the recognition of relationship. The filling out of relationship demanded by theory must allow its pace to be set by this keenness of recognition.

Recognitions are also events. The work of this book, and the life process that fed into it, has a high level of serendipity. Had I not lost touch with my friends that evening in Moscow in 1988, I would not have met Boris Podkosov from the city of Khabarovsk in the Soviet Far East who first invited us to Siberia and initiated that whole cycle of development. Just as my ideas grew by means of chance meetings with books, people, places, and musics, so the structure of this book reflects chains of thought and research that by nature could not have occurred outside of time in some perfectly calculated space.

To get at what I want to say about art, and about music in particular, I have needed to follow a circuitous path into unknown territory and use a new kind of map of the human to navigate it. Again the question of integration is crucial here. In the life of thought, we habitually understand ourselves as beings in whom biological and cultural factors operate together. We sense that even where harmony is lacking, there is always some way to get to it not far off. Insofar as we rely on an implicit version of Darwinism, we grasp our distinctive identity as a species precisely in terms of the emergence of cultural behaviors that have formed on the basis of biological ones. Our working model of ourselves as humans broadly assumes the

integration and convergence of these biological and cultural levels. This notion of human identity has so far seemed self-evidently useful: we point at something—in this case, ourselves—and say that's it; that's where it begins and ends, that's who we indivisibly are. But could it not be that in the extremely brief history of human attempts at self-knowledge, taking our collective self for granted in this way is no longer sustainable?

I want to free us from a metaphorical structure of wholeness and integration that seems utterly pervasive, not only in the ideologies that sustain human societies but—more dangerous—in the critical and analytical perspectives that we have deployed to explain them.

To do this is to look hard at human identity, to untie it, pull it apart, and open it up as a space in which are colliding two powerful organizing forces— the organic and biological on the one side and the cultural and linguistic on the other. These forces embody two distinctive, active, and expansive forms of organization and, in particular, two distinctive ways of processing, storing, receiving, and moving information. In short, a new way of describing our human identity is called for. We are no longer where biology and culture converge, but where biology and culture collide. We are exactly and uniquely where biology and culture collide *as forms of organization*. In fact, their collision constitutes our identity as a unique species of being.

I did not arrive at this description all at once, and it may help to position some of the points en route to it. There were, in fact, two routes: one concerned with music and the other with speculative anthropology. A new perspective on music began to gather shape for me after the sociologist Simon Frith invited Chris Cutler and me to improvise on percussion and keyboards at a conference on the semiotics of music at Keele University in 1983.[2] As I read the papers written by the semiologists, I found not a deep convergence of music and language underlying their superficial differences, but a split that widened the longer I looked at it. I started to rethink the history of music in the light of its tensions with language, as a series of incursions in which music had been colonized in different ways—as, for example, in the "theory of affects" in the Renaissance, or in the "music as the language of feeling" idea in romanticism, or finally in the incursion of semiology itself—and I began to think of aesthetic production as firmly opposed to the priorities of symbolic communication. My own identity as a musician and composer was in play. My attitude to words was already ambivalent; the lectures and seminars of George Steiner that I had attended were still reverberating in my mental ears.[3]

But if music refused to conform to models centered on communication and meaning, then what kind of intelligence did it address? I found, by chance, in Lancelot Whyte's *Aspects of Form* a powerful stimulant that made me far more aware of the richness of organization and even self-organization in the material world.[4] I began to hanker for a model of human identity that fully conceptualized our material being as biologically intelligent. Further readings in theoretical biology[5] and cybernetics[6] allowed me to grasp how this could be understood in terms of different kinds of informational system: there was information as it moved in the intelligence of the body and the senses, and there was information as it moved in the communication system of language. I worked toward an idea of the fundamental heterogeneity of the human informational field.[7] Fred Dretske's landmark study on informational processes in the production of perceptual representations, on the one hand, and semantic concepts, on the other, proved highly suggestive.[8]

An important question, for an artist concerned with subjective experience, was to find out how subjectivity might emerge from the informational and energetic processes of a living system. I found in Edmund Husserl's phenomenology a description of how a subject might form itself continuously in relation to its experience as it passes through time.[9] But if I transposed this abstract description into a human informational field considered as conflictual, then the self-production of the subject would no longer be univocal and would become in some way multiple. The accent shifts onto the processes of subjectivation, a move that makes the subject potentially plural. In what follows I outline how the consequences of this emphasis on subjectivation work themselves into the central arguments of this book.

Once the human informational field is conceptualized as conflictual and not homogeneous, the processes of subjectivation analyzed by such thinkers as Félix Guattari and Gilles Deleuze cease to be multiple merely because their fields of enunciation are multiple, and become multiple on a deeper and more ontological level.[10] In a varied informational field, there is scope for diverse types of informational stream, to which correspond recurrent or habitual phases of subjectivation of different kinds. Subjectivation becomes not a process of importing the elements of an identity from outside but the self-production of subjectivity under particular informational conditions. The old Cartesian center gives way not to a decentralized field but to a work space in which objective processes compete for attention.

To get at this ontology of subjectivation, it is necessary to begin by pushing away social process and considering subjectivation as mental process. To be more accurate, we have to position subjectivation at exactly the point at

which cybernetic process becomes mental process, the point at which information streams within a living system give rise to centers of attention and memory. These centers are the dramatis personae of my book. One such center is the *locutionary*, or talking, subject, generated in the serial stream of language. An inner loquacity of the mind comes forward as one of the core mental attributes of an animal adapted to language use. The serial sequential code of language imposes a particular form of informational activity with a particular kind of rhythm. This locutionary subject is closely linked to (but does not dissolve into) a discursive subject, shaped by social interaction, and committed to the responsibilities of rule-bound discourse.

A second important center of subjectivity is the *sintonic*, or gazing, subject, generated in the gradual morphings and variations of sensory experience. I use the word "sintonic" to mean a particular kind of attunement of sensory processes with environment, that is not directly functional in terms of survival and the location of resources. It is easiest to become aware of this when we do very focused business and then stop. In a hunter's pause for rest at the top of a hill, he may for a moment give up his search for signs of prey. Rolling a cigarette, he surveys a receding set of embedded horizons, leading back, valley by valley, hill by hill, to the blue distance. He feels a sense of expansion. Just for a moment, he forgets who he is and what he does. He is in some way taken up with doing what he sees, no longer seeing it for what he wants from it. This form of subjectivity arises, in other words, when attention is given to sensory experience as such. In its social and active form it becomes the aesthetic subject formed in aesthetic experience.

The third type of subjectivity to be introduced is the *oneiric*, or dreaming, type, with the explicitly dissociated experience of the dream. However their actual content may be evaluated, dreams constitute a vivid current in human experience, providing almost tactile models of potential other selves. The social form of the dreaming subject is the ritual subject, now no longer in the grip of a dream unfolding toward it but enacting a script created in the collective social imaginary.

What most deeply connects each kind of action with its corresponding subject type is the kind of information flow that each activity requires. Information is encoded, processed, and transmitted in a particular way in the social activities of discourse, art, and ritual, just as it is for each corresponding subject type. Here I acknowledge the (selective) influence of Gregory Bateson's writings on communication and art—his idea, for example, that painting could be a "code for transformation" of information: his attention to artistic technique as giving information more important than what a painting might on the surface "represent."[11]

If a richer imaginative content distinguishes ritual and art from everyday social life, they are also marked apart from it by an underlying tension. In principle, human language is an open system, a means of communication superbly unlimited in its capacity to handle any kind of information. But in the actual practice of social groups, it becomes effectively a closed system, limited by rules of discourse that allow, or forbid, what may be said, in what circumstances, and by whom. Here the difference between locutionary and discursive subject becomes concrete. Languages, as they are actually used in real societies, articulate a primary prepolitical ideology that excludes or ignores certain categories of information.[12] Because human beings inhabit a larger biological, ecological, and cosmic reality, these rejected kinds of information do not just fade away but accumulate into fault lines, points of trouble for social ideology. It is at, and to, these fault lines that artistic and ritual actions offer their splendors. The imaginative branchings that fill out the domains of the aesthetic and the sacred are contained and quarantined by a discursive tension, a troubled boundary that reflects a failed attempt to impose a fictional coherence on human experience.

Insofar as this book has a polemical dimension, it answers to the fact that this fictional coherence is all too often replicated in the human sciences, that is, transferred directly from the object of study to the analytical method. That rituals occur at ideological fault lines can easily be misread as meaning that ritual is society's way of compensating for its own inadequacies. But the "function" of ritual (if we must use the word) has to be thought of in terms of the total human biocultural system and not in terms of the social system. Far from ritual being a social product, the symbolic dimension on which human society is based first develops through ritual. Here I use the account of human language evolution proposed by Terrence Deacon.[13] Ritual is the means by which humans were originally able to develop the capacity to imagine relations of a symbolic type. It provided the special repetitive and mnemonic intensity by which the absent thing symbolized by a symbol could acquire some kind of traction. Without ritual, the idea, or rather the conviction, that something you see or hear could "stand for" something else could never have happened. Ritual therefore articulates a presocial humanity into the world of a socialized humanity.

As it evolves, language gradually pulls free from these ritual moments and transforms itself, across eons of time, into speech—a tool so completely flexible and portable as to be instantly available to anyone anywhere. Standing apart from this development, ritual repeats and confronts the crisis of the birth of symbolism. That humans everywhere do ritual attests to the problematic of this birth—that could neither be resolved on a new level

of symbolic coherence nor be absorbed back into human animality. I have found in Siberia, for example, that the strangeness and illogicality of what people do in rituals, and say about what they do in rituals, often makes sense precisely as a *commentary on* symbolic meaning.

In the doing of ritual and the making of art, the emphasis shifts away from language and onto sensory information. Ritual actions, explicitly aimed at summoning and negotiating with spirits and gods, paradoxically bring forward the bodies and gestures of the participants in a very concrete way. To explore the informational coding of ritual is to examine how a set of actions separates out a slice of space-time, to confront within it the real incoherences that stem from the fictional coherence of social ideology. In art, on the other hand, it is the aesthetic objects that set themselves apart as special forms of embodied information. To explore the informational coding of art is to see how art things are made, how their exact informational character distances them from other human production, and how the promise of aesthetic experience is imbued in them. Both the enactment of ritual and the making of art are types of social action in a total social cultural field; at the same time, they stand apart as processes having a specific informational character reflecting their respective origins in oneiric and sintonic subject types. Filled out from the inside by the productive pressure of human imagination, they are simultaneously constrained and bracketed from the outside by complex maneuvers of isolation and appropriation.

A basic cultural topography is visible everywhere in the human world. Important differences in how information is encoded mark a separation between everyday social life, ritual practices, and artistic ones. These differences cross-cut the social divisions and stratifications of complex societies. The same fissures appear in the cultures of disadvantaged immigrant communities as in the cultures of the "entitled" audiences who might go to hear the music of Helmut Lachenmann or John Cage.

The tradition of anthropological inquiry into ritual preserves a conceptual geography in which causal arrows of various types point from society to religion. But the cause of the separation that these arrows bridge and ultimately dissolve is never properly examined, and the argument is effectively circular. For a new cultural topography, religion will be neither a mechanism for the solution of social problems nor the product of social causes, but a response to the emergence of human language and society inside the larger totality embracing society, nature, and cosmos.

The same causal arrows crop up in social histories of the arts in the shape of ideas of reflection and expression. But artistic work refuses meaning by virtue of the informational gap that marks it out inside the field of social action. Music, for example, generates the conditions for a specifically

aesthetic listening subject—a subject that never dissolves into the verbal and discursive subject for whom a listening experience may acquire retrospective meaning. Here obviously I stand against Lawrence Kramer's idea of music as text and musical listening as interpretation of that text.[14] Indeed it is as aesthetic experience that musical listening becomes the major theme of the second part of this book. In the heart of the listening experience, the processes of subjectivation that underlie the production of art and ritual in general are given a specific turn and impulsion. An ontologically radical musical experience whose resonances extend well outside that experience is possible. Paradoxically, it is only through narrowing the focus onto an exact perceptual psychology of music that its more general power can be tracked down. The perceptual psychology of musical listening is in turn structured by music's particular informational character, and specifically by the folded and recursive nature of musical form and of music-making procedures.

When we listen to music, the normal model of agency (who is speaking to whom) is suspended, and this allows the subjectivity inscribed in music to come toward us as a formative "other" to be engaged with. But this is not for us to read the composer's own subjectivation from the music or to reproduce it in some way. Rather, when we perform our listening of the music, we are sharing in the formative risks taken by its maker(s). More than musical structure per se, what most deeply shapes the listening experience is the spread or accumulation of this aesthetic risk in the work—however much that distribution is the outcome of a technical effort of music making. Aesthetic risk is explicitly present in improvisation, but implicitly present in all kinds of music, except for those that systematically set out to eliminate it (which perhaps moves the risk onto another plane).

Three key musical figures stand out as proposing new ways of listening and as having explicitly integrated a theory of listening into their musical work. In the penultimate chapter I consider John Cage, Pierre Schaeffer, and Helmut Lachenmann critically from the perspective of the ontology of the listening subject.

This concludes a brief summary of the central arguments and themes of this book. A final chapter reaffirms that the core operative aspects of a new aesthetics must be the ontology of an aesthetic subject and the immanent connection between aesthetic experience and the inscription of a particular approach to production into a material to give it a specific informational character. In conclusion, these thoughts are brought to bear on two discussions in different fields: the question of the autonomy of art in other cultures, as treated in the ethnomusicology of Ted Levin and Steven Feld, and what turns out to be a related issue in the relatively new field of enactive and embodied aesthetics.

2 Information

December 2012, Café Oto, London: I do not know how this piece of music is going to end. Everything seems to be suspended. A cymbal goes on lightly, like wind in the grass, and dark tones lurk in some unfathomable deep frequency zone. There is nothing to say that this couldn't go on forever. A great deal seems to have happened since we began, and now is a chance to let this happening reverberate slowly through layers of consciousness. Once again we seem to be giving, but this time giving space and time—space and time to breathe, to let events sink under their own weight, slowly and without fuss, with nothing extra to themselves, just as they are, going on down. We play on, or the music plays us. I do not know how this piece of music is going to end.

In this investigation, "information theory" does not get us very far. Information theory looked for a quantifiable measure of information and came up with the idea of the "bit."[1] A bit is the unit of information that removes the uncertainty between two equally likely possibilities. But if I ask you to recommend me a plumber, and you say, "There is so and so: he is cheap, but not always reliable," the first part of your statement, according to information theory, contains information, and the second part does not: it increases rather than decreases my uncertainty. This tells us that in real life, intelligent beings find states of doubt useful and informative. It becomes clear that information theory applies essentially to machines or systems designed to carry out specified functions. But to examine how information works in a human context, and not a machine context, is to remind ourselves, first, that all cogitations are the activities of intelligent living beings whose informational processes adeptly make use of risks and uncertainties, and, second, that all cogitations occur not in abstract mental space but in the particular material environment of the structure of a living being, based, at least on this planet, on the behaviors of complex carbon molecules forming proteins.

So no to machines. Information starts with life. It springs up in the relationship between a living organism and an event, between something that lives and something that happens, whether it's a sudden change in the chemical state of the body or the snapping of a twig in a forest. Although the terms of this relationship—the living being and the event—are both made up of physical energies and materials, the relationship is neither symmetrical nor reversible. A living being is organized in a way that is completely different from how its environment is organized. What makes it a living being is exactly that it is in the business of *organizing itself*, and maintaining and furthering its organizational wholeness throughout every change in its environment. From this point of view, the watching eye, and the light and shadow that fall on it, are anything but equal. I think of my brother's dog, Bella. To watch Bella as she sits alert in the classic Gainsborough pose of the hunting dog, every detail of her face alive in motion, as her eyes, ears, and nose constantly scan and survey her world, is to see a living being be bathed in information and to know what information is. Information is asymmetrical, and the relationship of eye to light and ear to sound and nose to smell has implications that run one way and not the other. Bella is grasping the implications as every living being needs to grasp the implications, "decoding" the information received, interpreting environmental changes in terms of their repercussions and how these might connect to what to do next, and ultimately to how you survive in the longer term.

Criticizing the abuses of information theory, Katherine Hayles has written about an ideology of cybernetics that erases embodiment and promotes the idea that information is immaterial.[2] But to decode information is not to remove it from a material form into an immaterial mental universe in which it is "understood," but to transfer it from one material form to another.[3] It is just that the newer material form is more closely connected with an action or response of some kind. Information is always in material form. So far as humans are concerned, the most radical and far-reaching break in the material forms in which information is encoded is between the organic materiality of the sensory systems and the inorganic materiality of cultural systems. An organic world of nerves, chemicals, and neurons that carry subjective impressions confronts a cultural world of signs—signifying objects, such as audible words or visible marks. These signs allow precise and far-reaching communications between the nervous systems of individual organisms and generate a new kind of collective world in which those organisms interact. But there is no clear way of seeing how information passes between the two worlds. Each world has its characteristic materials, and these materials impose divergent ways of encoding information.

This difference in encoding is systemic, in the sense that there is something in common between all the different ways in which information can be biologically encoded—whether in molecular organization or in the behavior patterns of neurons—and something equally in common between all the different ways in which information can be culturally encoded—whether in speech, architecture, or clothing. The material difference in how something is encoded follows from a difference between two kinds of system. It was Humberto Maturana and Francisco Varela who first emphasized that every living system both follows a systemic logic and is actualized in a particular physical structure or medium.[4] The biological system of an organism allows it to maintain a dynamic and balanced relationship to its environment while exchanging energies and materials with that environment. It is from this dynamic and reactive exchange that it constantly extracts and renews its stability.

In language, however, stability and reactivity, locked intimately together in living systems, are dissociated from one another. Human languages change, but change is not their mode of being as such. A language can drop words and adopt new ones, but its tempo of change is far slower, and it maintains itself as an enabling pattern inherited across many human generations.[5] Languages embody sufficient flexibility to encode and carry a vast diversity of information, but they carry the information *for us*: it is we who are changed by the information, not the language as such. Although languages are slowly shaped by varied ecological conditions and the terrains in which their users find a living, once a language is up and running, it acts as a vehicle for information and is structurally independent from the information it carries. Nothing in a living system has this kind of independence, because organically encoded information is nothing other than an actual state of the system itself.

If human beings both are information (e.g., genetic, cellular) and exchange information by means of language, information is at work inside each of these domains, but how does it translate between them? Cognitive psychologists Stephen Kosslyn and Zenon Pylyshyn argue that translation between verbal and perceptual codes cannot occur directly.[6] A description in words cannot have a detailed part-to-part determinative relation to the experience that is being described. Strictly speaking, in the absence of a set of rules for converting each minimal piece of information into another, there could be no "encoding" going on at all. Given that there is neither subjective nor analytical access to this zone of encounter between two systems that appear so different, the concept of a heterogeneous informational field would seem a better starting point than the current, if often implicit,

assumption of a homogeneous one. On the most basic level, the domain of biological information and the domain of language-born cultural information operate in highly divergent ways. The two domains are essentially two different kinds of systems that select and process information in ways that are specific to themselves as systems.

Gregory Bateson memorably defined *information* as a set of "differences that make a difference."[7] For a living system, a set of differences "makes a difference" because the receptor of the information is active and not passive. A living system has attitude toward its environment: it prefers some things to other things. If it is a plant that uses sunlight, it will grow more leaves to get more of it. A bug that ingests only material of a certain chemical makeup will have a sense of smell tuned to the crucial difference. A hunting dog will want to know about everything around her to see whether there's something worth a chase or a bark. So all living things are alert to the differences around them that make a difference to their lives; they are informational systems filtering a continuous input of potential news from the world around them. This information changes them but allows them to maintain their systemic integrity as a constant. In this Batesonian sense, language must, on the contrary, be that to which a set of differences makes no difference. Not only is language simply the vehicle for carrying information between organisms, but its function would be impaired were it to be changed by the information it carried.

If language had no material existence, it would, logically, at every point be entirely shaped by the information it carried. Its materiality would offer no resistance to the information it carried. But information must always be encoded in some specific material. And language does indeed have material existence—namely, as sequences of audible sounds, visible marks, or other objects chosen to be used as tokens.[8] This materiality of language, the fact that it must negotiate, and therefore materially occupy—if often very briefly—the physical space that separates individuals, imposes fundamental and necessary characteristics on its mode of encoding information. Whether this materiality takes the form of vibrating air or hand-copied manuscripts stacked in a monastic library, the same basic fact is true: signs come in sequences or rows: one sign follows another. Interpretation depends on sequential ordering. Hermeneutics has a material ontology.

The serial sequential nature of language is also the characteristic that most powerfully defines the mental work of it.[9] What underlies and precedes an output message in language is a work of composition that somehow compresses complex multidimensional representations into a single serial information sequence. What underlies and follows the reception of a

linguistic message is the rapid and sequential deployment of interpretative "schemas"[10] that allow the recipient to form some kind of mental representation that (it is hoped) relates to the intention of the speaker. Hearing and reading seem, in this respect, equally bound to sequential and largely automatic and unconscious processes.

As living systems evolve to more complex levels, they develop specialized sensing modules and a nervous system capable of synthesizing representations. These representations can be thought of as organized groups of informational differences bearing on action in the world or attitude toward it. They may have varying degrees of stability, memorability, and formal shape. They may be sensed in any sensory modality, or synthesized from any combination of several. In the case of humans, representations either arise directly in sensory experience or are generated from messages encoded in verbal form. But in the case of words, how does this generation happen? The representation is not itself given in the verbal message. Rather, the verbal message gives instructions or suggestions for the forming of an appropriate representation in the mind of the recipient.[11] This seems clearest when someone invites me (verbally) to imagine something; then I actually try to imagine it rather than receiving the images directly from the words. Yet it would seem perverse to say that words do not represent anything. This would be to deny the existence of a symbolic function altogether. Is the way in which a word stands for something at all comparable to the way in which a visual image in the mind stands for a visual scene that's in front of the person doing the seeing?

In human visual perception, sensory input originates at the point at which differences in light fall on arrays of photosensitive cells at the back of the eye. Rod cells detect light, cone cells color; different cone cells correspond to different colors, these diverse signals being eventually recombined in the visual centers of the brain. Seeing is a highly selective process in which muscular control of eye movement and lens focus at the front of the eye are coordinated from further up in the hierarchy of visual perception. The light-sensitive cells, with their control systems, pass on electrical impulses to the roughly 1 million fibers of the optic nerve, which runs out of the back of the eye to deliver pixel-like information packets to the visual centers of the brain. In the brain's neuronal networks, information is encoded in the rhythms of the extremely rapid firing of large numbers of neurons.[12] For example, the movement of an object in a particular direction in the visual field is typically encoded in a noise-corrupted and statistical activity pattern across a large population of neurons, a pattern from which the representation of the movement of the object is "finally" retrieved.

When we see a moving object, we see a definite vector of movement and not a blur of statistical activity; there is an extraction of the definite movement from its noisy background.

Despite the complex encoding of visual information in diverse specialized channels, the orderly array of retinal locations is preserved in the passage from retina to brain. This enables the visual cortex to image a space that corresponds to the relative spacing of objects in front of the retina; the space that you mentally "see" matches the space toward which you are facing. The relationship is iconic, that is, based on formal similarity. To stabilize this image, the brain compensates for both your body's movement through space and eye movement, whether following a moving object with a moving gaze or the saccadic motion involved in looking at a static object. Different types of information are selected and integrated to assign height, width, and depth to objects. So the phrase *final retrieval* refers to a complex process of organization and synthesis of numerous visual data streams in a mental three-dimensional space that is isomorphic with the field of vision. This visual mental space is in turn integrated with tactile messages from the body's nerves to build an implicit image of the body as positioned in a space and as having a viewpoint inside that space. You not only see; you feel yourself as being in the space you see and as occupying a particular position in relation to the things around you.

How, in contrast, is information encoded and processed in a cultural system? Clifford Geertz defines *culture* as "a historically transmitted pattern of meanings embodied in symbols, a system of inherited conceptions expressed in symbolic forms by means of which men communicate, perpetuate, and develop their knowledge about and attitudes toward life."[13] Countless other definitions of culture are to be found. They may vary as to the contents listed, the categories of humans they forget about, and the activities embraced, but they all highlight the symbol (or its homonymic equivalent) as the central mechanism of cultural transmission. This suggests a direct, if preliminary, comparison of (cultural) symbol and (perceptual) representation, on the basis of their informational and coding characteristics.

A symbol, as an external representation, an object in the world that is perceived as indicating something that is not itself, requires conventional agreement on the part of its users: encoding and decoding is not automatic and inbuilt, as in the case of biological representation. Individual symbolic objects such as words need to be relatively permanent and stable. The symbolic code that inescapably underpins every domain of every human cultural system is human language. The symbols that make up human

language are signs that belong to a system of signs; their way of pointing at objects depends on their relationships to each other in the system, not on their being either like their objects or in some relation of proximity to them in space or time. The relation is a conventional one; a particular human community simply operates a shared agreement that a particular sign occupies a particular place in the system of signs and so is used to indicate a particular object. The link between a particular sound in a particular language and its meaning is not wired into the brain; you have to learn it.

To make language work, we learn to interpret symbols fast. As habitual language users, we are alert to perceiving something as a symbol of something else rather than perceiving it as itself. To learn a language is to absorb a library of interpretative schemas that leap into action the moment that symbols are detected. Hear half a word, and you are ready to know what it means. See half a sign, and you are primed to complete it. So although symbols are things in the world that we perceive and are therefore also perceptual representations, what makes them work as symbols is the sudden and rapid triggering of specialized language-hungry interpretative schemas that jump into the process of perception and deflect it from the object itself—for example, the sound of a spoken word as an actual physical vibration flying through the air—to what that object stands for in the world of language.

In a biological system, information is received, transmitted, analyzed, and stored by variations in the states of activity of the parts of the metabolizing entity itself. Each part is a subsystem with a series of levels of coding, each with its own characteristics. Coding at any level is selective for the priorities of its subsystem at that level and may also involve generic data compression and error-compensating coding factors. The code is not the same in one part of the system as in another. And inside each part, the code may vary between input and output and anywhere in between. So coding in biological systems is heterogeneous, modular, and hierarchical.[14] But in language, coding is homogeneous, nonmodular, and nonhierarchical. The combinatoric level is single, autonomous, and universal. There is just one level on which everything is written into the code, and it is always the same code. This level, where the elements of the code are combined into utterances, is unique, autonomous, and universal. It works the same way for every human language in every circumstance.

A further and crucial difference between organic coding and cultural coding turns on the question of time. In a living system, information is always in the same time flow as its own variants, always coexistent at any moment with both its richer, more detailed versions and its more schematic stripped-down versions. In the case of the moving object, for example, the

resolution of a definite image of the movement of the object in space does not put an end to the statistical activity of the neurons producing the information to be resolved. But with a language system, information is assembled irreversibly into prefabricated discrete packets distributed sequentially or serially in time.[15] You cannot eat your words. Time is striated. Every utterance has a beginning, a middle, and an end, and follows in a crocodile chain of previous and later utterances. The system that makes this possible remains unaltered (in principle) by any one thing that is said in it. The system itself effectively exists outside time. You learn it as a child, and it is there when you die. The same applies to the individual information-carrying elements, the words of the language, which must be durable to be instantly recognizable. To use language is to bring together two distinct planes of time: the slow, almost immobile plane of the permanent outside-time language system, and the fast, immediate plane of utterance. In contrast, representations form in the sensory system of an organism not by the convergence of two separate planes of time, but by the continuous arrival of information streams that are being constantly filtered and recombined in a single time flow.

The idea of a "final retrieval" all too easily suggests a moment at which something jumps across from the workings of nerves into the subjective domain of mental imagery—the moment, as it were, at which the perceptual neurons finish their work and the magic of subjectivity is set in motion. In fact, the opposite is often the case, and the economy of attention may well redirect perceptual attention away from something as soon as its image has been clearly resolved. But this doesn't make the image final in the sense of detaching it from ongoing process. If world imaging is linked to the potential action responses of the organism to its environment, these responses are always ongoing. The work of the senses is continuous and forms the organism's alertness to its world. A perceptual system constantly takes in new information and encodes it into rhythms of neuronal behavior, even if the organism never becomes aware of it and never acts on that information.

This flow and presence of information in excess of the data that is about to be, or that has already been, incorporated into a putatively "final" representation, is turned to advantage. The system keeps its information available and on hand at different levels simultaneously so as to allow attention to draw on greater detail, should this become necessary, by retuning the selectivity at work at lower levels. This retuning is known in the psychology of perception as "reverse hierarchy procedure."[16] In the normal course

of things, explicit representations are generated from an upward flow of automatic information processing that itself remains implicit. These are the representations that meet the demand for rapid and categorical scene interpretation. If, for some reason, the automatic system fails to deliver and something feels wrong or ambiguous, reverse hierarchy procedure comes into play, redirecting attention onto lower levels, to take into conscious perception detailed information that previously had been implicit.

This perceptual capacity to rerun the productive process of our imaging of the world might be thought to be of marginal interest, but not so. It is the path by which perception tests the hypotheses of cognition; it is the way in which we clarify whether we are really seeing what we think we are seeing, or really hearing what we think we are hearing. It is how we decide, in case of doubt, whether something is real or not, and ultimately whether we ourselves are real or not, in the sense of knowing that we are awake in the world.[17] Although the domain of sensory experience is a domain of representations that correspond to the organism's patterns of need and activity in the world, these representations are never quite completed; they can always morph toward more detailed and less generic versions of themselves as environmental information is continuously absorbed. Not only is there a continuous input of new information at lower levels, but also a continuous potential availability of variant versions of every explicit representation. This intrinsic nonfinality of perceptual representations will become increasingly important in the argument that follows.[18]

There is also something directly appealing in the idea of the nonfinality of perception that relates to the experience of music and painting and indeed to any moment in which we find ourselves absorbed in listening or looking. This is exactly when something becomes perceptually interesting. We look a second time, and what we see makes us want to look even more. Our purpose-driven connection to what we are perceiving is put aside. We no longer see a bread knife lying on the kitchen table; we see the particular way sunlight reflects off its blade. We no longer hear a police car; we hear a sound that rises and falls in a complex way that we can follow until it finally merges back into the urban rumble.

In composer Pauline Oliveros's notion of "deep listening" is the idea of setting aside the crude demands that we normally make of perception so as to accord it greater respect. A new ethic of musical work would then form itself in the light of this respectful kind of perception. Composers, she feels, should listen to things that are not usually thought of as giving off audible signals, such as the silence of their own still bodies. Listening,

in this sense, would then become a guide to a better way of being in the world, less exploitative, less hysterically rational, and this could enter the composition of music in both a literal way, as a phenomenological treatment of sound, and a more subtle way, as the necessary ethical position of the artist as it bears on decision-making. "My body is sound / Listening guides my body / Sound is the fibre of my being and of all sentient beings without exception."[19]

3 From Semantics to Imagination

In summer 2005 I asked the late great *xoomei* throat singer Kongar-Ool about how musicians in Tuva talk about music.[1] "When we speak about music in the Tuvan language," he said, "this is not to fix things, as in Russian music, or written music. Instead we work toward a common idea in a very improvisational way: the situation stays very free, and we don't use language to prevent that." Sayan Bapa of the Huun-Huur-Tu group answered a similar question by saying: "We talk about music in both Tuvan and Russian, Russian if you want to be quick, Tuvan if you want to be deep." Multi-instrumentalist Radik Tulush said, "Generally musicians don't talk so much, but play. If you speak Russian you tend to slip toward thinking in terms of Russian music: everything very analytical." Russian music was "too grammatical," and I started to get the feeling that Tuvan is to Russian as music is to language. In Tuvan there are fewer distinctions of tempo as an isolate, for example, but many distinctions of tempo as a part of a whole style of playing. A style of playing comes over, perhaps to both players and listeners, as a complex unity, an irreducible experience. A musician who has been through Russian music school, on the other hand, has interiorized an analytical vocabulary, considers everything separately, and then puts it all together at the last minute. It was important, I learned, for a Tuvan musician to begin playing Tuvan music before going to music school. Going to music school and then taking up traditional music was a bad idea.

The Tuvan musicologist Valentina Suzukey described Tuvan musicians to me as reluctant theorists: "I found that the musicians worked intuitively and empirically and had no vocabulary to theorize or generalize their thinking: they would just say, 'This is how we do it' and 'That isn't how we do it.' If I identified and named an interval, the musician would say, 'What the hell is that?'" Outsiders, too, quickly discover that musicians would rather show than explain. I learned this the hard way by having throat-singing lessons: my teachers would demonstrate a particular style, tell me

its name, wait for me to imitate it, smile at my attempt, demonstrate it over again, and so on. It's notable that the only analytical commentaries on throat singing that could provide a method for outsiders are written by non-Tuvans: Tran Quang Hai (1980) from Vietnam,[2] Ted Levin (1999) from the United States,[3] and Mark van Tongeren (2002) from Holland.[4]

Musicians in rehearsal move between doing music and talking about it. Some of this talking must include communicating how you experienced, say, a particular version of a song. To communicate an experience seems like an ordinary thing to want to do. But how precisely can you get a perceptual experience into words? How can information pass from coding as perceptual representation to serial coding as language? How deep and far back do the demands of serial coding go in the organization of what is to be encoded?

The term *semantics* is used in the study of language to refer to linguistic content as a subsystem of language, alongside other subsystems such as phonetics and syntactics. This suggests that a structural treatment of linguistic content could be developed to show how content is organized in ways that parallel structures of syntax. But the idea of treating content as a subsystem of language, if taken literally, seems suspect, because it implies that nothing enters language from the outside. It pushes further away the boundary that I'm interested in, which is the interface between linguistic and nonlinguistic representations, whatever that may turn out to be.

One argument for a semantics determined from below, rather than from the requirements of language code, applies information processing models to the formation of perceptual representations, and then carries the explanation on upward into the domain of semantics. For Fred Dretske, the transition from percept to concept is "fundamentally a matter of ignoring differences (as irrelevant to an underlying sameness), of going from the concrete to the abstract, of passing from the particular to the general. It is, in short, a matter of making the analog-digital transformation."[5]

Is Tuvan music-speak analog, and is Russian music-speak digital?

For musicians of my generation. the move from analog to digital sound, exemplified in the switch from vinyl to CDs, was how we started to think about the difference between analog and digital. We had taken for granted a world in which the inexactly quantifiable behavior of a physical medium—tape coated with magnetic particles, or vinyl shaped by the imprint of a vibrating needle—had been made to respond to the inexactly quantifiable behavior of sounds. It had been possible to create a surrogate kind of musical experience that made use of the parallels in the behaviors of different physical systems. The warmth came from the fact that you felt embraced

by the sound because the sound embraced itself; the hard edges between different notes and timbres were squashed and smoothed by the various inaccuracies and technical shortcomings to give something equivalent to the sensory interest of a live event.

The move from analog to digital, a massive changeover in an entire industry, seemed definitive and dramatic. A sound would now be encoded into zeros and ones. But anything falling below the threshold at which the coding worked was left out of the equation. So in the early days of digital, the reverberations after the end of a solo flute note in a lively room would begin to distort and sound wrong. Later, the threshold at which the code was effective was improved, and you could listen to the sound disappear into silence.[6] We remembered that ears too have thresholds and learned that the difference between analog and digital was not as absolute as we had thought. But if this difference is not absolute, why then does Dretske refer to *the* analog-digital transformation? You would think that in a hierarchical perceptual system, every upward step in the direction of feed would involve prioritizing some information over the rest, pulling it out of a prior state of having been embedded in a richer matrix of other information.

Dretske's project is to show that information theory is pertinent to philosophy by using the theory to explain how concepts come to be formed. To do this, he maintains certain a priori formal definitions of *concepts* and *beliefs* so as to hold them apart from perceptions. He then inscribes this distinction onto his map of human mental process in the form of a radical break between analog processes, restricted to the domain of perception, and digital processes, restricted to the domain of conceptual cognition. He assumes that percepts and concepts are directly comparable and that concepts are percepts that have undergone a specific change. But by restricting the abstraction of information to the domain of concepts, he underrates what a perceptual system does and gives insufficient attention to the fact that perceptual objects are constructed by a synthesis of diverse informational inputs, including inputs from memory.

The conceptual level may, rather, be simply the last in a series of analog-to-digital conversions. This begs the question of what makes it the last, and the answer would need to be the intervention of some factor from outside the perceptual system—something that cuts in to the perceptual process and takes the information onto another plane of action. In the case of a nonsymbolizing animal, this cutting point would be the point at which what you are perceiving becomes plainly linked to an urgent course of action. In the moment when an animal forms a belief that what it is seeing is a rapidly approaching predator, what is cutting into the perceptual

process is the recognition pattern associated with flight behavior. There is a convergence of the visual image with an interpretative schema coming in from memory and strongly associated with getting the hell out of there. In the case of a symbol-using animal, there might be an imperative need to communicate, which would trigger an encounter between perceptual information and language. But you cannot explain this as an upward extension of a one-directional process. It is, rather, that something coming up from below is being cut into by the operational demands of a serial coding system of communication.

But this idea of a vertical perceptual process being cut into by language could itself be too confining. After all, part of what I have been saying is that perceptual processes at lower levels are not cut off, even when a definite representation has been decided on and presented to consciousness. The idea of a space of negotiation might be a better starting point for describing the mental processes of a conflictual being. Ian Robertson describes a potential conflict between conceptual thought and mental imagery in problem solving: "Mental imagery and verbal-analytical thinking can be mutually inhibitory, under certain circumstances. Pre-school children's thought is heavily dominated by mental imagery–based thought processes, but these capacities tend to atrophy under the influence of a largely verbal-analytic–based school curriculum. While certain types of problem are better solved by verbal-analytic thought processes, others—insight problem solving, for instance—are best solved when these modes of thinking are suppressed and mental-imagery based processes are used."[7] Here there is no sense that verbal-analytical thinking is in some way "above" imagery-based thought processes. The idea is more of different resources that can be channeled in different directions according to the type of problem to be solved. For this reason, it seems unwise to restrict a priori the class of mental representations taken up into language to that of concepts.

Generally we think of concepts as being the elements of thought: we think them or think with them. So they are already very close to verbal language. But imagination is a much larger and deeper domain than this. For artists, the importance of imagination seems self-evident. But it has taken a long time for the cognitive and scientific study of imagination to get far enough off the ground to suggest how imaginative mental representations might articulate in some way with language. Kant's work on what he called a "productive faculty of cognition" was an early landmark in the history of imagination studies.[8] But Kant still thought that the core process of cognition took place with concepts, not with mental imagery: only concepts were sufficiently formal, abstract, and active. Later, with the development

of computational models, formal and abstract models for human thinking would return with a vengeance. Some researchers focusing on more pictorial models of human cognition felt they had to fend off a definite pressure to apply these models.[9]

An important breakthrough came with George Lakoff and Mark Johnson's theory of "image-schemas."[10] These are representations that are grounded in specific bodily sensory experiences yet abstract and general enough to transpose to different contexts of experience. For this connection to develop, there needs to be a similarity in pattern between the original context and the new context. Lakoff and Johnson analyzed linguistic metaphors to show how they are not merely figures of speech generated on the level of language, but reflect the deeper processes that allow the extension of image-schemas into zones of experience other than those in which they originated. Some of these zones may include what we would normally think of as abstract thought: "Pre-conceptual structural correlations in experience motivate metaphors that map that logic onto abstract domains. Thus what has been called abstract reason has a bodily basis in our everyday physical functioning. It allows us to base a theory of meaning and rationality on aspects of bodily functioning."[11] A picture begins to emerge of a mental activity in which much of the work previously thought of as conceptual and abstract is in fact closely grounded in the bodily specifics of humans and how these specifics are expressed in the organization of subjective experience. This is radically different from Dretske's model of a mind that has to strip away the informational richness of sensory experience to reach a cognitive level at which thinking may take place.

But if so much of cognitive activity is the combination and extension into new domains of information-rich and multimodal image-schemas, how are data ever prepared for coding into language? Deprived of a thick layer of prelinguistic conceptualization, does language just make do with a thin layer? One way to answer this is to say that it is conceptual structure that is expressed in language rather than concepts as such. So what happens at the interface between cognition and language is that bits of conceptual structure are abstracted from image-schemas. Conceptualization is not an additional layer that comes "above" imagination, forming a mode of cognition that would satisfy Kant. Instead, conceptual structure is being seized from anywhere in the whole cognitive activity.

As their thinking developed, Lakoff and Johnson began to expound a neural theory of metaphorical connection.[12] Underlying this theory were new discoveries that shifted our idea of brain processes as following fixed anatomical patterns to a far more dynamic model of neuronal networks.

Once the extent of the plasticity of the brain had been grasped, it became possible to show how patterns of individual experience were reflected in, and reinforced by, the recruitment of neurons from more general functions. This gives us a way of understanding how individual human minds grow apart from one another to achieve an extraordinary diversity. It also shows how certain experiences can feed into a common culture, and even acquire a cross-cultural universality.

A metaphorical connection, such as that between affection and warmth, is learned when two experiences repeatedly occur at once. This kind of connection can easily be shared between individuals because of our physiological similarities. In the neural theory, a repeated synchronization between the firings of different groups of neurons results in the growth of new neuronal connections between them. A cross-modular connection of this type is itself modular: that is, it is specific to the information-bearing structures and their exact connections rather than being the result of the intervention of a specialized kind of neural network concerned with the abstraction of patterns from sensory data. There is no process of abstraction in which information is reencoded in a more generalized form into something like a conceptual prelanguage. Instead, an imaginative and fictional dimension comes forward: affection, physiologically linked to warmth, itself becomes warm.

In human evolution, cultural development began well before organic development closed: the human being was not only the producer of culture but its biological product.[13] The structure of our biological organization modified itself as it adapted to the new environment of culture, itself an output of our way of life. We would not otherwise have had the brain, the hand, the larynx of a thinking, tool-using, speech-speaking animal. This suggests that the emergence of culture does not destroy the modularity of organic structure per se, but is dependent on the adaptation of ensembles of specific organic modules to new roles. In other words, the informational character of language and culture is superimposed onto that of a living system, and the modifications made by that living system to accommodate the emergence of culture are consistent with the maintenance of its own informational character. Current research into human language, for example, does not suggest an integrated and specialized language competence grounded in a specific biological structure: it suggests, on the contrary, that using language involves the coordination of many diverse skills of different types, each of which may be grounded in a different biological structure—connected in turn to other kinds of nonlinguistic competences.[14] What focuses all of these skills together is the art of language itself, an art that flourishes exactly and almost exclusively at the communicative

surface where human individuals cross paths and minds. It is the technical demands of this communications interface that make human language a radically new and different phenomenon in the informational universe.

One of Bakhtin's great insights is that it is the irreducible singularity of the physical perceptual viewpoint of the individual that makes "the other," and the urge to enter dialogue with this other, so essential.[15] The fact of the other's viewpoint is in your face from the moment you coexist in a shared space and time. You see what's in front of you, and the other sees what's in front of him or her. Watch my back, and I'll watch yours. Human dialogue makes meaning by collating sense, gearing together the sensory viewpoints of more than one individual. But the counterthought comes quickly: it is precisely language that creates the problem of the other's viewpoint or, rather, rephrases what had been another kind of relationship and draws attention to it. Language merely sends us off to solve the problem it creates. Nevertheless, the divergence between perceptual and linguistic informational modes hardly inhibits us from rapidly and efficiently comparing and combining perceptual viewpoints within a shared social space. If this constitutes a powerful operative mesh between perception and language, how and when do the informational differences in the production of representations become really consequent?

4 Subjectivation

*Around 1990, having connected in my mind shamans and improvising musicians,
I was still thinking of shamans as performers in a Western sense, but performers
who had developed skills to manipulate their audience's frame of mind. Possibly
this was the way forward that Ken and I (rather arrogantly) saw for our own
music at the time. We'd noticed, from listening to the few recordings of Siberian
shamans we had, that the way they played the drum seemed to involve almost
constantly changing the tempo and shifting the accent. There was no equivalent
to this in any other kind of music I had ever heard.*

*By chance we met a researcher at Novosibirsk State Conservatory who was tran-
scribing recordings of shamans drumming and getting into all kinds of notational
problems over the rhythm. To look at these scores was to imagine shamans doing a
lot of very complicated counting to play them. The approach seemed misguided. It
was around this time that I drew a connection with Robert Ornstein's work on the
psychology of time.[1] Ornstein had suggested that our subjective sense of duration
depends on how a succession of events is grasped—in particular, how events are
divided up into groups for storage as information. A span of time in which events
could be quickly and simply grouped would be experienced as subjectively shorter
than the same span of time containing more frequent and less classifiable events.
He conducted a series of experiments whose results supported this hypothesis.
Could it be that shamans were deliberately confusing their audiences, suggest-
ing multiple different modes of grasping their drumbeats by constantly varying
their tempo and accent? Extrapolating from the idea of subjective duration to a
wider idea of subjective experience in general, and thinking of Husserl's picture of
the subject constantly forming itself in relation to the objects of its experience,[2] I
imagined that shamans were subverting the normal ways in which their audience
members continuously produced themselves as subjects so as to bring them into
highly suggestive states of mind.*

*This idea of what shamans were doing did not survive for long. In person,
shamans almost invariably spoke about "seeing," encountering spirits, and using*

the drum to modify or negotiate with their own inner states. They were not, in this sense, performing for their audience at all but for the spirits. However, the connection between subjective experience and how we process, group, and store information stayed in my mind. Was it possible that subjectivity mediated between informational processes that were prior to experience and what people did with that experience afterward, in the sense of what motivated them to do certain things in certain ways? Could subjectivities of different types channel and orientate conflicts arising in the human informational field into the distinct forms of motivation that show up in all human cultures?

The social institutions and patterns of behavior that constitute the visible shape of human society accumulate from the actions of individuals over long periods of time, and these actions are motivated (even if, to paraphrase Marx, nobody ends up with what they wanted). How is it possible to connect this world of motivated human action with informational processes that appear to be nonvolitional? One approach could be to deconstruct motivation as merely a retrospective trick by which individuals or groups lay claim to actions that are actually determined otherwise. A second approach begins by going back to what might correspond to purposive motivation on the level of the organism.

Conducting a final exorcism of transcendent purpose from the science of biology, Humberto Maturana and Francisco Varela insisted that properly grasping the organism as an autonomous self-organizing (or autopoietic) system requires expelling from it any idea of purpose at all.[3] They were adamant that although questions of teleology, purpose, and design may be useful in the descriptions of outside observers, every state of a living system is always complete and always continuously expressing how the elements of the system are dynamically working together at that point in time. A fetus, for example, does not have the purpose of becoming an adult and is not *for* becoming an adult; rather, a fetus is a complete expression of a state of the system of an organic individual at a given point in time. So anxious were they to quarantine the autopoietic system from the descriptions of the outside observer that they suggested using the term *deformation* in place of *information* to describe how changes in the environment impinge on the self-organizing process of the living system.

They exaggerated their case. At least beyond a certain level of evolution, living systems develop means of representing their states to themselves, becoming their own observers and producing their own self-descriptions. The concepts of information and encoding acquire objective weight because the organism, with or without an external observer, continuously prepares

incoming information for the representations it needs to image itself and its own changing states within its environment.[4]

An external viewpoint to any situation is possible in theory—the much vaunted viewpoint attributed to the observer in objective and scientific procedure. But as Donna Haraway pointed out, we cannot actually occupy this position, because as living beings ourselves, we are always in active relationship to whatever or whomever we are observing.[5] So this detachment of the observer is fundamentally imaginary, even if the contribution from imagination is hidden behind the many detailed and technical procedures that are deployed to exclude bias. But this doesn't mean that the "observer" has to be autistic. In other words, this observer, who is imaginary, may, by a further act of imagination, operate the nonautistic belief that other sentient beings have minds. We as imaginary observers can legitimately imagine that other beings imagine.

In this limited way, and putting aside temporarily the major questions of the continuity and coherence of subjectivity, something like a Cartesian theater goes on inside every intelligent being, and Descartes wins over Dennett.[6] Also in this limited way, any biological system counts as a "who," having an intrinsic teleology that gears its activities toward an adaptive maintenance and reproduction of its own structure in an environment.

With the arrival of human language there is additionally a "communicative who." A new communication system is now in play, geared to the sending and receiving of messages between the individual organisms that together constitute a biological system. Language, in this sense, foregrounds the individual against the background of genetic identity. In animal languages, the communication system is largely a special extension of the activity of the biological system and continues to be an expression of its intrinsic teleology.[7] But human language is an open formal system of extrinsic signs that generates, distributes, and redefines the purposes of its user communities.[8] There is a new kind of teleology, to be negotiated in some way between the individual language user, "I," and the community of language users, "We."

But to accept the two opposed teleologies of organism and language as givens that directly determine and motivate what goes on in the human world would be to have the field of social action defined top down on the basis of the two sets of systemic characteristics. It would imply a rigid and Manichaean confrontation between a biological self, driven by a primordial will to live, and a social self that has perfectly introjected the logic of society.[9] In fact the informational vectors at work in the human field are active and expansive rather than purposeful. What, then, would a symmetrical

upward movement toward purpose look like? Where in the interactive field, and in what sense, and in what way, do centers of activity and attention arise?

To answer this is to pinpoint some of the key ontological moments that arise in the human informational field. Taking a step back, the "who" is no longer the already present and always already-taken-for-granted "who" of purpose but a subject that is continuously coming into being in the systemic processes. *Subjectivation* is the process of this continuous coming into being. The accent shifts from a fixed monadic entity, the "subject" dear to philosophy from Descartes to Sartre, to the dynamic process by which the subject is continuously produced. In the history of thought, this investigation belongs to Michel Foucault.[10] Following Marx, Foucault focuses on political subjectivation. He sees political control not as limited to the imposition of external discipline but as interiorized in the construction of a historical subject. Political power works not just by imposing from the outside but by getting inside people so that they willingly carry out what power wants them to do. What carries power into people is how it organizes what people know or think they know. Knowledge is not neutral but structures both its objects and its subjects, and makes its subjects the objects of government. The subject must then be understood as the continuous output of a sociohistorical process and not as a given and autonomous agent. But Foucault's idea of the subject is limited to this sociohistorical level and does not register the presocial materiality of the human. Or rather, he does not register it as an active field, only as the passive field in which sexuality or bodily hygiene, for example, are shaped by political power. So Foucault suffers from the same problem as Marx: he is not materialist enough.[11] It is necessary to take a further step, a step back, and grasp the human as produced by the continuous collision of sociohistorical systems and biological systems, understanding biological systems as active informational fields and information as a potential relation between material physical events in any world in which beings are sentient.

This stepping back takes us away from the social history of the subject and toward its ontology. As the investigation of being itself, an ontological perspective is always looking for a further backward step, rather as physicists look to the smallest particles of all in search of answers to the biggest questions. A material ontology of the subject concerns the informational conditions under which a subject comes into being. These conditions are connected to time, how time is organized, and how the organization of time interlocks with how information is grouped and processed.[12] This ontological coming into being is not something that gets completed before

the construction of a discursive self kicks in and history begins. It is a continuing process partly hidden behind the more visible historical and social processes, partly in tension with them, and partly making itself felt in certain forms of activity that do not cohere with dominant discourses.

The presence of a living system is an absolute condition for there to be subjectivity, and subjectivity happens only inside living systems. Jonathan Smith wrote, "Each part of a living system is equipped with its own intrinsic space-time. When the system functions, the space-times of its constituent parts interact in various ways. As biological systems are able to insulate their component parts from environmental influences to a greater or lesser extent, one may propose an answer to Schrödinger's question, 'What is life?' characterizing biological systems as those systems complex enough to isolate their component space-times."[13] When complex living systems develop brains with a high degree of plasticity, this capacity for the isolation of space-times carries over from physically distinct anatomical organs to groups of neurons recruited from more general functions in the brain. Patterns of individual experience develop, corresponding to recurrent neuronal connections, and particular types of information processing. In other words, because many of the neurons in the brain are not allocated fixed functions, mental activity can form subsystems that are not tied down anatomically and structurally but are still capable of temporarily isolating their own space-time from others.

Clearly the brain has fixed modules—limbic system, frontal cortex, and so on—and itself functions as an organ, or part, of the whole organism: mental space-times may be experienced that correspond to these anatomical differences. However, the brain is not only an anatomical part of the body; it is also a physical structure developed for the needs of a mental activity capable of generating virtual bodies and reconfiguring them according to which groups of neurons are firing with which.[14] And this question of the readiness of neurons in the brain to be linked or unlinked to others, to synchronize with others or—in our case, especially important—to set up counterpoints with them, underlies the vastness of what can be experienced and what can be imagined by a mind. The space-times of subjective experience may be limited by brain anatomy, but they are not determined by it. What is far more likely to shape these space-times is the prevalence of certain types of information flow that are given in the operative ways that a mind has to relate to its body and its world.

When a pattern of experience becomes reflexive and begins to experience itself as experiencing, it is in a process of subjectivation.[15] The nature of this reflexive process, how a subject retrieves memories of its own earlier

phases and projects itself forward in imagined future phases, that is, the kind of information processing in which it consists, is shaped by the kind of information flow that generates the original patterns of experience. This flow is itself shaped by the potentials and limits of the materials in which information had previously been encoded. The biggest difference is whether these materials are part of the organic materiality of the living being itself, or whether they belong to an exterior language-world in which objects have been individually recruited to stand for other things. It is this individuation of the exterior sign that entails a specialized system for sign recognition and in turn defines a particular kind of information flow in the minds of humans.

Much about the general nature of the subject would seem to apply to the core self of the biological organism, described in the work of Antonio Damasio.[16] The parallel is useful, although Damasio's main focus is on consciousness and the emergence of a conscious self. He outlines the biological evolution of consciousness in successive stages. In the first stage, there is a protoself, "a coherent collection of neural patterns which map moment by moment the state of the physical structure of the organism in its many dimensions." From the protoself develops (during evolution) a core self, an imaged account of object-organism relationships in a spatiotemporal context. So the core self is a set of representations of how the protoself is modified by its encounter with objects, that is, by experience. He notes that although this process of representation is transient, it is in practice continuous because there is a permanent availability of provoking objects.

Damasio doesn't find it problematic to attribute several selves to an individual organism; the trick is in how these selves are embedded and connected. My argument requires other distinctions and reserves the concept of self for an organizing center whose ontology is powerfully mediated on the level of social interaction: a self is built up in active social relation to other selves. Furthermore, except in pathological cases, and *pace* Damasio, we tend not to think of a single body as being occupied by more than one self. The notion of subject is, however, more flexible, and refers to any identifiable center of subjectivity, even if transient and discontinuous.

Damasio's project focuses on evolution and the resultant structures. But in my description, a subject is seen as always coming into being, not as a structure resulting from a completed process. So the structures produced during evolution form the background conditions for the coming into being of subjects, but they are not the subjects themselves. The key question, the one that lies midpoint, as it were, between the question posed by Foucault and the question posed by Damasio, is, Out of what kinds of informational processes do subjects make themselves?

In perception, a representation is fixed largely by attribution of source: sensations are synthesized in terms of an event or object belonging in a world more or less known to the perceiver. But as we have seen, the permanence of this world as a totality does not underwrite the finality of the interpretation that is happening at any one moment. A perceptual representation occurs at the same time as other versions of itself, and in an informational work space in which comparison with these other versions is ongoing. One might say that it occurs at the intersection point of different streams of information and that this point moves as the streams move and change and the proportional strength of each stream varies. But in language coding, a representation is fixed by contrast with other representations in a system that is immobile and permanent. To activate that system is to launch equipment that sprints to different points in the system and gets back in time to supply the next bit of the thing you are saying, or the next interpretative schema for understanding what someone else is saying to you. This all happens so fast that you do not know it is happening—unless something goes wrong and you cannot find a word or have to correct your understanding of an earlier part of a message.

It is this moment of encoding or decoding at which the modular images and conceptual structures that immediately precede or follow the articulation into language spark across to the language system stored in memory. The countless rapid connections between the fixed and static plane of the language system and the immediate situation in which we need to communicate are marshaled by the quasi-automatic timetables of utterance and interpretation. This is the serial moment of a locutionary subject—a process of subjectivation that develops from this exact characteristic of the time in which language is in play. Everything here is geared to the production or interpretation of a sequence of signs in time.[17]

A language system must be known to its users. The language code is internalized, and humans have brains adapted for language use. The representations encoded in spoken language pass from being encoded as radiating pressure waves in air, to being encoded in a neural representation of audible speech. More precisely, there is a very rapid sequence of acoustic mapping of the incoming signal, followed by phonetic processing for word recognition, followed by linguistic processing. Our specialized language recognition facility seizes language from any incoming auditory signal as early as possible—within a few milliseconds—for phonetic processing. Once a language signal has been recognized, we immediately begin to parse what is being said through a narrow moving window of attention and short-term memory, deploying limited "look ahead" as part of our way

of understanding sequences of words and their organization.[18] In short, language, specially speech, involves a highly specific and constrained movement of attention in time.

Words, for example, arrive as sounds, part of the total composite sound wave reaching the ear that embraces the background sound, the hum, the richness of its entire frequency spectrum, and all the other voices that may be audible but do not seem to be addressing you but to be conversing among themselves. Suddenly you realize you are being spoken to, and the words addressed to you instantly detach themselves from the total sound wave and become subject to entirely different analytical processes. You don't have to know how to do this or to think of doing it: it is automatic in adult humans. Above all, the serial moment is this automatic quick-fire intervention of the interpretative schemas by which fragments of sound are picked out and immediately combined into symbols recognized one by one as elements of a system stored in memory. In every instant that this connection between sound and symbol is made, it is complete and finished, and you are already going on to the next.

It is precisely through this narrow moving aperture of moving attention that we, as social beings, set out to define ourselves in relation to others and to articulate our own subjectivity on the level of self and social narrative. As language users, we are tightly held to the serial language time scheme both pragmatically and psychologically. The limitation is not so much semiological—the alienation of the sign, rigidly and arbitrarily representing the absent, from the immediacy of bodily sensation—but the seriality of signs in the medium and the effect of this seriality on the continuous production of the talking subject. And this applies as powerfully to the inner voices, the circular monologues of a sleepless night, as to the to and fro of dialogue.

In spoken language, individual speakers are personified and named as participants, and the talking subject finds a position and an identity in the language system. Each *person* (from the Latin: *per-sonare*, to sound through the actor's mask) has an individual voice, often instantly recognizable by its timbre. There is a dialogical obligation to speak, to answer, to make oneself apparent in language, an obligation that binds the individual language user into the community. Each speaker deploys a grammar of social, spatial, and temporal comparison to generate a dynamic definition of position in relation to others. Each participant is responsible for maintaining a shared semantic tempo by appropriate contributions—"to sustain a particular definition of the situation," as Erving Goffman put it.[19] No one should drop the ball. There are, in addition, significant neuronal connections between the perceptual systems of language audition and the motor systems that control speech production. Hear language, and you are always on the point

of answering. All of these factors reinforce the binding in of the language user to its serial moment.

A contrasting kind of time flow emerges from the nonfinality of perceptual representations.[20] Sensory experience is vivid, yet paradoxically what illuminates it from within is its potential to be other than what it, at any moment, is. Perceptual time is a time in which information is both continuously arriving and continuously waiting and potential—a time of depth and ongoing simultaneity in which events and objects glow with the likelihood of imminent transformation. This stems directly from the informational structure of perceptual systems, but is fully realized only when perceptual systems evolve to the point at which perceptual input is no longer directly and automatically linked to instinctual responses. At this point, different qualities of attention become freely possible. It is when we, as humans, turn our attention to perception as such that we sense the aura of the continuous possibility of a reconfiguration of the pattern. This aura is protoaesthetic: it is the sintonic tuning between organism and environment, between individual and world.

For the nonfinality of perception to become more than merely potential, a distance must open up between perceptual images and the interpretative schemas that would normally be delivered from memory to link an image to a course of action. An automatic recourse to interpretative schemas dominates when objects are constantly assumed to stand for other objects, as they are in human language. The thrust of language is to assume that objects of perception are not worth perceiving as such, but only for what they signify. In this sense, objects deliberately designed to encourage nonfinal perception may be reacting against a semiotic form of perception overeager to dissolve sensible experience into meaning:

Aesthetics is the discipline dealing with the attunement [sintonia] of organism and environment. This attunement is disturbed by the acceleration of stimuli in the infosphere, of semiotic inflation, of the saturation of any attention and conscious space. Art registers and signals this struggle but at the same time sets the conditions to discover new modalities of becoming: aesthetics appears at the same time as a diagnostics of the pollution of the psychosphere and as a therapy directed at the relationship between the organism and the world.[21]

What opposes sintonia is not, as Stephen Zepke thinks, the contemporary condition of semiotic inflation but the emergence of semiotic communications as human language in the first place. Other species, busy with survival, are unlikely to have much time for meditatively attuning themselves to their environments. Sintonia is, rather, something like the process of the core self as felt by humans when language is relaxed from. Its form of

temporalization is that of a sequence of adjustments, its time is circular and incremental, its subject absorbed, in the sense that there are no inherent limits to the input and reconfiguration of perceptual information.

The distance that opens up between locutionary and sintonic subjects comes from the difference between the types of information flow that characterize their processes of subjectivation. These processes are made possible by the capacity of the cerebral infrastructure to coordinate its neuronal elements in different ways at different times. The resulting centers of attention, which experience themselves as experiencing, and therefore as subjects, are highly defined by the kinds of time flow and the particular rhythms of synthesis through which their experience is constructed.

As humans acquire culture and its new informational processes, motivation becomes complex and multiple, reducible to neither biological nor social drives. The capacity for subjectivation becomes both a mode of navigating a conflictual field and the mediating form by which the biosocial determinants bearing on human existence express themselves in diverse motivational streams. The moment a protohuman forgets the original reason for carving a hand axe and becomes absorbed in looking and turning and handling the object itself, the axe starts to become a perceptual machine, and this machine starts to reinforce the sintonic subjectivation that underlies the forgetting of its instrumental function. The moment a protohuman, glancing at a hand axe, sees in it no more than a sign of the status of its owner marks a certain level of semiological proficiency that will one day read everything and sense nothing.

This distinction between locutionary and sintonic subject is highly suggestive for mapping how different informational processes connect to contrasting channels of activity and attention that show up in all human cultures. But although this was inspired by thinking about shamans, it does not directly address the shamans' rituals. We need to look elsewhere for a form of subjectivation that could apply to ritual. The way that a shaman "sees" a spirit seems bound up with the fact that the shaman is performing, or doing something special or in a special way. To locate this intersection between performance and seeing, we turn to dreams.

5 Dreams and the Oneiric Subject

The origin of the dreaming subject is mysterious. Perhaps we dream because our brains are moving stuff from one kind of storage to another—the kind of off-line processing that computers do in down-time. But this does not explain why a subject is necessary for this movement of information to happen. This would require a performative idea of the way that memory works: you can't remember something without it being you that remembers it, and that's you in a fully historical sense, performing your memories differently each time.

Another approach tackles the question of the subject straight on, suggesting that the dream subject replays a level of experience that is suppressed during waking life. Is the anxiety felt by the dream subject the repressed anxiety felt by the awake self about its own alienation from "pure" prediscursive and sensory experience?[1] Here it is the problem of the subject that summons up the information, and not the other way around.

A further kind of theory starts from the idea that sleep, necessary for the renewal of the organism, requires us to withdraw from sensory input from the world around us. The psychologist Ludwig Strumpell first proposed, in 1877, that as a result, images are detached from the usual organizing matrix that gives them their "psychic value" and begin to "hover in the mind dependent on their own resources."[2] More recent neurological research has suggested that just as we don't stop breathing when we go to sleep, the neural circuits that are normally in use during the day activate themselves from time to time through the night. This activity might then generate the sequences of images that make up dreams.

I would extend Strumpell's argument to include not just images of the world but the kinds of self-imaging associated with the subject's ongoing self-production in waking life. It is not just the images that hover; the dreaming subject itself becomes a hovering subject disconnected from the usual logic of waking subjectivation. Lost too are those guiding aspects of

self-experience that we think of as will and purpose. In other words, the dreaming subject is also deprived of the illusion of control.

Dreams are vivid. They seem to be happening, but they are imaginary. True, when we are awake and in a suggestible state, we sometimes imagine something that is not really there. Usually our perceptual verification techniques ensure that we are not deluded for long. But these techniques are not available in dreams. Indeed, look closely at something in a dream, and it often turns into something else. The anthropologist Michelle Stephen says that dreams can be seen as a product of an "'autonomous imagination,'" dissociated from the everyday self.[3] The dream is being imagined to the dreamer. "Mich hat getraumt," says Herzog's Kaspar Hauser of his visions: "it dreamed to me."

Dreams blend frames derived from varied scenarios that have recently been taking up your mental space. They are narrative, but the stories don't follow a real-world logic. Connections between an event and the next tend to be associative rather than through the usual space-time continuities. Synchronic relations of association are translated into sequential ones: formal or emotional connections become contiguities of space and time. This gives the dream the sense of being, if anything, more meaningful than an episode recalled from everyday life. The dream narrative appears as a sequence of not-yet-decoded signs, an intriguing story in a language not yet understood.

So dreams feel as if they need interpretation. Indeed when we recount or recall a dream, we are surely already interpreting it. But an authoritative interpreting voice is often called for, and this suggests the need for a specialist skilled in the hermetic arts of decoding the dissociated narratives of another's subjectivity. Throughout history, practitioners of dream interpretation built up lists of the precise meanings of the signs that occurred in the dreams of their clients. The first surviving compendium of such lists was written in the second century AD by Artemedorus of Daldis. There are also sophisticated discussions of dream interpretation in the Talmud,[4] compiled between 200 BC and AD 300; phenomenological descriptions of dreaming experience in the Upanishads,[5] the sacred Hindu texts that reach back to the seventh century BC; and careful, nuanced reflections on the prognostic potential of dream in the treatise *On Dreams*,[6] written by Synesius, a Christian bishop of Ptolemais in the early fifth century AD.

Dreams stimulate a more general enthusiasm for the meaningfulness of unexplained events—producing a cultural vocabulary applied not only to dream phenomena but also in everyday waking states. Human cultures generate and inhabit worlds that are riddled with signs. The kinds of

unexplained events that come forward to be interpreted are coincidences, anomalies, and nonlinear phenomena. While you are traveling in southern Siberia, three crows fly across the road just in front of the car as you leave town. Perhaps no one says anything at the time, but everyone will have noticed. If, a little way down the road, the car breaks down, the significance potential of the crows will be actualized. It's enough for the driver to say, "The three crows ...," as he gets out to fetch tools from the trunk. Everyone understands what is meant. And in this more general atmosphere of alertness to signs, there is scope for the worries of individuals to read certain clues as proof of the malevolence of a neighbor or of some act of pollution committed by a relative.

But above all, dreams furnish an almost universal empirical experience of dissociation, providing the key model for the cultural construction of other kinds of dissociated states. The practice of *incubation* comes as an important mediating form between dream and ritual. Incubation is the ritual for the significant dream, undertaken by a person in need of dream omens or advice. It is a three-part sequence made up of a preparation ritual, a night spent in a special sanctuary, and a purification ritual on waking.[7] Here the empirical change of state embodied in the rhythm of wakefulness and dreaming is ritually formalized to become the model for all rituals of change of state.

Dream experiences are fundamental to the construction of belief systems. A recent essay in religious studies points out: "Religion was the original field of dream study."[8] Writing of the beliefs of the Daur of Mongolia, Caroline Humphrey states, "It was in dreaming that an adult's soul could leave the body. ... When a soul left in a dream (*zeuwde*), it could enter the world of the dead and meet the ancestors."[9] Roberte Hamayon in Siberia writes: "The autonomy of body and soul—this idea comes from the experience of dreams."[10] Michele Stephen says about the Mekeo of New Guinea: "Dreams (*nipi*) constitute one of the most important contexts of everyday experience in which the soul is defined and discussed with others. ... The actions of the soul are related in the third person, at least at the beginning of the dream account, making it clear that the dream is not my action, but the action of my soul."[11]

Here is a single dream: it is the dream of a client with a heart condition who had sought help from a shaman, living incidentally a very great distance away. In her dream, a white bear comes to her and tells her to wake up, get out of bed, find a particular plant she has, and get that plant out of the house as quickly as possible. She does as instructed and, now fully awake and out of bed, is astonished to find that this one plant, a gift from

a cousin (toward whom she has ambiguous feelings), is inexplicably yellow and withered, all the house plants having been a healthy green the day before. She throws the withered plant out of the window and returns to bed. The next morning her medical condition is greatly improved. Leaving aside what cannot be explained in this account, we see how a dream can be energized by worry, while its imagistic content, its dream material, brings together a vocabulary of the everyday and the contiguous (the house, the plants) with a vocabulary of the metaphorical and the associative (the bear, the instructions). If, in the culturally appropriate interpretation, the white bear is the soul of the shaman that the shaman has sent to the client, we can see the arrival of the message-bearing bear also as a way that the mind has of telling itself something regarding the deeper state of affairs of its interests. Be that as may, the client's narration of the dream will feed into and energize the collective belief that shamans have the power to heal at a distance and that dreams are significant.

But not only does the client dream of the shaman; the shaman also dreams of the client. "Shamans have ordinary dreams only very rarely, usually the dreams have some meaning, there is some message. ... Shamans can avert disaster even without waking up. In dreams, one can ask questions and receive answers to them. Sometimes, when I come to some house, where something bad is at work, I specifically go to sleep for fifteen minutes, and when I wake up, I understand suddenly, what the problem is, how to get rid of the unclean spirit."[12]

But there is a deeper and more essential connection between dreams and beliefs. Dreams are precisely zones of experience in which perception is not permitted to criticize belief. In dreams, our dream bodies are complicit with the script of belief. They obediently carry out the actions demanded: they climb impossible towers, squeeze through tiny holes, encounter bears, or fly across rooms. Here is another: One day recently I remembered an outdoors concert that had involved exceptionally loud and explosive fireworks, and I recalled the sensation of the shock waves in my ears. That night I dreamed an old childhood dream about nuclear war: I was fleeing on a boat packed with other refugees: then I felt the shock waves in my ears of an explosion from far above. I asked the others if they had felt anything. After waking I realized that whereas my daytime recall of the fireworks experience had been abstract and schematic, in the dream I had actually *felt* the shock waves in my ear. The dream had supplied me with the virtual body to do this with.

Dreams are not just cultural texts or rhetorical devices: they can be motivating vectors of the radical imagination in which an indeterminate

reconfiguration of deeper concerns produces an alternative narrative. If a dream narrative matches some meaningful course of action, it has survived its entry onto the plane of society—like a randomly mutated genetic narrative that is put to the test, first in the ontogenetic and then in the ecological environments. Dreams can connect to shifting social realities to generate new belief systems.

Gloria Wekker tells how the earth-mother goddess Mama Aisa came in a dream to the Creole woman Renate Druiventak in Surinam. In the dream, the goddess told her to mobilize the other women around into collective action to overcome the extreme poverty in which they found themselves. Wekker notes that Druiventak did not see the goddess as a transcendent being, but as one of her own multiple subjectivities, a part of herself with whom she consulted, after waking from the dream, to work out what kind of action to take. Between them, the women developed a form of autonomous agricultural work as a political intervention against poverty and powerlessness.[13]

A striking phenomenon found in many of the contact situations in which Western society encroaches on other cultures is an upsurge of religious dreaming. The local inhabitants, disoriented by the sudden threat to their traditional ways, turn to dreams for religious guidance. This can lead to the development of new symbols, myths, rituals, and social movements that help people respond to massive and frequently painful disruptions of their lives.[14] In cargo cults or millenarian movements, or for that matter jihadi ones,[15] the logics of action can operate swiftly. Confronted with white colonization and imperialism, a previously stable and self-sufficient society develops a new sense of an imbalance of power: people begin to feel powerless, confronted by new types of power that they don't understand. Individuals dream in the normal course of events, but now a particular dream comes to a particular individual and is interpreted as a prophetic dream. There is a great enthusiasm in the telling and retelling of the dream. It seems to elicit in the listeners' imaginations a part of the bodily sensation of the dreamer. The "owner" of the dream may be recognized as a prophet and become a kind of magnet for everyone's hopes. A new world is imagined in sensory form in which the oppressive power relations are reversed or dissolved. A new belief system emerges or an old one is adapted. People's bodies tune themselves to the new script, becoming alert to new kinds of information. Increasingly events are selected for interpretation as the signs of the new world coming into being.

We have here in synoptic form a process in which a culture is, for historical reasons, no longer able to provide the desired cognitive security.

Into this context comes an input from the imaginative processes of one or more members of that culture. The imaginative representations are grouped and linked to events and features in the real world, forming a new kind of sensory experience and a new belief system that becomes increasingly convincing.[16] Cultural contact situations show us in accelerated form how dreams, as responses to emergent cognitive difficulties, have a significant input into the historical development of human cultures in general.

Outside of these situations of cultural impact, anthropology has been slow to pick up on dreams as an important type of cultural data. Against this positivist suspicion of dreams, Elisabeth Kitsoglou has argued for "a unified approach towards dreams and reality" to open up connections between imagination, creativity, and political agency.[17]

What is the ontological moment of the time of dreams? For the everyday waking consciousness, the grouping of events into an ordered series of representations is how the self continuously creates itself and its order.[18] Although the dreaming subject is also awake in the sense that the nondreaming sleeping subject is not, the active dimension of perception and parallel self-creation seems to be lacking, and the parallelism breaks down. In the dreaming subject, watching and doing have become separated from one another: the subject is simultaneously actor and spectator. The experience of time is of an unfolding inexorability; everything is driven along by an exterior teleology, an inaccessible purpose, a story line that comes toward the subject as an irrevocable factuality. This is why dreams are the model par excellence for dissociated states in general and for the dissociated states of ritual in particular. The oneiric or dreaming subject is awake to itself as the actor of another's script, as if hypnotized by the narrative of the film that unreels toward it through the projector. The dreaming subject cannot intervene in the continuous authorship of the script. What happens, happens. Yet the subject is not stuck in an instantaneous present, and its peculiar detachment allows it to have thoughts, memories, and anxieties about the dream events. It's just that these thoughts, memories, and anxieties don't have the grip that they have in waking life. A musician dreams: "I remember again that I need to fetch my instrument from the hotel, but then I meet so-and-so, and all the time I am with so-and-so, and all the time on the complicated journey I undertake with so-and-so, I have an anxiety that I should be doing something else, and then I remember again that I need to fetch my instrument from the hotel, the concert perhaps now already beginning."

In all the dreams alluded to, the presence of emotion as a loose organizing principle makes dreaming less random than if it were the experience

of pure dissociation and nothing else. Ernest Hartmann, with his "contemporary theory of dreaming," has suggested the importance of "loose connections" for mental and emotional well-being. Dreaming is at the far end of a spectrum, at the other end of which is the controlled and tightly connected way our minds work when we are awake and focusing on solving problems. According to Hartmann, the value of loose connections is to facilitate our coming to terms with difficult emotions. By multiplying and varying the forms in which underlying emotions are expressed, dreams weave them into our mental experience and diminish their dysfunctional effects. The function of dreams in the psychology of the individual is therefore to dissipate emotional arousal and make traumatic experience easier to cope with.[19] Are dissociated states in general responses to problematic and difficult situations?

The idea of dissociation as an essentially nonpathological state has quietly insinuated itself into the mainstream through the work of Georges Lapassade,[20] Gilles Deleuze and Félix Guattari,[21] and others. This development was reinforced by readings in the ethnographies of other cultures that distinguish pathological from nonpathological states differently from how our own culture does. Certainly within the pathological frame defined by our own culture, researchers have insisted that dissociative activity cannot adequately be described as an idea or a group or train of ideas, "but rather the self-conscious purposive thinking of a personality. … Thus the agent that carries out a post-hypnotic suggestion into effect as an 'automatism' is not an isolated idea or train of ideas, but a subordinate personality operating for the time being independently of the primary personality."[22] Outside the pathological frame, the notion of dissociation as a normal state of being was propagated by Friedrich Nietzsche and William James and explored in fiction, notably by Virginia Woolf.

But in many cultures, specific religious and ritual practices offer institutional means for powerful forms of dissociation that at least temporarily disable participation in everyday social life. Here the more traumatic aspects of dissociation for the subject are overcome by learning and habituation. Within these cults or practices, dissociation becomes a performance skill in which the dissociated subject follows a script that is organized in a way that does not match the structure of everyday reality but is nevertheless committed to. What enables this commitment is a special state of the body-mind relationship in which, as in dreams, the bodily senses no longer criticize the cognitions arising in the script. Again as in dreams, the narrative appears to be projected to the ritual performer from elsewhere.[23] The subject enters the believed-in world, the sacred world, and acts out the

doings of that world with the body appropriate to it. These experiences are interpreted as manifestations of the power of the sacred and of powerful gods and spirits. "Then I gave up for the Lord to have His way within me."[24] Here, in Pentecostal religion, for instance, ritual and dream subjectivities seem to converge, just as they do for the shamans.

One night in the Altai we set up camp by a stream that runs into the Katun River. A kamlaniye ritual is to take place and I am to join in. The three of us take up position between the camp fire and the river.[25] *I close my eyes. From the front, the hot heat of the fire. From the back, the cold force of the river. We begin to drum, each in his own rhythm. As a musician you have your musical thoughts; you hear a cross-rhythm and you think, Should I go with that—or not? But each of us is looking for something else, each in his own way. I feel the night energy coming off the others' drums. Then, very quickly, as if a gear had been changed somewhere, I sense the power of my drum as an autonomous force. As the drum comes alive, it expands. It becomes an impossible object, willfully moving, and moving my body with it, and at the same time huge; it has grown enormously into the entire landscape in which I am, this landscape now tilting and swooping as if the country I am in were a giant bird. I hang on for dear life. Mentally I can move neither forward nor back. (Later I will think, I am a neophyte, an uninitiate, a dabbling fool.) At last, at a certain point, it is suddenly over; the drumming dies down, the feeling falls away. Everything is normal again.*

6 Imagination Space

It still astonishes me that sensations and images can walk through the mind like ghosts, that I can pause while writing this and instantly imagine music—the music sounding full in my mind, the sensation of actual physical vibrations, the feel of the texture and grain of different timbres. The fact that these sensations are not coming from my actual ears in no way diminishes their force.

In the Hermetic-Gnostic tradition, imagination is recognized as itself sacred. There is a profound distrust of literal verbal language, which is seen to hold the Holy Spirit fettered in its syntax. The prehistoric knowledge, the *prisca sapientia* that was revealed directly to Adam and Moses by God, had to be protected from the profanity of secular language: the memes of God would be broadcast in the form of pictorial and hieroglyphic representations. With thought pictures, the Hermetic philosophers sought, according to the Rosicrucian Michael Maier, "to reach the intellect via the senses."[1] This silver thread of vivid diagrammatic representation runs hidden through the visible landscape of Western rationalist thought from its very beginnings. Explicitly antilanguage though the tradition is, these diagrams are constellations of word and image that not only suggest new ways of thinking (namely, Benjamin and Adorno's *darstellungsform*)[2] but also say something about the nature of imagination.

Johann Herder, in the Enlightenment, called imagination "the knot of the relationships between mind and body" relating to "the construction of the entire body, and in particular of the brain and nerves—as numerous and astonishing illnesses demonstrate." Herder was arguing for the vital importance of imagination in generating human culture. As a romantic nationalist, he wrote about the nobility of folk life in general, and shamanism in particular. He was the first to position shamanism within a form of cultural nationalism in which the primary capital is the collective imagination and how it structures modes of perception and communication.[3] When, in April 1990, Ken Hyder and I arrived to be interviewed by a young Khakassian

journalist before a concert in Abakan, Siberia, our interviewer turned out to have been a candidate in the previous elections to the local soviet. At the core of his political program had been the reinstatement of shamanism as the spiritual legacy of his people and the heart of their national identity.

The philosopher Mary Warnock observed that imagination "is necessary ... to enable us to recognize things in the world as familiar, to take for granted features of the world which we need to take for granted and rely on, if we are to go about our daily business."[4] At the opposite end of the spectrum of excitement, Lev Vygotsky wrote in the 1930s of how "the entire future of humanity will be attained through the creative imagination; orientation to the future, behaviour based on the future and derived from this future, is the most important function of the imagination."[5] Can Warnock and Vygotsky even be speaking about the same thing? Is the imagination that plays a role in the perception of the real world the same as the imagination at play in the making of speculative fictions? Or should we follow Sartre, who thought that they were completely different processes?[6]

Antonio Damasio has described the evolutionary origins of imagination in terms that make it of fundamental importance. Beyond a level of elementary simplicity, all living systems require the development of images of the world and of themselves in the world. These images are not the imprints of an autonomous reality, but empowering and operative maps of a co-involved reality by which the organism knows where it is, which way to go, and where to find what it needs.

Images are representations drawing their materials from sensory experience and configuring those materials using attributes of the space-time of that experience, but without being confined to them. Damasio identifies what he calls an "image space" in which images of all sensory types explicitly occur, as against a "dispositional space," in which memories store records of implicit knowledge. It is on the basis of these records that images are constructed in recall for recombination and transformation. He points out that explicit imaging occurs in or close to the older sensory cortices of the brain, while the dispositions, the implicit records of knowledge, are associated with the higher-order cortices that are more recent in evolutionary terms.[7] This suggests that the equivalent of thought in animals takes place in terms of immediate images in the older sensory cortices. We can sometimes see signs of hesitation between two impending courses of action: for one split-second, the cat imagines *both* how hard the wall behind her is to jump *and* her previous confrontation with the dog.

In our general usage, the term "imagination" usually refers to the "creative" or "free" imagining of nonfunctional and counterfactual images. What is

imaginary is that which is not. Human speculative and creative imagination occurs most notably in discursive contexts in which imagination is to be performed as such. The range of these contexts is vast and includes the notion of literature in European culture—described by Paul de Man as "where the negative knowledge about the unreliability of linguistic utterance is made available. … Literature is not fiction because it refuses to acknowledge 'reality,' but because it is not *a priori* certain that language functions according to principles that are those, or are like those, of the phenomenal world."[8] The process of writing a novel, if we can imagine it sped up a few thousand times, might lead us to the Gebusi spirit mediums of New Guinea, who work at the quick-fire real-time end of human imaginative performance. Their role is to improvise in public a verbal flow of imagery expressing spiritual orientations, social desires, and inner states, using a style and rhythm that always stands out from the give-and-take of everyday talking.[9]

Given such depth and range, we can see imagination as the way in which the whole informational field of the human is experienced by us—not, of course, as a whole field all at once and not as information as such, but as a mental activity of imaging that takes place in what Daniel Dennett called "the phenomenological garden" of subjective experience—the entire generative image space in which the collision of biological and cultural forms of organization is experienced and configured.[10] Part of the work of this imaging is the production of local and temporary subjective coherence between different types of information.

While, as we have seen, perceptual images and language representations are coded in opposite ways, the boundary between them is extremely mobile: language takes up elements of images as bits of conceptual structure from anywhere in the whole image space. Once a signal (in a listening-to-language situation) has been recognized as language and phonetically processed, it becomes an input into a total neural activity that connects different types of representation—visual, auditory, linguistic, and tactile. The permutational capacity of language feeds into an imaginative activity that both simulates perceptual and motor interaction with the environment and allows computation and reconfiguration in ways that are not possible in actual interaction with the environment. The combinatorial skills of language, the understanding that elements can be abstracted from their place in a flow and differently ordered and combined, is a vital factor in this development. At the same time, as Seana Moran and Vera John-Steiner point out, the capacity for imagining something other than what is immediately available to the senses is necessary not only for the working of the symbolic relation in general, but also for us to have a way of understanding any particular thing that anyone

says to us.[11] In our image space, we are able to achieve a kind of mutual interaction between language and sensory experience.

Imagination has generally been kept to the margins in the study of how humans acquire knowledge of the world. Yet in its broader cognitive sense, imagination is the primal action of subjectivity. More than anything else, we are imaginary. The skill of self-observation by means of imaged representations is a vital part of the process of subjectivation and lies at the very base of experience. Subjects are oriented to imaging their own experience, and the models for imaged experience derive from perception of the outside world. Subjects reach toward gaining control of physical structures capable of acting and gathering the kinds of sensory information from the environment with which they are concerned. In this process, their capacity for both imaging their own experience and imaging themselves as experiencing it becomes increasingly emancipated from the more automatic informational processes from which they originally spring.

A basic informational continuity connects aesthetic to sintonic processes of subjectivation, as it connects ritual to oneiric processes and discursive to locutionary ones. The active form of the sintonic subject is an aesthetic subject. Sintonic contemplation is drawn into the shaping activity of making art, with the excitement and interest in working a physical material toward an imagined image that itself evolves and responds to new perceptions of the material. The recursivity of the making processes in art echoes and expands on the recursivity of the perceptual processes that define sintonia. Correspondingly, the oneiric subject discovers its external avatar in ritual: the dream dreamed to the dreamer now becomes a sacred script assembled in a collective imaginary. The ritual body becomes inspired, possessed, or charged, the performer taking on the spirits of bears and wolves, complete with the bodily sensations that allow the sacred narrative to go on unchallenged by doubt. The locutionary subject, meanwhile, is matched by a discursive subject—the one who, beyond the sheer momentum of talk, assumes responsibility and voices the necessary knowledge and unknowledge of the social group. Here too, in the world of the discursive subject, it is important to recognize that such sociological artifacts as the legal systems or foreign policies of nations, are partly constructs of the imagination.

The space of the imagination is the generative space from which these three fundamental categories of human action continuously emerge. Each of these domains is given specific form by the impact of social and historical factors, while retaining a distinct informational characteristic deriving from structures of subjectivation that are specific to the unique evolutionary moment of the human animal.

7 Topography of Culture

Kunga-Boo, who was both, described the differences between shamans and lamas in terms of the kinds of problems they dealt with. "When someone comes to me with a small problem, I chant sutras with them at the temple," he said. "When someone comes to me with a big problem, I get out my suitcase." He gets the black suitcase out from under the bed and opens it to show us the feathered headdress, "and we go out into the taiga, and I shamanize."

Lamas definitely seemed part of a status quo. The Buddhists in Tuva had well-appointed temples, and their big men were driven around in limousines. Foreign money, perhaps. Shamanism in the history of Tuva had fulfilled the function of a counterpower at the level of clans, but it never developed, never tried to develop, the techniques to consolidate the whole society and design a political and social integration. The Buddhists, in contrast, were in the business of consolidation, and by 2010 they had decreed that no one could officiate as both a lama and a shaman. When Kunga later took us around the new museum in Kyzyl, he refused to enter the gallery of Buddhist art and waited outside, muttering what we took to be imprecations.

In Tibet, the bombo shamans are the masters of paradox and ambiguity, and contrast their own immediacy with the book learning of lamas. "Lamas read from books, bombos must speak from their mouths. All comes from the innards. It is not poured from a flask or dumped from a basket. If you have no consciousness, you cannot do it."[1] I like to think that bookishness stands for a habitual reliance on prefabricated interpretive schemas that dull experience under an alibi of efficiency. The point is not to fetishize spontaneity itself, but to explore what can be done by stepping away from discourse to reveal enigmas of experience and social order. Of course there is a tradition, but it's subterranean—the lineages of ancestry and teaching in shamanism.

These boundaries between shamans and lamas, which are all established from a point of view, suggest something of the tension between different forms of power. On the other hand, something essential is also being said about different types of cognition, and where religion has consolidated its power, the underdog may be the artist rather than the shaman.

Liang Shuming, writing in 1927, saw China, India, and the West as epitomizing three basic variations on a general cultural topography. In the West, politico-economic power pervades society and marginalizes aesthetic experience. In India, it is the power of religion. Only in China has aesthetics developed a correct relation to society, with Confucius and the notion of *ren*, which translates roughly as aesthetic education.[2] The Swiss anticommunist Carl Burckhardt saw the essence of culture as aesthetic; the aesthetic domain was, for him, in permanent tension with the state and with religion.[3] Both state and religion lay claim to universal and necessary validity, whereas cultural actions are, in essence, free, and involve an investment of excessive energy that removes them from the category of the strictly functional. Both thinkers were risking very general acts of transcultural comparison; in doing so, both identified the three most basic categories of human action.

Imagine, as the starting point, the total activity field of the human, in which occur not only all social interactions but also the interactions with a larger environment comprising energies, materials, weather and plants, seasons, and the human bios with all its appetites and rhythms, strengths and limits. ("Bios" here means the totality of [human] spatiotemporal biological life.) All of these elements may have distinctive informational characteristics, but within that diversity, the collision of linguistic and biological informational modes stands out. The continuous event of this collision constitutes the core of human historical identity and impresses itself on the topography of every human culture.

The relation between the human informational field and the topography of human culture is mediated by three forms of subjectivation, and this shows up in the universal distinction among three forms of activity: the discursive, the ritual, and the aesthetic. Each of these takes a distinct informational form.

Although these forms of action are all forms of social action, this fundamental topography is not given by the logic of society itself. Rather, the logic of society has to be understood as an input into the field, a specific "socio-logic" comprising the patterns of action of the discursive subjects of particular societies. These subjects are historically formed as the active agents of a specific cultural discourse and ideology. On the other hand, the fissures that divide ritual, art, and discourse from one another do derive

from the logic of society in the following indirect sense: it is the inbuilt failure of socio-logic to reckon with the wider reality of which it is part that opens them up. This shows up in the fact that these domains of action do not lie easily with one another but exist in states of mutual tension.

To understand the ambition and failure of socio-logic, we need to understand how the primary ideologies constructed by all human societies deal with indeterminacy by acts of exclusion.

The self-justification of socio-logic proceeds on the basis that society is operating in a "functional" manner. In reality, what is done in society is not determined by ecological necessity but largely by cultural and historical choice. Consider two examples from opposite ends of a spectrum. We know of Amazonian tribes whose hunters recognize that the use of rifles in place of bows and arrows by the neighboring tribe is far more efficient but whose attitude is, "That's the way they do it, but it's not the way we do it." These hunters are being transparent about the arbitrary nature of culture. The Awá, for example, if and when they finally start to use rifles, continue to make arrows and carry them on the hunt because that is what you do.[4] In contrast, we have the completely opaque argument advanced by our own social ideologues to the effect that globalization is an objective force and turbo-capitalism is merely science applied to human affairs, an argument that exactly echoes the determinism in Marx. The notion of function, in other words, always refers us back to how the choice of context in which things are more functional or less functional was made in the first place.

We need to consider that as human culture develops, aspects of human behavior that had previously been more tightly programmed on the genetic level get loosened up and become subject to cultural choices. In parallel with this, the human species develops extended childhood in which extensive learning can take place. The frontal cortices of the brain expand, and their neural networks develop greater plasticity. From an ecological point of view, this means that a wider choice of survival strategies is possible, and so a wider spread of habitats. But because every human culture also modifies its environment, these choices are not strictly determined ecologically. Ecology sets limits to them, just as human biology still sets limits to them. But they are historical choices, the result of a unique trajectory through time and space of a unique human group.[5]

In this process, the control of certain aspects of life passes from an organic type of control to a cultural type of control. As basic informational modes, the organic and the cultural differ profoundly in terms of the relation between order and indeterminacy. It is this difference that makes cultural control a cognitive drama.

The self-organization of living systems hinges on a definite form of this relation: order is not fixed and static but a kind of dynamic balancing, like the ability to not fall off a bicycle. The essential integrity of the system remains stable while it exchanges energies and materials with its environment. Where indeterminacy in a nonliving system produces an inevitable reduction—and ultimately collapse—of organization, living systems actively exploit indeterminacy to increase complexity, that is, to broaden the range of possible states of activity in different parts of the system.[6] This expansion of possibility allows a more flexible range of responses to an unpredictable environment. In fact, living systems do not just make do with the accidental such as it is, but actually produce and maintain it within themselves—random genetic mutation being a well-known example.[7] Modularity and compartmentalization, combined with the use of specialized dedicated coding, prevent indeterminacy from breaking down the central stability of the system.[8]

Turning to human culture, what is most immediately striking is the polarization of order and indeterminacy. They are no longer in a complex and intimate interactive relation as they are in a living organism. Order appears in human culture as a rigid, immutable structure from which indeterminacy is excluded. Social power is projected as absolute and inflexible: the *nomos*, the law, the strictly observed custom—a foot wrong and you are out. This projection precedes any political division of society that might have made it necessary—the division between men and women being the possible exception. Pierre Clastres describes how at initiation in prepolitical societies, the law is physically cut into the bodies of each tribal member without exception: the law precedes the political institution of leadership.[9] As Susan Buck-Morss put it, the law has to be called into life and sustained from a position before and beyond the law, and this demands a miracle.[10]

In our own society, the projection of self-sufficient order is reflected in social theory, which tends to establish a logic of order as such, excluding and marginalizing whatever does not fit. A number of critics—I mention Fred Katz and Russell Hardin[11]—argue that the dominant trends in contemporary social theory fail to hold back from an excessively ordering zeal, and Kostas Axelos points out that theorizing a social or cultural system as a closed system is itself an action that contributes to making the system closed.[12]

Any human language can in principle be thought of as a single ubiquitous communicative channel applying a single set of selective filtering characteristics at the point of input where messages are composed; the filters ask only what can be said, and in what words. At this point, human language breaks down the informational compartmentalization that typifies living

systems and seems to become infinite—an unbounded medium capable of registering not only every possible human thought out to the furthest reaches of what a mind is capable of, but every refinement of social encounter, and even the accidents and ambiguities of social experience itself.

But although human language is, in principle, capable of an infinite variety of messages, in practice every language is limited by discursive rules that do not ask what can be said and in what words, but rather lay down the law about what may or may not be said, by whom, and how, and when, and where. In this regard, Herbert Marcuse was right to speak about "The Closure of the Universe of Discourse" even if we need, in retrospect, to disengage an observation about discourse and language in general from a critique of capitalism in particular, a maneuver noticeably recurrent in this book.[13] There is, in practice, no language that is not the language of a particular community; there is no language that is not geared to the needs of a unique culture grounded in a specific way of life. Each individual culture inducts and initiates its new members, defining itself against the unknowable, the immeasurable, and the incomprehensible, and projecting an implicitly continuous affirmative order. These discursive rules of a culture's self-definition are embedded deep into the language it speaks, so that in this light, language in general no longer appears as an all-flexible communicative system, but as a medium of cultural memory, a precious and mnemonic store not only of what is known and how we live but also, implicitly, of what is unknowable and how we most definitely do not live.[14]

Despite this deep investment in the selection of its store of knowledge, every culture is forced to confront the potential knowledge excluded in its selection. This potential but repressed knowledge, indeterminate from the viewpoint of the system of the culture, is constantly pushed forward into cultural life by the force of the biological, ecological, and cosmic systems in which a culture has to operate but which do not submit to its control. What is excluded by discourse is not obliterated, but haunts it as a kind of negative shadow, a dark aura of inadmissible and dangerous possibility.[15] To maintain the fiction of adequacy under these conditions, human cultures reserve special domains in which an otherwise forbidden encounter with indeterminacy takes place. These special domains are quarantined by important discursive changes in the rules for language use. They are the domains of the sacred and the aesthetic, distinguished this time not by their unique imaginative content but by the discursive tensions that surround them. Here discourse seems to set up the compartmentalized coding that language itself dissolves. Topographically, these domains occur at the fault lines at which cultural discourse repeatedly and unavoidably encounters its negative shadow.

Even cultures with powerful internal divisions must go through the motions of shared language and belief. Their fault lines are often in disputed territories where the boundaries of different interest groups are contested. For example, very different rituals surrounding menstruation may be enacted by the women, and the men, of a single culture, but the fault line representing the sexual contradiction is common to the whole culture.[16] My argument is not that the war between women and men is generated on a cognitive rather than on a social level, and therefore is not a real political contest between groups with different interests, but that sex and gender relations are problematic for any discourse that emphasizes the permanence of order against the fluidities of change; once the difficulties emerge, they will act as focus points for the informationally distinct practices of ritual and art.

Ritual and art are forms of action that bear a distinct informational character because they originate in other forms of subjectivity, the oneiric and the sintonic. But actually existing ritual and art are not pure projections of the oneiric and sintonic: first, in the field of social action, the oneiric subject is displaced by the ritual subject, and the sintonic by the aesthetic: second, their actualization as forms of action is the continuous historical outcome of a struggle of definition and a negotiation of boundaries, even if this struggle may reach a tense stability.

The primary element in the struggle for definition and boundary is that in its drive for an effective mastery, socio-logic attempts to appropriate and recuperate ritual and art into itself.[17] The term *recuperate* acquired its contemporary meaning in the writings of Guy Debord[18] and has had much resonance in the post-1968 critique of capitalism, but once again, we need to understand the process in a much wider anthropological context. I could go further than simple recuperation or repossession: in ritual and art, socio-logic sees the essential vehicles for its own cognitive drama. Indeed, ritual and art, in permanent collision with the delusions of socio-logic, may come to mean what society wants them to mean. Their real force, however, is not on the level of meaning but on the level of generative ontology: they continuously disturb the political ontology of the culture and undo the repetitive ontological moment of the discursive subject. Ritual and art are, in this sense, always treacherous for society. This would seem to be the tragic nexus concealed in the topography of culture.

In the total informational field of a culture, the setting apart of certain cognitive and sensory material is the most important feature of the cultural topography, bearing directly on the basic informational processes of the culture. The fundamental logics of action are those that establish the

main informational discontinuities and generate this cultural topography. All human cultures are, in this respect, contemporary with one another, and together form the collective achievement of the particular animal that completed an evolutionary commitment to symbolization.

Is it inherently reductive to speak of a society or of a culture as an informational field? Were the argument to stop there, it would be. The history of thinking society in terms of information goes back to the invention of cybernetics in the 1940s and the immediately consequent emergence of structuralism in anthropology. For Lévi-Strauss, society became ultimately a homogeneous field of exchange in which every connection refers back to the preprogrammed structure of the human mind. This depoliticizes and dehistoricizes our notion of society and achieves a kind of explanatory apotheosis by evening out all differences in the field of study. The homogeneity of informational fields returns in the work of Pierre Bourdieu, for whom societies are ultimately reducible to arbitrary collections of fields inside each of which players negotiate over differences that need not amount to anything beyond themselves. This book, however, begins from an objective *hetero*geneity in the informational field, a heterogeneity visible in the topography of culture. It is only once the uneven and broken movement of information inside cultures has been mapped that we can move on, analytically, to the question of what this information might mean. Religions explicitly claim to be the repositories of ultimate meaning, yet the meanings they reveal and perform are in reality far less important as meanings than they are as indicators of discontinuities in what meaning is.

In this sense, the shamans seem to have an intuitive grasp not only of the human being as a totality with social, biological, ecological, and cosmic dimensions, but also of the weight of the formal, we might say informational, differences between how different kinds of knowledge are generated and communicated.

8 Discourse as Cultural Phase

In *The Gutenburg Galaxy*, Marshall McLuhan quotes the Joycean jest, "Sink deep or touch not the Cartesian spring," and comments, "But for centuries to come the West chose to be motivated by this simple mechanism and to live as in a dream from which artists strove to awaken us."[1] This idea, that an entire way of life is like a dream from which art might shake us free, is intriguing. The secure, clockwork Cartesian world, in which a rational God directs an ordered universe, lasted from the Renaissance to the late nineteenth century. It was a formative pattern that permeated the thinking and the way of life of all educated European society. At the same time, as Joyce knew, you had to burrow down to find its mechanisms. People were so wrapped up in it for so long that its workings sank away and out of sight to become a kind of unconscious. This deeply internalized, second-nature Cartesian world is exactly a discourse, exactly a passage connecting a structure of experience to a structure of power, exerting the kind of deep gravitational attraction by which certain arbitrary social arrangements are made to seem entirely natural.

I have referred to the normality of dissociation. Now comes the idea of the dissociation of normality. Perhaps we do, all of us, live in a kind of dream, and perhaps, if so, the dream state is the state in which signs and words seem to stand for something else beyond themselves. Perhaps the sensitivity of social power to the threat of being shaken out of its dream by art and ritual derives from the dependence of that power on a symbolic relation that could only have been reached in the first place through ritual dissociation. So how did we get to this place where we now are? To answer this, we need to go back some way before Descartes.

Imagine us, first, without human language. We dispose of a wide and sophisticated vocabulary of vocal sounds and bodily gestures. But everything we describe and indicate with these signals is connected directly to the action of doing so by being in the same space, the same moment, the

same situation, or being in some way similar in form. Signals that are close to what they refer to are called *indexical*. Signals that are similar to what they refer to are called *iconic*. This is the way animal languages generally work: a mix of indexical and iconic signals.

According to Terrence Deacon,[2] human language originates with the use of objects or markings as tokens for *absent* things or individuals. The need for symbolization, he suggests, arose from a unique survival strategy that, around two and a half million years ago, combined hunting in male groups with feeding in nuclear family groups. Pair-bonding and kinship relationships had to be sustained at a distance. There was pressure for agreement within human groups to represent the relationships inside the group in a durable way, unaffected by fluid situational realities and immediate contexts. There was a need for a kind of representation that was not tied down to the here-and-now of indexical and iconic immediacy. The first symbols would have addressed this problem. They would not have been words, but durable signs—objects, carried or worn, or body markings, but possibly also objects deposited in places, such as stones lodged in the crooks of trees.

All of this would have long preceded the emergence of speech as the primary medium of symbolic representation, but it would have created the need for such a medium. The evolutionary costs of making the necessary adaptations to produce speech would have become worthwhile. The physical evidence for changes in the position of the human larynx and speaking apparatus shows that the essential shift to conventional signs took place prior to the development of speech as the main channel for human language. Long before we began to speak in words, we were locked into an uphill and counterintuitive struggle to suppress the type of immediate and one-to-one indexical relationships between stimulus and signal that form the basis for all animal languages and that had formed the basis of our own.

Following the categories established by Charles Peirce, it is the point at which a group of indexical relations becomes an entity in and of itself that marks the beginning of the symbolic relation.[3] Beyond this point, a symbol is no longer tied to the circumstances of any one indexical link and is free to stand for anything you need to represent: stand for it anywhere, anytime, exclusively, and always. Before this point was reached, each iteration of a signal was intimately tied to its triggering occasion: the whole event came as a package each time—an indexical package of stimulus, intention, and signal. How could a group of iterations of an indexical relation cohere to the point where it could be mentally grasped as a thing in itself?

Searching for a means by which early humans managed to escape the bounds of indexical communication and develop and learn a new kind of

symbolic system, Deacon settled on the idea of some kind of protoritual activity.[4] This would have involved a great many repetitions of the indexical relations and a high level of emotional involvement in the group activity of acting out this repetition. It would have been a group activity carried out for itself and not forming part of the action sequences of everyday life. Likely, the social group itself supplied the model for the group of iterations comprising the symbol. Where each individual simultaneously or in turn repeated the same action with regard to some object, each individual would become indexical of an iteration of an indexical relation, and the group of individuals as a whole would come to be indexical of the group of indexical relations considered as a unit in its own right.

Emotional immersion in this group activity would be immersion in the symbol made up of the indexical instantiations constituted by the individual group members, who could feel in each other's continued participation the projected security of a symbolic relation that could apply in the future and in other situations. The durability of the human group would underwrite the imaginative belief in, and commitment to, the durability of the sign. The sign, in a symmetrical development, would underwrite the identity and cohesion of the group. The death of an individual would no longer be simply the loss to the group of a good hunter or, for that matter, an extra mouth to feed, but would assume an altogether new importance requiring new kinds of symbolic behaviors to maintain the integrity of the symbolic relation itself. We can feel the link here to the belief that the dead in some way go on existing for the group, and to the practice of keeping tokens of this continued existence in the form of bones and, ultimately possessions, buried or otherwise preserved.

Was ritual initially the special zone in which human symbolic behavior first emerged, and were protolanguage and protoritual in the beginning two sides of the same coin? In this regard, some resonant comments by Michael Taussig on Emile Durkheim's anthropology of ritual come to mind.[5] First, purely through his approach to ritual and in the absence of a constructive theory of symbolization such as Deacon's, Durkheim, in his *Elementary Forms of Religious Life* (1912), decides that writing is the elementary form of language and that it is the visual and tactile image, and not the spoken word, that is crucial.[6] Second, the representation of the totem by means of a visual sign expresses not a specific and targeted need for representation but the need to make an image, *whatever the image is of*. The point is not to have the image in front of your eyes so as to renew the presence of what is represented in the image, but to experience the power of external material signs *whatever these signs may be*. As Jacques Derrida points out, this power

of abstraction itself, of inscribed thought without content, returns as the key figure of structuralism, although, of course, structuralism privileges certain structural relations over others, on the implicit, never deconstructed, grounds that these relations correspond to the most important and universal human experiences.[7] For Taussig, on the other hand, fetishization of the sign is the mother of all fetishizations, leading all too quickly to the fetishization of the state in particular. These three thinkers, coming from very different angles, have all sensed a Deacon-esque stratum of language in which the power of the sign, linked to the power of the group, must be affirmed for itself. Finally, the affirmation of the power of the sign is also the group's affirmation of its power to articulate the world and establish the discursive and political ontology of its members.

Polarization of Order and Indeterminacy

Can this shed light on why order appears in human culture as a rigid immutable structure from which indeterminacy is excluded? I think it begins to. The power of the sign and of the group is affirmed for its own sake. What is important is that there *be* a symbolic relation and that there *be* a group whose relation it is. This is the necessary pathway to move the human animal from a precultural sensory world into the dream world that is the symbolic social order. The human animal submits to the power of the symbolic relation and the power of the group in one go. This symbolic relation is not targeted and specified but stands for the symbolic relation in general. Or, to the extent that it is inherently targeted, its target is the group itself. Only through grasping and submitting to the relation in general do humans gradually come to inhabit a world of accurately targeted symbols that become effective in a new communicative network.

If the content of social order is the power of external material signs *whatever these signs may be,* then within the limits of what is eco- and bio-logically possible, this content is arbitrary. Rather than being constructed on some principle inherent in society as such, it will tend to organize itself as a system of signs. As a nonbiological and external system of communication, signs must form a stable system that is structured to disambiguate. On the spectrum of any variable used in the system, points that are actually used in a particular language are distanced from one another. There is always a gap to separate a sound from other sounds it could otherwise be confused with. There is always a gap that keeps one meaning clear from other meanings. This departs from the analog nature of many biological processes in which gradual change on one level is communicated as gradual change on

another. Typically each level has different thresholds so that when more than a certain amount of a certain kind of information is received, there is an abrupt switch-over in response. So in a biological system, analog and digital aspects are mutually interactive, but in a language system, there are only digital aspects. The analog aspects are displaced into what accompanies the language system in the way of tone, voice, gesture, and so on.

This distancing from analog process means that language holds itself apart from the fluid succession of time. As a mode of grasping, preserving, and communicating form, it articulates form as static—as standing up to time, as standing against time. The continuously self-adjusting biological form interacting with entropy is now overlaid with a cultural form that resists decay and reads entropy as toxic. As a substitute for succession in time, language offers syntax: a series of fixed states or perspectives connected hierarchically but ignoring any intermediary movement, a technique for linking elements dissociated from the time that would otherwise have been their connecting dimension.

Once language becomes speech, it becomes an internal part of each individual member of its community. It is as one of us that I find my voice. Belonging to community and belonging to language become one thing. On the formal level, the discourse of each human group rigidifies itself against time—the medium of continuousness and indeterminacy. But this would-be cool maneuver is heated by the madness of belonging. The formal structure does not just make itself available as a resource, but is compulsively pushed to completion and imposed on a recalcitrant reality. And that reality is, more than anything else, us.

Discursive Subject

The commitment of humans to symbolization as a way of life commits each human group to inventing a specific cognitive world with a collective, exclusive, and arbitrary identity for the group. In line with this, each group develops and imposes its own model of selfhood, initiating each individual as an appropriate operator of its symbolic system and an appropriate object of that system.

Every human culture is projective rather than neutral: its memory is actively performed rather than merely retentive: its knowledge is passed down the generations not by being made available as a resource but by instruction and persuasion. It constructs its members as subjects by repeatedly modeling their experiences rather than acting as a passive network for the expression of the raw experience of individuals. The discursive rules of

each culture both mark out certain zones of experience for rejection and form an active discursive subject in every individual accepted, trained, and initiated into that culture.

Does this discursive subject have an ontology parallel to that of the other kinds of subjectivity we have met with? Two uses of the term *ontology* must be distinguished. One refers simply to what is available to be put into a process at the start (e.g., as used in computer science); the other refers to the ongoing conditions that not only initiate a process but continue to shape it. They are, respectively, a "dispositional ontology" and a "generative ontology." It is the second of these that applies to the origination of diverse subjectivities in the human informational field. Yet this second meaning has often been marginalized by an unreflective and technicizing strain in Western thought. (I use the term "technicizing" to mean the procedure of reducing a problem to technical aspects uncritically derived from easily accessible or familiar techniques or technologies.)

It is only in the light of this distinction between types of ontology that it can make sense to speak of an "ontological moment" for the discursive subject. The idea is that dispositional ontology is tied to, or assumes, an act of definition situated at some definite point in time. There has to be a point at which it is said, *Here is what there is*, and this is what goes into the process at the start. On the largest possible scale, this is the mythical act of a culture's self-inauguration, the point at which what *is* becomes what *must be*. From the point of view of generative ontology, this inaugurating act will be repetitive and could, as a repetitive act, be seen as the ontological moment of a type of subjectivity. Undergoing this repetition becomes the nearest thing that a discursive subject has to an ontological moment. It is a political ontology, a repetitive act of definition that demands obeisance to established order. It is, in fact, the repetitive act par excellence. In it are fused recognition, definition, and affirmation. Against this political ontology are arrayed, in principle, all acts of improvisation, dissensus, and innovation, as well as acts that posit other forms of power.

In his critique of modernity, Bruno Latour attributes this founding of political ontology specifically to the "modern constitution" of Western rationalist culture.[8] He sees it as a ritual affirmation of inherent superiority over other premodern cultures that builds itself into rationalist and scientific procedures. But human cultures have always thought this way. Every human culture—whether divided and political, or undivided and "prepolitical"—practices a political ontology of repetitive definition. Equally, every human culture has to face the return of the expelled truth in the form of hybrid domains situated within itself, in which what was defined as unacceptable is experienced and articulated otherwise.

The discursive subject is not the locutionary subject. The distinction that Foucault used between utterance (*phrase*) and statement (*énoncé*) is consistent with this difference. The discursive subject makes statements that establish and maintain a network of rules about what is meaningful; these networks ultimately constitute complete discourses. To make statements requires utterances, speech acts, but utterances are not the same thing as statements, and they take place in the field that statements have established.[9] In fact, as we saw earlier in this chapter, the discursive subject is coeval with the ritual subject and in its most basic form precedes the locutionary subject. The discursive subject develops historically as the subject that inhabits the cultural models that emerge to replace biological structures of control. Increasingly each individual's experiences are assimilated into these models to be synthesized into elements of a narrative centered around the subject.

This personal narrative, which anchors itself by repeatedly revisiting the political ontology of its culture, articulates the subject to the culture. By projecting the narrative, the discursive subject actively projects the culture. The subject does not directly grasp itself as being constructed by social discourse, but rather as emergent in an apparently natural process of interaction, first with immediate family, then with widening social groups of different types. It achieves its self-imaging through its imaging of others, accumulating a vocabulary of obligation, shame, pride, retrospection, anticipation, narrative rehearsal, autobiography, and so on. This active and participatory vocabulary that demonstrates the introjection of discursive cultural values divides the discursive subject from the locutionary subject.

The difference is important because the discursive subject, in the normal run of events, fictionally arrogates to itself the doings and goings-on of all centers of subjectivity within its domain, acting and feeling as the sole occupier and owner of a body, and as a complete self bounded by the skin of that body. In reality the largely unacknowledged heterogeneity of subjectivity goes on, shaped by biological and psychological patterns that unfold polyrhythmically throughout the individual's socialization and life span. This other life is ambiguous: on the one hand familiar, intimate, part of us; on the other, inadmissible and indeterminate from the perspective of the determinate world of the discursive subject.

There are two important and framing ways in which indeterminacy bears on the explicit representations of human experience—first, in each individual's sense of self as a unique historical being in irreversible time, a uniqueness whose limits are set by a potentially accidental—because genetic—specification of general human characteristics and potentials,

and, second, more subtle, in the residual presence of information filtered out in the selective and synthetic processes that form representations in the perceptual system. That is, with each perceptual synthesis, the surplus information excluded and retained only on a lower, more information-rich level, appears as indeterminate noise. Acts of grouping and organizing incoming information involve the exclusion of those parts of it that are not relevant to the representation. This process of selection intensifies on the level at which the discursive self applies interpretive schemas rapidly and habitually to link perceptions to already planned courses of action. We find, correspondingly, in art and ritual, a feel for drawing connections between what is almost too close in to be clearly perceivable and what is beyond or outside the scope of human perception, contained as it is in our own mortality.

Indeterminacy in Contemporary Art

Perhaps this is the moment for a hymn to improvisation, first, because an improvised action cannot, by definition, be repeated. Improvisation directly attacks the formula *what is must be*, and says instead, *what is … could have been otherwise … and certainly will be otherwise.* Second, improvisation is against plans and automatisms.

We see distinctive traces of indeterminacy throughout the spectrum of artistic production in self-consciously historical societies. The generative importance of the improvisational and the accidental enters everywhere, even when not explicitly presented as such. In our own culture this becomes explicit as artistic method in the early twentieth century. Hans Richter, looking back in 1965, described the encounter of Dada with chance as follows:

The conclusion that Dada drew from all this was that chance must be recognised as a new stimulus to artistic creation. This may well be regarded as the central experience of Dada, that which marks it off from all preceding artistic movements. This experience taught us that we are not so firmly rooted in the knowable world as people would have us believe. We felt that we were coming into contact with something different, something that surrounded and interpenetrated *us* just as we overflowed into *it*.[10]

But this contact with the indeterminate, once outed, can be discerned as a visible, if subtle, theme much further back. Dryden, wrote Dr. Johnson, "delighted to tread upon the brink of meaning, where light and darkness begin to mingle; to approach the precipice of absurdity, and hover over the

abyss of unideal vacancy."[11] Johnson was perhaps glossing the moment in Paradise Lost when Satan proceeds out of hell and over the seething mass of Chaos, the formless void without dimension, into which he could drop without end. The form of words may be an echo, but the attitude has radically changed between these two texts. In 1785, the English artist Alexander Cozens suggested in his book, *A New Method of … Original Compositions of Landscape,* the use of random inkblots to stimulate the imagination and get students away from imitating familiar models.[12] A change in the attitude to indeterminacy forms an essential part of modernity in Western culture. Perhaps its clearest manifestation is the emergence of ideas about painting as spontaneous performance in Jackson Pollock, Franz Kline, and others in the 1940s and in the idea of a freely improvised music.

First advocated by the painter Nikolai Kulbin in 1910, who wanted to bring the dissonances of real life into art, free music—*svabodnaya muzika*—would "emulate the spontaneity of nature" and be played on new instruments.[13] Nothing is known of what Kulbin and his circle achieved in practice, and it was the idea of the new instruments that would take deeper root in experimental Soviet culture, through the work of Arseny Avraamov and others on sound synthesis and the use of industrial sound in art. The other half of Kulbin's equation, the idea of a music without writing, a music of spontaneity, lived on in the margins of artistic movements that were more often focused on visual or theatrical work. The actual emergence of a freely and collectively improvised music as such happened within African-American music as it developed from New Orleans to bebop and beyond. This collided with a new interest in indeterminacy, open form, and aleatory technique in postwar European composed music, which ultimately lifted free improvisation clear from the jazz idiom in which it had developed as a practice.

Exposure to the indeterminacy of collective interactions is deliberately chosen by musicians engaging in free collective improvisation. Several techniques are deployed to amplify the amount of indeterminacy in improvising situations: the use of unstable acoustic systems with unpredictable behaviors; the exploitation of every aspect of sound, such as undefinable noise factors and fluid transformations; the use of deliberate shape-breaking strategies; and a frequent change of playing partners to avoid unconsciously learning the habits of others.

The absence of a notated score doesn't just mean there is no predetermined form to be unfolded; it also means there is nothing to coordinate or synchronize the intentions of the musicians as the music unfolds. I watch, for example, the fingers of guitarist John Russell's left hand as they form the

shape corresponding to the chord he has just imagined, and then he hesitates, and then the moment has gone; the fingers never reach the strings, and he does something else. He cannot see into the minds of the other musicians; he can only hear them. I might make a sound that I intend to mark the end of a musical phrase, and there is nothing that stops you from hearing it as a sound initiating a new phrase or a sound that continues the current phrase. And what you play (or don't play) next will reflect your interpretation of my intentions and of the opportunities they have presented. Our different intentions in each moment are generated by our different constitutive listenings to what is happening in the previous moment.

A musical intention is an intention toward form: it aims for a particular consequence in the immediate future. It relies on the use of interpretive schemas that connect a musical event to expectations about what follows it, and these schemas derive from musics that are not themselves improvised. It assumes prior knowledge of musics in which what is played in each moment is played as if some particular outcome were going to follow from it. But in free improvisation, this "as if" acquires quotation marks, and the suggested outcome will either not happen or will turn into something else. The unfulfilled implications of each musical act are a vital kind of information that forms an integral part of the overall impression. The aesthetic heart of improvisation is the opening out of this rich field of possibilities, containing not only what was actually played but also what might have been played. Collectively improvised music is an assault on the authority of interpretive schemas that plunges their data back into states of autoregeneration. It is chemical and molecular and works at the base of experience.

And this is perhaps why the best improvisation seems to demand something besides skills of listening, quickness of response, instrumental virtuosity, or sense of shape: namely, decisive intervention of acts of willful imagination where the individual player rises to the otherness of the possible and throws it hard against the fact. It is possible to read this moment as a metonym for art in general. A certain actor (Orson Welles) "seems to have derived from Brecht a conviction that dramatic thought consists of proving that a character who does something might well have done something else. The viewer should be guided to a free movement of the mind so that an actor does not appear all one thing, and action, however determinate, is unpredictable."[14]

The logic of society, with its iterations of factuality and determinacy, has to be understood as one input among several into the total field: a specific "socio-logic" comprising the patterns of action of the discursive subjects of particular societies. To understand this is to go against our sociologizing

habits, but it's a crucial step. The human being is not defined by society alone. The structure of social knowledge and the organization of social action in terms of that knowledge form part of the total field but do not determine it. Other kinds of cognition are possible. Socio-logic is one phase among other phases of a more general cultural activity that also takes ritual and aesthetic forms. The sense in which socially forbidden knowledge is exposed in the rituals of traditional societies and the sense in which interpretive schemas are (one wants to say "ritually") destroyed or challenged in contemporary art are connected, and while neither is a direct threat to the continuity of social and ideological order, they are nevertheless powerful pointers toward its objective limits.

Silences

If we could draw a line from the craziness of art and ritual toward the rigidity of discourse and power, and then continue that line onward, we might find … silence. Silence is where hopelessness has congealed, where the whole burden of a culture has come down on the shoulders of individuals who coexist in a discursive tension so great that they must at all costs avoid the truth. They inhabit a hinterland cut off by some socio-logical fire wall from access to ritual or poetic or musical forms of unfreezing. The truth would be just too terrible to admit. These are Bourdieu's "social silences." These are participational invisibilities. Michelle Alexander has written about the culture of silence in black families in the United States when a family member is convicted of a felony: only with silence can shame be avoided.[15] Elisabeth Noelle-Neumann has looked into the spiral of deepening silence when minorities don't speak up because to do so would itself increase their isolation.[16] At the other end of the socioeconomic scale, Gillian Tett has described the cultivation of silence in financial institutions with regard to what happens if things go wrong—if, for example, virtual financial instruments are suddenly measured against real-world criteria.[17] This is the silence of emptiness, but also of absolute fullness where people never stop talking about something else, for fear of the void opening up where the thing is that they cannot talk about. It is the mirror image of the kinds of framing silence that mark the edges of ritual and aesthetic moments. These other, framing, silences are dynamic and generative; they are the brief moments immediately before or after music, or the apophatic silencing of the discursive voice by a premonition of the extraordinary.

9 The Sacred as Cultural Phase

Later the same night, our hosts invite us for a picnic by the river a short drive out of Ust-Ordinsk. It's a mellow evening, with plates of cheese and meat and cucumbers, jugs of mare's milk alcohol, and bottles of vodka on big carpets. We talk about music, about playing old music on new instruments. Yeremi Hagayev, who has been introduced as the local shaman, is sitting opposite. We offer him some mosquito repellent, which he accepts. After a while, he gets up and moves somewhere behind us and gets a fire going. At a certain point in the evening, someone says, "Yeremi is ready for you now." We get up and approach the fire. We can see he is praying to the spirits of the sky and the spirits of the earth. He seems to want us—Ken, me, and Boria—to stand quite close. Spartak, I notice, is filming. I suppose I am expecting Yeremi to get out a drum, but he reaches down and pulls a knife out of the fire, its blade glowing red-hot. He holds it up, then suddenly draws it across his tongue. A loud hiss that's right in front of you and goes right through you. His mouth steaming. Shock. I feel myself go limp inside. Yeremi drops the knife, swiftly runs his hands up and down our bodies muttering rapidly. Whatever it is he is saying, I feel it go right in. Then it's over. The whole incident lasted only a few seconds. Spartak's camera ran out of film as if on cue. I have just experienced something that ought not to be possible.

Did Yeremi tell us something? Was he giving us information? In his own terms, he was, in fact, *doing* something to us, changing the objective condition of our being. Driving out any illness or sorcery or bad thought that might have been lodged in our bodies. But it's across his *tongue* that he pulled the knife. It was a dramatic statement about language, a way of showing that when he put spiritual force into our bodies, he was empowered to speak with the force of his spirits. Technically, of course, it was also a brilliant demonstration of shock therapy. Inner language, the easy lope of the discursive subject, was stopped dead in its tracks. Something happened here that was like one set of codes getting stopped and another stepping in for exactly a precisely defined moment of time and space. Precision. No frills attached.

The ritual marking out of a bounded physical space and time draws a magic circle around a special cognitive space-time, inside of which types of information happen that are impermissible elsewhere. A nonsacred space can be ritually transformed into a sacred space, and then brought back at the finish to its profane condition. The action of ringing a small bell or burning a sprig of juniper may be enough to make someone's living room a receptive zone into which it is safe to invite spirits. The circle is magic because it isn't really there; you could transgress it at will. You could carry on with the everyday codes and chat with your friends while a ritual is being performed. But disrespect to the spirits is thought to bring on spiritual sanctions like illness or accident. A boy from Ust-Ordinsk died in a motor-bike crash just the other day because he hadn't shown respect to a spirit. Everyone here knows that spirits are dangerous and not to be treated lightly.

The anthropologist Caroline Humphrey noted that ritual typically comprises actions that occur in other contexts: aspersion, libation, fumigation, lighting lamps, daubing, piling stones, sending smoke, offering, eating, bowing, circumambulating, dancing, beckoning, making vessels or containers, tying ribbons—so the data transformed by the formal codes of ritual are objects and behaviors that also occur in the functional business of daily life.[1] The process of preparing food for the family, for example, happens every day in a nonritual context. Ritualizing this activity, as when food is prepared for the spirits, applies a set of formal changes that modify this activity. Someone preparing a meal for the spirits is likely to repeat, exaggerate, and formalize actions such as sprinkling or stirring that would be done in a purely functional and economic way when just cooking for the family. Ritual involves an array of processes or codes for transforming information, for applying sets of formal changes to an input of data. What counts most here is not a change of message but a change of code.

Unfortunately the sociological analysis of ritual has often been message oriented rather than code oriented. It has asked, "What does cooking for the spirits mean?" rather than, "How do you cook for the spirits?" This first question, although interesting, is not the most fundamental one. Ritual, as the performance, or simply the doing, of the sacred is not an expression of the logic of society and its meanings, but an important mode of utterance of what is omitted or made problematic in the emergence of that logic in the first place.

It is true that what Yeremi did was not an action that would occur in another context. But there is a link. Yeremi is a Buryat shaman, and in Buryat culture, it is common for shamans to come from families of blacksmiths.

When we asked him, later that night, how he had learned his technique, he told the following story: "My grandfather was a blacksmith, and one day when I was a child, I went into the smithy, and he had his fire going and he suddenly did that thing with the knife in front of me. I ran away screaming. Sometime after that, my grandfather died, and I understood that his spirit had passed into me and that I had to do the knife thing. But he never explained to me how to do it. I just had to do it."

A proverb from Yakutia, farther to the north, says: "The blacksmith and the shaman are from the same nest." A shaman's coat and drum usually have iron accessories, made by blacksmiths, and the tools blacksmiths use are said to have souls and the power of flight.[2]

Yeremi's speed and concision are exceptional in the world of ritual. Generally it is everyday language that runs faster, saves on the energy of attention, cuts corners, and uses its quick-fire interpretive schemas to skip along its sequences. The ritual code invests more energy; slows the delivery; disrupts the smoothness; exaggerates, stereotypes, and repeats gestures and sounds. Three times you pass the drum beater around the body to ensure no evil comes to you from behind—not once but three times.

These primary markers of exaggeration, stereotyping, and repetition, which tell you that you are entering a ritual space and time, are often accompanied by a shift toward iconic isomorphism in the relation between symbols and what they are held to represent. But as soon as symbols are no longer symbolic in the full systemic sense, that is, defined by their differences with others in a set, the possibility of an unlimited series of further interpretations opens up. The quick and complete interpretive act by which the meaning of a symbol is located in terms of other symbols loses its force. Instead, a series of interpretive acts opens up, extending the iconic meaning by finding other things to which the symbol bears some formal similarity. A cross indicates the crucifixion for Christians, but it is the holy trinity that the action of "crossing oneself" inscribes on the body, with a final "Amen" added to complete the four points. Seemingly drawing on the iconic relation between the cross shape and the barred gate, some vampire movie heroes also protect themselves from incursions of evil with crossed index fingers.[3]

If symbols in ritual codes often lose their conventional unambiguous meaning, it is here in particular that ritual seems to reverse and replay the prehistoric emergence of symbolic language. The symbolic signifier splits into many parallel repetitive, redundant instances: the ritual breaks down symbolic relations into indexical ones. Singly or in combination, these indicate a signified that remains relatively abstract and undefined. This

allows certain limited operations of combination but with a meaning that remains ambiguous and indeterminate. As Victor Turner put it, symbols in ritual become "polysemic" and acquire "a fan of referents."[4] Meanwhile the signifier itself has become more present, not only through its reiterations but also by distancing itself from the ubiquitous and nonlocalized symbolic system of everyday language.

Alfred Schutz, discussing the phenomenology of the sign, points out that as language users, when we understand a sign under normal conditions, "we do not interpret [it] through the schema adequate to it as an external object, but through the schemas adequate to whatever it signifies. ... An interpretative scheme is *adequate* to an experienced object if the scheme has been constituted out of polythetically lived-through experiences of this same object as a self-existent thing."[5] Ritual, in his terms, would be a means of restoring to us an interpretive schema adequate to the signifying object, by which this object could regain its quality as a self-existent thing. Ritual situates and frames the action in the here and now, not only by delineating itself as a very distinct zone in space-time but by this shift in the nature of signification. There is an attentive resituation and restitution of the participants into the moment and place in which they are present. The participants are temporarily withdrawn from the mobility of the sign offered by everyday language. The use of ritual symbols explicitly reembeds the sign in a tension between presence and absence that, outside ritual, is kept implicit and hidden. While explicitly addressed to the spirits of a sacred world, the gestures of ritual bring forward the human body and its actions in a concrete and immediate way.

Ritual knowledge, especially when we catch it being passed between generations or between experts and novices, is not set out in such a way as to explain how something works in terms of principles but involves familiarity with all the specific occurrences of a phenomenon. A procedure may need to be repeated until all the concrete instances in a set have been exhausted. Some forms of shamanic training require every individual part of the initiate's body to be individually consecrated by a spirit if the shaman is not to risk death during healing séances.[6] And as every ethnographer of shamanism knows, interviews with shamans usually start with the shaman displaying her or his knowledge in list form, even if the question was intended to avoid just that. Again, what is important here is not the content of the lists, the fact that each item can be allocated a cultural meaning to be decoded or not decoded by the ethnographer, but the repetitive formalism that characterizes them—the accent on iteration and the correct completion of a set.

Ritual Body/Ritual Subject

The body has generally been poorly used in cross-cultural analysis. David Le Breton, for instance, treats the "premodern body" as if there were no difference between the body constructed by Christianity, with its extreme tearing apart of flesh and soul, and the bodies constructed by the myriad other human cultures that we happen to share history with.[7] He forgets too that even in Europe, the pre-Christian body lurks in the older shamanistic background that Carlo Ginzburg writes about.[8]

Behind the formalities of ritual itself, a certain general mode of physical posture and gesture can be made out: not what the body does, but how it does it. Marcel Mauss, in *Les Techniques du Corps* (1936), instigated an anthropology of how the body is used in society, but without drawing any distinction among ritual, aesthetic, or quotidian domains.[9] An anthropology of gesture developed in the writings of André Leroi-Gourhan, Marcel Jousse, and Victor Turner.[10] Eugenio Barba, drawing on Jerzy Grotowski and Étienne Decroux, proposed that all performers in all human cultures do the same basic things when they prepare to perform, that is, they organize their bodies, and their minds within their bodies, differently from how they organize them in everyday life.[11] They use a different balance, a different distribution of attention and physical energy. Barba calls this the "preexpressive state" because it is prior to any specific expression or discourse. In a preexpressive state, a performer might, for example, begin a movement by invoking, perhaps only briefly and subtly, the opposite movement. The hand that is to reach out momentarily moves back in toward the body so as to emphasize the outward action when it comes. This is an inscription of exaggeration into the body, requiring an extra investment of physical and mental energy. It is a quality that cannot be reduced to the formality of the actions themselves, but remains vested in the inner economy of the performer's body for the duration of the performance.

Emile Durkheim, despite arguing that ritual objects have no intrinsic quality that makes them ritual, nevertheless makes an exception for the human body. The body is the essential and intrinsic ritual object. It is also the site of what he calls "sentiment"—a kind of generalized emotion that holds society together but cannot be generated on the level of quotidian communal action and discourse. This suggestion, which we return to later, can be linked to the idea that emotion changes the body, and that through the changed body, the subject sees and feels the world in the different light of the emotive script.

The term *preexpressive* is perhaps inadequate. Whatever posture a body assumes is potentially expressive. What is being expressed is that the body is itself an object of the ritual, and that the performer has entered a different ontological state. How can the physiology of an actual body be attuned to the set of formal actions prescribed in a ritual? The oneiric dreaming subject provides the model for a dissociated state in which this other kind of experience is possible: a special body is acquired—a body for whom the inexistent can be as vividly present as anything ever is. The ritual subject develops from this oneiric subject as the dream activity is transferred into the realm of social action. The ritual subject acts for others, and in relation to others, entering a collective cultural imaginary, the sacred world, and enacting the doings of that world with the body appropriate to it.

A distinct tradition of thought in anthropology, beginning with Maurice Bloch[12] and Bruce Kapferer,[13] has moved away from the message-oriented interpretation of ritual to bring out the importance of performance. However, *performance* is not well defined. Carole Pegg, who makes performance a central theme of her work on Mongolian music and dance traditions, resists the dangers of an attempted definition altogether.[14] Her shamans and musicians demonstrate vividly that performance allows, mediates, empowers, and connects aspects of identity and tradition, but we don't quite know how. Performance involves timing, a complex body, a set of physical gestures, but we still have an explanatory gap. Edward Schieffelin spells it out, warning, "I deem it impossible to find a universal, properly boundaried, definition of performance that would indicate the domain."[15] He confines himself to emphasizing two crucial aspects that are operative—by which he means operative for the researcher. First, performance is contingent; it is an event, so the presence and response of an audience and the incidence of any unplanned factors all have to be taken into account in any description or analysis. Second, the category of performance embraces any human social event that involves expressive and communicative aspects that can be significantly analyzed in terms of "how they are done."

At first sight, this seems too broad and dilute a description to be helpful for the analysis of ritual, tending to merge it back into communicative practice in general. It converges with the way that the concept of performance is used in linguistic analysis, or in kinesics, say. In practice, Schieffelin develops his analysis of Bosavi spirit medium sessions[16] toward the observation that the cognitive content of the ritual is ambiguous and inconclusive, and that this stimulates participants to creative and imaginative meaning making. The "how things are done" becomes a matter of how individual participants negotiate a way through the séance to extract some useful

meaning from it. It is, in other words, not how the ritual is actually done but how meaning is salvaged from it. His alternative to the meaning-based approach, with its emphasis on a textual meaning to be recovered from the symbolic content of the ritual, turns out to be a more anarchistic version of the same thing, where textual meaning takes the form of a range of possible individual interpretations. We should not forget, either, that any propositional statement in verbal language relies on the recipient constructing a meaning for it indexically and from a point of view.

A more useful definition of ritual performance could focus on the intersection of different planes of information. One plane, that of immediate action, is defined as requiring no particular reference to models of action beyond what is automatic in the operation of perceptual and motor systems. The other plane, the sacred, is a plane of imaginary extratemporal organization that requires retrieval and combination of elements from memory. This is nonautomatic, although, as knowledge and technique, it may become "second nature." Every ritual has its occasion, but also involves the conformity of actions to models—which requires bringing together elements from these highly separated series. This is reflected in the idea of ritual reenacting something that happened in a special mythical time, before historical time-as-we-know-it began.

In the case of language, the distance between these two planes of information, although objectively present in the opposition between the language system and any given utterance, is unobserved. It is traversed effortlessly and immediately, instantly and automatically. There is no call for bringing forward the difficulty of this task; it requires no marker or dramatization; it simply passes as the intersection of planes whose connection is so intimate as to be invisible.

The performance of ritual, in contrast, gives far more weight to the relation between the planes. By bringing forward both the immateriality of the beings it addresses, and the materiality of the physical gestures with which the addressing is done, ritual performance ensures that its "how it is done" is marked by an explicit and particular effort of conjoining these planes. This is what lies at the heart of the "how it is done" of ritual. The same is true of artistic performance, where, for instance, a musician has to bring together the plane of a composed piece, having some kind of virtual existence outside space-time and the plane of the physical here and now—her exact state of being, the dynamics and kinesics of her body, the acoustics in the room, the temperature of the instrument, and so on. The preexpressive in Barba's theory is made necessary by the extra effort required in bringing together such separated planes of organization—in remaining true to both

the imaginative model and the here and now—rather than merely carrying out a set of actions in a perfunctory and economic manner. So a good performance is one that succeeds in projecting the artistic or other-worldly model *into* the here and now, remaining sensitive to every relevant detail of both planes.

In a famous passage, Roland Barthes describes listening to a Russian church bass: "Something is there, manifest and stubborn (one hears only *that*), beyond (or before) the meaning of the words, their form (the litany), the melisma, and even the style of execution: something which is directly the cantor's body, brought to your ears in one and the same movement from deep down in the cavities, the muscles, the membranes, the cartilages, and from deep down in the Slavonic language, as though a single skin lined the inner flesh of the performer and the music he sings."[17]

Transition and Affliction

Anthropology has divided ritual into two main categories: rituals of transition and rituals of affliction. Rituals of transition address predictable and often regularly occurring movements across boundaries, such as changes of social status, life cycle, and change of season. These are the rituals studied by Arnold Van Gennep in his classic work, *Les rites de passage*.[18] Initiations, baptisms, communions, weddings, and funerals are rituals that move people into and out of groups and between different statuses within groups, acting like the opening and closing windows and doors of a house whose essential walled structure must remain solid. Philip Larkin wrote about the "blent air" of a church, in which the different forms of seriousness are fused—christenings, weddings, and funerals all connected.[19]

Van Gennep shows that many different types of ritual share a common three-part structure: a departure from the original status and the profane world, moving on to a time spent in a sacred liminal state, and closing with reincorporation back into the profane world, now with the new status. Generally the liminal state is defined by a clear transformation of the everyday codes of behavior, and this often takes the form of reversal. In a liminal state of reversal, what must not usually be said *must* be said; what must usually be done *must not* be done. Here is the whole tribe of carnivalesque comportments: talking or walking backward, transvestism, masters waiting on servants, ritual pollution of sacred objects or places, and so on.

Van Gennep's house image is reassuring because it suggests unity and complementarity of design. In reality, the house is a rigid frame whose components are defined by mutual antithesis and held apart by emptiness:

its windows and doors are structural gaps through which blow in the external forces of cosmos and bios. Ritual is not an aspect of social design but a negotiation between society and world. Cultural ideology struggles to impose a rigid structure on a reality through which life irreversibly flows. This ideology cannot, in its own terms, deal with one thing becoming another, with transition between categories: on the contrary, transition becomes the occasion of a discursive crisis.

This is all the more clear in the case of the other main category of ritual: the rituals of affliction that address ill turns or calamities such as illness, accidents, aggressive black magic, or anomalous or inexplicable events such as eclipses or meteorites. Like rites of transition, these rituals are in three parts, beginning with a preparation and ending with reincorporation. But they are not for moving a person across an awkward gap between two positions in a social structure, and the ritual body that is altered is not primarily the body of the person for whom the ritual is conducted. The accent shifts onto the preparation of the officiant, the person who enacts the ritual: it is the doer of the ritual who must be separated from his or her everyday social identity, brought into the special liminal state, and then returned to normality afterward.

In southern Siberia, a shaman is generally someone who, like everyone else, occupies at times different social positions—herder, hunter, grandmother, blacksmith, and so on—fully inhabiting a network of social and productive roles. Preparation for a séance pulls the person of the shaman out of this network to prepare her for a form of direct contact with spirits that would be highly dangerous otherwise. Only someone who has undergone specialist training is considered capable of tracking down and negotiating with spirits powerful enough to bear on human affliction. The liminal state at the center of the ritual of transition becomes, in the ritual of affliction, an encounter with indeterminacy, a confrontation from which a good outcome is hoped for. This is not something you do lightly. It bristles with dangers and taboos. Nor do you go into it unarmed. It has to be prepared for. Nor, finally, can you step out of it carelessly when you feel like it: you have to follow the right procedures for sending back the spirits, quieting the place, and returning to your usual self.

To do a ritual, you need to remember who you really are, in the sense of remembering your shaman spirit and forgetting your everyday self. For this it is usual to have a personal song, called an *algysh* in Tuva. The words of the *algysh* tell of your birth and ancestry, of the place where you first stood on earth, of the horses there, and the mountains and sacred places. They may also tell of your personal achievements and list your shamanic

attributes, naming parts of your costume, the shoulder lacings, the talis-mans that hang in your drum. "I have taken my spotted horse, I have put on my coat with *eerens*" (an *eeren* is an object ritually transformed into a vessel for spirits or spirit-energy: a shaman's coat and drum will have such objects dangling from them): this song you will probably use in every ritual throughout your shamanic life.

Shamanic séance, as practiced in southern Siberia, follows the pattern of the ritual of affliction. The occasion for a séance is when an individual or family approaches their shaman for a spiritual intervention to resolve some inexplicable and afflicting problem. Shamans also take care of transition rituals, and I keep the term *séance* for interventions that involve special pro-cesses of subjectivation. Although a shamanic séance is an opening toward indeterminacy, it is set in motion and brought to a conclusion by the use of determinate ritual sequences that are carried over from one session to the next. This is what makes shamanizing a method and distinguishes the séance from an attack of madness. The ritual is not the indeterminacy itself, but a technique for entering it and then using it. It is something like riding in a small boat on a fast river. You don't know what's going to happen, but you have some control of your own movement in the flow. Shamans take this responsibility into themselves.

Two main things happen in shamanic séance. One is the tracking down and negotiation with the spirits—the autonomous, unpredictable, and unreliable beings who inhabit the collective imaginary of shamanism; the other is the process of interpretation, during which the outcome of this negotiation is translated for the client and the participant community. Interpretation, as in the case of dreams, is the membrane through which culturally meaningful information is abstracted from indeterminacy. It may go through several steps, from the inarticulate expressions and private lan-guages the shaman uses for speaking with the spirits, through esoteric for-mal modes of speech and their special narrative forms, finally arriving at a set of instructions and recommendations to the client. The client will not necessarily "understand" these instructions, which formally reflect their origins in a logic of spirit rather than a logic of the everyday, and this is part of their authority and their effect.

Dan Sperber wrote that "arbitrariness is one of the means of symbolic production: e.g., a collection of ordinary objects transformed into relics, pebbles tossed at random and interpreted by divination, surrealist experi-ments in automatic writing, etc. Symbolic thought is capable, precisely, of transforming noise into information; no code, by definition, would be able to do this."[20] Despite Sperber's different terminology—he is opposing code-less "symbolic thought" to codified linguistic thought—he has grasped one

of the crucial informational differences that sets rituals of affliction apart from normal communicative modes. Technically, he might have said that no *single* code can transform noise into information, leaving open the possibility of a second code that picks up the noise of the first, suggesting, in turn, a complex interaction of multiple simultaneous codes. Be that as may, Sperber's words hint that human symbolic production echoes the generation of indeterminacy in living beings as an integral part of their way of survival as dynamic systems.

Precisely because the indeterminate is autonomous, it is, in its ritually framed form, explicitly a source of the very highest authority, so it becomes important for a shaman to demonstrate loss of control during the séance, and this is often expressed in the role of an assistant who helps the shaman up if she falls, fetches things required during the ceremony, and generally gives the impression that she is in a state of mind in which everyday looking-after-self is no longer on the cards. It is the shaman's loss of control that gives the seal of authenticity to the information that the shaman delivers toward the end of the séance, proof that the shaman temporarily gave up normal physical coordination and acquired the body demanded by belief in spirit. During the séance, the shaman's bodily senses did not say, "This is not happening, this is not real," as they would have done to correct an illusion in an everyday waking state.

The bounded indeterminate zone of the shamanic séance is actualized in a specially induced dissociated state of the performer's psyche. In everyday life, the discursive self negotiates the noncoherence of the total human-nature system by discontinuously reconstructing a fictional continuity. For the shaman, the ritual of the séance intervenes in this unnoticed rhythm, blocking the usual passing of one mental phase into another and setting up macrophases. The momentary lapse in the narrative self now becomes the spirit journey episode. The retrospective reconstruction of narrative continuity now becomes the episode in which the whole journey is given a narrative and interpreted. If the construction of a normal narrative-discursive self requires the socialization and training of the child, shamans must also train—but in the ritual techniques that enable this self to be given up and then returned to at will. Indeterminate psychic behaviors then become a source of information bearing on questions for which answers are not otherwise to be had, such as where shoals of fish will be tomorrow, who stole your sheep, or why this person is ill.

There have been suggestions in the new fields of neuro-phenomenology and neurotheology (!) that shamans make use of integrative altered states of consciousness (ASC) that intensify connections between the limbic system and lower brain structures, projecting synchronous integrative slow

wave (theta) discharges into the frontal brain. According to Michael Winkelman, these processes facilitate community integration, personal development, healing, and much else.[21] But Richard Castillo argues the opposite: that brain imaging studies of shamanic ASC do not support limbic-cortical integration so much as dissociation—that is, the deintegration of normally integrated functions in the brain and nervous system.[22] These dissociated types of consciousness are made possible by the prefrontal cortex and therefore cannot be the evolutionary result of habits of integration brought on by trance states. My position remains that variation in the space-times of human subjectivation is not determined by brain anatomy so much as by the recurrence of certain types of information flow that arise in the different ways that a mind has to relate to its body and its world. Focus, in other words, more on subjectivation, and less on states of consciousness. Dissociation in ritual subjects exemplifies how conflict can arise intrapsychically between those cultural and biological ways of knowing encoded in differing modes of subjectivation.

States of ritual dissociation are extremely widespread—Erika Bourguignon identified dissociative phenomena in 437 out of 488 societies for which there was relevant ethnographic information[23]—but it is important to see them not as universal mechanisms of brain behavior reacting to definite physical stimulations but in terms of the different kinds of processing work that minds do in differing informational conditions, and the varied forms of subjectivation that correspond to these conditions.

After various preparatory moves, such as assembling personal power objects, laying and lighting a fire, purifying the place with burning juniper, giving food and milk to the spirits, donning the costume, and warming the drum on the fire, a shaman usually begins by summoning a personal helper spirit, a familiar, the personal spirit of the individual shaman, a spirit whose iconic form (often animal, but sometimes plant, moon, ancestor, insect, or storm), while apparently given arbitrarily, comes to stand for the shaman's own shamanic being-open toward spirits and cosmos in general, and ready to step out from the shaman's normal self to make these encounters happen. This helper spirit, often summoned by singing an *algysh*, greets the shaman's entry into the sacred. The ability to summon spirits is acquired by repeated autoconditioning: the shaman learns to imagine the spirit, to recall the spirit as a vivid presence from memory.

In the following, Nikolai Mikhailov, a Buryat shaman, speaks about his helper spirit—his great grandmother. He can summon her instantly, with a clap of the hands, and his imagining of her is enriched with stories of her own shamanic powers that implicitly pass into him.

She starts to shamanize, she's in the yurt, she spins, she flies out of the square open-ing—with a stick—and she flies in a certain direction and she lands and where she lands is the source of the illness—someone hid the source there. Four strong young men have to run after her and try to tear out the illness: if they can't, she bites it out, eats it, takes it back to her place, vomits, and burns the vomit. She flies out of the roof as sweet as a swallow, and she goes to the sick person: she has a special stick with her. People run out of the yurt, and after three hundred meters, she lands like an aeroplane, she comes down where the wrong thing is, where someone has hidden it; the four young men running. ... I only pronounce her name and [claps his hands] in this second she is near me.

A spirit originates in the moment of feeling a compelling connection between an outer thing perceived and an inner state felt. For a Siberian sha-man, this first encounter, the enormously resonant moment of choosing or meeting a personal spirit, is likely to happen during a period of prolonged isolation out in the wilderness of the taiga. Simply, the spirit accosts the shaman. Gifted with this experience, which seems to come from nowhere and everywhere, the young shaman begins to feel the way forward, to understand that what is being talked about is not so much a doctrine and method as the accumulation of concrete and individual experience.

In an interview with Yevgeniy Antufyev, the Tuvan shaman Kara-Ool Tyulyushevich said:

I have a helper-spirit: a tall, white-robed, old man with white hair. When I was twelve years old, grandfather took me to the sacred cave Saryg-Arzhaan on the On-dum mountain, that is in Kaa-Khem kozhuun. And there he performed a special ceremony, so that the spirit master of the cave would become my helper. When I became a shaman, I went back there twice. It is a good place to gather power, to feed the spirit, to ask for assistance. Sometimes I hear a human voice from behind my right shoulder; sometimes he advises me what to do in this or that case. It is as if I am not only one person, but two, even though one of them is mostly silent.[24]

For the particular information or intercession required to resolve a dif-ficulty, access is often needed to a further relevant spirit or series of spirits, A shaman will extend and develop connections with increasing numbers of spirits, learning to recall their iconic forms at the drop of a hat. The movement from one spirit to the next is experienced as a spatiotemporal movement of the dissociated self, often with sensations of bodily flying. These experiences are constructed partly from the shaman's personal rep-ertoire of images and partly from knowledge of the collective sacred imagi-nary. But it is dreaming that furnishes the bodily experience of traversing the kinds of space-time whose contiguities and distances are built up on the basis of associations that are semantic, iconic, or emotional. In Tuvan

shamanism, this space-time is conceptualized as the Black Sky referred to in sacred cosmology: "The White Sky and the Black Sky are far behind the Sky which is seen to our eyes."[25] These skies are known to the inner eyes of the shamans. Although different individuals experience the Black Sky differently, all agree that they often pass through it. But it is not a given that this journey will be successful: the shaman may never reach the intended destination, may get sidetracked by other spirits, or find that the relevant spirit is out of sorts and refuses to negotiate. One possible outcome is that nothing can be done or that a further and more powerful ritual is required at a more propitious time.

On one particularly vivid occasion in Tuva in 2005, I felt this shamanic journey as a spatial experience of sound. Stepan "the wolf-shaman" Manzyrykchy was drumming and singing into his drum about two meters to my right. It was light in the yurt, but if I closed my eyes, I had the illusion that the *dungur* drum was no longer situated at a particular point in acoustic space but substituted itself for the whole space. By singing into the drumhead in different ways, the wolf-shaman made his voice seem like a kilometer away, then suddenly rush toward me or dart out to either side. Somehow my ears were interpreting the resonances added to his voice by the drumhead as the kind of information carried by sounds from which the ear normally decodes the location of the source, the trajectory of the sound through space, and, consequently, the characteristics of the space itself. By changing these resonances, the wolf-shaman made it seem not only that his voice was coming from elsewhere, but that he and I were in some other kind of space altogether, intuited on the basis of the sound. I felt that I had been given a glimpse into the primal moves of a vast history of human manipulations of acoustic space—a field embracing the Pygmy hocketers, the Venetian stereoists,[26] the designs of Greek theaters, the invention of loudspeakers and headphones. My experience even echoed the descriptions by early ethnographers of shamanic séances:

Suddenly he commenced to beat the drum softly and to sing in a plaintive voice; then the beating of the drum grew stronger and stronger; and his song—in which could be heard sounds imitating the howling of the wolf, the groaning of the cargoose, and the voices of other animals, his guardian spirits—appeared to come, sometimes from the corner nearest to my seat, then from the opposite end, then again from the middle of the house, and then it seemed to proceed from the ceiling.[27]

Michele Stephen's idea of the "autonomous imagination" was helpful for thinking about dreams, but Stephen's larger context was the anthropology of religion and how experiences of the sacred present themselves as neither "imaginary," as in daydreaming, nor "real," in the sense of taking

place in the everyday world.[28] It is as if the experience were being imagined to the subject by a sacred other—an autonomous subject—who has temporarily taken over. Shamanism is, among other things, a set of techniques for entering these dissociated states. Reports from dissociated states contribute to the construction of a collective imaginary of representations that is shared not only among ritual specialists but among all members of the culture. This sacred collective imaginary is imagined and conceptualized as another world with other kinds of inhabitants, like us but not like us. Specific extensions of imagination into other states of being that cannot be directly accessed include this kind of spirit life, as well as after-death states. This is connected to the prehistoric emergence of death ritual.

Today in the West, it is hard to conceive of ritual as an opening toward indeterminacy. What we know all too well is the pomp and palaver of institution and social order, the ceremonial repetition of political ontology. Between the enormously contrasting experiences of, say, a shaman tossing milk to the spirits with a nine-eyed spoon somewhere in the wilds of Central Asia and the changing of the guard at Buckingham Palace, unfolds the long history of what Taussig would call the fetishization of the state.[29] Rituals of affliction increasingly give way to rituals of transition, and within rituals of transition, the liminal phase shrinks away to the advantage of the other phases. Beginning with the Neolithic agricultural revolutions, societies become stratified and hierarchical. Specialized political institutions emerged, and a division of power between political and sacred forms of authority had to be negotiated. In the kingships of Mesopotamia and Egypt, the spatial form taken by this division of power shows itself in the emergence of the palace-shrine axis. At moments of crucial decision making or great difficulty, the king proceeded to the shrine for the ritual of incubation and the royal dream. The dream would be interpreted by a specialist, no doubt as well versed in political realities as in sacred wisdom.[30] In the modern period, the balance shifts decisively in favor of secular power, and the mirroring of secular power in religious institutions that themselves postpone and limit spiritual experience. But the rituals I have been discussing are largely those of prepolitical society in which there are no explicit political institutions; there is only the implicit political power of the society itself over its members. Although shamanism has adapted on exceptional occasions to hierarchical secular power, notably in Korea during the Three Kingdoms period (57 BC–AD 668),[31] it has generally been practiced by hunting and nomadic peoples whose ways of life are spread across nonintensive ecological environments and only loosely articulated with political systems that are, in any case, usually imposed from outside.[32]

Ontological Moment of Ritual

Ritual sets apart an informational domain in which occur patterns of representations that are otherwise occluded and excluded from cultural discourse. These patterns of representations occur at the fracture points at which the continuous field of order and meaning projected by the culture breaks down, the places where unavoidable discontinuity is concentrated. Ritual, in this sense, is a site-specific pattern of behavior, even if the fractures of more complex societies cannot be mapped onto simple divisions of time and space. In fact, in complex societies, new ritual arises spontaneously, from the bottom up, specifically where cognitive fractures translate into social fractures, and groups employ symbolic procedures to mark themselves apart from other groups.[33]

But if ritual is, in every society, continuously sustained and renewed by people's engagement with it in the present, what underlies this engagement? Turning back to undivided prepolitical societies, occasions for ritual, whether of transition or of affliction, are occasions of anxiety. A person faces either a transition from a familiar group or status to a different and unfamiliar one, or some fearful affliction. Only when a ritual of affliction addresses some general event or phenomenon that seems just anomalous or inexplicable, such as an eclipse or earthquake, does the anxiety prima facie reside more in the community itself than in any one of its members. Empirically, it is clear that for individuals suffering illness or death in the family or anxiety about an important change of social status, ritual provides relief. This relief is not drawn directly from the message or meaning provided by the ritual (whether explicit or itself requiring interpretation), but comes rather as a consequence of the ontological event of entering a different cognitive field from the everyday. Insofar as ritual reconfigures fragments of conceptual and imaged structure to form a new meaning for its participants, it is the ontological event that both enables the reconfiguration and gives it its continuing force and consequence.

Consider the following argument. Experience arising in the psyche, but not configured in the fictional unity and continuity of the discursive self, is repressed. Repressed experience remains in the psyche in the form of potential reconfigurations of what had been articulated in the subject's narrative. This repressed experience is not only cognitive but also emotional and motivational. The emotional resonances of repressed experience are evident in the madness of the nonadjusted individual, but also in the daily suffering of the adjusted individual. Jacques Derrida seems to echo Deacon's conflict between symbolic and indexical relations when he describes

the violence inflicted by signification on experience. The force of the sign is that it tears meaning loose from immediacy: to place a sign over a feeling is to rip that feeling out of the body that is feeling it. Language is not a function of the narrative self; on the contrary, the narrative self is a function of *différance*, the deferral and removal into absence on which symbolic language is entirely dependent.[34]

If we went only this far, we might be looking for how rituals actually express this repressed cognitive-emotional content. But there is no channel by which individual content could be expressed in a socially structured ritual unless we are prepared to step back into the nineteenth century and conceptualize the phase of indeterminacy as a kind of cathartic "tribal" free-for-all. Part of the problem, of course, lies with the culture, not the individual. Since part of what cultures articulate is their own capacity to condition and articulate experience in its entirety, the objective failure of culture to achieve this is projected onto the individual as her or his own inadequacy. Major cultural anxieties come back toward the individual because the human body is itself the site of birth, sex, and death—matters that potentially endanger the static rigid categories of cultural systems. The individual carries the can for the rage of culture against nature. (But not all individuals equally: one of the offshoots of this argument would describe the roots of misogyny.) In many contexts, human pain is not just the pain itself, but the additional pain of guilt for the introjected inadequacy of culture: a person who is ill is letting the side down and is made to feel it.

As language developed, symbolic systems gradually freed themselves from the need for repetitive indexical instantiation in protohuman ritual. During this process, the abnormal dissociated body of the protohuman ritual participant slowly became the normal "associated" body of the person belonging to a society: that is, the state of symbolic hypnosis became the state of the everyday wakefulness of a symbol-using animal. The belief in the operational reality of what cannot be directly sensed now comes to dominate. But our physical bodies still deploy sensory systems capable of criticizing our cognitions. When this criticism is consistently refused and ignored, the physical body builds its emotional state and becomes charged with the tension of that refusal. It is this body, unacceptable to social ideology, transparently visible and expressive to its neighbor bodies, yet inadmissible, to which ontological value is returned when it enters a ritual situation. This is why healing is a fundamental and universal metaphor for ritual efficacy. People come to ritual because they sense that it temporarily breaks the nexus, the alienating knot, of the discursive self.

But the affliction that "healing" addresses also always takes a particular historical form and is always situated on a particular fault line of a given culture at a given historical moment. The situations in which Tuvans come to their shamans for help today are not the same as they were before Tuva was absorbed into the Soviet Union in the 1940s. The psychologist Tamara Vassili told me how the mentality of the traditional herding culture, with small and separated extended family groups, had produced an introverted mindset that found adjusting to the more socially anonymous environments of towns and cities difficult. The mere act of walking down the road and passing people you did not personally know, with no given formality to manage the occasion, could create intense insecurity. So shamans now spend more time dealing with cases of black magic, where people suffer the unresolved aftermaths of these nonencounters, in which the person who just walked past them perhaps put a curse on them or a bad thought into them. Introversion, according to Vassili, takes a depressive form when things go badly. Traditional Tuvan culture did not need to provide for dramatic expression of emotion. She sees the shamans as providing a hysterical-dramatic counter to the depressive type, with the shamans' clients identifying temporarily with the imaginative flight and the drama of spirit interactions.

Ritual symbols are to be experienced, not understood. The term *experience* refers to nothing else but the encounter between a subject and a representation, but as seen from the subject's point of view. In other words, it concerns how the representation changes the subject. "The basic law of liturgy is, 'Do not say what you are doing; do what you are saying.'"[35] What Caroline Humphrey argued for shamanism applies to ritual in general: the use of ritual symbols enables an opening toward indexical and iconic forms of representation that is difficult to achieve in other contexts.[36] She refers to Maurice Bloch's writings on nonverbal knowledge to the effect that most knowledge is of the way things look, sound, feel, and smell and is experienced all at once rather than in linear sequential fashion.[37] Not only is ritual for the reexperiencing of this knowledge, but the connection of vividly experienced nonverbal perception to reflective beliefs that are verbally articulated, if in unusual ways, is felt as immediate in ritual moments. They are moments at which approval is felt for a category of direct, sensuous experience that is kept away from expression in nonritual contexts. The discursive self is here being abrogated and the accumulating tensions of an impossible responsibility temporarily dissolved. There is relief from the seriality of language and the continuous obligation to enact a self fully committed to the projection of the culture's everyday order.

This relief is also the relief of accessing, of knowing, a form of knowledge that cannot be known otherwise. The special codes of ritual performance have drawn us into a ritual space and we are no longer blocked in by the cognitive fault lines of the culture. The ontological change in us means, too, that we are no longer blocked in by the same fault lines as they are inscribed in our discursive selves. Carlo Severi, who studied Cuna shamanism, concluded that shamanism "is not to be considered only as an institution. Rather, its ultimate function appears here to be the construction, by way of traditional concepts, of a paradigm to balance the inner terra incognita revealed in suffering and the twin terra incognita situated at the limits of perception. The confrontation of these two aspects of experience—one situated too far and the other too close to everyday perception—reveals the fundamental features of the traditional representation of suffering."[38]

Anthropology

As key objects for anthropological study, religion and ritual have generally been construed either as results of general social process or as the cause of effects required by it. Whatever can't be explained this way is allocated either to the transcendent itself, for those who "believe," or to psychology, for those who don't. In the case of shamanism studies, the political history of this territorial division is particularly evident. The terms *ecstasy* and *trance* were applied early on and reflected a Christian horror of illegitimate and pathological forms of transcendence. Ironically enough, by divorcing shamanic practice from its social background, this later made shamanism highly exportable to post-Christian Western societies. Indeed, in the 1950s Mircea Eliade popularized a charismatic account of shamanism, and anyone involved in shamanism studies had to reckon until recently with his fascistic idea of a transcendent cosmic imperative.[39] This alone provided a strong incentive to take the opposite line and explicate shamanic experience exclusively in terms of social structure and social meaning. This is the background against which we must understand Roberte Hamayon's assertion that "according to the symbolic representations of shamanic societies, the shaman's ritual behaviour is the mode of his direct contact with his spirits; hence it is functional behaviour that follows a prescribed pattern."[40] But although there are techniques that the shaman learns during training, in an actual séance the shaman is mentally grappling with spirits with their own highly unpredictable behaviors. As the Tuvan shaman Ai-Churek said: "You just have to believe in yourself and your visions, and go on. Who is

as strong as a powerful spirit? Not me!" Symbolic exchange with the spirits goes on, but the key point is that the actual transactions, negotiations, and dialogues between shaman and spirit are not rule determined but left open by the rituals: this openness is precisely why they take place at all. They cannot therefore be said to follow a prescribed pattern in the sense of a pattern laid down as a rule or a course of action to be followed. These exchanges can be represented only by polysemic symbols and groups of symbols, using the particular open relation between signifier and signified that empowers such symbols to mediate between indeterminacy and determinate meaning. The formula "symbolic exchange" needs also to register the fact that the continuously present and responsible narrative self cannot be assumed. The operation of both symbols and actors inside ritual phases is of a different order from how it is outside these phases: the all-embracing field of symbolic exchange proposed in Lévi-Straussian structuralism annihilates this distinction.

To resume: inherently dependent on larger, prior, and more complex systems such as those of the human bios and the surrounding cosmos, cultures are exposed to factors that are, from the point of view of their own projections, indeterminate and beyond control. Social ideologies continuously reiterate their capacity to articulate all of experience while in reality excluding some of it. Every child is born into a cultural surrounding that presents itself as a masterful, self-sufficient englobing lifestyle that has every uncertainty already covered. This is the political ontology whose mantra is, *What is, must be.* Because this proposition is untenable, human cultures are actually discontinuous, differentiating within themselves special isolated phases, inside which other forms of cognition are at work. Among these phases are to be found the ceremonies and activities identified in anthropology as ritual. Ritual expresses not the social logic itself but the inherent failure of that logic to articulate what it excludes from itself—all that is animal, uncontrollable, inexplicable, nonsensical, fluid, or ambiguous. Oriented to the precise points where a particular social logic breaks down, ritual connects these breakdowns to a deeper psychoanthropological and universal level, where it confronts the material and informational conditions from which the inherent limitations of social logics arise.

How does this compare with the various models produced in the anthropology of religion? Functionalism assumes precisely the continuity of nature and culture that must (and here does) constitute the primary object of investigation. Malinowskian functionalism was a reaction against speculative evolutionary theories of culture and set up a model of culture as an integrated whole, itself integrated with its physical environment. The

task of the anthropologist of religion was then that of showing how ritual behavior turned out to have a function for the total survival system. But this "turned out to have" was a sticky problem, in that it was not clear why there was a problem to be solved in the first place. If rituals were so functional, why was their function not self-evident?

The basic parameters for approaching this question were put in place in the early twentieth century by Emile Durkheim, and in many ways they are still at work in sociological thought today. Durkheim recognizes that the same objects could be transferred from the category of the profane to the category of the sacred and that the meaning of the sacred component of the object could not therefore be connected to its intrinsic qualities as an object.[41] Looking further afield for this meaning, he finds himself rejecting the explanation given by the ritual participants: that objects become sacred because they become vessels for spiritual forces. He deduces finally that the real meaning of the sacred objects is society itself. But once again he has to deal with the fact that this "true" meaning of the sacred objects is not self-evident. He advances a number of curiously psychological arguments to fit this non-self-evidence into his thesis.

Starting from the observation that "purely economic relations leave men estranged from one another" (which reads oddly like a quotation from Marx), he argues that things that concern the whole of society need to be separated out from things that concern everyday life.[42] Whatever concerns the whole of society is too abstract to be directly conceptualized and verbalized. Here Durkheim draws a line between himself, the analytical sociologist capable of grasping abstract thought, and the member of the native culture, for whom abstract concepts, such as patriotism, need to be represented by physical objects, such as emblems or flags. He follows this up with the argument that the power of society over its members is the more effective for not being perceived as such. A certain complication is introduced here: while participants are highly conscious of the difference between what belongs to the everyday and what belongs to ritual ceremony, they must remain unconscious of the true meaning of sacred representations for these representations to be effective.

Durkheim draws on the distinction between verbal discourse, which is used for immediate communication, and emotional states, which have more influence on people's behavioral disposition. Rituals are for generating emotional states, or sentiments: "The [ritual] emblem is not merely a convenient process for clarifying the sentiment society has for itself; it also serves to create this sentiment; it is one of its constituent elements."[43] This creation and regeneration of sentiments occurs best in participational

ritual moments—"of crowd hysteria," as the British anthropologist Evans-Pritchard was to comment archly later.[44] At these moments, in other words, sacred symbols inscribe the force of society back onto the participants, who become, at least temporarily, the unaware objects of society's force. In this way, Durkheim's model relates strongly back to the idea of ritual's essential role in the emergence of symbolization.

These points define a three-point analytical schema for the social study of religion and, by extension, the social study of art. First, it is at heart a functionalist argument. Although Durkheim explicitly acknowledges an autonomous role for the biological individual and its impulse to *vivre*, this is only to show that societies shape themselves in some way to individual needs. Yet he also registers the exceptional importance of the human body in ritual—which suggests the body as the essential and indeed "intrinsic" ritual object and the site of sentiment. All the same, the function of ritual is unambiguously social: it is to provide the sentimental glue without which society would not hold together.

Second, ritual objects have ritual meaning imposed on them regardless of their intrinsic properties. A Tuvan shaman knows how to enliven an object, sprinkling it with milk mixed with *artesh* (juniper), or to purify an object by burning *artesh* and ringing small bells. It is enough to tie a *kadak* (ribbon) to something to turn it into an *eeren*, a vessel for spirits. In Durkheimian thought, such procedures highlight a tension between object as object and object as sign; this tension returns with a vengeance as soon as sociology is applied to art.

Third, the wrongness of belief is established as a paradigm, in the sense that sociology would forever after tend to look for the false belief systems that impose meaning arbitrarily on objects and coerce the attitudes toward these objects of participants in the relevant social field. This tendency reaches a certain apotheosis in the work of Bourdieu. It is also widespread in the tradition of critical theory. As Jacques Rancière has pointed out, critical theory claims to transcend those thought structures that bear the imprint of a specific historical genesis, but if we apply critical theory to itself, we find exactly the historically generated kinds of thought structures it purports to be free of.[45] Foremost among these is the idea that the majority of our fellow citizens are somehow hypnotized into states of wrong belief. In Guy Debord's *Society of the Spectacle*, they will morph into the victims of an all-engulfing and terminal illusion.[46]

Against Durkheim, Evans-Pritchard made the point that the groups involved in totemic ritual that he studied are not the main corporate and residential groups around which everyday social life revolves and have no

joint activities outside the ceremonies.[47] This observation opens up a raft of problems about whether it is the society as a whole that is at issue or whether the detail of the internal structure of a society must be shown to be imprinted on the expressions of social solidarity in its rituals. Using a basically Durkheimian framework, anthropologists have discussed the extent to which different types of society impress their social structures on their religious structures. Victor Turner, with his concept of *communitas*, in some ways restores and expands Durkheim's original proposal of a very generalized social solidarity. He also goes further into the precise way that sacred symbols operate, suggesting that they are functionally designed for the participants to "fully receive" the meanings they communicate: "In ritual, root metaphors cause a fusion of two separated realms of experience or two different understandings of an event or even a symbol into one illuminating, iconic encapsulating image."[48] One senses that Turner is more with his participants than Durkheim. Indeed, in 1957 he had left the Communist Party to become a practicing Catholic. Many anthropologists, perhaps making up the discipline's mainstream (Max Gluckman, Siegfried Nadel, Victor Turner, and Max Marwick, for example),[49] go on to argue that the social function of ritual is to refer small scale structural conflict to the solidarity of the broader society for resolution.

Of course, presented in this extremely schematic way, the concept of society appears to feature in these accounts as hypostasized, and this does no justice to the thoroughness with which many ethnographers have explored in detail the active processes that connect social structure and ritual organization. But there is always, lurking in the background, a conceptual geography in which causal arrows proceed from the space marked "society" into the space marked "ritual." It is this conceptual geography that I would wish to challenge first. In this sense, I am more with the shamans than with the anthropologists. A discourse about spirits and spiritual energies, drawing connections between ritual actions and their consequences for persons, at least recognizes that humans have a dimension that is undefined by any logic of society and irreducible to social being. Furthermore, this dimension is accurately conceptualized in shamanic thought as integrated into the natural environment and the cosmos.

The import of this way of thinking for ethnography is that it puts in place the heterogeneous informational matrix that human actors must negotiate. This richer informational field displaces the monodirectional conceptual field of a traditional sociology that seeks to sociologize everything, and therefore carries out exactly the same maneuvers of selection and exclusion as those carried out by the cultural discourses it purports to

be studying. The following, by no means unique, description of method and selective process in ethnography is illuminating:

The main objective of the modern [1967] anthropological fieldworker is to discover principles governing the interaction of the members of the society he is studying. He tries to develop a model of their social behaviours that will economically summarise and account for as many as possible of the instances and episodes that he observes. In this attempt he takes note of any kinds of phenomena likely to illuminate his analysis and perfect his model. Beliefs in witchcraft and sorcery ... may have this function of contributing to his understanding of total social process, but only if he records them in such a way that their social relevance can be fully appreciated and their value as indices of social relations fully exploited.[50]

One wonders how the beliefs of this model ethnographer function in turn as indices of another set of social relations.

10 Art as Cultural Phase

Sociology versus the Aesthetic Object

Now see how the ethnographic viewpoint extends into the sociology of art: "The observation that agents attach connotations to things and orient to things on the basis of perceived meanings, is a basic tenet of interpretivist sociology. But its implications for theorising the nexus between aesthetic materials and society are profound. It signals a shift in focus from aesthetic objects and their content to the cultural practices in and through which aesthetic materials are appropriated and used to produce a social life."[1]

On the surface DeNora seems to be criticizing the old Durkheimian emphasis on belief. But the notion of aesthetic objects having a "content" that is independent in some way from connotation and meaning remains problematic. This simply further underlines how sociology has a fundamental difficulty in approaching aesthetic objects. Sociology can itself be thought of as a codification and rationalization of socio-logic, emerging on cue to relegitimize society in a Europe no longer subject to the old hierarchies. While initially demonstrating in the fact of its own existence the falsity and obsolescence of religious beliefs, its headway against art has not been so easy, if only because art has resisted being swept away by history. The unexpected recrudescence of religious beliefs can perhaps be cast as communal reaction against modernity and globalization, but the same cannot be said for art. And in the aesthetic object, sociology confronts a phenomenon that even though physically present and tangible enough to be bought and sold, is paradoxically more inner than the phenomenon of ritual action. If, in ritual, it is enough for an object to be submitted to mere formalities to acquire its sacred component, in art, the formalities are no longer mere, because the focus moves onto the actual making and shaping of the object itself.

To penetrate the innerness of the aesthetic object requires us to understand this making and shaping in terms of informational processes. It seems extraordinary that the sociology and social history of art have had so little to say about how art is made. To be more precise, any discussion in these disciplines of how art is made has tended to ignore the process of artistic making as such in favor of a technical examination of the exact materials and techniques in use. This certainly allows an efficient linkage of works to their productive and economic backgrounds. Marble can be used for sculpture or construction. With bronze you could make a statue or a ship's propeller. But what distinguishes artistic making as such from, say, making a useful tool is that artistic work doesn't treat materials as inert and simply to be knocked into shape, or as icons of economic value or usefulness, but rather as stuff whose given texture and structure has to be perceptually engaged with—stuff that, if you look at it the right way, has a magnetism of its own, irrespective of any other kind of value. Tuvan stone carver Alexei Kagai-Ool: "I watch the stone a long time, until I see an animal form. I don't have an idea: I look for the material, the material has to speak to you." Alexander-Sat Nemo: "A real carver puts in total concentration, forgets everything else: there is just stone, hands, eyes, there are no other thoughts."

In 1997 I came to a kind of crisis in my own music: I felt split between composing and improvising. They were no longer complementary activities for me: improvisation was making my approach to composition feel obsolete. My problem was that improvisation was such a fast and dialogical medium: every proposition demanded an immediate answer. The vital thing was the interaction between one statement and the next. The sounds themselves disappeared into this flow. They were not recoverable. Composing was the opposite of this: I worked everything out slowly, notating notes and rhythms, holding onto them and fixing them carefully on paper, building up structures, sequences, symmetries. But I lacked a way of making the actual quality and shape of the sound central to the process. Then in March 1997, when the composer Iancu Dumitrescu was in London, I interviewed him for Resonance magazine, and he talked about his work: "I begin with trying some sound: I concentrate and focus my intention on it—as in phenomenology. Then—again like phenomenology—I eliminate everything around that isn't strictly part of it. I start to isolate a very small world. This concentration and stripping away of everything else is not a stressful or desperate procedure; it is meditative, observant."[2] Immediately when I heard this, my mental block was gone. I had been improvising at home placing objects on the strings of a lap-steel guitar to interfere with their normal vibration, and I at once started to make notes on what I was doing. These were not standard musical notations but detailed instructions

about the physical objects and actions that together made up the sound-generating
system. Soon I found that by staying long enough with a very limited setup, listen-
ing, and listening again, I could figure out how to grow structure out of it.

How we see or hear changes as we continue to look or listen. The attraction
of materials considered for themselves is not based in one-off all-encom-
passing acts of perception, but in the continuous reactivity of perception
with itself as it goes ahead. This opening up of looking or listening, which
pays special attention to the dynamics of appearance, is at the heart of the
aesthetic attitude. Once this way of perceiving something for its own sake
is up and running, the way in which perceptual information is attended to
starts to produce a specific kind of subjectivity, that is, an aesthetic subject.
The flow of information in time takes on a character distinct from that of
other kinds of experience. Attention is constantly referred from individual
perceptions to relationships between them, from individual moments in
sequential time to relationships between these moments.

This kind of attention involves an interplay between sintonic processes
and a skill of combination that perhaps derives from language. Sintonia
already generates variant configurations of a perceptual field. Now comes
in a skill of combination that invites the fixing and comparison of these
configurations. This intervenes into sintonia as an autonomous mental
process and starts to give it a definite direction. But beyond that, it impels
us to reach out, take hold of the perceived object, and physically reshape
it. With this we reach a critical point that is absolutely fundamental for art
and for art's informational mode: it now becomes possible to organize the
relations between different configurations of the same material.

This organizing process underlies both the kind of looking or listening
you do when you make work, and the kind of looking or listening you do
when you appreciate it once finished. The perceptual process is the same.
It is hard to think of another field in which production and reception are
so entwined. An object that has the quality of relational configuration is
a thing of aesthetic interest and is recognized as such from either point of
view. An object to be perceptually grasped all at once belongs to a different
functional agenda, in which perceptual processes get themselves over and
done with at once in acts of recognition.

It follows that in the case of art, it is the nature of the objects themselves
that holds them apart informationally from the socio-logic of language: it
is the objects that originate the context. This is the reverse of ritual, which
begins by visibly and audibly marking out a special cognitive space into
which are then transferred types of objects and activities already present in
everyday life.

What it is about works of art that brings them forward as special? How does this singling out work? One of the factors that bears on this is that artistic material is perceptually cut away from its original functional or symbolic context. The eager aesthetic glance that first picks out a material refuses in the same moment to read it according to the functional or symbolic routines through which it may originally have made sense. Out of context, the material flaps like a torn molecule with its keys no longer locked to the appropriate receptors. It demands new forms of completion or replication.

In the days of wars between tribes, this cutting away of context took a very literal form: objects of ritual or status value for the losing tribe were carried off as loot by the victorious tribe and a new value imagined for them. Our museums are packed with loot, and the process of detachment from original meaning is repeated on the level of reception, where a canon of great works abstracts and anachronizes works from the contexts of their artistic production, to become timeless museum masterpieces. Finally, the process is repeated yet again in Duchamp and the "found object," which fetishizes the act of looting itself. Art is recognized and re-recognized as such by being literally or metaphorically stolen from its prior context and estranged from meaning and function.

Beyond this, art also contains a specific proposal: the potential for an aesthetic experience, that is, for an event or process that in some way changes the experiencing person. At the heart of this experience is a continuous becoming and transformation of form that precipitates the emergence of a specific kind of subjectivity. The second part of this book explores the ontology of this aesthetic subject in the context of listening to music.

If art, like ritual, is a response to the collision of the human animal with symbolic language, then it is possible to define it objectively as a specific form of activity that both occurs in all human cultures and embodies a specific form of informational process.

There are three well-known counterviews to this approach. First, art is an institution that reaches its authentic form only in a particular culture and a particular epoch of that culture—namely, our own. Second, art has no general existence because societies can be found in which neither aesthetic objects nor the role of artist are singled out or named.[3] Third, art is whatever a social group chooses to recognize as art, because the function of art is precisely to be a vehicle of pure social difference and nothing else.[4] Such opinions bear, for example, on curating decisions about whether certain objects are best placed in art galleries or in ethnographic museums.[5] However, they assume that the characteristics of art are given in the characteristics of the

social system of art as an institution. They take as axiomatic exactly the presupposition I wish to destroy.

Formalism

In a famous essay of 1917, "Art as Technique," Victor Shklovsky suggests that the impact of poetry is generated not so much on the level of the novelty and variety of images themselves as on the level of how they are formally presented and combined. Poetry is not "thinking in images" but "thinking in words"—with images employed for what they do to words, and not vice versa. He argues that only when works are constructed to be perceived in a poetic way can they be identified as authentically poetic. This construction follows certain procedures: the use of imagery to heighten intensity; parallelism, direct or negative; similes and comparisons; repetition and symmetry; hyperbole and other figures of speech. All of these procedures intensify the sensation of the objet—in this case, a distinct sequence of words.[6]

Formalism is as alert to poetic construction in Slavic folk tales as in Tolstoy's novels. This clarity with regard to objective criteria and willingness to apply those criteria anywhere they become relevant seems to outshine the socio-logical positions of Bourdieu et al.: the objective informational difference that defines art is hardly dependent on the construction of art as an institution.

Formalism as a school of thought crystallized at a particular time and place—Petrograd in 1917—and was soon in conflict with the official version of materialism. Roman Jakobson describes how "Formalist!" quickly became the insult of choice directed at anyone who might wish to discuss the material informational structure of art.[7] The accusation would still be around sixty years later, when the Henry Cow group encountered the Swedish alternative music movement (*Vi har vår egen sång*) in 1976. Our approach to progressive culture at the time involved the music itself being progressive on the level of form, and not just acting as a rudimentary vehicle for the message of socialism. For the Swedes, as for Cornelius Cardew and many others on the Left at the time, this was a kind of bourgeois formalism.

If prosaic practical language operates an economy of attention, with a relentless drive away from words themselves and toward what they signify, poetic language puts this into reverse and restores attention to words as words. But a word newly attended to in this way is not reduced to its purely sonic or visual dimension and is not cut off from denoting something in a symbolic system. Rather, through its own heightened presence, it opens up the distance within the symbolic relation that is usually hidden and,

across this distance, summons its signified into imaginative presence. We recall the sense of a specific effort across distance referred to earlier in the performance of ritual. "What we call art exists to make stone be of stone, to restore the 'feel' of objects, and the sense of life," was how Shklovsky put it.[8]

From here develops the idea of art as alienating experience from the automatisms of attentional economy imposed by language mechanisms. The point of poetic imagery is not to elicit an act of recognition but an act of vision in which the thing is seen as if for the first time. (This idea bears on Lachenmann's music, as we shall see in chapter 13.) Historically, the technique of alienation appears in the use of other languages for poetic expression: Sumerian for the Assyrians, Latin for the medieval Europeans, Arabic for the Persians, Old Bulgarian for the Russians. Whether using archaisms or neologisms, esoteric codes or new urban dialects, the language of poetry is always a construction rather than a habit. Finally Shklovsky proposes that prosaic rhythm is economical and simple, and poetic rhythm is a more complex infraction of it.

This approach to literary materials marks an important moment of change in the history of aesthetics. Boris Eichenbaum writes how earlier "academic" aesthetic theory had more or less marginalized its object of study in favor of top-down psychological and sociological theories of art.[9] In retrospect it is clear that these theories were simply expressing the position of society itself—or obfuscating it, which would amount to the same thing. The formalists had no need to argue with the academicians: they simply went through the door that had been left open and began looking carefully at the materials themselves. As we now know, the door soon closed again.

The formalists teach us that art, like ritual, involves an array of processes or codes for transforming information, for applying sets of formal changes to an input of data. The philosopher Julia Kristeva would later develop the formalist idea toward considering its effects on the subject.[10] The normal subject is thetic, that is, generated in acts of linguistic affirmation, so by subverting the symbolic function, poetic language subverts the subject. This is done by the interference of rhythm, color, texture, and nonsymbolic association and causes a reversion to the primary processes by which bodies and subjects begin to constitute themselves in childhood. Here her thought encounters its bedrock in psychoanalysis and its pessimistic fixities. An aesthetic approach will go beyond this point, taking these primary processes as part of the generative energy for the new forms of subjectivation arising in aesthetic experience.

Art and Ritual

In 2003 I composed a piece for ensemble with solo clarinet. It was dangerously ritual. I had recently acquired—on the spur of the moment—a Korean gong called a jing, *of a kind that I imagined would have been used in shamanic ceremonies. It was black and unpolished and charismatic. I had also been provoked by a remark of Iancu Dumitrescu to the effect that the serialist composers had "dismembered" sound with their pointillist approach and their obsession with permutations. This dismemberment of sound connected in my mind to the idea of dismemberment as the ritual death of the person who becomes a shaman.*

I decided I wanted to combine a ruthlessly dismembering musical approach with a ruthlessly holistic one. In the piece, the solo clarinet is the victim of the process; the instrument's possibilities are torn apart into segments with forbidden zones dividing them from one another. The clarinet part uses wide pitch intervals and wide time intervals, each sound being treated as an isolate. The whole piece itself is also audibly dismembered into its sections. The clarinet solo, naked and unaccompanied, is framed by monstrous gong crescendos with added strings and winds that form a holistic mass. I called the piece "Vers Kongsu," the French vers *meaning "toward" (but also "verse") and the Korean* Kongsu *referring to the pronouncements of the spirits through the medium of the shaman during the ritual. With this title I wanted to say that the piece goes toward this altered condition but without reaching it. Why do I consider "Vers Kongsu" a piece of music and not a ritual gesture? Because it is made with the ear, because the imagination brought to it is aural imagination, and not an imagined sacred. Because I attended to it itself, and not to the spirits. Because I worked as a listener, and not a believer.*

Is the boundary between ritual and art not too complex and ambiguous, and are they not, in historical and ethnographic fact, too interwoven, for them to be understood as the outcomes of separate informational processes? Having almost entangled myself, can I sit back and disentangle the aesthetics of Titian or Bach from the rituals of church, or from the framing religious motivations that structured the contracts and commissions they received?

As forms of action, however, ritual and art are highly distinct from one another. Artistic action is directed toward physically shaping material in the real world, in the light of perceptual relationships in the imagination. Ritual action is directed toward a collective imaginary, itself imagined to produce physical effects in the real world. The activity of art focuses on opening and shaping a particular passage between imaginary and real. In ritual, this passage is taken as given, already collectively imagined, and the point is to use it effectively to change the real world. And this again is why the action of art is an action of making, and the action of ritual is an action of doing.

There is a lack of hard fact on which we could base a definite prehistorical precedence as between ritual and art. Early hand axes seem to have been finished far beyond what was functionally necessary, but no directly ritual role for them has been established, for instance, in association with early burial rituals. Making hand axes is not simple; it involves skills of hammering and damping, as well as knowledge of processes of extraction, the resistance and structure of the material, and so on. Many hand axes were never used to cut anything with, showing no signs of use or edge wear under electron microscopes, and they seem to have been manufactured in impractically large quantities. It is very hard to look at a good Acheulean flint biface made 200,000 years ago and not see and feel it as a work of art. Yet the first unequivocal evidence for ritual burial dates to only 100,000 years. This suggests that humans were carefully shaping flints long before the development of collective imaginary belief systems.[11]

Everything changes when we enter the era of cave painting some 36,000 years ago. Surveying the abundance, sophistication, and variety of its creations, Jill Cook, curator of prehistory at the British Museum, described the Upper Paleolithic as "an era of artistic freedom without parallel until, indeed, our own 20th century."[12] It is tempting for the shamanically inclined to see this as a period of incipient specialization in which certain gifted or vulnerable individuals entered states of dissociation on behalf of their communities. The new technique of representing three dimensions on two-dimensional surfaces may have originated as a way of fixing and recreating the visions, dreams, and hallucinations of these early shamans.[13] Zoomorphism, the art of assuming subjectively the body of an animal, begins because the copresence of other animals with us in the world gives us a vision of other kinds of bodies, like ours but different. The shaman who enters a belief world may draw on this resource to acquire the body with which to enact the sacred script: the shuffling or lumbering body of a bear, the leaping body of a deer, or the eagle's winged body. In every case, the imaginative work that maintains the normal experience of a human body is temporarily abandoned, and the senses no longer exercise a critical function over experience. The cave paintings, generally done in parts of the caves not used for day-to-day living, may have been intended to represent these special experiences and were perhaps themselves regarded as acting as vessels for spiritual forces. I have seen Siberians touch rock paintings to receive spiritual power from them. In this sense, the paintings seem to assume a place intermediary between sacred and aesthetic.

How is the boundary between the ritual action and its equipment, on the one hand, and the art object, on the other, negotiated in present-day Tuva,

a Central Asian culture that is both shamanistic and the home of a thriving artistic culture of throat singers and stone carvers? First, the boundary is tense and under negotiation. You find musicians who say, "Shamanism is not for me; it is dangerous to touch it." You find shamans who say, "So and so is a weak shaman, a mere artist." But then you find other shamans who happily get on stage to perform a ritual to an urban audience as part of a concert. And in a general way Tuvan artists and musicians, like those elsewhere in Siberia, feel free to draw on shamanic culture. Tuvan art is shamanic in a deeper way than simply referencing shamanism. It is produced within the framework of a creative psychology that is often conceptualized and experienced as spiritual. An artist is free to ask permission from spirits and to receive help from spirits in the context of making a piece of work. At the heart of Tuvan artistic imagination is an idea of nature as a totality, a cosmos. An artist strives to open toward this cosmos, and artistic skill is knowing how to work this opening toward the cosmos into the materials of sound or stone. Each thing or event in the world is connected to every other thing by networks of invisible forces, but this connectivity is at first hidden, so that to reveal the connectivity is also to unveil the inner nature of things themselves. This unveiling is often done in a spiritual state, and it is tempting to think that for Tuvans, a spirit is the personification of a node of connectivity to the cosmos. Gendos Chamzyryn, musician: "When I'm playing, a particular spirit comes to me; it's above and comes down into my body and sometimes I'm playing and singing and it's not me doing it; it's someone else. It's the spirit from where I'm born, a place that's light and kind and beautiful." Alexei Kagai-Ool, stone carver: "The carver has to feel the stone, be in dialogue with it. Before I start, I have to converse with the spirit of the stone, I do a ritual, I need to ask the spirit." However the claim to, or acknowledgment of, contact with spirits is not for everyone. Alexander-Sat Nemo: "When KK started to sing, I listened with eyes closed and my eyes saw ancient Tuva. I felt it, no cars or electricity. He was like in a shaman's trance, his eyes closed, giving out a big energy. I told him afterward and he couldn't understand what I was talking about. He didn't want to know."

In Tuva a person who listens to music or looks at art may receive *küsh*, the spiritual force residing in the work as a result of the artist's inner moment of creativity and dialogue with the spirits. But what happens next is conditional on how this person perceives and receives this force. So art does not itself have a direct and objective power to change a person and the surrounding circumstances . The ritual actions of a shaman, on the other hand, are aimed at having objective results and are felt to achieve them. A

shaman is called when things build up to a head in real life and become dangerous or uncontrollable. Shamanizing is case oriented, and art is not. A piece of art is something that a person could encounter or not, respond to or not. True, a performed art, like music, tries to be as case oriented as it can, tuning itself to time and weather, place, and the feel of an audience. But this can't match the detailed crafting of a shamanic ritual to fit a personal crisis, with the careful astrological reckoning, the "inner" and "outer" observation, the probing questions asked. The shaman, in other words, individuates the person, establishing not only his or her kinship and provenance, but this person's exact trajectory in the cosmos. Even when a shaman administers a known medical cure, it is the shaman's mental attitude that empowers the medicine and targets it toward the client's illness. Sergei Ondar, shaman: "Without the inner state—mind and heart—medicine would be no more use than water."

While art addresses persons, ritual objectively changes the world around and inside persons, dealing with all the circumstances, near and far, that bear on the case. The power and cunning of artist and shaman diverge— the shaman primed to negotiate sacred worlds, the artist ready to hone a particular vocal technique or visualize the exact way a deer leaps. We can watch where the care goes, where the attention goes. When the shaman Kunga-Boo Tash-Ool, who is also a carver, speaks of his carvings, he uses an unequivocally aesthetic tone: "Look at this, look at how beautiful it is, how the two goats are standing together, the composition." As the only carver I know who works in horn rather than stone (the soft stone called *chonar-dash*), he talks about horn being a finer and stronger material than stone and how this allows him to achieve greater delicacy in the figures. His work frequently shows a sense of exploiting variations in color and texture of the material to achieve a more vital quality in the figure. In this sense, the carver Kunga is truly a maker, focused on taking physical stuff and crafting it into a concrete image. But as a shaman, Kunga also makes ritual objects that have a ritual function, such as acting as vessels for spirits. Such objects may be the *ongon* given to householders to keep in their homes, to be prayed to, or given small sacrifices of food.[14] Here his approach is completely different. Although the *ongon* depicts three human figures, it does so in the most rudimentary way: the work is done quickly, using felt, metal, or wood—whatever is at hand. The care is directed at ensuring that the *ongon* really is a recipient and holder of spiritual energy. Its form is merely adequate to this function.

This difference as to where care and attention are focused was made even plainer to me by a shaman who had previously attended music college.

Sergei Tumat said, "When I shamanize, I'm not here, not in the place where I'm playing the *dungur* drum, it's just my material body that's there: I'm away with the spirits, that's where my total attention is. If someone touches me, tries to get my attention there in the yurt, that's dangerous; it would be like falling a long way. So it's completely different from playing music to an audience, where you have to be there, to be attentive to what your material body is doing, to everything I learned in music school." Ritual directs attention and action toward the collective imaginary, sustained by a belief that transformations in that imaginary will react back onto the real world. Art, on the contrary, directs attention toward transformation in the perceptual world. Here what counts is sensory circulation, and everything is ambiguous in the sense that any one figure or level of figuration may refer to others without closure or unidirectionality. The implication is that religious art, in terms of the artistic process, thinks religion as a metaphorical resource. Artistic process must realize itself in a recursive form that is irreducible to literal interpretation. In principle, art traditions choose which levels to integrate into their internal formative processes and which levels to leave open as metaphorical resources. Obviously when there is an institutional obligation for literal meaning, that choice is made for them, but the question remains unanswered in the work. If I am using deliberately impersonal forms here, it is because none of this is a question of what artists themselves think; it's a question of the nature of the process they enter into when they start to make art.

Incubation of Western Art Music

It may feel disproportionate to deal so thoroughly with the tensions between ritual and art in the context of developing a theory of aesthetics. But in the case of Western art-music, the autonomy of the aesthetic from the sacred has not been as great as this music, in its modern, secular, rationalized forms, has claimed. To grasp this point, we have to look into the thousand-year incubation of Western art music within the Christian church, a defining factor in the anthropology of this music. When John Baily, an expert in Afghan music, asked, as a question of ethnomusicological method, "Why privilege representation of musical patterns over representation of motor patterns?" he fingered a key factor in ethnomusicology: the conditioning of Westerners by the hierarchies of their own systems of representation.[15] These hierarchies were established for art music during the period of that music's incubation within the church. It was the church that provided the matrix within which grew up the idea of a consciously constructed music.

It was the epistemology of that music that became musicology and fed into ethnomusicology, where it colored and still colors the West's take on other musical cultures.

In the Middle Eastern Judeo-Christian traditions, settled and hierarchical, ritual is generally performed in special custom-built institutions: the Temple, and then also churches and monasteries. The very early Christian ritual had been essentially Jewish, and the Jewish cantillation allowed improvisation on the base of traditional forms and cadences.[16] The Jewish temple had had an orchestra with lyres, harps, trumpets, cymbals: "When they lifted up their voice with the trumpets and cymbals and instruments of musick and praised the Lord … then the house was filled with a cloud … so that the priests could not stand to minister by reason of the cloud: for the glory of the Lord had filled the house of God."[17]

But certainly by AD 400, the use of accompanying instruments was thought by many church fathers to be a dangerous influence.[18] The heterodox practices of the young church are by now becoming stripped down, centralized, standardized. Instruments, improvisation, and any interest in a transcendent sonic experience are on their way out. The monodic chant, unaccompanied, now becomes the central musical expression of the Christian rite. The voice, privileged as the essential carrier for the ritual, is represented as internal, inaccessible, dissociated from the physical being. Singing and listening become activities of the soul rather than of the flesh. In the same moment is the dematerialization of sound: as the body is expelled from music, it takes with it bodily time and all that is implied by the presence of bodily time in pre-Christian traditions. Out go, at this point, the motor patterns of rhythm and performance. Sound becomes pure, an exactly regular vibration, without physical shape. The church building closes itself off physically from the profane world and insulates itself from natural sound; the outdoor sound-world gives way to the magnifying reverberation of the hard, tall, and highly reflective walls of the edifice. In here, sound comes from everywhere and nowhere, an emanation rising toward the now vertically situated god.

At this time everything is, on the face of it, dictated by the demands of the ritual. But notice how much of this is carried forward into secular composed music, even as the attention shifts gradually to the work of making the sound image itself. The discovery of autonomous techniques for this making will eventually lead to the emergence of polyphony and the Renaissance—beyond which composed music is no longer contained and contextualized by its liturgical function.

Music under the medieval theocracy is a total sign. That is, it does not reflect liturgical content in its structure but stands, holistically and charismatically, as sound, for the *illocutionary* force of the Word—the Word that *does* rather than the Word that *states:* the Word as a generative force, and the Word that binds the soul of the believer mnemonically to the faith.

This sense of music as a total sign would eventually be worn away. Some relation between parts and whole was latent in the practical work of music making. Within the structure of the chant, melodic elements and details had always been evaluated, substituted, recombined; it was simply that the modus operandi was articulated within a theological framework. The process had been both gradual and diffuse. The emergence of polyphony, which would telescope and superimpose this process on itself, is the point at which music begins to refuse its role as a total sign and reject any way of mediating between detail and totality that might be imposed from outside.

In Europe, music levers itself away from the verbal text by acquiring its own textuality in the form of notation. A diagrammatic form develops, which borrows the idea of discrete particles from written language, but incorporates them into a mimesis of musical gesture, in which spatial relationships reenact patterns occurring in the plastic and holistic medium of auditory sensation. The inspiration for such a spatial mimesis may lie in the ancient practice of chironomy in which the Jewish cantor indicated by hand gestures the melody to be sung from the Hebrew text. We see here how the text of music is put up against the text of language. Once it discovers a notational technique, Western art music will nurture and maintain an obsessive textuality in which the value of a work is seen to reside more deeply in its textual form as a written score than in any one realization of it. Numerous aspects of a liturgical attitude toward both performance and reception are welded into the core of what would later become "classical" music, and some of these are pulled back to the surface in the later discussions in this book. Hermeneutics begins with the interpretation of sacred texts, and some of this passes into the idea of the musician "interpreting" a composition.

A further reason for the cult of the text in music is perhaps a certain anxiety. When Renaissance artists start to draw on classical sculpture, architecture, and literature, as when Brunelleschi and Donatello leave Florence on their famous study-trip to Rome in 1401, or Bracciolini rediscovers the Lucretius manuscript *De Natura Rerum*, musicians discover, for their part, that nothing of their art survives. The Greeks and Romans had carelessly neglected to record their music in notation or on clay disks. Classicism in music is therefore a complete artifice, lacking the actual models toward

which to revert. The definition of what was classical was a curious historical negotiation. Grétry would later insist that the only authentically classical form in music was opera, adding that Haydn would never have wasted his time on instrumental music had he been introduced to Diderot.[19]

Around the same time as the beginnings of musical textuality in Hucbald's ninth-century Europe, we have descriptions of the use of a single-stringed instrument, the monochord, to teach singers the chant melodies. Here is the idea of separate tones envisaged on a vertical plan, the sense of a striated vertical space in which each note is clearly separated from the one above and the one below it. The monochord must have given singers the feeling that their voices were no longer hidden inaccessibly inside themselves, but out in the open and under their fingers. The word *organum* means instrument or tool; the *organum* in vocal music means, then, the instrumentalizing of the human voice, the realization of an essentially instrumental conception of sound in the medium of the human voice. Now the holistic gestures of earlier notation are made obsolete, and precise divisions of musical space on the page reinforce the dominance of pitch and duration in the hierarchy of musical values.

The practice of troping begins to take on a new urgency. Troping could mean the addition of new text, the addition of new text combined with music, or the addition of new melismas without text. In its first form, it consisted only of adding sequences or parts following on from sections of the chant. Later, with the technique known as farcing (stuffing), new fragments of text were interpolated into the original. It was a protocompositional technique whereby local composers could contribute to the body of liturgical music as representatives of particular monastic and church communities, often by adding tributes to important local figures and saints to the original text.

At what point is the grip of ritual values loosened up when it comes to determining the actual shape and detail of the music within the ritual? The technical turning point is the discovery of a way of organizing the relationships between simultaneous, as opposed to successive, sounds. This invention—the invention of organized polyphony—challenged the authority of the sacred text, not of course explicitly, but in terms of its operational pragmatics, as the sole integrative field for musical organization. Instead of varying by substituting melodic formulas for others, you could now take the chant or any part of it and build something new vertically on it.

From the moment the chant became merely a starting point, material for a compositional process, the alert musician would gravitate toward such other integrative principles as might emerge from the actual work of

building music on it. These new principles ultimately formed a matrix in which musical thought and experiment could interact directly without the mediation of a liturgical framework. The necessity of polyphony followed from the emptying out of musical space round the monodic chant and the pregnancy of this space for the possibility of textual substitution. Once the impulses toward textual commentary, substitution, superimposition, and glossing—toward, in fact, what we would call hypertext—became concretized in music, they began to divide and link continua in ways that no longer simply echoed the divisions of experience reproduced in Christian discourse. The specific textual plurality that distinguishes Christianity from Islam, the notion of synchronous commentary, trope, and textual and narrative diversity, is the major causal factor in the emergence of polyphony in the Paris cathedrals and not in the Baghdad mosques.

In short, a discourse centered on an unresolved cohabitation of transcendence and immanence (God, the Word made Flesh, the Son) finds itself transcended (metaphorically speaking) by art's immanent critique. Insofar as church legislators allowed themselves to be guided by an extreme distrust of music, they achieved the exact opposite of what they had intended. They were arming music for its own liberation struggle, forcing it to become a disciplined, self-conscious, technical skill; they had created the conditions for a learning process that would grasp more complex materials on the firm basis of what had been learned with simpler materials. They had made it necessary for music to discover its own generative processes, to find an equivalent to the gradual and collective folk process of elaboration and variation, but to find that equivalent in the sphere of conscious and organized practice. In this sense, the emergence of composition as an art is already implied in the liturgical demand for a body of musical material that can expand and enrich itself without simply laying itself open to the uncensored influence of other musical traditions.

More than any other religion, Christianity sees itself in terms of a constant and timeless identity adept at handling every swerve of history, and it passes this model on to the artistic practices that incubate within it. Western art music's extreme textuality, its prioritization of pitch and duration, and its accent on music and musical performance as fundamentally immaterial flow from this combination of timeless identity and adaptive fluidity, and would continue to define its tradition right up to and into the twentieth century. Even the "return of the body" in contemporary music—the new emphasis on the physical materialities of human body, musical instrument, and even sound itself—can be seen in this light. The historical *de*-materialization of music under its thousand-year incubation inside the

church with its radical body-soul split, looks very like the necessary precondition for this *re*-materialization of music to be so liberating.

Art and Society

Works of art in principle do not stand for anything and are not substitutes for anything; neither are they simply vessels for social meanings or for the solidarity of the groups for which they have value. They take on a veneer of meaning because meaning is given in the social world in which they are made and because it is to that world that they must speak and in that world that they must be acknowledged. Like ritual, art is not outside the social world, but a special domain inside that world. The boundary of that domain may be highly mobile, but it always sets up a distance between one kind of information and another. Inside the art domain, meaning is drawn irrevocably into a state of circulation or oscillation. So in Carlo Ginzburg's investigation of the paintings of Piero della Francesca, the works are seen not as vehicles for symbolic meanings but as devices for setting up circulations of meaning between present and past, between private and collective, and between particular and general.[20] The defining characteristics of works of art in relation to society follow directly from this objective informational structure. Socio-logic, however, constantly looks for new ways to appropriate art and pin down its meaning to the ideological advantage of one social group or another.

The meaning of art cannot, then, be said to be contained in it, in the sense that a form is sometimes held to contain a meaning, but exists precisely at the surface where the work encounters the world, where the meaning conferred on it from the outside reaches its limit and stops, while the circulation of meaning inside the work reaches a point at which it turns back on itself. These two kinds of meaning, colliding from opposite sides of a singular surface, cannot be anything but dissensual. For art, as we shall see, ontological consequence displaces meaning as the mode of resonating in the world.

This surface or boundary, where inner and outer kinds of meaning collide and dissolve, can also be sensed as the framing silence that precedes and encloses music:

Meaning in music—that must sound very strange for most people. Particularly in the West. It's here in Russia that the question is usually posed: What was the composer trying to say, after all, with this musical work? What was he trying to make clear? The questions are naive, of course, but despite their naiveté and crudity, they definitely merit being asked. And I would add to them, for instance, Can music attack evil? Can

it make man stop and think? Can it cry out, and thereby draw man's attention to various vile acts to which he has grown accustomed? To the things he passes without any interest?[21]

In these words, attributed to Shostakovich in Volkov's *Testimony*, the question of meaning is tackled head-on. But to understand how art works, we have to avoid collapsing meaning and consequence into one another. We have to preserve a fundamental distinction between them. Art has the possibility of being consequential precisely through its alteration of the terms of meaning. We can go into the music of Shostakovich asking, Why does this waltz come dancing in right after this slow movement? We can ask, What does this relationship mean? Or we can consider the music as something more like an implicit set of instructions for the journey of a listening subject. The questions that Shostakovich asks at the end of this paragraph are entirely consistent with this second interpretation: they are questions about the things that music does, or might do, and the kinds of consequences it might have.

Shostakovich is interesting also because, for obvious historical reasons, so many intentions, and of such a high degree of incompatibility, have been imputed to him. In this way of looking at it, the meaning of a work is what the artist meant to say in it. But what passes into the musical work are the artist's artistic intentions, ones that we might call "intentions toward form," themselves constantly developing in the process of making the work. Shostakovich, as composer, cannot directly communicate his political intentions to me as listener. He builds the work in a certain process of imagining, listening, and writing. Later I communicate with the work, with another kind of musical listening. Nothing passes directly from him to me. The communication is between him and his music, and then between his music and me. His music stands between us, in a certain sense, as an unknown. The signal of this is the silence that frames all music. Even music that bursts in, that interrupts, still cuts away the noise of communication.

What about the kinds of intention that we might call "unconscious"—the general social motivations that might work into and through the individual from outside? The social history—itself a historical expression of socio-logic—of European art music often presents music as reflecting social change. But what thought is really reflected in this idea of reflection? It seems to work as a dynamic equivalent to the unidirectional causal arrows that anthropology imposes on societies to explain their rituals. It was good to undo this conceptual diagram for anthropology, and it is good to do so for the history of art.

What a gift to historians it was too: "Mozart is a child of the Encyclopédie, Beethoven of the Revolution; their very greatness lay in the fact that they expressed the humanity of their own time, not the sentimental hankering after the emotions of the past."[22] "By 1600 ... the exuberance of the humanist movement was being disciplined and controlled by the Counter-Reformation and the rise of the great autocracies. In music this was to lead to a reaffirmation of linear thinking, but within the unequivocal framework of the major-minor key-system." "The impersonal, monolithic character of baroque music and of baroque art in general, itself a reflection of autocracy."[23] These writers think of their objects of study as automatically conforming to history in a way that they could never imagine themselves doing.

In reality, musicians and composers are doing technical stuff that is scaffolded onto an underlying basic form of artistic production. There is an inner history of the medium, whereby these technical possibilities are developed and explored by a community of listeners and players. This is the history of an aesthetic concern toward sonic and thematic material and the nurture of its sensory and sintonic qualities. But there is also an outer history, in the sense that the social formation, as it changes, looks for new forms of reflection, in music as elsewhere. To acknowledge that this logic of the social formation is constantly at work is not to say that music intrinsically bends to that logic. Music is made in the way that music is made, and it is made alongside society. For music to begin to express a social movement or a social identity, there has to be an act of appropriation, and this act of appropriation is, in principle, not party to the genesis of the work.

Again Shostakovich helps refine the argument. He may—we are not sure—have set out at certain points to write music that committed itself ideologically to the Communist Party, and at other points music that committed itself ideologically to a clandestine and informal anti-Communist community. But inevitably, as ideas take audible shape, audible relationships come to dominate over intellectual and symbolic ones. Music in which this does not happen sounds hollow, artificial, and second rate. Art that does not realize the potentials of art is not so much not art as bad art. Where art bends to the social formation, makes itself nothing but a vehicle of meaning, it compromises its nature and gives up whatever social force it might have deployed by virtue of its autonomy from meaning. Shostakovich, facing the unimaginable pressures of Stalin's terror, no doubt produced some bad art as a matter of survival, but he managed to keep his essential integrity and autonomy as an artist, and this is expressed in his continued capacity to produce great art to the end of his life.

Theodor Adorno argued that music objectifies the contradictions of a changing society by expressing them into its own technical dialectic.[24] This idea suggests that even if music is not conscripted by society, it is in some way obliged to volunteer. Something "expressive" by nature will seek a material to express, and social contradictions are the material that by nature comes forward to the musician.

But the act or process of expression in art is not as it has been understood to be, a kind of translation, or movement bit by bit from one code to another: it is an opening out of multiple possibilities of configuration that were only implicit in the original data. Only in the special sense that it is possible to feel the contradictions and possibilities of an entire situation can art be said to express its epoch: Shakespeare's plays express the contradictions of their time, precisely by the force of their author's resistance, in a highly unstable and dangerous social environment, to reductive acts of self-definition that would offer his work up for appropriation or censorship.

Music is a type of information having, above all, a reconfigurality that is immediate and explicit. It generally lacks the stable iconic relationships to its surroundings that might pin its constituent elements down to what they represent. Music cannot be said to reflect, objectify, or express the social formation, but rather whatever it is of experience and feeling that is torn by this formation and that cannot therefore belong inside the false completeness it offers. The historical pressure on music from the outside is therefore double: it must pursue a tactical and duplicitous relationship to ideological demands, and at the same time reflect on how discursive changes impinge on the sensory body. The underlying "content" of art in a historical society consists in how these discursive changes concretely and psychologically impinge on the sensory body and how that body can be reimagined for an aesthetic experience that can be consequential in the new changed situation. The body is a microcosm or metaphor of the total biosocial being, or that part of it that flourishes outside meaning and language. But the sensory body of art is always sensed and sensing through the tools available in the artistic tradition, and because the tools themselves have a history, its presence also has a history.

In reality, these abstract and general negotiations between music and society always take a particular existential form. They are the outcome of the doings of many individual musicians and listeners, each of whom is both unavoidably involved in the aesthetic process of music and palpably implicated in the continuous self-production of society. But the musician's role is not to "mediate" between art and society. The idea of mediation,

at least in its strong form, suggests a background cultural homogeneity in which fields of activity come in and out of focus as mediators mediate between them or not. The idea that it is ultimately the mediators who generate the things that they are mediating between gives the impression that there is nothing there already. In the case at hand, that would mean no such thing as society, no such thing as art, and, above all, no objective distinction between them.[25]

Musical Space in the Renaissance

The drama of the prince is precisely the struggle with indeterminacy, the need to take advantage of opportunities that are beyond his control.
—Gennaro Sasso on Machiavelli[26]

The institutional instability of the European Renaissance provides a vivid context for looking at the doings of individual musicians in a period of historical change. The music of the Renaissance begins to emerge after 1400 with the synthesis of a northern Burgundian and Flemish style (roughly; polyphonic, metric, and with syncopation) with a southern Italian one (roughly; melodic, declamatory, and with coloration). From a formal point of view, all the important musical changes that would spread throughout Europe until the emergence of Baroque in the seventeenth century are workings out of this new synthesis. There are deep changes in the way in which musicians and composers conceptualize and practice their work associated with the end of the medieval period. Musical skills are no longer to be organized in terms of their idealized function in a universal worldview; they must now meet specific and varied demands, and this in turn encourages a new kind of technical autonomy. In Guillaume Dufay (1400–1474), we see a composer perfecting his works "in conformity with his chosen end," as Zarlino was to put it,[27] in the sense that whether his task is to celebrate a papal coronation or the dedication of a cathedral, we get the feeling that the "meaning" of the work, its social pretext, is an opportunity to be exploited for musical purposes. These purposes in turn are distilled from the cumulative experience of negotiating the interface between music and social power. At the very least, Dufay contrives to translate the circumstances of his commissions into sets of formal limitations that pose the musical problems to be tackled by the composition. The constraints imposed by the commissions become the means of placing limits on musical variation, limits that in turn give a sense of self-sufficient unity. There is a new feeling of purposefulness, of ideas thought out, and

realized clearly and thoroughly and without inessential additions. In the first half of his career, Dufay brings to a culmination the art of the isorhythmic motet before turning increasingly to a more polyphonic conception with an expressive and humanistic approach to textual content. There is a developing process carried over from one composition to the next—not just the reuse of material but a learning process in which each piece written helps define objectives for the next.

The discursive change, which is absolutely central to the Renaissance and the transition from feudalism to early capitalism, is that the discursive subject is no longer positionally defined by kinship, occupation, or place of residence, sealed into a fixed status by an absolute hierocratic dispensation. The self "without qualities" must now be realized through its own immanent power. People struggle to define themselves through their actions and to establish and maintain the scope for these actions. Although rigid and hierarchical systems continue to prosper, rulers find themselves questioning their own roles and responsibilities. Power has become uneasy.

Not yet psychologically conceived, the medium of space and time through which this self moves, and through which it interacts with others, comes sharply into focus. The re-presentation and exploration of ontological space and time is a primary characteristic of Renaissance art; we find it in painting, sculpture, literature, drama, and music. The old medieval unities are giving way to a new imaginary; works of art begin to affirm both inner coordinates and outer boundaries in ontological terms. The semanticism of the Middle Ages, as a means of connection between not-touching elements, had been a different response. In fact, any conception of distance or perspective would have diminished the power of a medieval work to refract the one supreme work and threatened the intimacy with which every variation united with its idea. The introduction of distance, measurement, depth, striation, segmentation—these now become the paramount technical challenges to be mastered. It was no longer possible for art to return the image to the subject without clothing it in time and space.

The sense of space is crucial for the Renaissance world—Copernicus, Uccello, Columbus—but how does this work for a sequential form like music? First, incipient tonal structure and the organization of time are abstracted from the sound itself to become the structured musical space-time into which musical figures are then to be placed. The sound begins to have implications. We no longer hear it as a continuously self-sufficient moment; we hear it in constant relationship to something that has now been drawn out of it and placed alongside, behind, and around it. The music's continuousness, its unity in time, is no longer an inherent property

of the sound-texture itself, but is repositioned outside the sound into this newly structured musical space-time. The relation of the actual sounds to the organization of tonality and time is now exterior; we grasp it precisely by virtue of the segmentation of the sound-texture into sections that follow one another in time. It is the cadential closure of these sections that casts into relief the implicit structured silence against which they unfold—a structure that in turn reveals the relationships of the sections to each other. Renaissance music, in other words, imagines a new kind of listening.

Alongside this presentation of new ontological conditions come ways to reimagine in art the new social and legal condition of the individual. In such occupations as market or real estate speculating, commercial fishing, or prospecting for precious metals, for example, the individual is repeatedly subjected to a dynamic uncertainty in which relatively large successes or failures can happen almost instantly. These speculative kinds of occupations are highly characteristic of the Renaissance and relatively uncharacteristic of feudalism. We have only to dip into Cellini's autobiography (a chronicle of unmitigated vicissitude),[28] or to think of the extraordinary balancing acts by which the Medici family maintained dynastic power in the Florentine democracy, or to consider that Magellan's expedition of 1520 returned with just 18 of the 270 men he had set out with. Again, what concerns art is not the condition of the individual as seen from the outside as an element within a new structure of meaning, but how this condition is actually experienced. The motional structure of Renaissance music emphasizes a new sense of risk and advantage, expectation and surprise, tactic and strategy.

I want us to step away from the music-historical temptation to unearth a dialectical conspiracy between discursive and aesthetic subjects. Artists were not asking themselves how best to genuflect to the ideology of the new rising bourgeois class. They took the commissions from the new patrons but used them to follow agendas partly defined by the technical issues opened up by their own increasing autonomy and specialization and partly driven by a need for an ontological riposte to the demand for reflection. At the heart of this process is a convergence between new ways of building musical relationships, and the need for a new motional environment for the sound. Listen, if you will, to a Mass of Machaut and then immediately to a Mass of Palestrina. Palestrina's music still thinks its sound as fundamentally immaterial and holds itself aloof from the material body, but it builds a space-time related to that in which actual bodies move. The subject of Renaissance music, forced out of the old world-meaning, does not wait around to pay homage to the victors, but learns to walk, to balance; it finds new ways to situate itself, to know itself, to eventualize itself in time.

Social Difference and Subjectivity

The informational differences that distinguish art actions from other forms of social action can be efficiently outlined using the concepts of society and individual, but we sense that this schema is reaching its point of exhaustion. The particular existential form taken by the negotiations between music and society cannot be adequately described by simply introducing the "individual" in the abstract. Nor is the problem overcome by simply situating the individual into history as a "type" or representative of that historical moment. It is obvious that an implicit filling in of this "type" takes place in our minds, even if we want to avoid it. Notably, in the entire passage above, the individual, while certainly undergoing historical transformations, is assumed to be European, white, of either aristocratic or bourgeois class, and almost certainly male.

The kind of close-up ethnographic or historical work that would be attentive to exactly who everyone is—in terms of social difference—tends to lose sight of the deeper processes at work, especially those that fall outside the general category of social process. Perhaps it takes a poet to grasp the surface and the depths in one form of words: "When those who have the power to name and to socially construct reality choose not to see you or hear you, whether you are dark-skinned, old, disabled, female, or speak with a different accent or dialect than theirs, when someone with the authority of a teacher, say, describes the world and you are not in it, there is a moment of psychic disequilibrium, as if you looked into a mirror and saw nothing."[29]

Socially disadvantaged and marginal groups in complex societies do not share fully in the structure of subjectivity—the organization of the psyche—imposed by the dominant ideology. This goes deeper than the question of identity. Studies that interpret art as responding to a need for expressing a singular or collective identity run the risk of another kind of social determinism, because the need for identity is construed as a social need, and art is therefore understood as having the social function of meeting this need. Without abandoning the idea that identity is being expressed in some way and on some level, it is possible to turn this around. A person who is marginalized by a dominant discourse and its subject form is likely to be particularly open to other forms of subjectivation, such as those offered in the experience of certain forms of music. Expressing an identity through participating in this music would then be both a way of marshaling these new or different experiences of subjectivation and a way of participating in a collective imaginary. By adhering to a particular musical style, a social

group acquires a magical version of itself. It ceases to be defined by its negative social position and defines itself positively by its identification with a whole but undefinable entity that has virtual existence in the imaginary and aesthetic world of the music and its other stylistic accompaniments.

The day after performing in a festival of improvised and experimental music in Budapest, I was invited by the organizer's brother to bring my Siberian drum to the center for autistic children where he worked. Whatever happened there—Was it a concert or an episode of therapy?—it was clear that these children had no access at all to the dominant form of the discursive self, so that the drumming process—I was obviously very alert to signs of response—proposed a completely different form of engagement. I could feel each drum hit radiating through our bodies, and I could feel us both afraid and gradually overcoming our initial fear. This raises the question of the relation between multiple forms of subjectivity and persons who, for one reason or another and to vastly differing degrees, are not included in the dominant form of discourse and its associated form of subjectivity; or who are included, but on condition of being jammed in passive mode, always acting the role of the object of discourse. Getting out of this jam can be stimulated by entering another type of ontological experience that may be nonverbal, that may use sounds or images or movements. Another kind of subjectivity emerges that is not assimilated into the discursive self given, or withheld, in the discourse. On this fundamental level, what happens in the sophisticated, knowing, "high-art" context of an improvised music festival is deeply connected to the kinds of "primitive" reaching out that might happen between a musician—completely inexperienced in this situation—and an autistic child. And this is clearly one of the forces and potentials of improvisation: people work out how to do something together from scratch, and they do this in all openness.

How much discursive stress, and of what kind, is projected onto you depends on who you are. Women, blacks, immigrants, benefit claimants (perhaps an ever-expanding list of categories) live at society's raw fracture points and get the blame for the existence of the fractures in the first place. The inherent limitations of ideology are projected onto them as their own failure, and this projection often takes place in a very physical way, that is, it demands to be etched into the mode of bodily self-imagination. This process of layered social discrimination, ranging from subtle turns of phrase to the deployment of state and other forms of physical violence, has proved so far to be an integral part of how socio-logic operates in a complex society. At the point of impact, the logic of such a society splits into many different

local logics. The exact form of appropriation of a given art form at a given time and place expresses a self-division of society that no longer opposes the individual as a monolithic entity but as the limited set of possibilities made available to the particular type of person you are defined as being. But as we go into the following discussion of music and ontology, we bear in mind that a politics of ontological experience is implicit in every form of music making in which self-definition could be part of the outcome.

II Music and Ontology

11 Toward a Materialist Ontology of Art

Is it possible to ground this discussion of art as an informational structure more deeply in its ontological character? Having grounded art's genesis in the ontology of a sintonic subject and then having worked toward art as we empirically find it, I realize that ontology has slipped too far into the background. Turning away now from sociology and history, it is time to rediscover ontology inside the experience of art as it is for us and to bring the ideas here into maximum contact with the main act—the art itself and our experience of it.

To do this, I examine in some detail (but not quite yet) what it is to listen to music. Rather than analyzing this musical experience immediately in ontological terms, I loop outward through perceptual, cognitive, and psychological considerations before returning to an ontological perspective at the point where I consider what possible consequence musical activity may have for the wider world. The need for this curved path arises because my adoption of an ontological perspective has been, and remains, selective with regard to the philosophical tradition from which it springs.

I have said that by *ontology*, I mean generative ontology, that is, whatever concerns the conditions, primarily temporal, in which subjects come into being. This coming into being is thought of not as a single originary event or birth but as a continuous process. A subject is a secondary type of dynamic structure that plays some coordinating role in the primary dynamic structure of a living system. Living systems are sufficiently complex as to have component regions that are partly insulated from one another. Where regions of a primary structure have recurrent or persistent distinctive temporal and informational processes, and these differences become important for the coordination of attention, there subjects may arise. I have argued that both sensory perception and the use of a serial coding system such as human language involve distinctive forms of temporality and that each therefore has its own type of emergent subject—continuously coming into

being under the temporal conditions generated by that specific activity in the primary system. This, in succinct form, exemplifies what is meant by the idea of a *materialist ontology* of the subject.

Now opens the intriguing possibility of also being able to situate such ontological processes inside aesthetic experiences. To do this would be to write a materialist ontology of art. But as soon as we turn to the question of ontology within art, we encounter a philosophical tradition that has made aesthetics a pivotal field for understanding human ontology in general. This claim, that art has a vital and powerful role in relation to the grounding of human existence, is sufficiently intriguing for us to want to investigate. The philosophical tradition affirmed in Heideggerian existentialism, and developed in differing ways by Luigi Pareyson and Gianni Vattimo, proposes that art is a radical and generative form of ontological action that, by its originality in founding its own new worlds, potentially refounds our actually existing worlds.

But I am reluctant to follow the philosophical method that first filters out the real world so as to create a laboratory of the mind in which things can be dealt with systematically and one at a time. This procedure all too often involves the insinuation of a set of conceptual restraints, inherited from a specific historical tradition of thought, that operatively replace an input of data from the real world. The experiment tends to work through the implications of these conceptual constraints rather than addressing anything beyond them. This limitation (admirably summarized by Dretske in his preface of 1981) makes doing philosophy less useful, in a direct sense, than it might otherwise be.[1] But beyond this, the procedure implies a hermeneutic circularity, which must be a fundamental problem for any self-critical philosophical project. In this sense, the relevance of such philosophical actions to the world can only be via historical processes of induction and resonance that are a priori as mysterious as they are for art actions. The practice of a deliberate hermeneutic insularity in art, the inward referentiality of its significances, would seem to apply just as immediately to certain forms of philosophy. There is a double meaning in the ontologist's strategy of placing herself alongside the work of art in history: to use this alignment with art's perspective not just to understand the ontologies of being, but to find, in the energy of art, an analog for the potency of philosophy itself.

Nevertheless, it has to be said that Heidegger is commendably explicit in the way that he clears the detritus of the world from the decks of thought. Of paramount importance is what he calls the "ontological difference," the difference between conceptualizing *being*, which is always specific and multiple, and conceptualizing *Being*, which he describes as the horizon within

which being is possible. The idea of horizon is intended to suggest both containment and distance, that is, that Being is no longer immediately present once being has been installed, but retreats to the edge of being, from whence it constitutes some kind of limit. Horizon also defines the zone in which light falls, in which it is possible to dwell and to develop relations with things. (I can't resist noting that for the part of my life in which I am a composer of music, this already feels very familiar.) For Heidegger, the kind of thinking that forgets or ignores the ontological difference on which this radical difference between being and Being is founded is metaphysical: it sets out to explain the multiple beings in the world in terms of their multiple specific origins.[2] The main currents in contemporary aesthetics are complicit with this metaphysics because they skirt around the ontological meaning of art and try to explain it as either the product of a specifically aesthetic consciousness or faculty or the expression of structures external to it, such as social, psychoanalytical, and so on. So Gianni Vattimo, in his development of Heideggerian aesthetics, opposes himself to what he calls the neo-Kantian tendency, for which the key term is Kant's notion of "disinterest." In his view, aesthetic experience is understood by neo-Kantians as an immediate and ahistorical kind of experience, disengaged from the real world, and produced by, and addressed to, a specific form of consciousness, and therefore ultimately inessential.[3] Against this, Vattimo draws on the poietics of nineteenth- and twentieth-century art—especially the writings of Kandinsky—as staking an important claim that art is capable of grasping experience at its most embryonic and constitutive phase and is therefore of vital importance. This poietics in turn draws on an earlier tradition of idealist philosophy, which promoted intuitive and spontaneous forms of knowledge as superior to rational and discursive forms. Placing himself, as a philosopher, alongside the manifestos of the art movements, Vattimo argues that art is an ontological event because it alters the presuppositions that organize the world in which, and to which, we are committed: art spurs a reconfiguration of our being in the world: in Heidegger's language, art is the event of Being.[4]

But when it comes to making explicit how art achieves its ontological effects, Vattimo backs away from close engagement with the art itself. First, he accepts wholesale the additional Heideggerian premise that word-language is the given ground of human being and that all art-languages are founded on it. For Heidegger, naming in language is what brings things to their being for us: human language has no specific character as such, but is universal and given.[5] Following from this, the real encounter with a work of art does not happen in the way in which it is experienced, but dialogically

and in verbal discourse; the actual experience of the work is mere prelimi-
nary.[6] This would seem a highly regressive move in my terms, taking us
directly back to Durkheim and systems of belief. But for Heidegger, dis-
course and language are one: not socially produced, but a given of the being
of humans.[7] Be that as may, having moved the crucial encounter out of the
experience of the work and into the nonart domain of discourse and lan-
guage, Vattimo then paradoxically situates art's foundational or prophetic
power entirely within the work itself rather than concretely in a subject's
experience of it: that is, he omits and expunges the active engagement of
the person who experiences art and the active commitment to such an
experience. It is the power of the work alone that founds a new world: the
new world does not emerge in the perceiver's active engagement with the
work. In this, Vattimo draws away as a thinker from a close-up engagement
with aesthetic experience itself. His anxiety about a neo-Kantian aesthetic
consciousness as the cipher of what is specific and autonomous about art
brings about this failure to engage closely with it in all its specificity.

In the next chapter, I develop my argument so as to overcome this dis-
tance. First, I take on the problem posed by the specificity of art for which
I have precisely been arguing, a problem that the Heideggerians bring to a
head and then dodge by dissolving art into language at the last minute. If
art is as special, and as informationally distinct from language as I believe
it is, how does it produce an effect on the everyday world in which we,
as persons, take and articulate decisions, and name and develop ethical
and political positions? Or, more pertinent, how does it do this without a
radical dependence on the very systems of belief and modes of interpreta-
tion that surely an ontologically radical phenomenon ought to be challeng-
ing? I go forward on a determinedly neo-Kantian basis, holding out for the
specificity of aesthetic experience to show how it is exactly this informa-
tional specificity that empowers art to call into being an aesthetic subject
in the perceiver. The ontological power of art can flow only from its way
of situating into a world the subject called forth in aesthetic experience, so
that this new and speculative subject-world relation carries over into the
wider world. The ontological force of art is not encrypted within art, to be
activated only by retrospective interpretation in the nonart domain of lan-
guage and discourse; rather, it is a concrete aspect and result of the subject's
actual real-time inner performance of the work as aesthetic experience.

Because I want to place the specificity of aesthetic experience at the center of my analysis of art and its effects, I place musical listening at the center of what music is. From this perspective, *music* may be defined as *sound that has listened to itself*. This shorthand way of putting it derives from my practical involvement in free collective improvisation—a form of music making in which the listening of the players to one another substitutes for a score as the primary source for a continuous emergence of form. I realized that when I compose music I am also (by definition) working without a preexisting score, figuring out the implications of what particular things might sound like in relation to one another, so that the written score, as it comes into existence, is a transcription of the sum of a series of listenings. The difference with improvisation is that a composer does not work in real time but makes innumerable passes over decisions that the improviser can take only once; this enables a kind of cumulative form that improvisation cannot give. But even where a high degree of abstract calculation is involved, and nonaudible structures such as narratives, diagrams, or formal designs play their part, deciding how things sound and how they should sound is the absolute arbiter of the compositional process.

Music, whether composed or improvised, is the trace or record of a series of listenings and of acts of forming that are informed by these listenings. Without yet opening up the question of form itself, we can say that the cumulative density of listenings and their inscription in sound traces out an emerging and developing subjectivity. We sense the sonic presence of an intelligence, choosing, deciding, moving, retreating, hesitating. This intelligence is not there just to be retrieved from the music as a kind of "content," but to be actively engaged with by the listener. And this already suggests something of what could be meant by the idea of an active listening.

How does this musical intelligence connect to how our ears and minds generate perceptions of sounds and their relationships? Prior to Locke's *An*

Essay Concerning Human Understanding, drafted in 1671, the world of appearances and things and the world of ideas, abstractions, and understandings were conceived as directly linked.[1] One could substitute, for example, a Galilean mechanics for a structure of Platonic ideas—a leap of nearly two thousand years—without doing serious damage to this intimate connection. Only after Locke would human understanding be thought of as the activity of a mind with its own structural and systemic depth, and only on this basis could human perceptions be thought of as interior constructions.

An actual perceptual psychology of music is therefore an extremely recent development. There are of course brief flashes much earlier. We find in Aristoxenus, a pupil of Aristotle and of the Pythagoreans, the notion that the act of listening to music involves a cumulative interaction of sense-perception and memory.[2] We find, even in Boethius in the Middle Ages, a brief discussion of the reality of sense data.[3] Yet for the most part, and certainly following the suppression by the church of empiricist tendencies inherited from classical thought, abstract speculation becomes the order of the day. The importance that music had for medieval discourse was less to do with its practice than with its place in the theoretical edifice of theocracy. When music was elevated to the medieval *quadrivium*, as one of the sciences to be taught at university level, along with geometry, astronomy, and mathematics, this wasn't practical music but *Musica*, the speculative philosophy of music, which had nothing to do with questions of technique, aesthetics, or science in the modern sense. The medieval theocracy had every reason to obstruct the development of an actual science of music.

Perhaps there are also inherent factors that explain why the lag in the study of music should have outlasted the Middle Ages. Consider only the paucity of scientific work on sound and hearing, as compared with the wealth and resonance of the work on optics; the brilliance of Arabic optics throughout the European Dark Ages; the invention of the *camera obscura*, described in detail by Giovanni della Porta in 1558 in his *Natural Magic*;[4] the work of Galen, Avicenna, Descartes on light; Leonardo's inquiry into retinal inversion;[5] the discovery of stereoscopy; Leone Battista Alberti's treatise on painting and perspective; the fruitful interaction of optics with geometry and astronomy; Newton's work on color and refraction; the telescope and the microscope; the central importance, finally, of the speed of light in the mapping of the Einsteinian universe and the understanding of the atomic basis of matter.

Alongside all this, the work on difference tones by Young in the eighteenth century, Rameau's work on partials, Bosanquet and Poole in the nineteenth century, even the publication of Helmholtz's *On the Sensations*

of Tone in 1862, seem a dull affair. It's as if nature had, in the ear, superimposed and mixed up together every physical, physiological, and psychological dimension that, in the eye, is clearly separated, so that the perception of sound appears as an obscurely unified moment, whose elements are to be prized apart only with the greatest difficulty. As Pierre Schaeffer pointed out, we cannot even speak of a "sound-object" without immediately becoming aware that our very concept of "object" itself is intimately linked to the workings of the visual sense; the eye has, so to speak, provided us with models for the actions of perceiving and thinking. The ear remains, paradoxically, mute; we hear blindly.[6]

If we read Helmholtz's title as boldly freeing music from images of objects, whether fanciful or real, and connecting it at last to actual mechanisms of sensation, then can we derive a musical aesthetics from a study of these mechanisms? Is the very existence of music predicated on human sensory-mental structures that cause the sensation of numerical ratios between vibrations to be absorbingly interesting? Have these mechanisms been shaped by the needs of music, or is music the accidental by-product of skills needed for biological survival?

On the Sensations of Tone

I begin my detour into cognitive psychology with the very beautiful, humble, and suggestive pages with which Herman Helmholtz brings *On the Sensations of Tone* to a close.[7] Helmholtz was developing an empirical cognitive psychology that could be said to have been at least partly provoked by Kant's work. In these last few pages, he draws a connection between what he calls the "aesthetic enigma," and the modest advance he allows himself to have achieved in his research on how the perception of musical tones works. The aesthetic enigma is how it is that, confronted with works of art, we want to feel their ordering principles to be completely enfolded in the materials that constitute the work. We want to sense the law of the work everywhere in it, but without consciously knowing what that law is—without the work bringing it to our consciousness. Only afterward, if we make a critical analysis of the work, would it be possible or desirable to excavate these ordering principles.

The empirical research that takes up much of Helmholtz's book concerns the fact that we grasp musical tones consciously as distinct entities, but that in order to do this, we have previously and unconsciously analyzed the incoming sound wave, which always reaches the human ear as a single merged totality. We have identified within that wave the partial sounds

that are the constituents of single tones, and we have then assembled the tones from these partials.[8] It is these assembled tones, the product of a complex process that is not monitored by consciousness, that are presented to consciousness as if they were the immediate experience of musical sound. The point of this is that the melodic and harmonic connections that we then sense between different tone entities as the music goes on are based on our unconscious recognition that they share one or more partials. In other words, we have exactly the feeling that Helmholtz is talking about—a connection that is following some principle of order, but without us consciously knowing what that principle of order is.

There is, then, continuity between aesthetic experience and normal experience, in the sense that in both contexts, we consciously attend to sensory objects that appear to be immediate, while in fact having constructed these objects via unconscious processes. But if, in everyday life, we fit these perceptually constructed objects directly into our functional worlds, in aesthetic contexts, the perceptual process is carried on to a higher level, so that we unconsciously group and interconnect our first-order perceptual objects, turning our attention to the resultant new objects of a higher order. In this way, for example, we might feel the immediate connection between two musical motifs, but without knowing what the mechanism of their connection is. And as these motifs become assembled into themes, our attention turns to the themes and we might sense an organizational similarity between different themes, but again without consciously rehearsing its mechanisms.

A number of points flow from this numinous and open proposal by Helmholtz. First, the actual experience of music is both fundamental, and resolutely distinct, even divergent, from the retrospective critical analysis of it. This would seem a strong argument against Vattimo's suggestion that the actual experience is preliminary to the real encounter. For Helmholtz, the two aspects are indissolubly linked, but it is clear that a process of critical exegesis of the work is less central than the unconscious grasp of a sense of order within it. (And this applies just as unequivocally to painting, or wherever else we feel a connection between two objects because we have unconsciously noted that elements of them are common to both.) Second, it is the unlinking of perceptual acts from their usual role in terms of the need to identify and locate resources in functional cognitive worlds that frees them to be organized recursively among themselves. Whereas functional domains provide perceptual closure at the point where objects are linked to their use values, the aesthetic domain extends perceptual processes upward. This free cognitive space is then partly structured by the substitute forms of cognition given in artistic traditions. But these forms of cognition that

involve knowledge of what kinds of perceptual objects are desirable, and in what orders and hierarchies they should appear are relatively open and fluid. Their function is partly generative, and their principles are historical and contingent rather than based on absolute laws of form. (For example, the origins of sonata form as form fade out into a hinterland of speculation about dance suites.) This openness in artistic traditions is what makes it possible for an individual work to contribute to the history of its tradition.

There is a risk, however, in extrapolating directly from a model of basic perceptual processes upward onto the level at which, say, thematic processes or other large-scale forms of organization are at work. For this extrapolation to work, it would need to be true that as we become conscious of objects at each structural level, we become in the same moment unconscious of objects at the previous level. The perceptual mechanisms that Helmholtz analyzed are an innate given of the human organism, and a generally fixed distinction operates automatically on this level between conscious and unconscious activity. The very clarity of this distinction suggests that it reflects the workings of an attentional economy adapted to functional contexts. Does this mean that Helmholtz's extrapolation from basic perception to aesthetic perception has only metaphorical value?

The important point here is that in aesthetic perception, the perceptual syntheses by which we construct higher-order objects are typically incomplete because the organization of these objects is recursive and self-referential. The unconsciousness of normal perceptual processes that Helmholtz highlighted attests to the need for economy in the energetics of attention and to the fact that a recursive monitoring system—where you would be conscious of the process of becoming conscious of how you had perceived something, and so on ad infinitum—would be dysfunctional. The organization of aesthetic objects also acknowledges these limits to attention, but in a very different way: the self-referentiality of aesthetic structure brings forward as stimulus what normal perception avoids as a waste of processing power. Rather than becoming trapped in a perceptual loop, we are constantly referred from the ongoing sensory surface of the sound toward the organization and interconnectivity of the objects that are forming from it. Our attention is moving up, down, and sideways between the different levels of organization. We notice, for example, a connection between a pitch interval on a lower level and the transposition of a whole set of chords on an upper level, but this noticing is itself typically incomplete; it is not extracted from the flow of sound, but already changing into a new perception because a new piece of information on another level has already altered the relationship that first came toward us.

It is this recursivity of the patterning that makes any single act of synthesis necessarily incomplete and underlies the powerful feeling that Helmholtz referred to of a law that cannot be abstracted from the musical material that embodies it. A given music will not so much impose and maintain a division between conscious objects and the unconscious processes producing them as propose *a dynamic distribution of attention on various levels.* The resultant way of listening, effectively unique to each piece, is determined neither by the basic processes of the formation of perceptual objects nor by the rules of the artistic tradition that specify the types of higher-order objects and their possible groupings. So the distribution of attention appears as potentially highly specific to each work, and as a key site for the encounter between the proposal made by the work and the attentional predisposition of the listener. I would go further: because listening is always a performance by the listener, the variability of this attentional predisposition has radically individuating effects on the emergence of an aesthetic subject in the course of each listening.

Ici-bas

In late 2011, I was preparing a concert recording of my piece Ici-bas *for release on CD. When I am working on recorded material, my listening veers between total performance and the kind of directed or focused run-throughs where I am watching out for one or more factors that contribute to the total impression. Is there the right balance (or imbalance) between the instruments, between high and low frequencies, between right and left channels, or between the center and the edges? What are the aesthetic problems, and are they ones that I can mitigate by doing something to the sound, or should I offer them as they are to other listeners? I gradually discover that* Ici-bas *moves too slowly for the kind of sound it has. This discovery happens in zigzag steps: I begin to doubt, I listen again, get myself convinced that the piece works, then the next day I feel it fails. I work up the idea that at the performance, which I conducted myself, the tempo sounded right, but that some of the room's reverberation had not made it onto the recording: the chords and textures no longer sound rich enough to sustain as long as they do. Or, let's say, the distribution of attention becomes too schematic when listening to them. (Or is this just my attention now? Have I listened to them too often?) I put the piece aside in favor of other recorded material for the CD. But suddenly I go back to it and start again, and everything falls into place. I listen in a state of exhilaration; the imagined and the perceived have converged—the perceived, of course always more than perceived, because also suggested and implied by the actually audible.*

To observe this process in retrospect is to see how attention flows differently in each unique listening. No two listenings are alike, and you cannot predetermine what happens in a listening, however strong your intention to do so. A listening is always something that you launch yourself into. The music always does something to you, generates a particular center of subjectivity in you, around which your experience of the music turns. When a listener is empowered, as I sometimes am, to then take decisions about what he or she has heard and to change it, then a series of listenings is being inscribed into the sounding result. This is not so different from the initial process of writing the score, or of teaching myself how to conduct it, or of rehearsing the musicians. A series of listenings is not a journey toward the truth, but a process in which a truth is generated. It is not true that each listening is closer to the truth than the one before, but rather that at a certain point, it no longer makes sense to change anything: you arrive not at an end but at a feeling that a set of journeys is complete.

Your You versus Your Brain

To think about subjectivation is, among other things, to force an opening between the Scylla of the Cartesian ego and the Charybdis of the determinate brain. The same deadly duo reappear in the cadastral tensions between two prominent academic approaches to music. On one side, cognitive science, interested in mental processes and how brains calculate, finds in music something approaching a pure mental process in which it should be possible to model with the utmost clarity the interplay between perception and cognition. On the other side, music analysis looks at musical structure in terms of segmentation and hierarchical organization to explain how compositions—typically those of Western classical music—achieve their coherence.[9] Music analysis, if not exactly a hard science, at least sets out to cut away preconceptions and get to grips with the object of study itself. In practice, this has meant stripping away all the cosmological and metaphysical interpretations that earlier theorists had placed over music, so as to engage with individual compositions as forms containing melodic, harmonic, and rhythmic materials. The suspicion that music analysis holds toward exterior constructions remains to this day, in the sense that it sees cognitive science as importing preconceptions derived from more general models of brain and mind.

Music analysis in fact imposes presuppositions of its own: individual pieces are traditionally compared on the basis of their conformity or non-conformity with prototype forms. So inevitably the experience of music is seen as dependent on a knowledge of form in the listener equivalent to the

knowledge of form developed by the music analyst. Finally, if not explicitly, the experience of music *is* the recognition of form, and the recognition of the variant ways in which form could be actualized. In short, a kind of structural listening is prioritized that is volitional and conscious.

As you might expect, for many music analysts, the work of scientists investigating musical perception in terms of cognitive mechanisms threatens "the deletion of the listener as a free agent."[10] Cognitive scientists counter by questioning whether music analysis does not involve unexamined presuppositions simply assumed to be commonsensical. Ian Cross asks whether it would not be preferable to replace these presuppositions with insights deriving from cognitive theories of music.[11] But after examining these cognitively based approaches, primarily those of Fred Lerdahl and Ray Jackendoff,[12] and Eugene Narmour,[13] he concludes that they do indeed tend to replace the "listening I" with the "cognizing brain." Narmour, for instance, differentiates sharply between style-dependent factors and the "cognitive primitives" that carry the most weight in his theory.[14] He conceives of his primitives as biologically "hard-wired, innate" cognitive principles and as the main determinants of musical structure in cognition.[15] These principles bear on the musical expectation set up by a phrase with perceived regularities, on whether the expectation is realized or not, and on whether this happens in a predictable or a novel way. Narmour is saying that these are mental processes that derive from the way the brain works rather than deployments of cultural knowledge: it is your brain that is doing the listening and not your you.

One basic problem for the analysts is that the structural coherence of a piece may not have much to do with what it is like to listen to, and that many of the structural segmentations may not correspond to anything in the listener's experience.[16] Against this, where the analysts score over the cognitivists, is that the analysts don't see themselves as doing hard science, so they are ready to accept that a number of different accounts of musical organization can simply coexist. On the other hand, a single more inclusive account is, in principle, as necessary and useful as a batch of more precise but less inclusive ones.

As a more general proposal, the idea of a dynamic distribution of attention would seem to render the issue of volitional versus unconscious processes obsolete. Recursive organization will tend to divide or move attention between levels of organization so that the listener's synthesis of segments on any one given level will usually be incomplete. No cognitive theory has yet begun to tackle contrapuntal music, but the idea of a dynamic distribution of attention suggests that musical listening is essentially contrapuntal

from the start. Finally, both cognitive and analytic theories still carry the baggage of consciousness. The sense of a heuristic requirement to define the conscious output of unconscious processes (e.g., in Ray Jackendoff's "Musical Parsing and Musical Affect") suggests that a Helmholtzian metaphorical extension of the mechanisms of auditory perception onto the level of aesthetic perception is still at work, even if implicitly.[17]

Neither analysts nor cognitivists engage on a fundamental level with the question of what is distinctive in aesthetic experience or what is distinctive about the perception of an aesthetic object as opposed to a nonaesthetic one. Neither analysts nor cognitivists allow that music is an ontological event—the analysts because they have not looked at how subjectivity is generated, and therefore see the listener who comes to, and enacts, the listening as a kind of morally inviolate intellectual entity who will remain staunchly unchanged by it; the cognitivists because their basically mechanistic models debar looking at subjectivity in the first place.

Recursivity in Aesthetic Production

Earlier I wrote, "The recursivity of the making processes in art echoes and expands on the recursivity of the perceptual processes that define sintonia." How can we understand this in terms of the way in which aesthetic work is made in general? The formal aspects of aesthetic work arise through the fact that it is the cumulative trace of shaping actions taken toward a material. These acts of shaping are conditioned by a series of acts of perception that are alive not only to the material but through the material, to each other. The looking or listening is at any stage toward or into a material already inscribed with the traces of previous lookings and listenings. Hence every perceived form is held in intimate relation to its potential transformations.

To paraphrase John Dewey, an experience has form because it combines (active) doing with (receptive) undergoing. Action and its consequence are fused in aesthetic perception: "A painter must ... undergo the effect of his every brush stroke ... making and forming is artistic when the perceived result of its qualities control how the work is formed. The artist has the attitude of the perceiver."[18] The recursivity, then, lies also in the recognition, in the material as it evolves, of oneself as a perceiving self—as a cumulative sequence of viewpoints.

This is the perceptual process that generates the conditions for artistic subjectivation, but how does this work into the constructive or productive process? In a narrow mathematical sense, recursivity involves singling out an object, doing something to it, then doing the same thing to the result,

and so on. A recursive process is one that, when left to its own devices, automatically applies itself repeatedly to the outcomes it generates. The result is often a linear pattern, such as a series in mathematics, or an always-starting-over folktale about a storyteller telling a story in a story in a story.

But in music, recursivity is often constructive. The output of a process of constructing or generating an object becomes the input of a second process of constructing a higher-order object, of which the first object then becomes a constituent part, and so on. Here we are not just interested in the circularity of input and output, but in how the construction is actualized at each step. But this is neither a general characteristic of artistic production nor a necessary characteristic for something to be music. Paradoxically, the whole question of formal construction is laid bare by improvisation.

Despite the reluctance of improvisation to allow construction, it can happen that having hit on a musical form while playing, there is the chance to sustain and expose the form as such, in which case its growing arch becomes increasingly dangerous with every second. Can it be completed? Can its instability be turned into a magic oscillation? Can its collapse be the kind of failure from which victory can be extracted? The edginess here comes from the fact that a "free" music must be free to assume a form, but that it also—to realize itself aesthetically—needs to stay form free. In practice, a determinate form occurring in an improvisation often provokes diversionary lunges of ever increasing boldness. What emerges is a tensile architecture, where something is affirmed and confirmed (only) so as to resist opposing forces. Finally it is bold moves opposed by bold moves, pressures by other pressures.

To put the tensile character of form this way illuminates what is shared by musics that have architectural form and musics that don't. Both of these must produce an aesthetic experience. When we listen to any music at all, we ideally throw open the doors and welcome it in, body and mind, as a guest. The measure of the richness of this meeting connects to the music's capacity to bring to us a many-layered field of possibilities. One way to achieve this is to use embedded forms, where we are guided between different levels of synthesis by the active presence of midrange formal structures such as groups of notes, themes, tunes, chord sequences, and so on. These seem to stimulate cognitive and gestalt attractions—or are they cultural and modern?—toward completion, in the sense that their constructive procedures will tend to be sought as far down and as far up as possible within all possible levels of musical organization. There is also a no-stone-unturned dimension to this, in that the composer has (perhaps) weighed every single note against all its competing alternatives. I am not saying that constructed

music works purely cognitively, in the sense of achieving its effects cognitively; I am speaking about the infrastructure of experience, not yet about the experience itself.

At the other extreme, freely improvised music comes closest to unfolding the inner movement of the musical experience directly. It sacrifices a hierarchical separation of formal levels of one type in favor of using many different perceptual categories at once. It does this by turning off the filtering that enables the selection of what is and is not musical, or of what has or does not have musical value in the existing context. At the same time, it actualizes the unfolding of a field of possibilities in the concrete form of the players' recursive decision making in real time. In so doing, it gets at the kinds of materials that are used in the psyche for subjectivation and throws them about like furniture in a box-room—giving a feeling of multiple goings on in a complex angular space with tactile and visual dimensions in addition to auditory ones. Within the total range of musical experience, improvised music provides the listener with the most active mimetic stimulus for subjectivation. Its greatest aesthetic difficulty is how to get that potential actualized in an experience that is cumulative.

Tonal classical music, in contrast, is cumulative. It processes ineluctably along the arrow of time, demonically balancing the asymmetry of time against the asymmetry of the harmonic series. The point is not that what occurs earlier is isomorphic with what occurs later, but that what occurs earlier foreshadows what occurs later. The recursive relation between expositional closure in a classical sonata and the structural closure of the whole piece generates, in the time span between these episodes, a sense of only partial achievement that demands to be gone beyond.[19] In other words, recursivity lodges a teleological trajectory inside the work, and this trajectory mobilizes and organizes the aesthetic experience of the music: this is the inner drama that classical music aspires to. The closure of the piece provides a kind of synchronization of all the partial closures that have occurred at every structural level, so that all the incompletely grasped recursive relations herd up together at the point of completion of the complete architectural form. (This may need to be more extended than just a single point in time, as the endings of a great many classical symphonies attest.)

When formal construction is recursive, it casts into stark light the contingency of the starting point—the selection of an initial material for the process. We can imagine that for a classical composer, material would likely be motivic—that is, a kind of melodic shape that appears as a whole but as an incomplete whole, not yet a theme but not something so elementary as, say, the combination of two pitches, so an intermediary structure, a

motif. We can imagine our composer listening inwardly again and again to this motivic fragment. How will it be possible to develop an entire piece of music from it? Or, rather, how can its unfoldings best respond to the formal demands of completeness given in the musical tradition—a tradition that provides not only templates for architecture but also models for expansion, repetition, and variation. We think of the "classical" composer because it is at this point that European music first achieves thoroughness of composition. The isorhythmic motets of Dufay are works in an older tradition that specified a smaller number of larger objects, such as extended sequences of pitches and durations, to be combined with only limited modification, such as change of tempo, or transposition of entire pitch set. As true polyphonic writing gradually supersedes isorhythm as the central focus of Dufay's project, he begins to found the space that Beethoven will inhabit some four hundred years later, in the sense that a Beethoven sonata involves evaluating and potentially varying each note individually inside a tonal and rhythmic space defined by vectors of attraction that are not themselves sounded. In strongly tonal music, the pull of the tonic, the basic note of the piece, is like the pull of the moon in broad daylight, felt even when we are not hearing it and have not heard it for some time.

But let us come back to Beethoven in situ as he listens and relistens to the motivic idea that seems to be taking on for him the nature of material for a piece. You can hear him doing this: the *Grave*, like all slow introductions in the symphonies of Haydn, Beethoven, Brahms, or the toccatas and preludes of Bach, both is and symbolizes "the improvisational stage of a composition at the moment of its creation."[20] This motivic idea, which likely came to him as a whole and which he begins by playing around with, has an inner structure. It is attractive precisely because it came with an inner structure that seemed entirely immanent within it, but which it is possible to break down and reconfigure, so that ultimately he will be working with and recombining the smaller cells of pairs or of triads of notes that together made up the initial motivic object, and with these, he will form other motivic objects.

If we treat Beethoven as the quintessential listener of his own music, we see him drawn to a process of perceptual circulation directed at and into a motivic material that turns his curiosity toward what was excluded from each variation, toward the readiness of each concretization of the object to be other than what it is. There is an essential quality to the music that is formed in this way, which is that it stimulates in its listeners a series of perceptual acts that do not achieve individual closure but of which the objects are held in intimate relation to the information from which they were formed. Each object is held both synchronically in relation to what in a functional context

would be its own suppressed and diachronically in relation to its own potential variations. This is what empowers art to interweave and merge simultaneous and sequential modes of connection. In art a perceptual object will be held in relation to information excluded from it, whereas in a functional situation, the excluded information is immediately dropped, the abstraction registered as adequate (even if corrected later), and we can move on immediately to the following moment. If you trust Beethoven, you realize that all the intermediary structures, tunes, harmonic sequences, and so forth, some of which may seem not so inspired, some perhaps even insupportable, are there for these inner perceptual processes to take place. I have grown to recognize the moment of recognition in myself when I suddenly think, *Beethoven really does not care much about this tune*, or *Shostakovich really doesn't care much about the sound of the orchestra here*. The strongest art contains its weaknesses in a way that second-rate art does not.

A final point about the infrastructure of aesthetic subjectivation is that recursivity, itself an intensification and expansion of sintonia, intensifies the conditions under which subjects emerge. The phenomenologist Edmund Husserl tried to understand how entities in the human world come to have stability in time; he argued that retentions in human memory are not only of primary impressions but also of the act-phase of forming those impressions.[21] By multiple superimpositions of such retentions is built up a sense of our selves as passing through time and of the stable entities we perceive as passing through time alongside us. Husserl's analogy for this is precisely the activity of following a melody. It was this that triggered my referring to his thought, even though I'm working toward something else— namely, what is different about listening to music as compared to moving along through everyday experience. When we listen to music, our primary impressions are not formed in relation to stable objects as such. The stability of the objects develops only on the level of the relationships between them; the sound itself is transient, constantly disappearing. To extrapolate from Husserl, we could say that the retentions in memory are of the act phases of forming relationships between impressions, not of forming the impressions themselves. The act phases of forming these relationships are, arguably, acts of world building and world reconfiguring more than acts of dwelling and recognition.

Aesthetic Worlds (1)

A particular kind of subject-world relation is at issue. Imagine again a living organism sensing a surrounding world. A sensory world is not sensed

as pure sensation but as a meaningful and connected domain of action toward which intentions are directed. According to Friedrich Hayek, the activity of perception is not separate but a part of an overall functional behavior-disposition of the organism-in-its-environment: knowledge of the environment consists in the action patterns it tends to evoke.[22] We may ask to what extent this cognitive orientation of the senses has been wired in to their specific neurological structure, and to what extent it is imposed from higher-level cognitive faculties and, as a corollary, how flexible the arrangements between cognition and perception can get when perception is freed up from its functional role in terms of locating and identifying resources.

In aesthetic contexts, perception is also referred back to cognition, but cognition in and of a special and discursively bounded kind of world in which the nature of the objects and their relationships is such that implicitly, perception is drawn to itself, that is, to the relationships within a series of perceptual acts. This special perceptual world is organized in a contingent and therefore potentially malleable way because it does not have to— and in fact it must not—correspond to functional needs, even if it is often integrated metaphorically and metonymically with representations of the objects and tools relating to those needs.

It is of enormous importance to recognize that aesthetic perception is linked to the formation and dynamics of aesthetic worlds that embody particular forms of cognition. This is a point that has been repeatedly overlooked in perceptual psychology—for example, by James Gibson, who, applying the criteria of functional perception to painting, judged it to operate merely on the primitive level of sensation and field.[23] The "ecological approach" to listening developed by Eric Clarke also ignores any specifically aesthetic attribute of a domain, experience, or object, restricting itself to respect for the material specifics of different sources. Music is one source among all the sources constituting the human environment, and the perception of music is therefore subject to the same general ecopsychological processes.[24] An informational perspective proposes, against this, that different kinds of information are processed in different ways, which in turn elicit different modes of cognition. The modes of cognition of art—themselves concretely and precisely embodied in how aesthetic work is made—constitute the aesthetic worlds that temporarily displace the functional worlds in which human perceptual skills developed. These aesthetic worlds require and nurture other perceptual skills and other structures of knowledge.

But the world of the aesthetic subject coming into being in aesthetic experience is not determined by the structure of knowledge given in the artistic tradition. It is, on the contrary, a particular and unique world that

is unfolding in that particular experience of that singular work. The structuring given in a tradition is incomplete and held open. It is there for the purpose of generating experiences that are always personal. Its openness is an openness toward freedom in making. It specifies only types of objects and processes, and what kinds of forms are acceptable or preferred. The composer of a sonata, for instance, works with a set of normative options that form the implicit knowledge of a music-using community. During the work of composition, decisions are nested inside one another, so that an infinite degree of variation is possible on the basis of this knowledge.

It is always possible, too, for someone to come up with a new kind of variation that stretches the rules and eventually alters the implicit knowledge of the community. In the modern period, art communities and their traditions become less stable, and we see the extent to which a structure of knowledge defaults, under these conditions, back to a generative ontology phrased in a dynamic of not knowing. Paul Klee wrote in his diary: "I want to be as though new-born, knowing nothing, absolutely nothing about Europe; ignoring poets and fashions, to be almost primitive. Then I want to do something very modest, to work out by myself a tiny formal motive."[25]

There is, in any case, an irreducible element of childishness and ignorance involved in the making of art that gets exacerbated to the point of becoming almost a method in modernity. Part of sintonia is gazing at, or being dazzled by, something, seeing it as if for the first time, ignorant of its function and meaning. This ignorance may be self-imposed, but when let loose in the artist's studio, it becomes a need to invent, and what is invented is precisely a new way of relating to the object or material that is before us and toward which we have slackened our world knowledge. The sintonic moment implies an alienation from the main world and from the way this world pushes toward us the links between perceptual objects and their uses (especially interesting, this alienation, when objects are already highly designed for some technical function—I am thinking of the creative "circuit bending" by which electronic gadgets are converted into unpredictable sound-making machines[26]). Art begins in being lost, or in confronting materials as open potentials of action because their predefinition as purposive pieces of world equipment has been forgotten or temporarily abandoned. And this can even apply to other works of art, as when Kandinsky discovers "an indescribably beautiful picture, suffused with an inner radiance. I stood gaping at first, then I rushed up to this mysterious picture, in which I could see nothing but forms and colours, and whose subject was incomprehensible. At once I discovered the answer to the puzzle: it was one of my own pictures that was leaning against the wall on its side."[27] And I

think also of György Kurtág's sudden reappraisal of his own work as conforming too functionally to an existing model: "There was a major theme, a secondary theme, and a conclusion, all very respectable, but nevertheless quite stupid, simply impossible. I had to rewrite the movement from the beginning again, even though only three weeks remained before the premiere. In a great rush, in one night, I rearranged everything, tore it all apart, more or less made my way through it with a pitchfork."[28]

Hamburg, January 2010

Notes on first two sessions of improvisation workshop:

Session 1: instrument

Use instrument only in a new way. (Nicola swapped hands)
Find 4 contrasting timbres or voices: use only these.
Find most unstable sound.
Alter the degree of control you have over your sound production according to my signals.
Imitate an unlike sounding instrument—e.g., acoustic to electronic.
Imitate non-musical sound.
Vary physical movement max-min. (Part of instrument/all of instrument.)
(Different substances out of which instrument is made.)
Separate out variables, e.g., speed and volume.
Severe limits.
Dynamics: all sounds must crescendo or decrescendo.
(think of your instrument as a sacred voice speaking another language, the language of the spirits if you like)
(start from your instrument as some dull physical materials stuck together: try to bring out the inner life in these materials.)

Session 2: body

Play w eyes closed feeling the tactile sensation of being in the room and of everyone and everything there.
Divided body: upper tense, lower half relaxed and vice versa.
Half birds. Two conductors for left and right halves.
Resistance as the performance state.
Push air with hands.
Get ready to make a sound but hold back, then make it. Feel the holding back strongly.
Invert usual speed-volume relation.

(Compression: put extreme anger into a small quiet sound)

(Changes in micro-rhythms, in weight, in temperature.)

(string pulling through top of head)

(Feel energy from above, from below) (Get energy from nature/the sky ...)

(What nature? e.g., winter)

(Focus on where skull sits on spine.)

(gesture: free improvisation where you "play" half the time but you only "sound" half the time you are playing.)

Forgetting and remembering as preparation for playing.

(Play a short piece as loud, dense and fast as possible. Stop. Then immediately a free piece.)

Requiem for the Ancestors.

(secrets: 2 emotions on bits of paper)

(Close your eyes and imagine you are hanging above the circle formed by all the musicians. Improvise freely, but listening to all the sounds made by the group and being particularly aware of where in the circle they are coming from.)

(Movement: mobile players circulate among fixed players)

(become an animal: play it)[29]

The incompleteness of the solutions proposed in the cognitive worlds of art presents an opening toward close-up observation and physical engagement with materials in their most sensory presence. In this sense, to look, or to listen, is always for the first time—or, to put it the other way around, always in its here and now. What we engage with by such acts is never phenomenologically exhausted by them. The Tuvan sculptor turns and turns and turns the stone in ever changing light, or places it on a shelf where he will see it day after day until it catches him out and tells him what he needs to carve it into. Wherever there are paths for the immediacy of observation to enter into the work, an individual work has the potential to refound tradition.

Field Recordings, Xenochrony, and Charles Ives

There was a certain moment when listening back to field recordings started to get very interesting. I had already experimented with recording a fair amount, first as a member of the Henry Cow band, when we started to use the studio to generate music rather than just record it. Memories of a giant tape-loop wobbling slowly round the control room. Then in the 1980s, with portable cassette machines, picking up sounds in the street and incorporating them directly into pieces. A trip to London Zoo to record tropical birds, from which I ended up using a slowed-down

recording of a human child's outburst of sorrow. But in Siberia, given that you packed a recorder to record interviews, you could also make field recordings of performances of music and shamans' rituals. Listening back to these, I began to realize that recording always gave you more than what you had asked for. By a great number of subtle but eloquent clues, each recording situated itself in a very precise moment and in a very precise place. And this was before anything actually happened on the recording. As you never knew the exact timing in advance, you got the habit of turning the machine on and leaving it going on a nearby stone. A recording of a ritual could become a close-up performance by a grasshopper. Or of eagles talking among themselves high overhead as they looked down hungrily on a shamanic sacrifice of food to the spirits. My favorite bits started to be the bits around, before, or after the event itself. So recording, which I had thought of as abolishing time and space, was actually giving me a very singular and accented sense of time and space. From here it was a short step to superimposing different recordings to generate multiple layers of space-time for use in music. We had gone back to an earlier starting point: What happened when you asked listeners to attend to multiple different strands of time simultaneously? Xenochrony is the technical term for this, and you can hear it when several shamans participate in one ritual, each with a personal tempo of drumming, each addressing personal spirits. Xenochrony became, in fact, an important strand in the story of K-Space, the trio that Ken Hyder and I put together with Tuvan singer and instrumentalist Gendos Chamzyryn. It brought me back also to some of the intense listening experiences I had had earlier with Charles Ives's music.

With his music, Charles Ives brings the distribution of attention right into the foreground. Ives thought music should make this factor explicit as multiplicity and build it into its technique as a way of awakening listening. He named the transcendental mode of thought "the indefinite subjective" and tried to get his music less definite.[30] He wanted us to half-hear the distant singing from the church across the river—as if any particular piece of music always started up somewhere in back of itself the ur-music of all musics, the voice that's always sounding through the experience of being human in the world. In *The Unanswered Question,* the strings, flutes, and solo trumpet have independent tempi, tonal focus, and dynamic range; the strings sometimes play inaudibly. In *Central Park in the Dark*, the strings "represent" the night sounds and silent darkness. In the *Fourth Symphony*, he wants music without a specified foreground, the listener invited to move inside the material. His use of orchestral subgroups to realize the multiplicity of natural phenomena echoes the musical ideas of many Siberian cultures. As in looking at a landscape, he wants us to focus on the sky, taking in the

earth in an unfocused way, then vice versa, to focus on the earth and only vaguely perceive the sky and the tops of the trees.[31] Ives never articulated a theory of listening as such, but it is clear that he thought that music could be an expansive act and a process of freedom that changes the listener.

Aesthetic Worlds (2)

The topological structure—the exoskeleton—of music's aesthetic worlds is represented in the kinds of hierarchies of stylistic levels described by musicologist Jean-Jacques Nattiez.[32] On the uppermost level, he plots the universals of music; below this comes the system or style of reference, then the style of an epoch, the style of a particular composer in that epoch, the style of a period in the life of that composer, and finally the style of a singular work. Each level gives a range of possibility that defines the limits of the next level down: the universals of music define a spectrum in which a range of different musical systems is possible, and so on.

We have only to pose the structure in this way to imagine immediately the mediating processes that occur between the inner boundary of individual experience and the outer boundary of established knowledge. Thinking of the seething interplay between artists that characterizes, for example, the expressionist movement in painting, the almost daily formation of new alignments, alliances, and schools in the various European cities, the interruptions of war, the alignment and disalignment with the communist movement, the rapid switching of artists between cities, or the sudden arrival of a Van Gogh exhibition in Berlin, brings forward the key importance of how individual artists move within art worlds and respond to the work of others. In the moment at which an individual artist is struck by a previously unknown work, we see truth as an event and the importance of the encounter with alterity. "Tonic and dominant were nothing more than empty phantoms," exclaimed Debussy at the Universal Exhibition in 1889, amazed by the Vietnamese music theater and the Javanese Gamelan. [33] Why not, then, invert Nattiez's hierarchy and draw it bottom up, with the contingent and momentary perceptual events that happen to artists, and then their individual works forming series, their foundational energy generating stylistic thrusts in particular directions, these series of works then acquiring weight in public perception and setting styles in the music world as their composers make their names, epochs coming to be known by the figures who most radically founded them, the "universals of music" finally themselves on trial as we go, say, from tonal orchestral music into a *musique concrète* now assembled and processed on computers?

The Fifteenth Quartet

Listening late night at home to a recording of Shostakovich's Quartet 15, I have an immediate and powerful impression of beginning at the end. The music moves effortlessly from one place to another by changes in a few details, as if it were suspended on tiny invisible wires. Turning about to see what there is, its viewpoint careful, surveying, not abandoning itself at all to the expression of an exact emotion. That's finished with. A dispositional ontology of the end, not the beginning, a how things were at the end of the process, when it was all over. But it is not all over. It goes on, now turning to the matter of how time itself is. So it sets off from the point at which art means—succumbs to meaning, uses human death to stand for its own death—toward a generative ontology in which music is and listening is. Let me throw in that I have a right to misunderstand everything about the composer's intentions. I do know that this is the last quartet, but I am shocked to read afterward on the sleeve notes that the fifth movement of the quartet bears the title Funeral March—when the idea of funeral and the idea of march had, for me, dissolved much earlier. But the piece is going on. I understand now that its detachment has been afforded by a pulse—I will walk on from wherever I am—that finally gives way to a series of raw crescendo notes, pianissimo to fortissimo, the attention suddenly on the making of sound itself. These crescendos seem to throw into reverse the natural decay of sound, the natural decay of everything. What else? He lets himself go, he pulls himself back. Figures rise through the strings but are turned back. He stabs the table to make a point. This is far beyond expecting one pitch and getting another: this is expecting nothing and getting something—something rendered extraordinary by the mere fact of its occurrence.

And here I lapse into commentary. Ill, dying, and self-pitying though he may have felt himself to be when he sat down to write, none of this mere circumstance could count except as artistic material: no serious composer is better at living than at composing. Yet Shostakovich, dead, enters history beset by biographical meaning like a man besieged by an angry swarm of bees. The point is not to recuperate the pure structural musicological Shostakovich from under the meanings clustering onto his music, but to discover its generative ontology and even its potential connections to a radical political imagination. The references in his music are there for their quality of arguing among themselves. Even I, who misunderstand the references, can understand this. Shostakovich is in constant dialogue with his environment, both his inherited musical environment, his peers and predecessors, and an omnipresent political environment in which waves of paralyzing fear overtook you when a close friend or family member was

arrested. What appears in biographical terms as a series of commitments marching off in opposed directions, alternating with periods of guilt and self-hatred and mitigated only by episodes of sardonic humor, appears in the music as a necessary quality of dissensus. The information that is the musical form is in a state of dynamic undecodability: it is information that concerns further changes of state in other parts of the composition: the whole is centripetal, perceptual, a complex body. Everything we feel and look for and recognize in it on a personal human level can be summoned up only because the music is like this—in other words, because it isn't there, or at least not in the way we want to think it is. I do not care what Shostakovich meant. What is there is the way he held his brush. His gesture. His way of dealing with repeated minor thirds. And then, through that, his way of settling scores with Tchaikovsky or keeping ahead of the young Denisov. Perhaps even his way of sucking in his breath when he heard the phone ring, the way a person who's had tuberculosis might breathe—the texture of his being that is present in the way he attends to a sound.

The Other of Music (1)

For me as a listener to be able to recover in some way (or, to be more precise, to create my own new version of) the listenings of the music's maker or makers, I must suspend, or bracket temporarily, my normal social interactivity. My engagement in this creative recovery has to be in some way continuous and cumulative and even exclusive. Yes, one could imagine a form of music in which each individual phrase would be followed by a short audience discussion, but even with good musical memory, it would be very difficult for an actually musical listening to carry over from each phrase to the next. To some extent this is how it goes in musical contexts where people have come mostly to mingle and socialize: here, the focus on the music itself is discontinuous, and it is likely being read for its social meanings. But what are especially suggestive are those situations that are both intensely social and demanding of focused listening. I think of myself jammed up against a tiny stage in a packed New Orleans jazz bar. (The jazz played here, I should mention, is once-in-a-lifetime music, the composed material being more or less the occasion for a series of personal and unrepeatable performances of it.) The intense here-and-now of this room and its overspill on the street is a whirlpool of rapid social interplay; different moves are constantly being picked up as social moves by all present, acknowledged, interpreted, responded to, a continuously vibrating, flickering network of shared sociation. And yet, and yet, and yet, within this great alertness to

each other and to our diverse uses—some agile, some clumsy—of diverse codes (after all, I'm a stranger here, and that's what's making me peculiarly conscious of all this), not to mention our animal and erotic togetherness and merge, we are all also listening to this music on another level so deep inside ourselves that, however outspoken, however confident and brassy and punchy and outwardly given out, are the voices of these instruments, not to mention the languages and signals of our interacting bodies, the music still holds fast to a dimension as low and irrecoverable from inside our individual psyches as a dream in the absolute moment of dreaming. And this inwardness seemed paradoxically much clearer that night in New Orleans than when I sat a couple of years later, a ranked and silent audience member, for another extraordinary and possibly also once-in-a-lifetime occasion, a performance of Luigi Nono's *Prometeo, Tragedia dell'ascolto* in London's Festival Hall. And this is because withdrawal from social interaction is both assumed and formalized in the tradition of Western classical music performance—even when we are listening to a metamusical statement about what listening to that music might be.

To recognize this quasi-solipsistic dimension of musical experience is problematic only if one wishes to establish a smooth continuity between musical engagement and social discursive engagement. Here I take it as intimately connected to the emergence of a musically listening subject whose grounding is in perceptual processes and the phenomenological conditions arising from them. Art in general, and music in particular, inherit from ritual this move toward an unagented presence that stands away from the usual grammars of agency that shape the flow and rhythm of day-to-day verbal exchange. This presence in art addresses the listener from outside society, standing for some deeper connection between humans, but without exercising its fluency in that connection as a form of social power. Here I part company with Lawrence Kramer, for whom the listener's subjectivity "arises in a process of address and reply in which music acts as the ideal or authoritative subject." He relates this to Lacan's "big Other," an idealized social power embodying the symbolic order, "whose subjective character I re-enact as my own."[34]

Ut at the Luminaire

There is an alchemy in electric guitars played in a certain way by those who know how: it is connected to a kind of physics in which harmonics clash and squeeze one another under pressure. Once this happens, song breaks down, not lengthways but vertically; its vertical organization implodes, and this blows apart the

poetics of song and recreates them in another dimension. Music becomes a wall of pressurized air, effectively a solid object, yet one that has a turbulent inner structure into which you can reach. Within are floating, strangely serene elements; a human voice straining with unbearable expressive burden takes on a calm noble form, distant, remote, and fine, in the way that smoke from a far-off factory chimney can seem to bear all the pain of those who wasted their lives in it. It seems that inside this claustrophobic density of sound, things can pass and be lone. A great tree slowly crashing in a storm. Imbued with distance, not withdrawn and mean, but whole in time, shot through with loss, not chosen, or only suffered. The sound recedes. The mangled voices have broken down and stopped. There is simply a group of awkward figures on stage. When they played, they were inhabited by ghosts. When a song ends, they chafe against the state of being caught in light, of being watched, of having no way of saying, No, it's not us that are the object of attention. *So we share with them the burden of that other claustrophobia, the smog of light in which society touches and retouches itself. Until they start again.*

The Other of Music (2)

Not only is a listener's experience of music a flow of perceptual information already organized by a previous series of perceptual acts, but these perceptual acts and their concomitant awarenesses are, in principle, always someone else's. The subjectivity inscribed in the music that is ready to be engaged with, is ready to be engaged with as an other. It is time to attack the question of this engagement and this other. The context of musical listening suspends or places in parenthesis the normal model of agency. The possible descriptions that come forward from the perceptual-phenomenological account of the aesthetic subject remain highly ambiguous on the question of agency. Beyond this, we have opened the question of a specific kind of subject-world relation in the aesthetic experience. Now, beyond this again, lies the question still uncharted for an ontological approach, of the extent to which the new-born, brief, and circumscribed subject of aesthetic experience bears on the wider social world, and this would—arguably— depend on the degree to which there is an experience of engagement with an other within the encounter with art that could in some way change the social world for us.

We conceptualize the other through the primary model we use in our discursive and social interaction. We attribute personhood to the other of our interactions, that is, we recognize the characteristics of their actions toward us as those of an agent: a center of activity toward us that can be treated empirically as having unity and continuity. We do not have to

explore the interiority of this agent to impute dispositions to them; the totality of their actions toward us is enough to constitute their personhood and how it is toward us. Our "theory of mind" is only this ability to read other people's mental states—our idea of what a person is builds up as our intuitive vision, first of the human other, then, through this, of ourselves. It is our Newtonian rule of thumb for the social cosmos.

Without using the cognitive attribution of agency as an explanatory mechanism in and of itself (along the lines of recent cognitive theories of religion), I want to suggest that we also sense the other in the work of art as a person in parenthesis of some kind, perhaps an avatar of the artist who made the work. This composite virtual being is, to begin with, obscure. Then we begin to feel in it what we might call the objective person—fractal and characteristic gestures, tics and styles of movement—not only the given human frame, but everything that a lifetime's use and action has made of it. It is these aspects of a person that are imprinted most in their physical handling of materials: the traces retained in artworks of this handling speak eloquently of a person's involuntary ways of moving and of bearing himself or herself, and this is of particular point for the craft of forgery and its need to grasp and reproduce what the painter had long since forgotten because it had become second nature. It emerges that the other of art is, above all, a formative other—a person caught red-handed doing art by intending form.

Form and Formativity

The continuity and consistency attributed to personhood derive from the construction of persons as social agents by other individuals in a process of mutual reciprocity. Insofar as this attribution is a requirement for the construction of a discursive self and its narrative, it draws readily on a metaphysical view of the person as an unmediated indivisibility, the expression of a specific essence, a soul. But in the context of a theory of the informational field of the human, a person is nothing other than a real-time but accumulating negotiation between the living system of a biological individual and the varied subjectivities arising within the field of that individual. The real weight for us of the concept of person lies in the finality of biological death, the moment at which the negotiation is over: it is this finality that seals our representation of personhood.

In what sense can an artist's person, or personhood, be said to be present in his or her work? It is true that when listening to Beethoven, or Varèse, or Ellington, or Satie, one quickly forms ideas—quite possibly mistaken—about the kinds of people they were and the kinds of gestures they made.

What is going into their works is not, obviously, their biographical exis-
tence treated as a theme or subject matter, but a quality of the way in which
they do things. But no specific principles of inventivity are centered in
them as integrated beings. We think we know them through their works,
but they are more resolved in their works than they were in life. Their
inventivity defines itself in relation to the task at hand. Their existence for
us as persons comes from the continuity within a series of tasks and from
the characteristic ways in which they observed and touched their materials.

If I seem to be proceeding with almost exaggerated care, it is because I
am stepping here on the edge of the territory of Luigi Pareyson's philosophy
of aesthetics. Pareyson synthesized aspects of Heideggerian existentialism
with a Thomist tradition he drew from the French Catholic philosopher
Maritain. In Pareyson's writings, a person is an indivisible entity whose
autopoiesis is expressed in what he calls *formatività*. This formativity, or
inventivity, occurs in all human action, but is taken further in art, where
it becomes its own purpose, that is, it becomes itself autopoietic and not
simply a technique for the autopoiesis of humanity.[35] In art, the forming
activity, freed from functional purpose, exists for itself, that is, effectively
acts as a vehicle for the expression and inscription of the formativity of the
person who is making the art. Therefore, art is made by the whole person
and received by the whole person. Hence the ontological power of art is to
be understood as operating on the level of wholeness, in the sense that in
aesthetic experience and interpretation, a whole person encounters a form
that is nothing but the inscribed formativity of the whole person of its
maker. Through this wholeness of both producer and consumer, the power
of art to refound the world that is its own world is carried over into a poten-
tial refounding of the surrounding real world.[36]

Against Pareyson, if persons appear to be inventive, it is in the sense
that they are a cumulative and irreversible improvisation in a complex and
informationally heterogeneous space: a person is not inventive because a
specific principle of inventivity is centered in them as a unified being. There
is no work of the whole being. There may be work into which you put your
whole being, but the wholeness of being that you put into the work is
defined by the how of the putting. Furthermore, a work of art is a construc-
tion and therefore belongs to the heteropoiesis of human design, even if it
is intimately marked by the autopoietic aspects of emergent subjectivity.
Then finally, Pareyson's is a top-down theory, as an idealist theory, it must
be. But it also conceals a redemptive narrative: the return to wholeness is
underpinned by an implicit fantasy of achieving through art what can-
not be achieved in actual social life, namely, the authentically refounding

encounter between whole beings. A materialist theory of informational het-
erogeneity does not confront this as an either-or question: it holds, rather,
that the failures of social life continue alongside the successes of art (or vice
versa) without there being a narrative or causal connection between them.

If for Pareyson each work is the trace of the total formativity of the artist,
nevertheless, in relation to a chosen material, an artist develops for each
work the law of that particular work that Pareyson calls the *formative form*
of the work. It is on this level that we see the artist inventing a new way of
doing things in each work. This is distinct from the *formed form* of the work,
which is its actual material realization. So each work of art is a project of set-
ting up a dynamic relation between, on the one hand, what crystallizes into
a way of treating the material, becoming the law of the work, and, on the
other hand, the actual work itself, the *what is done*, as it unfolds. There is
always a central risk that one of these levels will be inadequate to the other.
It is on this point that the main aesthetic appraisal or judgment of the
work takes place as it completes itself. Is there, or is there not, this mutual
adequacy of *the way of doing* and the *what is done*? The ontological power of
a successful work will reside in the fact that it is both the first instantiation
of a new law, a new way of doing things, while at the same time it does not
exhaust the potentials of its law. A successful work throws into the world
a new way of doing things that has the unarguable authority of the work
itself to stand behind it.

Is there a way of bringing Pareyson's schema to bear on the detail of
musical experience as we have been outlining it? Can we configure a discus-
sion of aesthetic action and aesthetic intention within his schema? More
urgently, we need, in reverse, to understand how Pareyson's description of
the structure of the aesthetic event can be applied to what happens during
the time that we are listening to music. We need to go inside this event and
understand the texture of the subevents that constitute it.

Each music proposes not only a way of listening, a specific dynamic dis-
tribution of attention—which is still an essentially perceptual-cognitive pro-
cess of organizing sound—but also, beyond that, a characteristic sequence
of formative actions, oriented to our interpretation of sounds as bearing
intention, our reading of intention in what we hear. Just as to arrive at a
thorough understanding of another person's position it is often necessary
first to misunderstand it, so what deepens the experience of the aesthetic
subject is the moment at which the networks of intention appear to split
apart and the music does not do what you thought it was going to do. The
accent here is not on the unexpected, which is easy, but on the *otherness of
the intention*. Something else was meant but what you thought. *But what is*

that note doing there? Why is it being held so long? And without vibrato?? (I'm at a BBC recording of Berg's *Altenberg Lieder*, near the end of the first song.) Or the harmonic twist in the tenth of Schubert's light-as-a-feather *German Dances*. Or the ten-second silence after the opening section of Lachenmann's *Gran Torso*. This is when we feel the other's will toward us. These moments perhaps correspond to what François Nicolas called *moments favoris*, which he defines as opening up a privileged dimension for following and grasping the process of the work. He instances the descent of both pianos into the bottom register toward the end of Boulez's *Structures II*, a point at which the structures "become drowned in energy."[37] Lawrence Kramer has a related idea of "structural tropes," which occur where structural tensions and the illocutionary force of the music that sustains them become manifest. These are the pivots around which our understanding of music turns. "Interpretation," he writes, "takes flight from breaking-points."[38]

Aesthetic Risk

In listening, I am forming a form, on the basis of what I hear, that is in a dynamic relation with the intentions of the other—intentions that are themselves, above all, toward form. But I am not reproducing the formative effort and process of the maker. That process is not even given in the chronological order in which I hear the music. The work is in any case not a documentation of how it was made, but a necessarily open project of achieving mutual adequacy for the material and the form. As a listener, each of my performances of the same work is unique and unrepeatable and is necessarily susceptible to indeterminate variation from the very beginning, so that each performance is in that sense historical. And even insofar as I am constant, I come to the music as myself, with my own motivations, ways of doing things, preferences, or tastes. Chances are this is not the first time I've listened to music: each listening forms part of a series of listenings, a personal history in which, say, I heard Bach before Dufay.

The form that I form is my performance as listener, and in performing, I participate in the excitement and risk of the formativity inscribed in the work. Aesthetic form *is* this form that a listener's experience of the music takes. Its defining features are not the principal segments of structural articulation but the moments at which the intentionality of the other is illuminated. These are the moments of *but*, not the moments of *and*. The crisis of my form at these moments is how the sounds depart and diverge from my prior and ongoing understanding of the form-building intentions of the other. It is at these points that the law (or lawlessness) of the work

asserts itself in contradistinction to the actual manifestation of the work. It follows that aesthetic form is not a cognitive structure, a knowing, a reading, a recognition, but a complex of forces, an authentically psychological organization of events and processes. It is not the envelope that contains the content; it is not the skin and limit of the work. It is exactly what opens the work toward the world or makes the work an open world.

How does such a moment happen from a composer's (not necessarily volitional) point of view? It may be a moment at which the composer herself realizes that the mode of listening she had hitherto deployed was itself inadequate to the direction that the work was now taking. It is a moment at which a structural principle of some kind wrenches against the material or heaves the material into another place. Or the material refuses to bend to the structural principle. It may be, in this sense, a moment of technical failure—but a failure that is seized on and turned to advantage. It is the mutual resistance of the material and the structuring principles of the work to each other. We tend to say that it is the resistance of the material, seeing the structuring principles as active and volitional and the material as inert, an input into the active process. But this way of putting it oversimplifies the relation between organization and material. The really important point is that the form that I form as a listener hinges on the points of risk of aesthetic failure. The primary patterns of tension in a work are not those we usually think of, on the level, for instance, of a crescendo held back from, or a delayed arrival at a point of segmentation, a cadence perhaps, but on the deeper level of the arrival or nonarrival at a point of aesthetic danger. The music makes a move, and we think: *How is it going to get out of this?* The music makes another move, and we think: *How can that possibly be made to work?* This is the edge of music and counts, finally, for more than its structural closure.

To understand aesthetic form in this way takes us beyond questions of aesthetic unity, resolution, and structural closure and is therefore capable as a model of applying not only to works that are deeply embedded in tradition, but also those that espouse radically disjunctive methods. A work may catalyze a listening that is alert to structural integration, even if there is no structural level on which that integration culminates in an architectural whole.[39] The point is not, as Anton Webern said it was, that a work has to have a graspable structure, a unity, that is a prerequisite for the listener to grasp the music.[40] He is reproducing the formula: listener (subject) extracts (activity) structure (object A) from work (object B). This may or may not go on, but it is not what aesthetic experience is and not what engaged listening is.

The crisis of the mutual adequacy of the law of the work and its material may be evenly distributed or unevenly concentrated to varying degrees. This adequacy, insofar as the risk taken is successful, accumulates until it is sealed by the ending of the work. There is a definite span of time in which *way of doing* and *what is done* develop simultaneously but without immanent synchronization: aesthetic form has to be emergent and cumulative. Because the aesthetic form of the work arises only in performance, it requires the active presence of a subject coming into being and cannot be said to be inscribed in the work itself in the way that a work's structure might be said to be so inscribed. Structural relationship involves a removal of elements out of time to form and hold a stable synthesis at a given level of coding and, as such, may play an important role in a composer's technical work on a piece. But outside-time structural thinking must never be allowed to impede, block, or oversolidify the aesthetic relationships that are emerging in time, and this is true even when the work is in a fixed medium and not a time-based one. August Macke wrote how "time has a large part to play in looking at a picture. ... The eye jumps from a blue to red, to green (even if there is only a change of form), to a black line. ... All at once the eye runs over the blue, red and green again, led on by different forms this time, starting on a new cycle."[41] Helen Vendler said, "I believe that poems are a score for performance by the reader, and that you become the speaking voice" and wrote elsewhere about "a trajectory of changing feelings in the speaker. ... It is the patterns and under-patterns of the sonnet that enable us to see the way those feelings change."[42] All aesthetic experience is performed in real time. If I seem to be making too much of this difference between aesthetic form and structure it is because so much emphasis in music has historically been placed on structural listening.[43] But we do not need to take music's technical mask at face value. And, by the way, would it make sense to speak of "structural looking" as the right way to look at a Titian or a Cézanne?

Ontological Power of Music

Art traditions vary. They are in constant, if discontinuous, negotiation with the socio-logic of specific cultures and epochs. When Vattimo attacks the neo-Kantian tendency to see art as contemplative or immediate, and so merely parenthetical to ethical or political life, and when he therefore sides with the art of the manifestos, he is saying that radical art is reaffirming the ontological power of art. But in this case, "unradical art" would be denying that ontological power and supplying society with the neo-Kantian

contemplative experience that society wants. Western art music inherits a rhetoric of transcendence and apophasis from its incubation in the church and the ecclesiastical doctrine of a profound separation of flesh from spirit. The dualism of subjectivity in the listening situation can be seen as a failed encounter between a transcendent musical subject and a background discursive subject whose flesh remains ritually calmed and seated. All this is formalized in the archetypical listening situation of the concert hall, where the objective detachment of aesthetic experience is taken up and fixed in such a way as to make it absolutely secure. The broader consequentiality of the musical experience can hinge now on only two possibilities: what is retained of the listening subject in the long term, and what is communicated to the background subject at the moment at which it no longer stays in the background but, the music being over, steps forward to reclaim the foreground. This moment is marked in the concert hall by applause. The audience, silent for the duration, now asserts its collective power by erasing the individual listening subject with a sound that is categorically unmusical and atavistic.[44] The consequentiality of the musical experience is therefore presented as very fragile. We can imagine that with the sudden death of the listening subject, which was never socially adapted, which was indeed necessarily not socially adapted, which indeed tragically failed in its task of enacting metaphorically and in advance the wholeness of being as a social being, the experience is strongly normativized in the context that now abruptly steps forward.

The burden of consequentiality would seem then to shift away from this tightly enclosed and ritually conditioned moment and to devolve onto future time. The perspective here seems brighter. Memories can be activated, performed in different modes, private to their kind. Musical experiences may form a series of resonating chambers whose voices speak among themselves across a time and space preoccupied with other sensory modes. Here the autonomy of music becomes its durability rather than its fatal weakness. A listening subject regains memories of previous listening subjects. But is the consequence of music in the real world limited to a set of musical experiences that, while connected among themselves, are separated from the decisions and ethical choices of the individual who inhabits that world? Or, worse still, is this separation overcome only by a discursive construction of musical experience as a negative to the real world and a nostalgia for its own lost world?

Earlier I wrote that art's ontological power can flow only from its way of situating into a world the subject called forth in aesthetic experience, so that this new and speculative subject-world relation carries over into the

wider world beyond the aesthetic experience as such. In other words, the ontological power of art is not hidden inside it, to be activated only by retrospective interpretation in the nonart domain of language and discourse, but is a concrete aspect and result of the subject's actual real time inner performance of the work as aesthetic experience.

So how is it done? How can musical experiences step over the rituals of normativization and project themselves into the surrounding world with any force? How does an ontology of the aesthetic subject catalyze (from afar) an ontology of the political subject? I have two provisos here: first, forceful musical experiences are absolutely not restricted a priori to structurally disjunctive works or to contemporary ones; second, individuals vary enormously as to how they respond to music and learn to respond to music, so that when I speak about what music can and cannot do, I assume that both music and listener are fully realizing the potentials of the art. This includes the commitment of all at every stage of the process and brushes aside questions of bad art, slipshod performance, slack composition, and offhanded listening, even if these may be the norm in many circumstances.

What remains from a forceful musical experience is a certain temporal form, whether grasped or intuited, disjunctive or whole, but in either case not simply cognitive, not just a matter of knowing how it goes, sometimes in fact hardly knowing how it goes at all. It is a shape that has been inhabited, that has been lived in, that has worn you and that you have worn, that has, above all, like a life, been performed and generated by a subject, and that has marked that subject whose history it is now part of and exists within that subject as a resonating life-form. These sequences carry and imply their own virtual anatomies and emotions, but they are also sufficiently connected to more general motivational and motional structures to operate potentially in other domains. Without necessarily being immediately accessible to consciousness and recall, they work themselves down and back into the life of the mind—its dispositions, attitudes, and characteristic activities. They bring a glow to the background hum of unaccessed memory.

Can we assimilate these generative sequences into the category of image-schemas that Lakoff and Johnson proposed? Image-schemas were a way of explaining the metaphorical extension of patterns of bodily experience into other domains that were difficult to articulate in a direct way—in particular, the domain of abstract thought.[45] The bodily experiences in question were, however, seen as habitual, and so temporal in only a rudimentary, repetitive way. For an adequate mapping of musical experience, we need a more ambitious concept, one that connects to subjectivation, motivation, and action. But the notion of image-schema does gather together some

important components. It brings into relationship the idea of specific forms of bodily experience, the idea that something can be transposed in some way out of these specific forms, and the idea that the zones onto which this transposed element is projected are zones that are tricky to access directly.

Musical experience is an active and performative imaginary-perceptual organization of sound images. The imaginative process that forms and organizes these images is both the work of an imaginary auditory body and the work of subjectivation by which that body is continuously formed. The listener acquires in the music, and the specific mode of listening it proposes, the imaginary body with which to inhabit the work and with which to encounter and experience the events of truth in the work such as they are. In his phenomenology of perception, Maurice Merleau-Ponty develops an idea of the body as incarnated subjectivity.[46] This way of putting it suggests that to be incarnate is a singular and continuous condition. But in music we have an autonomous subjectivity, a listening subjectivity, pulled into being under the special conditions of musical listening. We are dealing with this subjectivity's forming of its own body-image, incarnating itself in sound, not quite confined to the auditory dimension, but activating ancient synaptic connections and sensing itself moving in space, responding to gesture with gesture. This body-imaging process of the listening subject can be understood as drawing on and repeating an ontogeny that echoes the primal experiences of the individual human subject, "first constituted," as Jean-Luc Nancy says, "by resonance and timbre."[47] But it can equally be understood as an important way in which music is a resource catalyzing the development and nurture of forms of corporeal organization and states of being.

The special value of this resource is given in the fact that it develops in a time of subjectivation free from the strictures of the symbolic relation and the normal grammar of agency, a time in which the synthesizing activity of the subject is not recurrently terminated in a series of symbolic or functional closures and automatisms, but is distributed, extended, recursive, and circulatory. The motional structures of art embody different and new ways of doing things, operative in their given perceptual and material media, but set into the world, and carrying the conviction of the example that is the singular work of art in which they occur. Each work of art has broken open a new passage between the imaginary and the real.

The zones of life onto which these motional structures are projected are, like the domains that demand metaphorical expression, not self-explanatory or self-evident; they are the areas of worldly experience that are passed over, or glossed over, by means of communicative forms that substitute for

thought, enabling social life to go on around them, or flow over them, as shared nonthought. They are silences. Aesthetic experience, a phrase that now carries the sense of experience as part of the history of a mind, is drawn into play at these moments of disguised cognitive fissure. The generative dimension of the motional structure motivates an opening toward the event of truth and toward dissensus; the loss deferred in the real negotiation between language and perception is not now deferred but assumed. The perceptual subject sketches, at these points of silence and veiled confusion, new models for the discursive self and its behavior.

Art is a domain allowing an otherwise inadmissible engagement with indeterminacy. The contingency of musical material in relation to the recursive processes of aesthetic organization echoes the contingency of a culture's founding moment: the force of forceful aesthetic experience pushes us back to the bedrock of the political ontology of culture, exposing its arbitrary nature, and making what *is* appear as an instance of what *could be*.

Music is sounded between persons, but its voice is parenthetic. It articulates the conflictual informational space into the interpersonal world by activating that space into a dynamic ontological environment in which the listening subject comes to life, acts, and is marked by its actions. The ontology of this subject potentially catalyzes a new ontology for the political subject. What is articulated on the level of tragic narrative is the failure of symbolic communication as discourse to include its own excluded. The quality of aesthetic experience that makes it potentially a window opening into another world derives from the fact that it constitutes a new world-body relation that relativizes if not reality itself, at least the discursive construction of social reality. In this sense, discourse is a dream from which art can wake us. To do this, art offers us an aesthetic body with which to experience the wakened state of art, and not the dream of discourse.

We return to the question of the person. In aesthetic experience, the sense of agency is loosened, and the emergent subjectivity is conditioned by a specifically perceptual structuration. So neither the virtual other inscribed in the work nor the interpreter-performer of aesthetic experience can be said to be "whole persons." Neither is the notion of the "whole person" in the wider world unproblematic. So Pareyson's model, in which art is interpreted by the same whole person who inhabits and takes decisions in the world, is insufficient. It is, on the contrary, the limitation and exact focus imposed by the sensory nature of art that allows the performance-interpretation of the aesthetic subject to work as a generative model for the refounding of the person who inhabits the world. The detour through

the perceptual and cognitive dimensions of music listening proves to have been necessary to understand this ontological force.

Expression

But this is not all. Music "moves" people in another sense. Indeed how music expresses emotion is central to how it is usually talked about, not only among listeners, but even in classes on the aesthetics of music. In the latter context, I mention contemporary texts by Peter Kivy, Stephen Davies, Jenefer Robinson, and Jerrold Levinson.[48] It will be obvious that I have needed to deemphasize radically the notion of expression in art in order to formulate a theory for which aesthetic experience is both fundamental and revelatory of an autonomous form of experience. Only with this in place are we in a position to understand the emotional content of art and reconfigure it in the terms so far developed.

In this light, the idea that art in general, and music in particular, is the language of emotions, shows itself up as a discursive maneuver of appropriation. Music history can be analyzed as a conflict between *expression*, where music fragments its aesthetic unity into an array of sound-symbols, and *expressivity*, where music insists on the centripetal force of aesthetic organization to maintain its autonomy from meaning and address those levels of motion at which subjectivity forms itself.

In practice, however, historical changes in the structure of discourse stimulated new impulses to objectify and to express, and this made a historical variable of the relation between motional structure and musical sign. Composers looked for ways of using the iconic elements of emotional representation without compromising their aesthetic project. We must imagine a process in which the cycle of recognition and response to musical signs is taken back into the music, so that the emotional gesture is aestheticized, while the aesthetic experience is intensified by the overcoming of what had threatened to distract from it. These emotional gestures are formed within aesthetic works and occupy an expressive space whose dynamics are centered in artistic processes, and not in the socio-logical processes in which emotions that might demand expression are produced. As such, an assembly of emotional gestures shared between works of art and their public constitutes what Robert Hatten has identified as a "style." This description softens an earlier one in which I described artworks as having a singular surface across which no one kind of meaning could pass. The expressive space of a style can be thought of as an extension of this surface beyond the limits of the work, such that the gestures that form the contents

of this space are shaped by the aesthetic logic of the work and of other works in the style. The interpretation of these gestures does not consist in a series of semiological identifications but refers back dynamically into the experience of the work.[49]

An important factor that historically exacerbates the antagonism between expression and expressivity is that, in the Renaissance, affect is treated as essentially static. It is not shown in its coming-into-being but in its timeless, heroic, statuesque form. The music of affect is both a series of signs to be interpreted in a synchronic system and a series of moods or tableaux or settings in which signs of affect are grouped together in various permutations. The representation of affect is therefore a brake on the development of motional structure and its corresponding expressivity. In the Baroque period that eventually follows, musical motion circles in on itself, taking the form of the repeated harmonic sequence. The music strives to meet the demands of both moving and staying still at the same time. The idea of objectifying emotional processes would still be alien to this period.

Only when history makes this idea necessary and relevant would music turn decisively to drama as the source for a new design. For this, we await Haydn, Mozart, and Beethoven. But even the development of transformational technique in the sonata would not dissolve the problem of expressivity. Composers would still write *expressivo* in their scores, half-wondering if they shouldn't be a little more specific. And here is an extract from a letter dated February 1, 1914, in which Schoenberg complains to the young conductor Scherchen that he is rushing the chamber symphony:

Then the B major part of the Adagio much too fast!! This begins quietly and contemplatively, and its intensification must *not* be *passionate*, but "inwardness intensified." It's a remarkable thing: passion's something everyone can do! But inwardness, the chaste, higher form of emotion, seems to be out of most people's reach. On the whole it's understandable: for the underlying emotion must be felt and not merely demonstrated! This too is why all actors have passion and only a very few have inwardness. I can't regard it with tolerance![50]

In real life, emotion occurs when connection develops or suddenly occurs between a change of bodily state and a stimulus, usually external, but sometimes retrieved from memory. Both the bodily state and the stimulus potentially provide definition of a specific emotion. The key point is that emotion changes the body, and through the changed body, the subject sees the world in a different light in accordance with the emotive script.[51] Suddenly everything looks gray, or feels bitter, or appears to be bursting with light and energy. The subject is aware of the change, aware that some normal state has been overridden by the new state, and this adds to the feeling.

Now come back to music: musical expressivity also connects to bodily change, but this time to the process of embodiment of the listening subject, by which the listening subject acquires the senses of the new virtual body through which the listener commits to that listening of that music. It is the emotion felt by a part of oneself that is carried out of oneself; it is "being moved," in this sense, that generates the emotion. Robin James wrote that *expression* assumes both a subject and a something to be expressed, contrasting it to *performativity*, with its implication that the performing subject is produced in the very process of its performance.[52] Even when music is designed to elicit a particular emotion, the force of the specific emotion depends on the energy with which the listener is moved by the music. And this perhaps explains the fact that listeners are often keen to talk about their emotional experiences of music, but do so, equally often, in a limitless and uncategorical way. James Currie observed that students, when asked what a piece of music they've just heard means,

> More often ... respond by listing their emotional reactions. Whatever the nature of the answers, though, what is nearly always to be noted is the infectious enthusiasm that the question in relationship to the music produces; the activity itself of being involved in answering seems meaningful to them. However, as the answers continue to tumble out of music's horn of plenty, the evidently meaningful nature of the activity per se comes into an increasingly contradictory relationship to the terms seemingly set up by the question itself. For one could be forgiven for assuming that pleasure in relationship to answering the question would come from answering it succinctly: What does it mean? It means x. And yet as the list of answers continues to swell, the possibility of establishing x fades. So music confronts us with the paradox that specific meaning is not a precondition for an activity being meaningful (full of meaning).[53]

As a clarinetist, I sometimes face the question of how to interpret a written part—even when this questioning and answering happens in an implicit way rather than in an intellectually conscious way. It sometimes feels right to add a dimension that is neither encoded in the musical notation nor given in the unspoken tradition of interpretive rules appropriate to that notation. I have heard an equivalent discussion between pianist and clarinetist in a rehearsal of the Brahms sonatas: "Here, in this section, I will make my phrases like propositions, ones that you answer." This dimension specifies in some way the shaping gestures of the music, referring to holistic ensembles of mental and physical organization. To enter it is like assuming a character, becoming another person, and one with a particular body, who perhaps walks in a particular way, speaks with a particular voice or tone—and sometimes, yes, feels a specific emotion. My understanding of

this process is that I am not doing this to communicate these things to the audience. I am doing them to get myself playing in a way that allows my mind and body to be most effective in the performance of this music. The particular is a pathway to the general. The particular things that I choose to bring to an interpretation are pathways leading toward a performance; the intention implicit in this performance is to interconnect detail and whole in such a way as to generate powerful perceptual ontological conditions for the emergence of a listening subject in each listener. And I would argue that even when Albert Ayler said on the cover notes of the *New Wave in Jazz* album: "It's not about notes any more, it's about feelings!" that's also what he meant.[54]

13 Three Poietics of Music

Within the potentially infinite scope of musical experiences, each music, and perhaps each instance of music, proposes to each listener an exact way of listening. What vectors of change move these exact ways of listening toward general but identifiable collective shifts?

At one extreme are large-scale processes, such as the profound reorientation of European listeners in the shift from medieval to Renaissance music cultures or the development of a music based on harmonics with the adoption of a horse-based culture by Central Asian peoples. At the other extreme are the propositions of individual musicians made in the small-scale context of a highly self-conscious art scene in which a distinctive individual position is rewarded. What we have, right here and now, is a very interesting situation of the latter type, in which listenings of many different kinds are being proposed simultaneously, not only by new technologies but also by the compositional output of individual musicians. In this chapter, I look at three individual musicians, John Cage, Pierre Schaeffer, and Helmut Lachenmann, each of whom has made a radical musical proposal and articulated a distinctive musical poietics. I compare them with regard to the kinds of listening strategy they have proposed in their music and in their theorizing of it. What kinds of distribution of attention are demanded by their musics? What kind of aesthetic subject emerges in their work and its listenings? How and in what modes is aesthetic risk distributed or concentrated in their works, and at what points? What explicit claims for ontological consequentiality do they make, and how well grounded are these claims?

John Cage and the Wandering Subject

John Cage (1912–1992) thinks his music should be the production of a "quiet mind," something that can help to quiet the minds of others. A "quiet

mind," for Cage, is a mind in which the ego does not obstruct the flow of information, in which the ego accomplishes, in fact, nothing, least of all by writing, performing, or hearing a piece of music.[1] Will is linear, allopoietic; only music without will can be autopoietically authentic and self-producing. The ontological renewal implicit in Cage's music is to bring us into harmony with the self-production of the world. We listen now to silence. Silence now means the totality of the unintended, not a literal absence of sound and movement, but the totality of all the sound and movement that is happening anyway when our intention is quieted. To hear the world is to silence the inner voice and live for a moment outside discourse.

In Cage's dualistic view, intention can only produce a catastrophically rigid mind-set such as that employed in the workings of traditional tonal harmony. Whoever sets out to compose a determinate piece of music cannot avoid laying down a dominant continuity that determines a line of hearing and prevents the listener's perceptual capacities from opening to any other possibilities. Cage's deterministic model of musical experience fails, of course, to respect the active nature of aesthetic perception, the constant sending back of the attention to adjust the filters and discover something new. It leaves out the listener's contribution to the emergence of a new and unique continuity with each listening. It's as if to say that aesthetic experience is not a performative creative activity, but the mechanical outcome of the material placed before it. Cage's view leaves out the fact that the intentions sequentially embodied in a classical composition are complex rather than unilinear; each note is there as a result of multiple choices and bears the quality of not being the other notes it might have been. So what you hear opens out into a field of unheard possibilities that crucially enrich the actually sounding music. There is a dominant continuity involved, but it is how the road is taken that counts. Cage, in his haste to carve out a new position, underestimates both the listener's active engagement in forming aesthetic experience and the potential complexity of that experience.

How does Cage propose to free himself, as a composer, from the intentionality that imposes such a rigid continuity on the listener? So invasive is intentionality (e.g., in improvisatory processes) that it can be gotten rid of only by using systematic methods. Cage turns to divination and the I Ching, and his music thereby implicitly claims the legitimacy and authority of the sacred. He withdraws from choice and devises for each piece a system or method that does as little else as possible but describe how a set of choices might be made. He is no longer present in his music as making audible decisions, but rather as channeling and filtering an input of chance relationships. There can be no specific temporalization of aesthetic

risk in the outcome. Cage has already played his cards well before the music begins to sound in the actions of performers. His presence to and in his own music is not that of a listener: he is not there in the music, hearing it and forming it. He is more of an organizer, a *metteur en scène*.

With chance methods, listening is cut out of poiesis. But if this is music that has not listened to itself and has not responded to itself musically, it would seem prima facie that it must constitute an unworked material, which the audience, assuming alone the creative responsibility, then turns into music. This, however, ignores the vital role of the interpreter-performer. It is the interpreter of Cage's scores (notably David Tudor) who listens on behalf, as it were, of the composer. It is the interpreter's listening embodied in sound that the listener comes to in the musical experience. But we should note that this aspect of Cage's music remains untheorized: Cage systematically avoids the question of the relations of production, making generous use of McLuhan's writings, in which media appear as pure and transparent technological outcomes without social structuration. Behind this discourse Cage surreptitiously applies his own taste to how his pieces should be performed, even when the idea had been to exclude that dimension from the compositional process. More generously, we might say that he carries out pragmatically the necessary adjustments in order to reduce and exclude unwanted expressive, or other, cultural components introduced by performers.[2]

Cage does indeed claim for his own work—and we find this often in contemporary music—a greater and more active role for the listener. Let's look at this claim. As we've already seen, it relies partly on a prior claim to the effect that listening to classical music is passive because the composer strong-arms the listener through the piece. In contrast, Michael Nyman, taking his cue from Cage, describes the activity of the contemporary listener as like wandering around inside a musical space or environment. Listening becomes much less passive, and people realize that they themselves are doing it, not having something done to them: "The listener should be possessed ideally of an open, free-flowing mind. ... The listener may supply his own meanings. ... Any act of imagination or perception is itself an arrangement."[3]

Wandering is a condition in which large-scale motivations and orientations are set aside so as to allow attention to fall on incidental details. We are not walking to the station to catch a train; we are noticing the reflections of buildings in canals. Is Cage setting up a structural looseness so as to unlink the detail of sound from large-scale formal organization? We come here to a fork point. We can think of Cage's music as offering a repositioned aesthetic experience in which small-scale perceptual processes attending to

the detail of sound are given an autonomous aesthetic value. Alternatively, we can think of his music as freeing the upper-level perceptual capacities that attend to larger-scale organization for an active and imaginative search for new kinds of relationships.

To pursue the first possibility, it is by no means clear that Cage intends to generate a closer attention to sonic detail in his music. True, the higher-level, more abstract processing activities involved in recognizing, sorting, and drawing connections between perceptual entities are relaxed, or unlinked, which might permit—but under what conditions?—a more intensive listening activity on the lower levels: a closer engagement with the grain of sound, the internal structure and character of individual events, and the connections (or lack of them) between these events. But this brings us up against a further important aspect of Cage's aesthetic proposition. To defeat intentionality, Cage opens music to all sound and renounces any intentional selective process, not only with regard to when and in what relationship sonic events occur, but also with regard to what types of sonic events occur and, significantly, to whether these events are of a kind that stimulate attention to sonic detail. On this point, the composer and sound-artist Francisco López tackles Cage head-on for what he considers to be his externality, for proposing a wholesale reassignment of all sound to music, when the point is to expand the depth and range of aesthetic perception.[4] In practice, the difference might come down to the demonstration of a new attitude toward sound versus a deeper working engagement with its inner detail. On one side is a gestural abolition of the boundary separating music from the rest of sound; on the other is a modification of the perceptual world of Western music and the selections and hierarchies of its permitted perceptual input. López is talking about an expansion of the perceptual world of music that brings the kinds of attention at work in music to bear on a wider range of sounds and in greater detail. Sounds included in the perceptual world of a musical tradition are typically reduced and simplified; such worlds develop not only by selective listening but in symbiosis with selective technologies of sound production. Sounds that have previously been excluded will be subjectively more complex when musical attention is redirected onto them. A program of expanding the aesthetic perception of sounds will focus attention more on the inner structure of complex sounds and less on the connections between simpler individual sounds. Does the exact way in which Cage abolishes or randomizes these connections lead us toward, and down, and into the insides of sounds?

A further extension of López's position might involve the development of a new listening competence that hears an individual sound as a field or

zone in which variable energies intersect. The identity of a sound is no longer how it stands against other different sounds in instant, if implicit, comparison, but how it constitutes a unique balance or imbalance of the forces shaping and transpiercing it, any one of which can vary independently of the others (a description that, incidentally, also connects to non-Western worldviews). Electronic music and the technology of sound synthesis provide a way of grasping this exact incidence of variables. The oscillator gives us an image of pitch as continuously variable and describes for us a pitch space in which motion and direction and position are possibilities; the filter gives us an image of harmonic space as continuously variable. So acoustic musical instruments can now be seen as generators with filters and amplifiers, and instrumental sounds can now be constructed in new ways. The cellist Fred Lonberg-Holm noted that "the atomization of the sound production process as found in the classical electronic studio had a deep effect on my understanding of construction of sound on the cello in that [I could] see the distance of the bow, the pressure of the bow and the speed of the bow as all separate functions which can have their own settings and envelopes (the way a filter or an amplifier or an oscillator are affected by the same envelope differently and the combined effect of three different envelopes controlling each parameter, etc.). ... For me, breaking things down to the smallest components to be taken apart and re-assembled has always been the approach I am most comfortable with."[5] Spectral composers are also familiar with the notion of microscopic listening—a listening that would correspond to the way Lonberg-Holm thinks about his instrument. But this kind of thinking belongs more typically to musicians than to composers, especially musicians who have to some extent absorbed the function of composer by becoming improvisers.

If we remain unconvinced that Cage's approach enhances attention to sonic detail as such, we now ask whether, on the contrary, the effect of decoupling detail from structure is to stimulate a search for relationships, even absent ones, between larger or medium-range sonic entities. In this sense, his music could be seen as depending on a form of listening already historically developed for other musics. That is, it relies on the imaginative capacities developed in the musical cultures it seeks to negate. It may be that in the absence of obvious relationships, the committed listener finds more complex ones. This would seem to be the key possibility for vindicating Cage's music: that it sets up a context in which relationship is expected but avoids relationships of previously known kinds, so encouraging the discovery of new kinds of relationships, more hidden, more supple, more complex. In practice this procedure subjectively distances music from

listener. The composer does not care for the listener. The composer is not proposing interesting new relationships but merely making material appear in which they may or may not be found. The listener has to stay cool, detached. Often at this point, the music's poietics intervene. These poietics are both inaccessible, and very near the surface because the whole accent of what is presented as new concerns poiesis. The listener is inside an idea.

Let me make this point using the piece *Variations III* from 1962.[6] Intended "for one or any number of people performing any actions," the score consists of two sheets of transparent plastic: one is blank, and the other has forty-two identical circles on it. Cage instructs the performers to cut the sheet with circles so that they end up with forty-two small sheets, a full circle on each. These should then be dropped on a sheet of paper. Isolated circles are then removed, and the rest are interpreted according to complex rules explained in the score. The information derived includes the number of actions and the number of variables that characterize an action. Cage does not specify the performers' actions, in fact goes out of his way to pre-empt such limitations on those actions as might arise from the musicians' musical habits.

To begin with, this looks like setting up a more autopoietic situation. Living systems, as we saw earlier, are characterized by states of readiness that are not specified before they have to be, whereas in mechanical systems, all the behaviors are determined by design from the very start. So in the process of its production, this Cage piece defers as many decisions as possible. The same principle is at work in the network of communication afforded by the use of cell phones. You agree to meet a friend at an unspecified location "toward the middle of the week," and gradually this gets narrowed down through a series of calls to the level of, "I'll be there in two minutes." But the point is that the autopoiesis of *Variations III* is not actually available to the listener. It's just the idea behind the piece, available only to the performers, for whom the dynamic of actually preparing the piece perhaps substitutes for the lack of dynamic in its method—which is absolutely static in the sense of being applied equally to every point in time.

Does a stance of indeterminacy represent or embody uncertainty and withdrawal as a response to a fractured world? This world in Cage is grasped not politically but as personal suffering. Cageian poietics depend on a psychological rhetoric of Zen no-mindedness, this being perhaps the most attractive escape route from personal suffering that came to hand. The emphasis is effectively shifted onto the discursive interpretation that the listener places on the experience. In this, Cage conforms to a general weakness in modern art for provoking a need for discursive interpretation,

which, if carried out successfully, provides a psychological satisfaction that falsely stands in for sustained sensory engagement. Such interpretation tends toward the stylistic, that is, toward an understanding of the artist's position in relation to others, a position with which the listener identifies or not. This, in turn, is symptomatic of a more individualized art environment. It's also consistent with the withdrawal of Cage's own intentionality from the level of empirical sound-work in composition and its repositioning on a philosophical level outside that process, where the listener is nevertheless still obliged to trust in it within the concrete actuality of listening.

The central imaginative proposition of Zen is that the abolition of the subject is the event of truth. But in real life, enlightenment produces a new discursive subject, and Zen is the psychosocial stance assumed by this remnant wanderer. The ultimate weakness of the Cageian proposition may simply be that however we configure the interplay of perceptual and cognitive processes, we are inevitably dealing with the fact that every aesthetic experience begins, develops, and concludes in time: a wandering subject is noncumulative, its becomingness gets nowhere, its journey not only incomplete and unresolved, but never undertaken in the first place. The ideal Cageian subject is detached, drifting, neutral, neither quite musically absorbed nor quite attending to everyday life in the usual way. Behind the ideal lies the suggestion of an ultimately escapist and regressive response to the world's suffering. At best the intellectual and stylistic surface of the music succeeds in masking this from us.

But there is joy in coincidence, and this forms a kind of commentary on aesthetic experience, even if not actually becoming it. This is not the coincidence of André Breton, Man Ray, Raymond Hains, and many others—not spatial coincidence, but the temporal occurrence of two things together, or nearly together, or not together at all when they might have been. A relationship of order is perceived between events that are nevertheless, and in exactly the same moment, perceived as indeterminate. The point of the sounds is how they are produced: not how they are produced technically, as we see in Lachenmann, but how they are produced methodically by the law, or system, of the work. We are not listening to musicians improvise or make random noises; we are listening to them doing something planned and deliberate. We might say, in the language of Pareyson, that there is here *only* the law of the piece, meaning that, paradoxically, the sounds acquire no form that is not determined by the method. In this way, they lay themselves completely open to the subjective "throw" of the listener, who also throws and sees what comes out. And if suffering and consequentiality are equated, absence of consequentiality becomes a kind of

generosity-within-the-fact, and freedom is gained by unlearning. But does this hermetic language ultimately reveal a kind of coherence that organizes a perceptual world in accordance with its own subjectivity? Or is the joy of coincidence simply an accentuated awareness of the unique collision of events in a continuously unique here and now?

Pierre Schaeffer and the Sonorous Object

If Cage wants us to listen to the unintended sound-worlds of the background, *musique concrète* cuts out from their background the raw sounds of thunderstorms, creaking doors, waterfalls, and steel foundries, capturing them on tape (before tape, on disk), and manipulating them to form sound structures. The work method is therefore empirical. It starts from the concrete sounds and moves toward a structure. From the perspective of the *concrète* musicians, traditional classical music starts at the other end. An abstract musical schema is devised, written down, and expressed into concrete sound only at the last moment, when it is performed by musicians. From this perspective, much of John Cage's output is as abstract and obsolete as traditional classical music.

Musique concrète emerged in Paris in 1948 at the RTF (Radio Télévision Français).[7] Its originator, leading researcher, and articulate spokesman was Pierre Schaeffer (1910–1995), at that time working as an electroacoustic engineer for radio. With Schaeffer, we step back from musical listening and start again from the elementary proposition that what we listen to are sounds. This is not a matter of aesthetic strategy, as it is for Cage, but a matter of fundamental research. Schaeffer's thought proceeds experimentally in zigzags. It doesn't reproduce spherically outward like Cage's from a central insight. Schaeffer hardly discusses the listening subject; he discusses the sonic object, how this object addresses itself to the ear, and the different kinds of attention of which an ear is capable.

Schaeffer famously proposed a new kind of listening, a reduced listening or *écoute réduite*, in which sound is listened to as itself, as an *objet sonore*, a sonorous or auditory object.[8] What this reduced listening aims to get rid of is an awareness of the sound as emanating from a source that might, in particular, cause the sound to be represented as the trace of that source. Also excluded at first are any meanings or associations the sound might carry. So the sound is no longer a vehicle for anything else; it becomes itself. Schaeffer modeled his idea of reduced listening on Husserl's phenomenological reduction. But this seems contradictory. In Husserl, the phenomenological reduction does not lead us to the thing itself but to a grasp of

how perception and intention arise in relation to one another. Schaeffer, on the other hand, seems to be placing his intention in parenthesis, at least temporarily. Or, rather, he is limiting his intention to that of the purely constitutive, the minimum that can constitute an experiential object.

In the Schaefferian project, once a sound, any sound, has been isolated from the functional perceptual world in which it might typically have signaled some ulterior information to the listener (think: sound of a doorbell), it becomes potential musical material. But because any sound can be isolated, and any a priori criteria for selection of sounds have to be gotten rid of, the result is that sounds present themselves as isolates with no particular character that might make them more or less musically interesting. Furthermore, the crucial factor that conditions *écoute réduite* is recording. It is when a transitory sound is captured on tape that it can be listened to repeatedly and subjected to treatments that strip away its connotations and reveal it as sound itself. So *écoute réduite* first emerges as an integral part of a set of studio procedures treating sound as material to be manipulated. When Schaeffer confronted the problem of how to construct a system of musical values based only on the sound itself, he was unable to go further than an attempt to catalog sounds according to characteristics that emerged not in some abstract and appropriately theorized space but in the existential conditions of the recording studio: the storage media for recorded sounds, the available treatments, loudspeakers and amplification, and so on. The practice of what he called *musique concrète* was highly dependent on the limitations of these technologies: "There was no way to develop musical organisation except via repetition, juxtaposition and superimposition of sound fragments. ... This was not down to an aesthetic position but to the technical limitations I was struggling against."[9]

In practice Schaeffer's intention toward sound came to be primarily taxonomic, and after a few early attempts at composing music with sounds, he increasingly defined himself as a researcher rather than a musician. When I interviewed him in 1986, he saw, in retrospect, this struggle to begin again from sound itself as leading to inevitable failure; there was no way the project could arrive at music, even a radically redefined music.[10] From this he drew the conclusion that any attempt to refound music via the study of sound itself would be similarly doomed: if he couldn't do it, it couldn't be done. Furthermore, he had by now redefined his concept of musical material. Musical material was no longer simply sound that had been isolated from indicative or referential functions, but sound articulating a musical schema that lent itself to being expressed in sound in more than one way. Nevertheless he did not, even now, rigidly counterpose music to sound but

rather saw a zone of gradation between them, leaving open the possibility of music emerging from sound work. After all, in principle, object and structure come into being in the same moment of grasping a phenomenon as both unitary and multiple. And in practice, it is possible, as Schaeffer saw, to allow musical considerations to quietly interpenetrate the selection and sorting of sounds without importing a specific musical a priori. This could involve the selection of a limited variety of sounds appropriate to an as yet undefined musicality.

Essentially what Schaeffer had done was to bring forward the constructive and selective aspect of listening as a field of focus. We learned that the perception of sounds as musical had always involved the unconscious suppression of information that was not given musical value. We could now attend to these previously suppressed elements, focusing on the grain of bow on string or the exact attack of a piano note. Above all we learned that sounds we had registered as nonmusical, as noises or as signals of events, could be listened to in a new way—as potentially musical. We could do this by relaxing the cause-and-effect connection and the impulse to interrogate every sound for the event that produced it, sensing instead its shape, that is, its exact beginning, growth, and decay. This is *écoute réduite* at work: a reduction that leads to an expansion because we now begin to hear what is structurally interesting in all kinds of sounds. In this way, Schaeffer paved the way for a compositional attitude that was open to new kinds of sound material and to new kinds of structure. As we shall see, Lachenmann affirms his debt to Schaeffer by describing his own music as *musique concrète instrumentale*. And Cage retrospectively described his 1939 sound piece, *Imaginary Landscape No. 1*, as *proto-musique concrète*, even if Schaeffer would have criticized both Cage and Lachenmann for the productive primacy of abstract calculation and writing (*graphisme*) in most of their work.[11]

The Schaefferian relaxation of cause-and-effect connections and the Cageian relaxation of intentionality are very different. When Cage listens to traffic noise and says it's more interesting than music, he picks on a kind of sound that is background, that has not been isolated and brought forward by the perceptive effort of a Schaefferian *écoute réduite*. The listener's ear has to just go out there and relax with the sounds in their original context. But it remains contentious to say that what we find interesting to listen to thereby becomes music, or comparable to music. François Nicolas cites Luigi Nono as suggesting a listening continuum that would embrace both music and traffic noise: "We're starting to know how to just listen, not just to traditional music, but also listening to the city, the acoustic environments in which we live."[12] But Nicolas strongly objects: "No! Musical listening

doesn't just come into being according to the whim of the listener—it must also be inscribed into the material that is being listened to." This suggests that the attention we show toward soundscapes is no more than a proto-musical form of listening. The contributing parts or agents of a soundscape typically don't listen to themselves, although, like birds in a wood or cars on a street, they may be responding to one another in other ways.

The technical limitations within which the concept of *écoute réduite* emerged apply also to the practical listening situation: the sound is captured forever on recordings, but these recordings are audible only through loudspeakers. Schaeffer described this in terms of the difference between direct listening and acousmatic listening. In direct listening, typical of the concert situation, the sources of the sounds are visible, in the form of the instruments and players. In acousmatic listening, all the sound is coming from loudspeakers and the sources are therefore invisible. Schaeffer argued that sounds detached from visual support are less likely to be linked back to their causes and so more likely to be perceived as *objets sonores* by the listener. This does not, however, tally with my own experiences at acousmatic concerts (specifically at the series Le Bruit de la Bande at the "102" venue in Grenoble in the years 1992 to 1994), and the reason for this, I would argue, undermines one of Schaeffer's important positions. In my experience of attending acousmatic concerts, usually given in near darkness and with live sound projection often by the composers, the ear's enthusiasm for projecting the source or cause of a sound—whether mistaken or correct—is undiminished. But what the ear is really doing is connecting sounds to an underlying level of gesture or movement having sonic implications but without being restricted to the sonic dimension. This connective act makes use of the subordinate connective act that allows us to read sounds in everyday life but uses imagination to go beyond it. It can do this because the context is an aesthetic one and we are not decoding environmental sounds to locate resources or avoid danger. The ear is free to grasp the sound in all its dimensions. The enthusiasm of the senses is opened up. The fact of allocating a source to a sound feeds into the total process because the source does not carry its usual functional implication.

It is in retrospect remarkable that Schaeffer did not give the concept of sound-gesture a far more constructive role in his analytical project: "Listening to the sound-object produced by a squeaking door, we can certainly choose to ignore the door and focus exclusively on the squeak. But the story of the door and the story of the squeak exactly synchronise: the coherence of the sound object *is* the coherence of the energetic event. This constitutes, so to speak, a unit of breath or of articulation: in music, a unit

of instrumental gesture. The sound object occurs where an acoustic action meets an intention to listen."[13] It seems unnecessary to then set out to abolish, as Schaeffer did, that aspect of a sound that makes it a trace of something else. There is a certain symmetry between Schaeffer and Lachenmann on this point. For Lachenmann, musical sounds are to be grasped as the result of actions in order to be freed from the false consciousness of musical habit. For Schaeffer, nonmusical sounds are to be grasped as not the result of actions in order to be lifted into the special consciousness of musical relationship. But a musical sound, a sound prepared for aesthetic experience, is already a trace of the multiple listenings of its maker(s). Even for Schaeffer, a sound has to be found and selected, and it becomes inevitably shaped and contextualized in the process of *concrète* composition. In other words, the sounds in *concrète* are in fact being heard in relation to actions, and the actions of the composer toward the sounds will tend to register, if indirectly, the actions that initially produced the sounds. It is this aspect that has the greatest resonance on the listener. It initiates a series of analogous dynamic shapes that overflow from the purely auditory into other sensory modes, including those of the body's sense of movement. A sound is not diminished by my grasping it as the sound of sandpaper on wood. On the contrary, the feel and movement of rotation and abrasion are elicited within me as part of the impact of the sound. Although this kind of alertness to the underlying gestures of sounds probably derives from the functional hard-wiring of auditory cognition, the metaphorical networks of an aesthetic context bring it into play in new and possibly synesthetic ways.

But these gestural aspects would not really become part of composers' conscious skills until the emergence of electro-acoustic music proper and its development of a new vocabulary of compositional thought. This new form grows from the encounter between *concrète* and the electronic music being developed in Germany by Herbert Eimert.[14] Where *concrète* starts out from whole sounds, electronic music, drawing on serialist thinking, builds sounds from the bottom up, using electrically generated waves, and treating each parameter of sound as an independent variable from the start. Finally the technologies developed to do this make the nature of the original material less important and the nature of what you then do to it more important, so that the difference between *concrète* and electronic music breaks down. It is the resulting fused kind of music that has come to be known as electroacoustic music, and this music is dependent on technologies that greatly increase the possibilities for sound generation, analysis, and modification.

Paradoxically, these new possibilities and methods often seem to have distracted artists from thinking and working aesthetically. Here is a comment made to me by electroacoustic composer and teacher Barry Anderson in 1986: "The situation now is that composers don't have much influence over what the machine-builders produce. The technology is so far in advance of the composers' invention that they are left with trying to assimilate, and to work within, the particular orbit presented to them by a particular machine. It's the technology which throws up the new possibilities." And Denis Smalley, in 1997, complains of the lack of hierarchical variety in most electroacoustic compositions, a problem he attributes to composers becoming too infatuated with the detail of individual textures, in a way that listeners coming to the music anew would not be.[15] He points to a general problem of insufficient and badly planned distribution of attention, with the listener being often directed to "listen continuously in a global, high-level mode."

While the in-built rapid obsolescence of newer technologies brings evident problems for the nurturing of artistic knowledge, something also seems to go awry when musical listening becomes conditioned by the possibility of manipulating sound radically and instantly. Although, with a lot of hard work, sound processing can be organized to integrate with the structure of a given sound-material, there is often a disconnect on the phenomenological level at which sound is experienced. For the composer, the technical work of actualizing a musical value for complex mathematical relationships eats away at the attention that might otherwise have been devoted to aesthetic and compositional problems. And as listeners, we quickly learn the characteristic auditory signatures of sounds that have been slowed down, sped up, or repeated, and we begin to identify these features independent of any qualities of the original material.

Schaeffer himself hardly composed after 1959, so his work has to be evaluated partly in terms of what it gave rise to. The vital contribution that *concrète* makes is already implicit in the name. It is the idea of referring to the ear, to what things actually sound like, of always conducting a pragmatic rear-guard action against abstraction wherever there is a danger of it, whether that abstraction is the application of serial technique to pitch-sets, or the application of advanced computer-processing techniques to spectra. *Concrète* stands against the colonization of music by technology, and the penetration of art by new insecurities that demand abstract and technical legitimations. Schaeffer may have wanted to do something else, but this is his enduring legacy.

Helmut Lachenmann and the Learning Subject

For Helmut Lachenmann (1935–), familiar sound structures in music, by failing to challenge listening habits, immerse the listener in a magical hypnotic sphere. He sees the idea of breaching or intervening into such magical modes of listening as fundamental to the European musical idea and as a crucial shaping influence on its stylistic development over the centuries. He explicitly aligns himself with this antimagical impulse. The prime example he gives of an overfamiliar magical sound structure is the German national anthem.[16] But this immediately points to a difficulty in the elision of magic and familiarity. A national anthem, while highly familiar, is a ritual signifier of communal sentiment and an explicit statement of political ontology, hardly an immersion in magical modes of listening as such. On the other hand, the music of Wagner, while immersive in a deeper, more magical sense than a national anthem, cannot seriously be extirpated from an account of the stylistic development of European music. Wagner's inspiration for using long-range harmonic suspension was Schopenhauer's idea that music communicates inner psychological states in ways that are involuntary.[17] Yet Wagner's innovation contributed to the crisis of tonality and ultimately to the emergence of the serial techniques that Lachenmann himself uses. Nor is it easy to trace the attack on magical modes of listening further back in music history. The stylistic development of European music, notably in its gradual emergence from a strictly liturgical role in the church, was driven by the search for technical solutions to the problems at hand. The ambivalent and censorious attitude of the church fathers toward music hinged on the rivalry between two forms of magic: immersion in music and immersion in God. Arguably the development of secular music, the idea of the concert as the locus of the listening experience coupled with the emergence of an orchestral sound concept, is a move toward a more highly immersive listening experience than that implied by, say, the Gregorian chant, even if the latter is more immersive in a theological sense.

All of these difficulties revolve around the central problem, which is that Lachenmann associates the hypnotic magic of music with familiarity, and that familiarity is a product of reception history and nothing else. But at the same time, he believes that a composer can and must make interventions that break up this familiarity.[18] So is he simply offering us another variation on a formalist view of art history, according to which a quota of necessary formal innovation is constantly being used up as audiences become familiar with it? Lachenmann certainly acknowledges this problem (without solving it) when he speaks, in the context of his own work, of an obsession

with alienated sounds that could become a "stylistic prison" rather than an opening out of the musical process.[19]

For Lachenmann, magic is that which is habitual, overfamiliar, not rediscovered in situ in the listening experience but imposed like a formula, hypnotizing the senses, impeding their awakeness and awareness, putting them on automatic. How does Lachenmann propose that we free ourselves from magic? "The art of listening, which in an age of a daily tidal wave of music is at once overtaxed and under-challenged, and thus controlled, has to liberate itself by penetrating the structure of what is heard, by deliberately incorporating, provoking and revealing perception. This seems to me to be the true tradition of Western art."[20] So music that truly respects the art of listening must always oppose itself to the bad listening habits of its age. Ola Stockfelt, writing in *Audio Culture*, makes an almost opposite point: that the complex multilayered sound environment of modern city life, with its multiple streams of auditory information, neither permits nor imposes a stable listening competence. On the contrary, we are constantly transiting between, and superimposing, different listening contexts requiring diverse competences.[21] In this sense, the auditory background whose effects Lachenmann decries could be stimulating the evolution of the skills required to listen to the kind of music he wants to write. There is at least an ambiguity here: on the one hand, a polyphony of perspectives could catalyze critical awareness; on the other hand, it could encourage drift, lack of focused attention, and detached resignation.

Putting aside Lachenmann's claim to critical and contemporary relevance, how should we read the idea of "penetrating the structure of what is heard, by deliberately incorporating, provoking and revealing perception"? In what new and nonbanal sense can perception itself be taken up into the work? Or does Lachenmann want to throw the listener in some way out of the music to watch what happens from outside, observing the mechanisms of perception at work in the very act of perceiving?

As a composer, his response to these questions has been to develop techniques that encourage us to "hear the conditions under which a sound- or noise-action is carried out ... hear what materials and energies are involved and what resistance is encountered. ... The manner in which [sounds] are generated [to be] at least as important as the resultant acoustic qualities themselves."[22] He wants us to pay attention to something that has often been marginalized in musical perceptual worlds: the way in which sounds are being physically made. But in practice, Lachenmann is not shedding new light on sounds with which we are already familiar. In order to bring forward and make audible the conditions under which a sound is made, he

switches over to a vocabulary of sounds that are altogether different. He is not in fact defamiliarizing the familiar but replacing the familiar with the unfamiliar. These new sounds require musicians to approach their instruments as physical sound sources by setting aside the traditional rules for playing them.

In European art music, instrumental technique traditionally veiled the physics and method of sound production. An ideal of spiritual purity and bodilessness had been inherited from music's earlier religious role. Value was placed on maintaining homogeneity across a range of behaviors of physical systems. Clarinetists, for example, worked at getting their notes to sound with a recognizably similar timbre in different registers. The advantage of combining what had previously been two instruments (*chalumeau* and *clarino*) into one was that it gave a much wider pitch range. But you then had to create the illusion that the instrument behaved the same way across the whole range, when in fact each register used the behavior of vibrating air in tubes differently, so you spent weeks practicing going over the break between the two registers. Much of a musician's technical practice is to smooth out such unwanted irregularities in the behavior of physical systems. Lachenmann's approach involves a partial deconstruction of this typical learning of the instrumentalist. What have come to be known as "extended techniques" often produce vibrational behaviors that are not stable across a range of variation. For example, certain fingerings on a clarinet produce multiple simultaneous inharmonic modes of vibration of the air in the tube, but it is often hard or impossible to discover a series of such fingerings that generate closely related timbres across a useful range of fundamental notes. The sounds may be new, but the question is what to do with them.

As Lachenmann's skills develop through his artistic life, as he stretches himself out and moves away from an initially reductionist stripped-down approach to instruments (as in many of the solo pieces written in the years 1968 to 1970, such as *Guero* for solo piano), he begins to use instrumental ensembles to construct sound complexes that seem virtuosic, glittering, and in their own way magical. These new sounds appeal to an appetite for the unusual and hitherto unheard. But things can be surprising for only so long. Have we merely exchanged the hypnosis of the overfamiliar for the magic of transient novelty? There is the risk that making something unfamiliar can be only a temporary measure. This would not be the case were the unfamiliarity to be a by-product of some other new quality. But Lachenmann, at least in words, elevates unfamiliarity as such to the status of a core aesthetic value. We might say that he hinges the claim of his music to have ontological force on this unfamiliarity.

Insofar as our attention is drawn to "sounds" or "sound complexes," these would seem to constitute the prime mediating structures in the music. Yet listeners (both familiar and unfamiliar with Lachenmann's music) often refer to the importance of *seeing* this music performed as the key to an adequate listening. In this light, we notice an ambiguity in the wording: "The manner in which [sounds] are generated [to be] at least as important as the resultant acoustic qualities themselves." Are these conditions to be presented in some way separately from the acoustic results? A number of different questions arise from this.

Lachenmann has not insisted that his music not be recorded, so he must intend for the conditions under which sounds are made to appear as part of the audible material constituting the aesthetic work. In this respect, a particular moment in his evolution as a composer is highly pertinent: this is his encounter with *musique concrète* at the IPEM-Studio in Ghent in 1965, during a period when he wrote his only solo tape work, *Szenario*. Following this exposure to the studio techniques of manipulating recorded sound, he wrote *temA* for flute, voice, and cello, a work that in a later commentary in 1983 he described as "the first step for me towards a 'Musique concrète instrumentale.'"[23] In this piece, Lachenmann made the performers' physical effort central to the work. Yet the ambiguity of what this means is still there for those who have performed or analyzed the piece. As Chris Swithinbank puts it, the physicality of the sound-making gestures is present not only in the acoustic result but also in the manner in which sounds intimate particular physical processes.[24] How might such an intimation work? It would seem likely that Lachenmann had absorbed from his exposure to the working methods of *musique concrète* the importance of the relationship between hearing and movement that carries over from the cognitive psychology of functional cognitive worlds into that of aesthetic worlds. If Hayek had already articulated this relationship for the functional context, Schaeffer made it explicit it for the musical context: "As we've seen, it's the instrumental gesture that focusses our rediscovery of the sound form. ... We have already strongly asserted the primordial connections between doing and hearing ... in the domain of the relations between auditory functions and motor activities."[25] What's interesting is that Schaeffer is writing in a context in which there *are* no instrumental gestures. It is precisely their absence that brings forward the way in which sound provokes the attribution of a sound-making agency of some kind. As part of our readiness to respond to sounds with our own movements, we impute action or gesture to sounds. And gestures or action patterns are potentially perceptual schemas in which several sounds are grouped together. But the direction of Schaeffer's research led him away from

using this potential principle of auditory gestalt as a support for building a typology of sounds. The core moment of *écoute réduite* militates against this by separating sounds from sources.

It was left to Denis Smalley to articulate the importance of what he calls "surrogates" for a theory of listening adequate to music without instruments.[26] Smalley noticed that listeners create "virtual sources" while listening to electronic music, and he developed the idea of gestures as the movements that are inferred from sounds by the listening ear. From here he goes on to suggest that electronic music listeners make sense of the music through a series of substitutions. On the upper level, quite subtle behaviors of sounds, changes in texture, and so on are related back to musical gestures, which are in turn related back to (virtual) instrumental sound-making gestures. But the most original aspect of Smalley's analysis is that he extends this chain of substitutions one stage further back, to arrive at a primary level of sound-making gestures that are not yet musical, such as scratching at a piece of wood or rubbing two stones together. This is so tactile, so visual, and so proprioceptive—as if one's own muscles were making the movements—that it becomes part of a continuum of human gesture that is not limited to sound-making activities but is defined, rather, by its quality of eliciting a spontaneous response in us in whatever sensory mode.

For Martin Kalteneker, "Listening to Lachenmann's music often implicates seeing how this music is performed in order to grasp how 'heterogeneous series' connect diverse sound producing media and techniques."[27] Kalteneker is here referring to a compositional technique that Lachenmann employed using groupings of heterogeneous elements as generative groups rather than using, say, a pitch series. For example, in the solo cello piece *Pression*, certain pitches are associated with sounds that *emerge from behind* other sounds, while other pitches *mask* other sounds when they occur. So the kind of distribution of attention proposed in Lachenmann's music invites us to perceive such connections rather than, say, to "follow pitch" while at the same time "following dynamics." The implication is that our musical culture has taught us to recognize homogeneous groupings, for example, a melody, or a chord, and to grasp connections between groups horizontally as a set of relations along distinct axes of comparison, such as pitch, or rhythmic organization. Against this, Lachenmann is proposing that we grasp sounds vertically in terms of how they are produced rather than how they sit in relation to other sounds in horizontal series. (Could the same sound have been produced otherly? What different sounds could be produced by the same set of productive circumstances?) But he is also proposing diagonal connections by introducing other kinds of groupings

that mix dimensions. These heterogeneous groupings are not only to be recognized and compared as intermediary structures in their own right, but to be grasped as fundamental to the law of the work. Kalteneker does not say why the workings of these groups do not function for him on the level of audibility alone. He may just be saying that with this music, we need to attend to the mechanics of performance to be able to grasp the musical process. In a similar way, a memory of seeing Jackson Pollock actually at work in Hans Namuth's film *Jackson Pollock 51* may enhance our way of looking at his paintings.

In Helmut Lachenmann's music, we step outside the world of classical music, in which the continuity and the presence and unity of instrumental production of sound are givens, the connection of sounds to sound-making gestures is held at a low attention level, and the players' physical gestures are left available for other types of function—such as that of showing the bodily attitudes associated with stylistic elements of various kinds. We enter a different aesthetic world in which the listener constructs, on the basis of the sounds, a series of imaginary gestures that become the articulating units of musical structure. The recognition of such gestures, which depends on the recognition of new kinds of starting and ending points and the drawing of new kinds of connections, is helped or cued by the visible physical gestures of the musicians, but without being limited to these physical gestures or their combinations.[28]

For the musicologist François Nicolas, the musician's bodily presence is vital to the experience of the listener.[29] The musical listener is always attentive to the body of the musician and its relation to the music. Nicolas doesn't refer to Gallese's mirror-neuron theory,[30] but he might well have done: the listener's body vibrates with the body of the player playing the music, and this provides the listener with cues and clues for following and grasping the musical events and evaluating their importance for the whole. It is the *corps-à-corps*, the body-to-body of player and instrument, that counts here. In what ways does the music affirm or deny the musician's body, explore it or erase it? There is a range of possibilities: from the virtuoso body enacting its triumphant mastery over the music, through the inspired body twisting in the agony of being tested to the limit, to the erased body, the pure executant of an abstract structure. Lachenmann would seem to be introducing a new possibility into this scheme: the musician's body as neither expressive nor erased by structure, but as the catalyst of a structure of gestures.

Nevertheless, by drawing attention to the work of the musicians as such, he brings forward the previously quiet metaphorical connection between the musicians performing a piece live on stage and the subjectivity emergent

in the music, the formative other that is ultimately his own presence in the music as its composer. A comparison here with freely improvised music is instructive. In free collective improvisation, the musicians *are* the formative other that is inscribing itself into sound in real time. And they are free to craft their own sounds as musical responses to the musical output as they listen to it. Here the notion of extended instrumental technique makes complete sense and is merely an extension of the principle that each improviser brings to the music an evolving personal vocabulary. Technique, gesture, and intention coincide in the pragmatics of the medium. The difficulty for a notated music in which many of the sounds are made using techniques that involve conscious difficulty for the player is that the players, far from being liberated by the new procedures, are more marginalized in relation to the musical process. Separated from what they know and not knowing— not allowed to know—what improvisers know, they become more dependent on the composer's text and guidance. There is therefore a surprisingly strong textual aspect to Lachenmann's music—especially his music for larger ensembles—as if, setting out to bring forward the praxis of sound production, it had turned out to be impossible not to also bring forward the didactic, textual side of the equation in conflict with that now expanded praxis. Sound no longer receives, in a demonstrative way, its purpose from a musical idea that is merely passing through the medium of the score. The sounds become audibly scored. It is the text that manifestly holds together the musical occasion and in so doing draws greater attention to the social labor of reading and following instructions. By letting the conditions of production out of the box, we make visible not only the physical conditions of production but also the psychosocial ones. The resultant problematic is not contained in or developed by the work; on the contrary, the work finds itself stuck with the problem of its productive relations, and it is left to the listener to find a new path through the metaphorical network linking the presence of the musician with the presence of the other in the music.

This train of thought concerning Lachenmann's music brings us to outline a confrontation between the potential for coercion in the ontological force of art and the need for a very open and empowering interface with which the listener innerly performs both the work and the aesthetic experience itself. An approach that inscribes into the work the project of changing or doing something to people will quickly compromise this fundamental process—without which any ontological force in music is simply referred to the level of discourse. Lachenmann (like Cage, but in a different way) underestimates the creativity of listeners with regard to older music that they know well, and yet are able to listen to in a fully engaged and creative

way. The question is not whether a piece of music, or a musical tradition, is familiar as a form or set of forms, but whether it offers us a dispositional ontology as opposed to a generative one.

A further problem arises from Lachenmann's quasi-Brechtian model: the thing to be demystified, the structure of what is heard, "is to be penetrated." But from where does this penetration happen? Is a double subjectivity being implied here? Suppose for a moment a foreground subject that only hears, and a more analytical background subject that watches and penetrates. Would we then be "feeling the double process," in Brecht's problematic phrase?[31] But doesn't any musical listening always penetrate the structure of what is (i.e., merely) heard? Again, the difficulty here may be with the explanation rather than with the music. We sense that Lachenmann does not want in practice to instigate such a fixed division in the listener's attention.[32] The process is not double. What we learn as listeners is how to listen, how to respond to the proposition of a way of listening that a piece makes to us, and this is always learned from the inside, or in a virtually embodied way, by doing it, and not from the outside, by thinking about it. So it is not with analytical thought that we penetrate the structure of what is heard; it is rather that we are provoked into forms of attention that are specific to this music. All musical listening is reflective, and this reflection arises in the music's recursive processes. Each musical instant elicits a retention and is therefore open to be changed retrospectively as it enters into relation with a new instant. The later history of a sound may in this way constitute a reflection on exactly how that sound first became audible. This, I would argue, is the form of "thinking" that can be said to take place in musical experience. Any move of Brechtian alienation requiring a move out of that experience must, if it happens, be reclaimed for the experience by again becoming the object of musical reflection, if the work is not to dissipate its aesthetic power.

There is a more fruitful positioning for the outside from which the structure of what is heard is to be penetrated. Richard Steinitz wrote about listening to Lachenmann's music, "It's a bit like viewing a fabric from the back, with the rough and fraying knots revealed and the pattern dimly perceived."[33] In this description, we are situated behind the sound-making process. The vector of our attention is through the actions of sound making, toward the relationships that constitute the musical organization. The relationships between sound making and sounds become the relationships on which the perception of aesthetic form depends.

All poietics occupy a difficult space in which are found the personal creative myths of an artist, the stuff they have in their heads that enables them

to go on working, the search for legitimacy and recognition in relation to the world, the need to articulate a self-representation in that world, the impulse to provide an interpretive context for their work—all this juggled out in a serendipitous sequence of dialogues and encounters with journalists, friends, and critics. Lachenmann seems, in various statements, to be attacking the complacency of bourgeois and commercial culture. Positioning himself against magic, he aligns himself with the Enlightenment and with rational scientific knowledge. But his music often defies any clear vector of discursive alignment. Even when sparse sonically, it is dense with musical thought, setting out its aesthetic risks by deploying itself in spans of sound, breath, hesitation, silence, and resonance that conflict with and undermine one another and whose articulations come forward as events of doubt and reinterpretation for the listener. It would be fitting, therefore, to end by bringing this music close to some words of Jacques Rancière: "What 'dissensus' means is an organisation of the sensible where there is neither a reality concealed behind appearances nor a single regime of presentation and interpretation of the given imposing its obviousness on all. ... This is what a process of political subjectivation consists in: in the action of uncounted capacities that crack open the unity of the given and the obviousness of the visible, in order to sketch a new topography of the possible."[34]

14 Conclusion

My argument throughout this book has been that we need to rid ourselves of the metaphor of wholeness to get at the deep heterogeneity of the human informational space. This book exists to rid us of that metaphor and to map that heterogeneity. Only on this basis can we reach a strong definition of the aesthetic as a type of human action and experience objectively defined by its distinct informational characteristics. These characteristics trace back to the conflictual informational space of the human.

To position the aesthetic in the new territory required us to chart a constellation of centers of activity in human space-time. We had to discover the aesthetic in relation to the sacred and also in relation to socio-logic, the logic of society. We had to discover this in topographical terms, and we also had to discover it in evolutionary, anthropological, and historical terms.

The core operative aspects of the aesthetic concern first the ontology of the aesthetic subject and second the immanent connection between aesthetic experience and the inscription of a particular approach to production into a material to give it a specific informational character.

Without a "systematic conception of the aesthetic domain" (as Bakhtin called for),[1] much thought and research remains worse than irrelevant because it draws conclusions from nonaesthetic activity and applies them to aesthetic activity. Critical theory, deconstructionism, and postmodernism have generally little or no conception of the aesthetic. The notion that a "text" is both profoundly and essentially historical, in the sense that it is the inscription of actions that are consequential because they occurred in the order in which they occurred, is unfamiliar in this cultural territory.

Of course there is an ambiguity in the term *systematic*. Does it mean that the aesthetic domain is conceptualized as systematic, with a hierarchical and operative part-whole relationship, or does it mean only that we lack a systematic and detailed description of it? I have developed the first of these meanings. Perceptual information is always operatively hierarchical and

passing upward and downward through different levels of synthesis. In artworks, this process is organized recursively so that attention is distributed on the different levels, and syntheses are generally incomplete. This is why aesthetic objects differ from other kinds of artifacts.

Armed with this definition of the aesthetic, I conclude by revisiting two current sites of discussion to show how the arguments advanced in this book might modulate their terms. While seemingly unrelated on the surface, these discussions turn out to be connected on a deeper level.

Ethnomusicology

Raymond Williams argued that the idea that the aesthetic domain stands apart from everyday practical life is merely a product of the divided consciousness of capitalist society.[2] By implication, to impose this distinction on other cultures is an imperialist maneuver. My thesis is the direct opposite: to deny other cultures an aesthetic dimension is to discredit their art. Making art is a practical affair like plumbing or hunting; the point is only that it has a very particular material basis in the way that it deals with information. This separates it from other kinds of practical activities and shapes the kinds of things that people doing it have to pay attention to. The issue here is the extent to which we allow that other cultures have a fully fledged aesthetic domain or reduce that domain analytically to an expression of ecological or other material conditions. At stake is a type of cognitive imperialism that is more insidious than just assimilating other people's art into the categories of the Western art world. Both protagonists I mention here are consciously dedicated to a nonimperialist stance in their practice; both have done a great deal to encourage non-Western artists and to get their work on the world stage. And it would be wrong to criticize such actions as patronizing. In Tuva, Kenin Lopsan said, "Like the sonnets of Michelangelo, the songs of the shamans belong to the world." He had felt the threat of historical oblivion and sought permission from the spirits to write them down and make them part of the world's heritage.

Everyone who studies Tuvan music reads the work of the ethnomusicologist Ted Levin, who regards mimesis as the key defining feature of Central Asian sound culture.[3] For Levin mimesis works as a kind of idea package that explains certain kinds of behavior that seem to have an imitative component. Tuvan musicians like to imitate natural sounds, and this he explains by the fact that Tuvan culture has a necessarily intimate relation to the natural world, based as it is on nomadic pastoralism. This emphasis on an objective relation between art and survival exaggerates the

importance of the imitative components in Tuvan music, which become, for Levin, the emblems and paradigms of the whole culture. Other more complex and more artificial aspects are marginalized, and we are left with a (surely unintended) subtext: Tuvan art is objectively determined in ways that Western art is not.

When I discussed imitation with Tuvan artists, I got a different story. Radik Tulush, musician: "It's not just nature; it's nature and the human being who inhabits it, who feels it: out of this feeling and thinking begins a dialogue. So it's not imitation, because something is coming out of yourself." Alexei Kagai-Ool, sculptor: "A carver is not representing nature in a visual sense: there's the presence of the human being, so nature is seen not just with the eyes." Zoia Kyrgys, head of the Xoomei Research Centre of Kyzyl: "The value and the beauty of the sound of an object is measured by its closeness to nature, by the skill to render its living life, not by way of imitation, but by going deep into its essence."[4]

In developmental psychology, mimesis is seen as a form of identification, an immature precursor of metaphor, that does not acknowledge any domain boundaries across which the identification is made. Metaphor, on the other hand, connects across domains that are conceived as different and quite possibly in tension with one another, and that is its point. The attitude of art to nature is metaphorical rather than mimetic because art always registers, or addresses in some way, the discontinuity between natural and social in the human being. Tildy Bayar used the distinction between metaphor and mimesis to question whether European spectral music wanted to communicate a metaphorical image of "the natural," or a direct literal representation of acoustic phenomena.[5] This question is germane to Tuvan music—which, after all, is also spectral. In Tuva, literal representations, where they occur, are in the service of metaphorical ones, and not vice versa. In a mature process of making work, mimesis is starting point, not end point; selection of material, rather than process or idea.

Levin's reductionism collapses art back into its material. For him, essentially there is no process: the work begins and ends with seizing some aspect of nature to be imitated. But on closer analysis this imitative component turns out to be itself a metaphor for a connection between inner and outer states. Although the outer part is closely associated with nature, it is not nature itself, either in the sense of how nature "simply appears" (which of course it never does) or in the sense of a functional interaction with the environment in the form of, say, herding or horse riding. It is nature passed through a particular sensibility, a perceptual attitude that expresses a metaphysical need to see beyond the surface.

Levin is loose also in his interpretation of what constitutes mimesis. For example, he describes *xoomei* throat singing as recognized by Tuvans as "the quintessential achievement of their mimesis." But throat singing is not a literal imitation of natural sound. Tuvans are expert at imitating natural sound when they want to, but throat singing is as highly stylized as, say, a Tuvan animal carving. No one would suggest that a carving of a yak doesn't represent an idea of a yak, but photographic accuracy is hardly the point. In Tuva, the word *chilandyk*, cricket, describes a style of singing that sounds like a cricket: the word *kangzyyr*, to howl like a dog, refers to a sad kind of singing. But equally our word *pizzicato* comes from the Italian for pricking or stinging. If Tuvan music literally concerns nature, must European music for strings literally concern sensations of the skin? My point is only that a metaphorically rich environment must be interpreted with great care, and nothing can be assumed about the simplicity of the people who made it.

For Valentina Suzukey, a leading Tuvan ethnomusicologist, the heart of the Tuvan sound concept is not mimesis but the idea that a drone and its harmonics are inseparable.[6] We can generalize this one step further to the idea that a sound and its transformations are inseparable and to the idea that the potential transformations of a sound are the "inside" of that sound. By filtering and amplifying the upper harmonics of a fundamental vibration, we are unveiling its hidden life. If we then, like Tuvan throat singers, perform melodies made of the changing harmonics of one note, melody becomes the unfolding in time of the inner nature of a single sound that, in that moment, in the act of unveiling, stands for all sound and ultimately all nature.

At the heart of Tuvan aesthetic culture is an understanding that a form, in the way it directly and simply appears, veils its own potential transformations. The desired truth—conceptualized by Tuvans in spiritual terms—is a "showing out" of either the hidden transformations themselves or the contiguous relation between the visible form and these initially hidden transformations. So the effort of Tuvan aesthetic looking is always to go in and to unveil the phenomenological potential of what is perceived. This movement of unveiling is also at work in a shamanic philosophy for which the sensory world is only one of several worlds, while a direct, sensory contact with other worlds is both possible and necessary. Ultimately, from this perspective, every act of unveiling is an opening out into the wider metaphysical cosmos of which visible nature is only one part. For this reason, the tone of Tuvan aesthetic experience is colored by a sense of psychological expansion that quickly goes beyond the concrete circumstances of the occasion.

A complex interplay between aesthetic and spiritual components shapes the culture of artistic imagination in Tuva. How does this read out into the process of making *xoomei* throat singing? Making art is a coinvolvement of embodied intelligence in the relations between forms and their transformations latent in a material—in this case, sound. The action taken toward sound—which is, centrally, to find and unfold its harmonics—reflects how Tuvans look at and feel in the world, as this looking and feeling are conditioned by the metaphysics of their culture. Tuvan aesthetic experience is an enactment—with the embodied intelligence of the performing audience—of the metaphorical relation between "doing hearing" and "being in the cosmos." The use of natural sound as sound material—in other words, the simulation of natural sounds—is framed by this larger metaphorical process. To be in nature is, for a nomadic herder, to be bathed in the sound of nature and implicated in a constant movement of sound between sounding beings—animals, humans, rivers, the wind. But *xoomei*, even as practiced alone out in the taiga, is not an effort of simple imitation and involves a stylistic formalization that registers the singer's singular presence in nature as an individual being with specific aesthetic and metaphysical priorities. Each singer works on the harmonics of their own fundamental notes and how to filter the harmonic scale of those notes in different ways by using the different resonating chambers provided by throat, mouth. and other cavities and how to sculpt these harmonics with the tongue. Each singer brings a personal voice and a personal technique, so much so that each is instantly identifiable by their unique timbre. Tuvan artists and musicians do not suppress their individuality to achieve an accurate imitation of nature, but bring it forward into dialogue with nature. The attention is not on the singer's imitation of natural sound but how the singer's approach to sound echoes a way of feeling for, and of looking into, the natural world. It is this echoing that is the core metaphorical relationship—a relationship between dynamic schemas in different domains, not simply between a style of singing and a river or an animal.

Now jump eight thousand kilometers to the southeast, from the dry steppes of southern Siberia to the rain forests of Papua New Guinea. In Steven Feld's writings, the ecological dimension in the art of the Kaluli people is theorized on a higher level than its equivalent in Levin's work in Central Asia.[7] Some of Feld's ideas prefigure the emergence, twenty years later, of enactive and embodied approaches in music cognition studies. Feld was inspired by R. Murray Schafer's book *The Tuning of the World*, key to which is the concept of "acoustic ecology."[8] Schafer is saying that we need to give importance to the relationship between humans and the world of sounds

that we inhabit. But he immediately introduces a proviso: that art concerns ideal soundscapes addressing the life of the imagination, so that music would propose an appropriately different and special relationship between humans and sounds. In Feld's thinking, this difference, hinting at an informational topography of culture, is largely dissolved. Aesthetics is seen as an aspect of adaptation. He quotes Roy Rappaport to the effect that art has the function of investing ecosystemic relations "with significance and value beyond themselves."[9] He mentions approvingly how much Raymond Williams disliked the division of aesthetic considerations from practical or utilitarian concerns. Feld's picture of the Kaluli world is one in which society and nature are mutually adapted, and aesthetic experiences are moments in which the feeling of this adaptation is brought forward as such. The organic unity of the whole constitutes the background: there is a kind of ecological merging of society into nature. Because the rain forest expresses itself in sound, sound for the Kaluli is truth about the environment, constantly revealing its temporal and spatial structure and process. Correspondingly, Kaluli song maps the space of human comings and goings as part and parcel of an environment that already expresses its own spatiality in sound.

Feld makes explicit mention of the danger of reductionism, but sees himself as going beyond the polarization between culture and its material and ecological basis that typifies much Western thought on the topic. He identifies three important kinds of linkage between expressive systems and knowledge of the environment that enable him to demonstrate the integration of aesthetic and ecological levels: inspiration, in which forms are imagined that are symbolically interpenetrated by environmental knowledge; imitation; and appropriation, in which elements of environmental knowledge are stylized and related in larger metaphorical patterns.[10] While broadening out from Levin's accentuation of mimesis alone, we sense that for Feld, the idea of expression still substitutes for any more developed idea of the aesthetic. However closely linked or not linked to what it expresses, a domain viewed as basically expressive is deprived of autonomy.

Embodiment and Enactive Aesthetics

In reaction to what has been perceived as the clumsily Cartesian approach of mainstream cognitive science, a new tradition has recently developed, referring back, via Mark Johnson,[11] to John Dewey. Dewey was a functionalist, not a very good one, because he did not analyze in detail the functional relationships he adduced, but he did adduce them. He held that art is functional for society and that social communication efficiently

mediates between experience and meaning. He argued that art is the climactic form of social communication, the most complete form, expressing experience the most completely. Art enacts more deliberately and fully the ways in which we organize unity in a field of perception or experience. He assumed, in other words, that in the human being, social, perceptual, and communicative systems are integrated on the highest level. However, he also held that art has a critical function, working "by disclosure, through imaginative vision addressed to imaginative experience ... of possibilities that contrast with actual conditions.""Art," he said, "insinuates possibilities of human relations not to be found in rule and precept, admonition and administration."[12]

In Mark Johnson's recent work, this divergence between what is and what could be—so important for Dewey—gets marginalized as he develops his concept of how art constitutes meaning out of the bodily conditions of life. While this is an extension of the earlier work I have quoted at length and approvingly on perceptual and linguistic structure in human imagination, it now tilts toward a formulation that requires or assumes a general theory of integration. The "bodily conditions of life" correspond, we presume, to "what is," and not "what could be" or "what is not." What Johnson calls "embodied aesthetics" situates aesthetic action and experience very firmly in the framework of a total process of organism-environment transaction: in aesthetic action, humans form and experience the prelinguistic, cognitive, emotional, and sensory-perceptual conditions in which meanings are constituted. Organism-environment transaction is conceptualized as a general unified continuous field, so that culture and preculture are merged. All in all, enactive embodied aesthetics carries out the same kinds of maneuver as Levin and Feld did in ethnomusicology, sinking and merging the human back into nature. The glissando from Dewey to Johnson turns out to be remarkably similar to the glissando from Schafer to Feld.

On the other hand, embodied aesthetics shifts the emphasis away from cognitive processes and how they respond to stimuli, and onto a lived experience of the bodily conditions of meaning constitution through the conscious experience of the lived body.[13] To the extent that this move hails the centrality of subjective processes, it is positive. To the extent that it naturalizes aesthetic experience and, by extension society itself, it is regressive. Aesthetic work is not geared to the production of meaning as such, but to offering the generative ontological conditions for the emergence of an aesthetic subject: the social meaning attributed to the experience and the work cannot be central to its mode of production. We note the lack of a theory of subjectivation in embodied aesthetics: it is assumed, following

Merleau-Ponty, that the body is the subject of experience, and the continuity and indivisibility of this body permeate a description of human experience in which beauty and truth are merged.

Selecting from Dewey's self-contradictory account of art, the embodied aesthetics school take up his idea that an aesthetic experience integrates all the elements of ordinary experience and thereby gives a larger feeling of wholeness in the interactive flow of organism-environment transactions. It is argued that this continuity of aesthetic experience with normal processes of living modifies and sharpens our perception and communication and hence drives the functionality of art for society. Against this, any such integration would be objectively false, although perhaps metaphorically "true" in the sense of supplying a feeling of integration. What counts is subjectivity and the subject's imaging of the body. Given that subjectivity always emerges in a specific generative ontology, we cannot reduce the body in aesthetic experience to a theorized general body in a state of general and everyday transaction with its environment. As a variably self-imaging process, the body itself is implicated in the aesthetic experience, in the sense that the aesthetic subject acquires a virtual body within that experience—rather than the physical body constituting a stable precondition, a continuous and whole environment-transactive backdrop that defines all experience as continuous with itself.

Gianluca Consoli goes much further toward establishing a special and exceptional character for aesthetic experience.[14] He argues, again following Dewey, that at the core of this experience is the temporary unification of diverse processes—perceptual, cognitive, imaginative, affective, and emotional. The enactive part of his thesis consists in the idea that the skill of experience, while it functions generally in a routine and transparent way to bring forward the surrounding world for us, can also function "as a mode of activity" at special moments when we inhibit these automatic workings, so as to explore the world in new ways and reflect on our findings. (This is the opposite, incidentally, of Alva Noë's kind of enactivism—which is that experience functions typically as a mode of activity.)[15] For Consoli, the skill of enactive experience reaches its highest form in the aesthetic domain and the development of the aesthetic attitude. It is the activation of this aesthetic attitude that permits the integration of all the involved mental activities in cycles of self-reinforced feedback. The aesthetic attitude is activated before the experience begins. Then, during the experience, it remains active, supporting and integrating all the subsidiary activities for interpreting and understanding aesthetic objects. Over time, aesthetic traditions have identified and nurtured the properties needed by the aesthetic

attitude to focus attention, consciousness, belief, and motivation in the way that it does. Finally, the evolutionary function of aesthetic experience is that it refunctionalizes existing systems—perceptual, affective, linguistic—in order to stimulate the acquisition of knowledge through a nonreferential, playful, disinterested, nonutilitarian experience.

Consoli substitutes for the aesthetic subject the aesthetic attitude—an attitude adopted prior to the aesthetic experience. There is no ontology; there is, rather, the deployment of a cognitive skill developed as a way to acquire knowledge via play. This epistemic virtue constitutes the evolutionary function of the skill. He has to work the long way around, via the selection of properties of the attitude as they are built up in the aesthetic traditions, to arrive eventually at the properties of the art objects themselves. But these, in reality, are the objects that immediately confront the aesthetic subject and have an immanent formal connection to the form of that subject's experience. He has nothing to say, can have nothing to say, about aesthetic form itself. The aesthetic experience is described as a two-step operation rather than being fully temporalized. First, we adopt the aesthetic attitude, following the cultural cues given in a tradition, and then we engage with the work, period. The output is some kind of informal knowledge whose functional usefulness for the culture underwrites its evolutionary necessity and constitutes the "explanation" for the existence of art.

But the particular eloquence of aesthetic form derives from the fact that the open and present relation between a form and its transformations is precisely suppressed by any semiological system. At the point at which cognition is articulated into language, it becomes subject to the rules of a system in which connections between signs within a global set—the language system—define all the individual one-to-one connections between signs and what they stand for. The continuous virtual presence of the global set, and the instant availability of quasi-automatic interpretative schemas, allows the use of signs to stand for objects that are neither present nor available. In this way, the human animal acquires a mode of communicating the outcomes of hypothetical models and of individuating and fixing their elements in descriptive propositions. In the same moment the human animal becomes a dual being—continuing to experience but endowed with a power of propositional description that operates externally to experience as it is directly experienced in the processes of embodied intelligence. How we mirror the world in our own beings cannot be transferred into language. So there is a radical disembodying in language, even if language returns to the body by way of the voice and the paralinguistics of gesture. A theory of embodied aesthetics could suffice only if it could adequately address the profound disembodiment implicated in acculturation.

A call might be—is often—made to the effect that a mature theory of cognition will place the emphasis on complexity and interconnectedness rather than on oppositional categories.[16] This book generates a theory of cognition only by implication. Nevertheless, the argument advanced here asseverates that the discontinuity described is a matter of objective fact, as are indeed many of the organizational incoherences thrown up by evolution. It is not, obviously, that there is no interconnectivity, but that the connections happen across a discontinuity that they do not dissolve prior to it being expressed into social space. As Martin Nowak complained, "Systems designed by evolution are often not optimised from an engineering perspective."[17] And one could counterpose Nietzsche's remark that "the will to a system is a lack of integrity."[18] We have only to think of our ecological destruction of the planet, the extreme risk of species suicide in nuclear war, or the failure to develop economic and political forms that do not waste massive human and nonhuman resources, to realize that we are not optimized as a species. Despite, or perhaps because of all this, we humans have a powerful longing for an integrated and coherent map of our own being. This is vanity and self-justification. It paints a picture of ourselves as logically and formally satisfying, when we are not. We need to be more humble with our legitimating constructions and more engaged in life in its given conditions. The question to ask should be this one: What minimal degree of coherence is necessary for us as a species type to survive and develop? Should our maps not show the dimension of radical incoherence that safeguards our adaptive potential—our capacity to improvise new responses to future conditions? This is what taking Darwin seriously means.

Xoomei is ... not only a musical genre ... but a philosophical consciousness ... and a psychological technique for stripping a person's soul of artificial and civilised cover, elevating it above the world, and precipitating it into the Great Infinity.[19]

Beyond all these discussions concerning the epistemics of knowledge is the excitement of knowing that in the social dysfunction of art lies the possibility of making ethical and political interventions into the world as it is. This is a different kind of call—a call for artists to look into themselves and ask themselves again what their deepest driving motivations are: a call for artists to identify and assume their responsibilities—not to society, but to us ourselves, as complex beings riven by flashes of diverse kinds of intelligence; not to the institution of art, but to the process that is made necessary by being human; not to filling up the cultural space defined by the institution and rewarded by the institution, but to stripping all that away and breaking through with serious intention, with long work deep in the process of actually doing it.

Notes

1 Prelude

1. Clifford Geertz, "Religion as a Cultural System," in *Anthropological Approaches to the Study of Religion*, ed. Michael Banton (London: Tavistock, 1966), 36.

2. The conference was organized by the International Association for the Study of Popular Music. This association, founded in 1981, brought together researchers who were unhappy with traditional musicology both as method and as failing to engage with the music that most people listened to—namely, "popular music." See, for example, Philip Tagg, "Musicology and the Semiotics of Popular Music," *Semiotica* 6, nos. 1–3 (1987): 279–298.

3. See, for example, George Steiner, "The Retreat from the Word," in Steiner, *Language and Silence* (London: Faber & Faber, 1967).

4. Lancelot Whyte, ed., *Aspects of Form* (London: Lund Humphries, 1951).

5. Paul Weiss, *The Science of Life: The Living System—A System for Living* (Leander, TX: Futura, 1973); Humberto Maturana and Francisco Varela, *Autopoiesis and Cognition: The Realization of the Living* (Boston: Reidel, 1980).

6. Norbert Wiener, *Cybernetics: Or Control and Communication in the Animal and the Machine* (1948; Cambridge, MA: MIT Press, 1961).

7. The idea of an "informational field" is central to this book's argument. A "field" in physics is a space in which any entering particle is subject to a force. By extension, the concept has been applied to mental processes, for example, in the concept of "thought-field" developed in a therapeutic context by Roger J. Callahan and Joanne Callahan, *Thought Field Therapy and Trauma: Treatment and Theory* (Indian Wells, CA: Callahan Techniques, 1996), and also in various highly questionable theories to the effect that human consciousness arises as an electromagnetic field in the brain. The philosopher Gilbert Simondon, in "The Genesis of the Individual," trans. Mark Cohen and Sanford Kwinter, in *Zone 6: Incorporations*, ed. Jonathan Crary and Sanford Kwinter, 297–319 (New York: Zone Books, 1992), 301, writes of

"pre-individual fields," by which he means fields of energy in which individuation takes place and further individuation is always possible. This is closer to what I mean, but I am more interested in information than in energy. The processes that are most important in the human informational field are informational processes, and they are initially noncoherent, so that operative coherence has to get worked out in particular parts of the field, rather than being a given at the start.

8. Fred Dretske, *Knowledge and the Flow of Information* (Oxford: Blackwell, 1981).

9. Edmund Husserl, *The Phenomenology of Internal Time-Consciousness*, trans. J. S. Churchill (Bloomington: Indiana University Press, 1950).

10. Gilles Deleuze and Félix Guattari, *Anti-Oedipus: Capitalism and Schizophrenia* (New York: Viking, 1977). Or, for example, Félix Guattari, *Chaosmose* (Paris: Galilée, 1992), 138. Or, in anthropology, Marilyn Strathern's "Dividual," which is the idea that in Melanesia, unlike in the West, a person is considered as having multiple social personae. See Strathern, *The Gender of the Gift: Problems with Women and Problems with Society in Melanesia* (Berkeley: University of California Press, 1988). Or see Roy Wagner, "The Fractal Person," in *Big Men and Great Men*, ed. M. Godelier and M. Strathern (Cambridge: Cambridge University Press, 1995). The multiplicity of subjects is, in all these cases, conceptualized as socially generated, when what I am concerned with here is exactly the opposite: how interior divisions exteriorize themselves onto a topography of culture.

11. Gregory Bateson, "Style, Grace, and Information in Primitive Art," in *Steps to an Ecology of Mind*, ed. Adam Kuper (London: Granada Paladin, 1973), 101–125.

12. I depart here from Pierre Clastres, who states forcefully that ideology comes into being only with the internal division of society and the emergence of a distinct political institution tending to be a state. See his posthumously published diatribe, "Les Marxistes et leur Anthropologie," *Libre* 3 (1978): 135–149, or the English version in Clastres, *The Archeology of Violence*, trans. Janine Herman (New York: Semiotext[e], 1994), 128–130. I adopt the use of "primary ideology" for two reasons at least: first, untruth is not the reserve of the political, but a potency of language and a secretion of the human condition: second, the exact articulation of political (secondary) ideology with primary ideology, for example, by recycling good old metaphors, is an important historical and social variable.

13. Terrence Deacon, *The Symbolic Species* (London: Penguin, 1997).

14. See Lawrence Kramer, *Music as Cultural Practice, 1800–1900* (Berkeley: University of California Press, 1993), and *Interpreting Music* (Berkeley: University of California Press, 2011).

2 Information

1. Claude Shannon and Warren Weaver, *The Mathematical Theory of Communication* (Champaign: University of Illinois Press, 1949).

2. N. Katherine Hayles, *How We Became Posthuman: Virtual Bodies in Cybernetics, Literature, and Informatics* (Chicago: University of Chicago Press, 1999), xi.

3. "Information is not an abstract entity but exists only through a physical representation, thus tying it to all the restrictions and possibilities of our real physical universe. ... Information is inevitably inscribed in a physical medium." Rolf Landauer, "Information Is a Physical Entity," *Physica A* 263, nos. 1–4 (1999): 63–67.

4. Humberto R. Maturana and Francisco J. Varela, *Autopoiesis and Cognition: The Realization of the Living* (Boston: Reidel, 1980), 88.

5. William Labov, *Principles of Linguistic Change*, vol. 1: *Internal Factors* (Cambridge, MA: Blackwell, 1994), 8.

6. "Zenon Pylyshyn argues that ... the translation between verbal and perceptual codes cannot occur directly," from Stephen Kosslyn and James Pomeranz, "Imagery, Propositions, and the Form of Internal Representations," *Cognitive Psychology* 9 (1977): 62. Stephen Kosslyn, *Image and Mind* (Cambridge, MA: Harvard University Press, 1980), 15: "The structural differences between visual and verbal representations preclude direct translation." See also H. H. Clark and W. G. Chase, "On the Process of Comparing Sentences with Pictures," *Cognitive Psychology* 3 (1972): 472–517.

7. Gregory Bateson, *Steps to an Ecology of Mind* (London: Granada Paladin, 1973), 351, 428.

8. See Paul Benioff, *Language Is Physical* (Argonne: Physics Division, Argonne National Laboratory, 2008).

9. Friedemann Pulvermüller, *The Neuroscience of Language: On Brain Circuits of Words and Serial Order* (Cambridge: Cambridge University Press, 2002).

10. I have adapted the phrase *interpretative schema* from Alfred Schutz's discussion of the phenomenology of the sign: Schutz, *The Phenomenology of the Social World* (Portsmouth, NH: Heinemann, 1972), 119. A schema is wherever a pattern or template is stored and is then applied to incoming new information. Schemas operate at every level in every mode of perception or cognition. They enable us to interpret experience in terms of our world. Examples of schemas that appear in this book are those that help connect incoming sensory information to a course of action; also Lakoff and Johnson's "image-schemas," first developed in Mark Johnson, *The Body in the Mind: The Bodily Basis of Meaning, Imagination, and Reason* (Chicago: University of Chicago Press, 1987); and of course Alfred Schutz's "interpretative schemes."

Obviously, when it comes to language, the phrase *interpretative schema* collapses a number of different processes into one packet. In reality, phonological schemas are deployed, then morphological, syntactic, and semantic ones, even if this all happens extremely fast. By using the term *schema* in both contexts, I want to say that receiving and interpreting a verbal proposition is initially comparable to receiving and interpreting a perceptual image, so as to show how different they in fact are.

11. Embodied approaches to comprehension also propose that understanding language entails performing mental simulations of its content. See Rolf A. Zwaan, "Embodied Cognition, Perceptual Symbols, and Situation Models," *Discourse Processes* 28 (1999): 81–88, and J. Feldman and S. Narayanan, "Embodied Meaning in a Neural Theory of Language," *Brain and Language* 89, no. 2 (2004): 385–392. One advantage of the "instructions" idea is that it removes any necessary link between the syntactic or propositional structure of language and the structure of mental representation.

12. S. Wu, S. Amari, and H. Nakahara, "Population Coding and Decoding in a Neural Field: A Computational Study." *Neural Computation* 14, no. 5 (May 2002): 999–1026.

13. Clifford Geertz, *The Interpretation of Cultures* (New York: Basic Books, 1973), 89.

14. This was first established for genetic coding and neural coding. In perception, sensory input coding is not efficient for transport or memory functions, and so is translated "into a neural code that is compact, explicit (easy to decode), and stable enough to support object perception and object memory." From Jeffrey M. Yau, Anitha Pasupath, Paul J. Fitzgerald, Steven S. Hsiao, and Charles E. Connor, "Analogous Intermediate Shape Coding in Vision and Touch," *Proceedings of the National Academy of Sciences* 106, no. 38 (2009): 16457–16462. This finding is consistent with the argument by Srdan Lelas, *Science and Modernity: Toward an Integral Theory of Science* (New York: Springer Science, 2001), 75, that in living systems, receptors and transporters are specialized apart in order to avoid importing energies and materials dangerous for organismic integrity. Receptors work on samples. Some receptors have to detect harmful substances in the environment. This basically divides the sense-world from the action-world.

15. "The syntagm is a combination of signs, which has space as a support. In the articulated language, this space is linear and irreversible (it is the 'spoken chain'): two elements cannot be pronounced at the same time. … Each term here derives its value from its opposition to what precedes and what follows." Roland Barthes, *Elements of Semiology* (London: Cape, 1967), 58.

16. M. Ahissar, M. Nahum, I. Nelken, and S. Hochstein, "Reverse Hierarchies and Sensory Learning," *Philosophical Transactions of the Royal Society of London B* 364 (2009): 285–299.

17. In a discussion on shamanic states of mind, the psychologist Chris Frith suggested to me that the difference between illusion and reality is that error is possible only in reality—which in turn requires ways of checking up on perceptual errors.

18. The idea taken up by Alva Noë in *Action in Perception* (Cambridge, MA: MIT Press, 2004), that the world itself constitutes our memory store and the primary resource providing detail to perceptions, does not acknowledge this nonfinality of perceptual processes themselves. It becomes perverse to conceptualize perceptual processes as not situated in the organism, when these processes are understood as hierarchical, reversible, and selective of potentially constant input.

19. Pauline Oliveros, "The Earthworm Also Sings—A Composer's Guide to Deep Listening," *Leonardo Music Journal* 3 (1993): 35–38.

3 From Semantics to Imagination

1. I've opted to translate the Tuvan *xoomei* as "throat singing," the commonly used expression, although it is inaccurate as a description. An alternative is "overtone singing," and a more precise definition is "double-voiced laryngeal singing." See Khamza Ikhtisamov, "Notes on Two-Part Throat Singing of Turkic and Mongol Peoples," in *Music of Peoples of Africa and Asia*, vol. 4, ed. Viktor S. Vinogradov, 179–193 (Moscow: Sovietskii Kompozitor, 1984), 187.

2. Tran Quang Hai and D. Guilou, "Original Research and Acoustical Analysis in Connection with the Xöömij Style of Biphonic Singing," in *Musical Voices of Asia*, ed. Richard Emmert and Minegishi Yuki, 162–173 (Tokyo: Japan Foundation, Heibonsha, 1980).

3. Theodore Levin and Michael E. Edgerton, "The Throat Singers of Tuva," *Scientific American* 281, no. 3 (1999): 80–97.

4. Mark van Tongeren, *Overtone Singing: Physics and Metaphysics of Harmonics in East and West* (Amsterdam: Fusica, 2002).

5. Fred Dretske, *Knowledge and the Flow of Information* (Oxford: Blackwell, 1981), 142.

6. Distortion in digital systems increases as signal levels decrease. See Peter Elsea, *Basics of Digital Recording* (1996), http://artsites.ucsc.edu/ems/music/tech_background/TE-16/teces_16.html, or James Broesch, *Signal Processing* (Burlington, MA: Newnes Instant Access, 2008), 14.

7. Ian Robertson, "Mental Imagery and Imagination," abstract for *Imaginative Minds: An Interdisciplinary Symposium* (London: The British Academy, 2004).

8. Immanuel Kant, *Critique of the Power of Judgment* (Cambridge: Cambridge University Press, 2000), 212.

9. For example, Roger Shepard, "Externalization of Mental Images and the Act of Creation," in *Visual Learning, Thinking, and Communication*, ed. B. S. Randhawa and W. E. Coffman (New York: Academic Press, 1978). See also Stephen Kosslyn, *Image and Mind* (Cambridge, MA: Harvard University Press, 1980).

10. While the concept of "image-schema" is implicit in George Lakoff and Mark Johnson, *Metaphors We Live By* (Chicago: University of Chicago Press, 1980), it is only made explicit in the afterword added in 2003. The earliest explicit development of the idea is in Mark Johnson, *The Body in the Mind: The Bodily Basis of Meaning, Imagination, and Reason* (Chicago: University of Chicago Press, 1987).

11. George Lakoff, *Women, Fire, and Dangerous Things* (Chicago: University of Chicago Press, 1987), 278.

12. George Lakoff and Mark Johnson, *Philosophy in the Flesh* (New York: Basic Books, 1999).

13. Clifford Geertz, "The Transition to Humanity," in *Horizons of Anthropology*, ed. S. Tax (London: Allen & Unwin, 1965), 42. See also Charles Woolfson, *The Labour Theory of Culture* (London: RKP, 1982), chap. 6.

14. Derek Bickerton, "Syntax for Nonsyntacticians," in *Biological Foundations and Origin of Syntax*, ed. Derek Bickerton and Eörs Szathmàry (Cambridge, MA: MIT Press, 2009), 12.

15. Mikhail Bakhtin, "Author and Hero in Aesthetic Activity" (1920–23), in *Art and Answerability*, ed. Michael Holquist and Vladimir Liapunov (Austin: Texas University Press, 1990), 23.

4 Subjectivation

1. Robert Ornstein, *On the Experience of Time* (New York: Penguin Books, 1969).

2. Edmund Husserl, *The Phenomenology of Internal Time-Consciousness*, trans. J. S. Churchill (Bloomington: Indiana University Press, 1950).

3. Humberto Maturana and Francisco Varela, *Autopoiesis and Cognition: The Realization of the Living* (Boston: Reidel, 1980).

4. Even the membrane of a cell is busy with representation: "Therefore we may say, not only that the structure of a membrane *refers* to some part of the environment, but that it makes also that part of the environment in a sense *present again* or *re-presented* in the structure of the membrane … in order to recognize and internalise it." Srdan Lelas, *Science and Modernity: Toward an Integral Theory of Science* (New York: Springer Science, 2001), 73.

5. Donna Haraway, "Situated Knowledges: The Science Question in Feminism and the Privilege of Partial Perspective," *Feminist Studies* 14, no. 3 (autumn 1988): 575–599.

6. Daniel Dennett, *Consciousness Explained* (London: Penguin, 1993), 17, 107.

7. Charles Darwin, *The Expression of the Emotions in Man and Animals* (London: John Murray, 1872).

8. Charles Taylor, *Philosophical Papers*, vol. 1: *Human Agency and Language* (Cambridge: Cambridge University Press, 1985), 10.

9. See, for example, the argument between Castoriadis and Habermas: Cornelius Castoriadis, *L'institution imaginaire de la société* (Paris: Seuil, 1975), 397; Jürgen Habermas, "Excursus on Cornelius Castoriadis," in his *The Philosophical Discourse of Modernity* (Cambridge, MA: MIT Press, 1987), 327–335, and his *Moral Consciousness and Communicative Action*, trans. C. Lenhardt and S. W. Nicholsen (Cambridge, MA: MIT Press, 1990); and Cornelius Castoriadis, *Les carrefours du labyrinthe V* (Paris: Seuil, 1997), 29.

10. Michel Foucault, "The Subject and Power," *Critical Inquiry* 8, no. 4 (summer 1982): 777–795.

11. Jonathan Hughes, *Ecology and Historical Materialism* (Cambridge: Cambridge University Press, 2000), 101, cites Leszek Kolakowski, *Main Currents of Marxism* (Oxford: Oxford University Press, 1978), 412–413, as denying that Marx has any conception of either human nature or external nature that is not socially constituted: "Man is wholly defined in purely social terms; the physical limitations of his being are scarcely noticed." Rudolph Bahro, in his "Interview with Fred Halliday," reprinted in Bahro, *From Red to Green* (London: Verso, 1984), 215, also argued that Marx was not materialist enough.

12. Again a political parallel is useful. Much has been written about recent protest movements in terms of the importance of the self-creation of political subjects within different types of structure—either horizontal, decentralized, and antihierarchical or centralized, vertical, and hierarchical. The crucial element of dissatisfaction with existing forms of representation and of "having a voice" point to the underlying importance of self-definition for the political subject. All forms of political representation involve specific time structures with regard to elections, parliaments, and so forth. To pursue this, see, for example, Jacques Rancière, *Disagreement: Politics and Philosophy*, trans. J. Rose (Minneapolis: University of Minnesota Press, 1999), and Marina Prentoulis and Lasse Thomassen, "Political Theory in the Square: Protest, Representation and Subjectification," *Contemporary Political Theory* 12 (2013): 166–184.

13. Jonathan Smith, "Time in Biology and Physics," in *The Nature of Time: Geometry, Physics and Perception*, ed. R. Buccheri, M. Saniga, and W. M. Stuckey, 145–152 (Dordrecht: Kluwer, 2003).

14. See Andrew A. Fingelkurts, Alexander A. Fingelkurts, and Carlos F. H. Neves, "Natural World Physical, Brain Operational, and Mind Phenomenal Space-Time," *Physics of Life Reviews* 7, no. 2 (2010): 195–249. This article explores the relationship between brain-operational space-times and subjective "mental" space-times.

15. Gilbert Simondon, "The Genesis of the Individual" (1964), trans. Mark Cohen and Sanford Kwinter (1964), in *Zone 6: Incorporations*, ed. Jonathan Crary and Sanford Kwinter, 297–319 (New York: Zone Books, 1992): "The subject can be thought of as the unity of the being when it is thought of as a living individual, and as a being that represents its activity to itself in the world both as an element and a dimension of the world" (306–307). My idea of subjectivation is essentially cognitive but recursive. But I am not against the idea that there is a "feeling" involved that may originate in the fact that neurons, like individual living organisms, inhabit an environment. Although the main part of the neuron, the synapse, functions (roughly) in a simple on-off way, the biological process prior to synaptic communication involves the exchange of materials between the neuron and its biochemical surroundings. The synchronization of ion flows from their environments into many neurons simultaneously could be the basis for the feeling of experience as unitary, as opposed to the actual cognitive processing of information taking place in the synchronization of synaptic firing. See Norman D. Cook, *Tone of Voice and Mind: The Connections between Intonation, Emotion, Cognition and Consciousness* (Philadelphia: John Benjamins, 2002), 191. A parallel but philosophically more sophisticated idea occurs in Alfredo Pereira Jr. and Dietrich Lehmann, *The Unity of Mind, Brain, and World: Current Perspectives on a Science of Consciousness* (Cambridge: Cambridge University Press, 2013), 239.

16. Antonio Damasio, *The Feeling of What Happens* (Portsmouth, NH: Heinemann, 2000), 154.

17. The question of time has not previously been dealt with in a way that is adequate to my argument, and I suspect that there are levels of technicality to which I cannot rise. Norbert Wiener, in "Time, Communication, and the Nervous System," *Annals of the New York Academy of Science* 50 (1948): 197–219, does little more than compare Bergsonian with Newtonian time; his concern is with the irreversibility of time in certain systems. Joanna Rączaszek-Leonardi, in "Multiple Systems and Multiple Time Scales of Language Dynamics: Coping with Complexity," *Cybernetics and Human Knowing* 21, nos. 1–2 (2014): 37–52, assumes the homogeneity of time so as to discuss the complexities of superimposed timescales. Meanwhile in biology, the subsystems of living systems have been identified as having nonisochronous times, system specific, and reflecting "circular logic and operational closure," as in E. Schwartz, "A Generic Model for the Emergence and Evolution of Natural Systems toward Complexity and Autonomy," in *Proceedings of 36th Meeting of the International Society for the Systems Sciences* (Denver, CO: ISSS, 1992). My best bet is Klaus Krippendorff, "On the Cybernetics of Time," *Systemsletter* 7, no. 1 (1978): 1–2, http://repository.upenn.edu/asc_papers/228. I can do no better than to adapt his

distinction between "ordinal time" and "circular time." Thus, the serial moment of the locutionary subject occurs in a stream of information in which everything depends on the order of events and speed is merely a product of system pragmatics. Perceptual or sintonic time occurs where circular time intersects with subjectivation processes.

18. Livia Polanyi, *The Linguistic Structure of Discourse* (Stanford: CSLI Publications, 1995), 44.

19. Erving Goffman, *The Presentation of Self in Everyday Life* (Edinburgh: University of Edinburgh, 1956), 53.

20. James Gibson, influential in the development of ecological psychology, contrasts the "flow" of perception, as a direct form of knowing, with cognition, which is indirect, essentially verbal, and whose events are initially discrete and synthesized by reference to memory. See Gibson, *The Senses Considered as Perceptual Systems* (Boston: Houghton Mifflin, 1966).

21. Stephen Zepke, *Deleuze, Guattari, and the Production of the New* (New York: Continuum, 2008), 29.

5 Dreams and the Oneiric Subject

1. W. Robert, *Der Traum als Naturnotwendigkeit erklart* (Hamburg: Hermann Seippel, 1886), 32, quoted in Sigmund Freud, *The Interpretation of Dreams* (Leipzig: Franz Deuticke, 1899), 27.

2. Ludwig Strumpell, *Die Natur and Entstehung der Traume* (Leipzig, 1877), 17, quoted in Freud, *Interpretation*, 19.

3. Michele Stephen, "Self, the Sacred Other and Autonomous Imagination," in *The Religious Imagination in New Guinea*, ed. Gilbert Herdt and Michele Stephen (New Brunswick, NJ: Rutgers University Press, 1989), 41–64.

4. Sandor Lorand, "Dream Interpretation in the Talmud (Babylonian and Graeco-Roman Period)," *International Journal of Psychoanalysis* 38 (1957): 92–97.

5. Wendy Doniger, *Dreams, Illusion, and Other Realities* (Chicago: University of Chicago Press, 1984).

6. Naphtali Lewis, *The Interpretation of Dreams and Portents* (Toronto: Samuel Stevens Hakkert, 1976).

7. Jean-Marie Husser, "Songe," in *Supplément au dictionnaire de la Bible, XII* (Paris: Letouzey et Ané, 1996), trans. by Jill Munro as *Dreams and Dream Narratives in the Biblical World* (Sheffield: Sheffield Academic Press, 1999).

8. Wendy Doniger and Kelly Bulkley, "Why Study Dreams? A Religious Studies Perspective," *Dreaming* 3, no. 1 (1993): 69–73.

9. Caroline Humphrey, *Shamans and Elders* (New York: Oxford University Press, 1996), 218.

10. Roberte Hamayon, *Taïga—Terre de Chamans*, new ed. (Paris: Imprimerie Nationale, 1993).

11. Stephen, "Self, the Sacred Other," 164.

12. Yevgeniy Antufyev, "Shamanism: The Bear Spirit. Interview with Kara-ool Tyulyushevich," Center of Asia, May 26, 2008, trans. Heda Jindrak, http://www.centerasia.ru/issue/2008/20/1772-dukh-medvedya.html.

13. Gloria Wekker, "One Finger Does Not Drink Okra Soup: Afro-Surinamese Women and Critical Agency," in *Feminist Genealogies, Colonial Legacies, Democratic Futures*, ed. M. Jacqui Alexander and Chandra Talpade Mohanty (New York: Routledge, 1997).

14. Anthony F. C. Wallace, "Revitalization Movements," *American Anthropologist* 58 (1956): 264–281; Robert Tonkinson, "Aboriginal Dream-Spirit Beliefs in a Contact Situation: Jigalong, Western Australia," in *Australian Aboriginal Anthropology*, ed. Ronald M. Berndt (Crawley, WA: University of Western Australia Press, 1970); Vittorio Lanternari, "Dreams as Charismatic Significants: Their Bearing on the Rise of New Religious Movements," in *Psychological Anthropology*, ed. T. R. Williams (Paris: Mouton, 1975).

15. Cargo cults are millenarian movements—usually in Melanesia—in which the focus is on obtaining material wealth, or "cargo," by means of new kinds of ritual activities. Millenarian movements are a more general category of religious movement arising when existing assumptions about power and social order are breaking down. For the relevance of dreams to Jihad, see Iain R. Edgar, *The Dream in Islam: From Qur'anic Tradition to Jihadist Inspiration* (Oxford: Berghahn, 2011).

16. Kenelm Burridge, *New Heaven, New Earth* (Oxford: Blackwell, 1969).

17. Elisabeth Kitsoglou, "Dreaming the Self: A Unified Approach towards Dreams, Subjectivity, and the Radical Imagination," in *History and Anthropology* 21, no. 3 (2010): 321–355.

18. Edmund Husserl, *The Phenomenology of Internal Time-Consciousness*, trans. J. S. Churchill (Bloomington: Indiana University Press, 1950).

19. Ernest Hartmann, "Why Do We Dream?" *Scientific American*, July 10, 2006.

20. Georges Lapassade, with Patrick Boumard and Michel Lobrot, *Le mythe de l'identité, éloge de la dissociation* (St. Augustin, Germany: Anthropos, 2006).

21. Gilles Deleuze and Félix Guattari, *Anti-Oedipus: Capitalism and Schizophrenia* (New York: Viking, 1977).

22. William McDougall, *An Outline of Abnormal Psychology* (London: Methuen, 1926), 543–544.

23. Julia Iribarne, "Contribution to the Phenomenology of Dreams," in *Essays in Celebration of the Founding of the Organization of Phenomenological Organizations*, ed. Chan-Fai Cheung, Ivan Chvatik, Ion Copoeru, Lester Embree, Julia Iribarne, and Hans Rainer Sepp (2003, published online), http://opo-phenomenology.org/essays/IribarneArticle.pdf.

24. Charles Harrison Mason (ca. 1907), *Church of God in Christ Official Manual* (Memphis, TN: Church of God in Christ Publishing Board, 1973).

25. *Kamlaniye* has a general meaning of shamanic ritual; however, the term is also often used to designate open-air rituals that do not involve a specific client but are to do with the shaman's spirits or with the spirits of the place where the ritual is held.

6 Imagination Space

1. Alexander Roob, *Alchemy and Mysticism* (Cologne: Taschen, 1996).

2. Shierry Nicholsen, *Exact Imagination, Late Work: On Adorno's Aesthetics* (Cambridge, MA: MIT Press, 1999), 3.

3. Johann Herder, *Ideen zu einer Philosophie der Geschichte der Menschheit* (Riga and Leipzig: J. F. Hartknoch, 1784–1791).

4. Mary Warnock, *Imagination* (Berkeley: University of California Press, 1978), 10.

5. Lev Vygotsky, "Imagination and Creativity in Childhood" (1930), reprinted in *Journal of Russian and East European Psychology* 42, no. 1 (2004): 7–97, 87–88.

6. Jean-Paul Sartre, *L'imaginaire* (Paris: Gallimard, 1940).

7. Antonio Damasio, *The Feeling of What Happens* (Portsmouth, NH: Heinemann, 2000), 332–333.

8. Paul de Man, *The Resistance to Theory* (Minneapolis: University of Minnesota Press, 1982), 10–11.

9. Bruce Knauft, "Imagery, Pronouncement, and the Aesthetics of Reception in Gebusi Spirit Mediumship," in *The Religious Imagination in New Guinea*, ed. Gilbert Herdt and Michele Stephen (New Brunswick, NJ: Rutgers University Press, 1989), 67–98.

10. Daniel Dennett, *Consciousness Explained* (London: Penguin, 1993), 43–65.

11. "Creative imagination emerges when fantasy becomes fused with thinking in concepts. ... The key to concept formation is semantic mediation. ... A person must

be able to be in an oppositional, critical, or reflective relationship with reality in order to fully internalise a concept's meaning. The imagination provides the capacity for this type of critical relationship." Seana Moran and Vera John-Steiner, "Creativity in the Making," in *Creativity and Development*, ed. R. Keith Sawyer (New York: Oxford University Press, 2003), 71.

7 Topography of Culture

1. David Holmberg, *Order in Paradox, Myth and Ritual among Nepal's Tamang* (Ithaca, NY: Cornell University Press, 1992), 105.

2. Liang Shuming, *Les cultures d'orient et d'occident et leurs philosophies* (Paris: PUF, 2000).

3. Carl Jacob Burckhardt, *Reflections on History* (Indianapolis: Liberty Classics, 1979). Both the above texts are quoted in Mario Perniola, *L'Estetica Contemporanea* (Bologna: Il Mulino, 2011), 204–207, 194–197.

4. Alfredo González-Ruibal, Almudena Hernando, and Gustavo Politis, "Ontology of the Self and Material Culture: Arrow-Making among the Awá Hunter-Gatherers (Brazil)," *Journal of Anthropological Archaeology* 30 (2011): 1–6.

5. Environmental determinism reached its peak in anthropology in the nineteenth century with Friedrich Ratzel. Franz Boas saw environment as only creating the conditions of possibility for multiple cultural forms. More recently, Andrew Sluyter, in "Neo-Environmental Determinism, Intellectual Damage Control, and Nature/Society Science," *Antipode* 4 (2003): 813–817, convincingly attacks Jared Diamond's Pulitzer Prize–winning *Guns, Germs and Steel* (New York: Norton, 1997). And Susan Kent, in "Cross-Cultural Perceptions of Farmers and the Value of Meat," in *Farmers as Hunters: The Implications of Sedentism*, ed. Susan Kent (Cambridge: Cambridge University Press Archive, 1989), argues that "although mobility has in the past been viewed as ecologically determined it is productive to view mobility as independent of ecology, that is, as independent of the environment or of economics, such as particular subsistence strategies" (3).

6. E. D. Schneider and J. J. Kay, "Order from Disorder: The Thermodynamics of Complexity in Biology," in *What Is Life: The Next Fifty Years. Reflections on the Future of Biology*, ed. Michael P. Murphy and Luke A. J. O'Neill (Cambridge: Cambridge University Press, 1995), 161–172.

7. Henri Atlan, *À tort et à raison* (Paris: Seuil, 1986), trans. Lenn Schramm as *Enlightenment to Enlightenment* (Albany, NY: SUNY Press, 1993), 51. Peter B. and J. S. Medawar, *The Life Science* (London: Granada Paladin, 1977), 101–102.

8. "Biological nature has a compartmental structure," wrote Michael Conrad in "Statistical and Hierarchical Aspects of Biological Organization," in *Biological Processes in*

Living Systems: Toward a Theoretical Biology, ed. C. H. Waddington (Edinburgh: Edinburgh University Press, 1972), 189. Andrew D. Miller and Julian Tanner, in *Essentials of Chemical Biology: Structure and Dynamics of Biological Macromolecules* (Hoboken, NJ: Wiley, 2013), note that compartmentalization "is a key part of the self-organisation process, if for nothing else than to sustain spatial integrity and prevent dilution of the reacting molecules that comprise each living system" (section 10.1.2). See also Tibor Ganti, *The Principles of Life*, ed. Eörs Szathmary and James Griesemer (Oxford: Oxford University Press, 2003).

9. Pierre Clastres, *La société contre l'état* (Paris: Editions de Minuit, 1974), 154.

10. Susan Buck-Morss, "Visual Empire," *Diacritics* 37, nos. 2–3 (2007): 171–198. Although here it is the sovereign as icon who supplies the miracle; it is only from the Neolithic onward that the enigma of law takes the form of the sovereign.

11. Fred E. Katz, *Structuralism in Sociology: An Approach to Knowledge* (Albany, NY: SUNY Press, 1976), criticizes Parsonian theory for its failure to register indeterminacy as an objective component of actual society. Russell Hardin, *Indeterminacy and Society* (Princeton, NJ: Princeton University Press, 2005), argues that much social theory sweeps the indeterminacy in strategic social interaction under the carpet. Indeterminacy is quite simply inescapable, and much social, moral, and legal theory is built on assuming the opposite.

12. Kostas Axelos, "The World: Being Becoming Totality," *Environment and Planning D: Society and Space* 24 (2006): 643–651.

13. Herbert Marcuse, *One-Dimensional Man: Studies in the Ideology of Advanced Industrial Society* (1964; London: Routledge, 2002), 69.

14. Ernst Von Glasersfeld wrote: "The 'real' world manifests itself exclusively there where our constructions break down. But since we can describe and explain these breakdowns only in the very concepts that we have used to build the failing structures, this process can never yield a picture of a world which we could hold responsible for their failure." From his "An Introduction to Radical Constructivism," in *The Invented Reality*, ed. Paul Watzvalik (New York: Norton, 1984), 38.

15. "Strongly held cultural beliefs, cognitive maps (worldviews), and cultural paradigms may block, delay or misinterpret the information [passing from ecological into cultural system]." Faith Balch, "Examining Constraints and Feedback as System Regulators in a Combined Ecological and Cultural System Model," in *Cultural Analysis and the Navigation of Complexity: A Festschrift in Honor of Luther P. Gerlach*, ed. Lisa Kaye Brandt (Lanham, MD: University Press of America, 2007), 75.

16. Chris Knight, *Blood Relations: Menstruation and the Origins of Culture* (New Haven, CT: Yale University Press, 1991).

17. This way of putting it makes a historical variable of what is sometimes an excessively pessimistic interpretation. The question as formulated by Sadie Plant—in

Switch Interviews 5, no. 1 (1999), http://switch.sjsu.edu:/web/v5n1/plant/—is the extent to which institutionalization penetrates into how art is made. She emphasizes the dynamism of the process by which what is recuperated is quickly replaced from below. But she is talking about a fast society.

18. Tom McDonough, ed., *Guy Debord and the Situationist International* (Cambridge, MA: MIT Press, 2002).

8 Discourse as Cultural Phase

1. Marshall McLuhan, *The Gutenburg Galaxy* (London: Routledge, 1962), 245.

2. Terrence Deacon, *The Symbolic Species* (London: Penguin, 1997).

3. Charles Peirce, "On a New List of Categories," in *The Writings of Charles S. Peirce: A Chronological Edition* (1867; Bloomington: Indiana University Press, 1982–), 49–58.

4. Deacon, *The Symbolic Species*, 401–402.

5. Michael Taussig, *The Nervous System* (London: Routledge, 1992), 125.

6. Emile Durkheim, *Elementary Forms of Religious Life* (1912; New York: Free Press, 1965), 149.

7. Jacques Derrida, *L'écriture et la différence* (1967), trans. *Writing and Difference* (London: RKP, 1978), 4, 12.

8. Bruno Latour, *We Have Never Been Modern* (Cambridge, MA: Harvard University Press, 1993).

9. Michel Foucault, *The Archaeology of Knowledge* (London: Routledge, 2002) translated from *L'archéologie du savoir* (Paris: Gallimard, 1969).

10. Hans Richter, *Dada, Art and Anti-Art* (London: Thames & Hudson, 1965), 51.

11. Samuel Johnson, *The Lives of the Poets* (Oxford: Oxford University Press, 2006), 149–150.

12. Alexander Cozens (1785), *A New Method of … Original Compositions of Landscape* (1785; London: Paddington, 1977).

13. Nikolai Kulbin, "Svobodnaya Musika," in *Studiia impressionistov*, ed. Nikolai Kulbin (St. Petersburg: Butovskoi, 1910), 15–26.

14. Colin Burrow, "Sudden Elevations of Mind," *London Review of Books*, February 17, 2011.

15. Michelle Alexander, *The New Jim Crow: Mass Incarceration in the Age of Colorblindness* (New York: New Press, 2010).

16. Elisabeth Noelle-Neumann, "The Spiral of Silence: A Theory of Public Opinion," *Journal of Communication* 24, no. 2 (1974): 43–51.

17. Gillian Tett, *Fool's Gold: How Unrestrained Greed Corrupted a Dream, Shattered Global Markets, and Unleashed a Catastrophe* (New York: Simon & Schuster, 2009).

9 The Sacred as Cultural Phase

1. Caroline Humphrey, *Shamans and Elders* (Oxford: Oxford University Press, 1996), 141–142.

2. M. A. Czaplicka, *Aboriginal Siberia: A Study in Social Anthropology* (Oxford: Oxford University Press, 1914), 32–37.

3. Mark Stephen Penke, *The Vampire Survival Bible*, vol. 2 (Lulu.com, 2012), 256. He points out that "in real life" such improvised crosses do not impress vampires.

4. Victor Turner, *The Forest of Symbols: Aspects of Ndembu Ritual* (Ithaca, NY: Cornell University Press, 1967), 28–29, 50–55.

5. Alfred Schutz, *The Phenomenology of the Social World* (Portsmouth, NH: Heinemann, 1972), 119, trans. from *Der Sinnhafte Aufbau der sozialen Welt* (New York: Springer, 1932).

6. Leonid Lar, *Shamani i Bogi* (Tyumen, Russian Federation: Institute Problemi Osvoyeniya Severa, 1998).

7. David Le Breton, *Anthropologie du corps et modernité* (Paris: Quadrige, 1990).

8. Carlo Ginzburg, *Ecstasies: Deciphering the Witches' Sabbath* (Chicago: University of Chicago Press, 2004).

9. Marcel Mauss, "Les techniques du corps" (1934), *Journal de psychologie*, March 15–April 15, 1936.

10. André Leroi-Gourhan, *Le geste et la parole* (Paris: Albin Michel, 1964). Marcel Jousse, *L'anthropologie du geste* (Paris: Les Editions Resma, 1969). Victor Turner, *From Ritual to Theater: The Human Seriousness of Play* (New York: PAJ, 1982).

11. Eugenio Barba, *Anatomia del Teatro* (Florence: La Casa Usher, 1983).

12. Maurice Bloch, "Symbols, Song, Dance and Features of Articulation," *European Journal of Sociology* 15 (1974): 55–81.

13. Bruce Kapferer, "Introduction: Ritual Process and the Transformation of Context," *Social Analysis* 1 (1979): 3–19.

14. Carole Pegg, *Mongolian Music, Dance, and Oral Narrative* (Seattle: University of Washington Press, 2001).

15. Edward Schieffelin, "Performance and the Cultural Construction of Reality," *American Ethnologist* 12, no. 4 (1985): 707–724.

16. In the spirit medium sessions practiced by the Bosavi people of Papua New Guinea, mediums enter states of possession in which spirits speak through them. While geared to curing the sick and identifying witches, the sessions are also collective improvisations, with any participant able to question a spirit.

17. Roland Barthes, *Image, Music, Text* (London: Fontana Flamingo, 1977), 181, trans. from "Le grain de la voix," *Musique en Jeu 9* (1972).

18. Arnold Van Gennep, *The Rites of Passage* (Florence, KY: Psychology Press, 1960), trans. from *Les rites de passage* (1909).

19. Philip Larkin, "Letter to Monica 10/8/54," quoted in Richard Bradford, *The Odd Couple: The Curious Friendship between Kingsley Amis and Philip Larkin* (London: Robson Press/Biteback, 2012).

20. Dan Sperber, *Rethinking Symbolism* (Cambridge: Cambridge University Press, 1975), 67.

21. Michael Winkelman, *Shamanism: The Neural Ecology of Consciousness and Healing* (Westport, CT: Praeger, 2000).

22. Richard Castillo, "Book Review Forum on Winkelman," *Journal of Ritual Studies* 18, no. 1 (2004): 96–108.

23. Erika Bourguignon, *Possession* (San Francisco: Chandler & Sharp, 1976).

24. Yevgeniy Antufyev, "Shamanism: The Bear Spirit: Interview with Kara-ool Tyu-lyushevich," Center of Asia, May 26, 2008, trans. Heda Jindrak, http://www.centerasia.ru/issue/2008/20/1772-dukh-medvedya.html.

25. Mongush Kenin-Lopsan, *Shamanic Songs and Myths of Tuva*, trans. Christiana Buckbee, Istor no. 7 (Budapest: Akadémiai Kiadó, 1997), 95.

26. Hocketing is the technique by which each voice is allocated a single pitch or a syllable, so that the melody and rhythm are woven from the interplay of voices across a social and physical space. It is found in the Pygmy Mbenga and Mbuti music cultures, and in late Mediaeval French motets. The Venetian "stereoists," as I call them, experimented in the late Renaissance and early Baroque with the spatial distribution of choirs, in particular on both sides of canals. Gioseffe Zarlino and Giovanni Gabrieli were among them.

27. Waldemar Jochelson, *The Koryak* (Memoirs of the American Museum of National History, vol. 10, parts 1–2: The Jesup North Pacific Expedition) (Leiden: E. J. Brill, 1908), 49.

28. Michele Stephen, "Self, the Sacred Other and Autonomous Imagination," in *The Religious Imagination in New Guinea*, ed. Gilbert Herdt and Michele Stephen (New Brunswick, NJ: Rutgers University Press, 1989), 41.

29. Michael Taussig, *The Nervous System* (New York: Routledge, 1992), 111.

30. Jean-Marie Husser, "Songe," in *Supplément au dictionnaire de la Bible, XII* (Paris: Letouzey et Ané, 1996), trans. Jill Munro as *Dreams and Dream Narratives in the Biblical World* (Sheffield: Sheffield Academic Press, 1999).

31. Chai-shin Yu and R. Guisso, eds., *Shamanism: The Spirit World of Korea* (Berkeley: Asian Humanities Press, 1988), 14–15.

32. Caroline Humphrey and David Sneath, *The End of Nomadism? Society, State, and the Environment in Inner Asia* (Durham, NC: Duke University Press, 1999).

33. Phil Cohen, *Sub-Cultural Conflict and Working Class Community* (Birmingham: University of Birmingham, 1972).

34. Jacques Derrida, "Interview with Julia Kristeva," in *Positions* (Chicago: University of Chicago Press, 1982), 28–30.

35. Louis-Marie Chauvet, *Symbol and Sacrament*, trans. P. Madigan and M. Beaumont (Collegeville, MN: Liturgical Press, 1995), 326.

36. Humphrey, *Shamans and Elders*, 110.

37. Maurice Bloch, "Language, Anthropology, and Cognitive Science," *Man* 26 (2) (June 1991): 193–194.

38. Carlo Severi, "The Invisible Path: Ritual Representation of Suffering in Cuna Traditional Thought," *Res—Anthropology and Aesthetics* 14 (autumn 1987): 82.

39. Mircea Eliade, *Shamanism: Archaic Techniques of Ecstasy* (Princeton, NJ: Princeton University Press, 1951).

40. Roberte Hamayon, "Are 'Trance,' 'Ecstasy,' and Similar Concepts Appropriate in the Study of Shamanism?" *Shaman* 1, nos. 1–2 (1993): 3–25. Gilbert Rouget attacks Hamayon in "Transe: théâtre, émotion, neurosciences," in *Chamanisme et possession*, ed. Laurent Aubert, 211–220 (Geneva: Ateliers de l'ethnomusicologie, 2006), specifically for belittling the emotional component in trance. Against Hamayon, he deploys Aubert's own *Les feux de la déesse* (Lausanne: Editions Payot, 2004), as well as Judith Becker's *Deep Listeners: Music, Emotion and Trancing* (Bloomington: Indiana University Press, 2004).

41. Emile Durkheim, "Le caractère sacré que revêt une chose n'est donc pas impliqué dans les propriétés intrensèques de celle-ci: Il y est surajouté," in *Les formes élémentaires de la vie religieuse* (Paris: F. Alcan, 1912), 328.

42. Emile Durkheim, *The Rules of the Sociological Method* (1895; Glencoe: Free Press, 1938), 114.

43. Emile Durkheim, *Elementary Forms of Religious Life* (1912; New York: Free Press, 1965), 262.

44. Edward Evans-Pritchard, *Theories of Primitive Religion* (Oxford: Oxford University Press, 1965), 68.

45. Jacques Rancière, *The Emancipated Spectator* (2008; New York: Verso, 2011).

46. Guy Debord, *The Society of the Spectacle* (New York: Zone, 1994).

47. Edward Evans-Pritchard, cited in Brian Morris, *Anthropological Studies of Religion* (Cambridge: Cambridge University Press, 1987), 122.

48. Victor Turner, *Dramas, Fields and Metaphors: Symbolic Action in Human Society* (Ithaca, NY: Cornell University Press, 1974), 25.

49. Max Gluckman, *Politics, Law, and Ritual in Tribal Society* (London: Blackwell, 1967), 258. Victor Turner, "Aspects of Soara Ritual and Shamanism," in *The Craft of Social Anthropology*, ed. A. L. Epstein (London: Tavistock Institute, 1967).

50. Max Marwick, "The Study of Witchcraft," in *The Craft of Social Anthropology*, ed. A. L. Epstein (London: Tavistock Institute, 1967), 231.

10 Art as Cultural Phase

1. Tia DeNora, "Musical Practice and Social Structure: A Toolkit," in *Empirical Musicology*, ed. Eric Clarke and Nicholas Cook (Oxford: Oxford University Press, 2004), 47.

2. Tim Hodgkinson, "Notes from the Underground; Interview with Iancu Dumitrescu," *Resonance* 6, no. 1 (1997).

3. Alfred Gell, *Art and Agency: An Anthropological Theory* (Oxford: Clarendon Press, 1998), 2–3.

4. Pierre Bourdieu, *Les règles de l'art* (Paris: Seuil, 1992). Arthur Danto, "The Artworld," *Journal of Philosophy* 61 (1964): 571–584.

5. Sally Price, *Paris Primitive* (Chicago: University of Chicago Press, 2007).

6. Victor Shklovsky, "Art as Technique" (1917), in *Russian Formalist Criticism: Four Essays*, ed. T. Lemon and Marion J. Reis (Lincoln: University of Nebraska Press, 1965), 3–24.

7. Roman Jakobson, "Préface" to *Théorie de la littérature: Textes des formalistes russes*, ed. Tzvetan Todorov (Paris: Seuil, 1965).

8. Shklovsky, "Art as Technique," 12.

9. Boris Eichenbaum, "The Theory of the Formal Method," in *Russian Formalist Criticism*, 105.

10. Julia Kristeva, "Le sujet en procés," in *L'identité, séminaire dirigé par Claude Lévi-Strauss* (Paris: Quadrige/PUF, 1977), 223–246.

11. Some light may be shed on the hand axes by considering the Awá tribe in the Amazon who engage in the production of vast numbers of arrows—far more than they need for hunting. Although the arrows themselves are functionally designed, the activity of making them seems to take off with a life of its own. Arrow making is a *technology of the self* according to Alfredo González-Ruibal, Almudena Hernando, and Gustavo Politis, "Ontology of the Self and Material Culture: Arrow-Making among the Awa Hunter-Gatherers Brazil," *Journal of Anthropological Archaeology* 30 (2011): 1–6. The actions involved are repetitive and in intimate relation with the body and with the particularity of the individual. Perhaps the piles of hand axes left by the Acheuleans can be read as evidence of the phylogenetic beginnings of personhood, first built up as a technology to be gradually interiorized.

12. Words attributed to Jill Cook, curator, in Tom Lubbock's review of the "Prehistory: Objects of Power" exhibition at the British Museum, "The Early, Early Show," *Independent*, May 28, 2002.

13. Roger Lewin, "Stone Age Psychedelia," *New Scientist*, June 8, 1991.

14. The word *ongon* is Mongolian and, like *eeren* in Tuvan, refers to something that is a vessel or container for spirits or spiritual force. Kunga often mixes Mongolian and Tuvan in his parlance.

15. John Baily, "Music Performance, Motor Structure, and Cognitive Models," in *European Studies in Ethnomusicology: Historical Developments and Recent Trends*, ed. Max Peter Baumann, Artur Simon, and Ulrich Wegner, 142–158 (Wilhelmshaven: Florian Noetzel, 1992).

16. Alec Robertson, "Plainsong," in *The Pelican History of Music*, vol. 1, ed. Denis Stevens and Alec Robertson (London: Penguin, 1960), 141.

17. 2 Chronicles 5:13–14.

18. See, for example, St. John Chrysostom, "Exposition of Psalm XLI," in *Source Readings in Music History from Classical Antiquity to the Romantic Era*, ed. O. Strunk (New York: W. W. Norton, 1950), 70.

19. Hugh Ottaway, "The Enlightenment and the Revolution," in *The Pelican History of Music*, vol. 3, ed. Alec Robertson and Denis Stevens (London: Penguin, 1968), 12.

20. Carlo Ginzburg, *The Enigma of Piero* (1985; revised trans. Kate Soper, Verso, 2000).

21. Solomon Volkov, ed., *Testimony: The Memoirs of Dmitri Shostakovich* (New York: Harper & Row, 1979).

22. Edward J. Dent, *Mozart's Operas: A Critical Study* (New York: McBride, Nast, 1913).

23. Both quotes are from Ottaway, "The Enlightenment and the Revolution," 21.

24. Theodor Adorno, *Philosophy of Modern Music* (New York: Continuum, 1949).

25. See Antoine Hennion, *La passion musicale* (Paris: Suites, 2007), 29–34, for a strong pro-mediation argument.

26. My translation of "Il dramma del principe è appunto la lotta con la fortuna, l'esigenza di sfruttare opportunità che non dipendono da lui." Gennaro Sasso, *I corotii e gli inetti: Conversazioni su Machiavelli* (Milan: Bompiani, 2013).

27. Gioseffe Zarlino, *Le Istitutione Armoniche* (Venice, 1558).

28. Benvenuto Cellini, *The Autobiography of Benvenuto Cellini*, trans. Anne Macdonell (New York: Everyman, 2010).

29. Adrienne Rich, *Blood, Bread, and Poetry: Selected Prose, 1979–1985* (New York: W. W. Norton, 1986), 199.

11 Toward a Materialist Ontology of Art

1. Fred Dretske, *Knowledge and the Flow of Information* (Oxford: Blackwell, 1981), vii–xi.

2. Martin Heidegger, *Introduction to Metaphysics*, trans. Ralph Manheim (New Haven, CT: Yale University Press, 1959–1987).

3. Gianni Vattimo, *Art's Claim to Truth* (New York: Columbia University Press, 2008), 40.

4. Martin Heidegger, "The Origin of the Work of Art" (1935), in *Poetry, Language, Thought*, trans. A. Hofstadter (New York: Harper & Row, 1971), 39.

5. Ibid., 73.

6. Vattimo, *Art's Claim to Truth*, 52–54.

7. Martin Heidegger, *Being and Time*, trans. John. Macquarrie and Edward Robinson (1927; Oxford: Blackwell, 1962), 203–210.

12 On Listening

1. John Locke, *An Essay Concerning Human Understanding* (Menston: Scolar Press, 1690).

2. Aristoxenus, *Aristoxenou Harmonika stoicheia: The Harmonics of Aristoxenus*, trans. H. S. Macran (Oxford: Clarendon Press, 1902).

3. Boethius, *The Consolation of Philosophy*, book 5, trans. H. R. James (London: Elliot Stock, 1897).

4. David C. Lindberg, *Theories of Vision from al-Kindi to Kepler* (Chicago: University of Chicago Press, 1976), 184.

5. Ibid., 164.

6. Pierre Schaeffer, *Traité des objets musicaux* (Paris: Seuil, 1966), 76.

7. Herman Helmholtz, *On the Sensations of Tone* (1862; New York: Dover, 1954), 368. (Although perception and cognition are two different things, perceptual psychology is generally defined as a subfield of cognitive psychology; Helmholtz's work on perception is regarded, for example, as contributing to cognitive psychology.)

8. Partials are modes of vibration. Most physical systems that vibrate regularly when stimulated do so because the restoring forces are proportional to displacement: the further from equilibrium point, the stronger the force for returning to it. These systems tend to vibrate not just at one frequency but at a set of frequencies corresponding to the series of whole numbers. Usually the lower numbers use up most of the energy, so the higher numbers are smaller, quieter vibrations. But they have a powerful effect on the sound quality (timbre) of the note produced. All of these frequencies, including the fundamental one, are known as partials.

9. Here are four of the classics in the genre: Donald Tovey, *Essays in Musical Analysis* (Oxford: Oxford University Press, 1935); Hans Keller, *Functional Analysis: The Unity of Contrasting Themes*, ed. Gerold W. Gruber (New York: Lang, 2001); Heinrich Schenker, *The Masterwork*, ed. William Drabkin and trans. Ian Bent, vols. 1–3 (New York: Dover, 2014); and Rudolph Réti, *The Thematic Process in Music* (New York: Macmillan, 1951).

10. Nicholas Cook, *A Guide to music analysis* (London: Dent, 1987), 223.

11. Ian Cross, "Music Analysis and Music Perception," *Music Analysis* 17, no. 1 (1998): 3–20. See also Naomi Cumming, "Eugene Narmour's Theory of Melody," *Music Analysis* 11, nos. 2–3 (1992): 354–374.

12. Fred Lerdahl and Ray Jackendoff, *A Generative Theory of Tonal Music* (Cambridge, MA: MIT Press, 1983).

13. Eugene Narmour, *The Analysis and Cognition of Basic Melodic Structures* (Chicago: University of Chicago Press, 1989).

14. Eugene Narmour, *The Analysis and Cognition of Melodic Complexity* (Chicago: University of Chicago Press, 1992).

15. Drawing on Jerry Fodor, *The Modularity of Mind* (Cambridge, MA: MIT Press, 1983).

16. Nicholas Cook, *Music, Imagination, and Culture* (Oxford: Clarendon Press, 1990). "A Schenkerian analysis is not a scientific explanation, but a metaphorical one; it is not an account of how people actually hear pieces of music, but a way of imagining them" (4). "The structural wholeness of musical works should be seen as a metaphorical construction, rather than as directly corresponding to anything that is real in a perceptual sense" (5).

17. See Ray Jackendoff, "Musical Parsing and Musical Affect," *Music Perception* 9, no. 2 (1991): 199–230.

18. John Dewey, *Art as Experience* (1932; New York: Perigee Books, 2005).

19. James Hepokoski and Warren Darcy, *Elements of Sonata Theory: Norms, Types, and Deformations in the Late Eighteenth Century Sonata* (Oxford: Oxford University Press, 2006).

20. Rudolph Réti, *Thematic Patterns in Sonatas of Beethoven* (London: Faber & Faber, 1967), 30.

21. Edmund Husserl, *The Phenomenology of Internal Time-Consciousness*, trans. J. S. Churchill (Bloomington: Indiana University Press, 1950).

22. Friedrich. A. Hayek, *The Sensory Order* (Chicago: University of Chicago Press, 1952).

23. James Gibson, *The Senses Considered as Perceptual Systems* (Boston: Houghton Mifflin, 1966). In *The Ecological Approach to Visual Perception* (Boston: Houghton Mifflin, 1979), Gibson admits that the perception of form in painting is a perception of an invariant. So there is a latent idea of aesthetic world here, but only latent: "Form perception itself must entail some invariant detection" (71).

24. Eric F. Clarke, *Ways of Listening: An Ecological Approach to the Perception of Musical Meaning* (Oxford: Oxford University Press, 2005), 42–47.

25. Paul Klee, in *Artists on Art, from the 14th–20th Centuries*, ed. Robert Goldwater and Marco Treves (London: Pantheon Books, 1972), 442.

26. See Reed Ghazala, *Circuit-Bending: Build Your Own Alien Instruments* (London: John Wiley, 2005).

27. Wassily Kandinsky, "Reminiscences," in *Modern Artists on Art*, 2nd enl. ed., ed. Robert L. Herbert, 19–39 (Chelmsford, MA: Courier Corporation, 2012), 28.

28. György Kurtág, notes for *Portraitkonzert* CD, Col Legno, WWE 31870, 1994, writing about his composition *Double Concerto*, opus 27, no. 2.

29. These notes were developed for my workshops with the TonArt Ensemble in 2010, with the help of an artist's residency with Verband für Aktuelle Musik, Hamburg.

30. Charles E. Ives, *Essays before a Sonata* (London: Calder & Boyars, 1969), 17.

31. Charles E. Ives, *Memos*, ed. John Kirkpatrick (London: Calder & Boyars, 1973), 106.

32. Jean-Jacques Nattiez, *Music and Discourse: Toward a Semiology of Music*, trans. Carolyn Abbate (Princeton, NJ: Princeton University Press, 1990), from *Musicologie générale et sémiologue* (Paris: C. Bourgois, 1987).

33. Claude Debussy, quoted in Alex Ross, *The Rest Is Noise* (New York: Picador, 2007), 41.

34. Lawrence Kramer, *Interpreting Music* (Berkeley: University of California Press, 2011), 48.

35. Luigi Pareyson, *Estetica: Teoria della formatività* (1950; Milan: Bompiani, 1988), 59.

36. Ibid., 16.

37. François Nicolas, *Les moments favoris: Une problèmatique de l'écoute musicale* (Reims: Noria, 1997).

38. Lawrence Kramer, *Music as Cultural Practice* (Berkeley: University of California Press, 1993), 12.

39. Fred Maus, "Concepts of Musical Unity," in *Rethinking Music*, ed. Nicholas Cook and Mark Everist (Oxford: Oxford University Press, 1999), 171.

40. Anton Webern, *The Path to New Music*, trans. Leo Black and ed. Willi Reich (Bryn Mawr, PA: Theodore Presser, 1963), 42.

41. August Macke, "Brief an Eberhard Grisebach, März 20, 1913," in *Briefe an Elisabeth und die Freunde*, ed. Werner Frese and Ernst-Gerhard Güse (Munich: Bruckmann, 1987), 300. Quoted in English in Wolf-Dieter Dube, *The Expressionists* (London: Thames & Hudson, 1972), 145.

42. The first quote is from "Helen Vendler: The Art of Criticism, no. 3," interview by Henri Cole, *Paris Review* 141 (winter 1996), http://www.theparisreview.org/interviews/1324/the-art-of-criticism-no-3-helen-vendler. The second is from Vendler's *The Art of Shakespeare's Sonnets* (Cambridge, MA: Harvard University Press, 1997), 23.

43. Apart from its axiomatic presence in music analysis, see also Theodor Adorno, *Introduction to the Sociology of Music* (New York: Continuum, 1949). "Structural listening" has been roundly criticized by Rose Subotnik in "Towards a Deconstruction of Structural Listening: A Critique of Schoenberg, Adorno, and Stravinsky" in

Subotnik, *Deconstructive Variations: Music and Reason in Western Society* (Minneapolis: University of Minnesota Press, 1996).

44. There are perhaps finer distinctions to be drawn. For the composer György Ligeti, synchronized clapping is horribly reminiscent of Communist rallies under the Rakosi regime. Unsynchronized clapping suggests to him listeners' freedom to express individual responses. See *György Ligeti Un Portrait*, film directed by Michel Follin, written by Arnaud de Mezamat, Judit Kele, Michel Follin (Paris: Artline Films for Arte, 1993).

45. George Lakoff and Mark Johnson, *Metaphors We Live By* (Chicago: University of Chicago Press, 1980).

46. Maurice Merleau-Ponty, *Phenomenology of Perception* (1945; New York: Routledge, 1962), 475.

47. Jean-Luc Nancy, *Listening*, trans. Charlotte Mandell (New York: Fordham University Press, 2007), 14.

48. Peter Kivy, *The Corded Shell: Reflections on Musical Expression* (Princeton, NJ: Princeton University Press, 1981). Stephen Davies, "The Expression of Emotion in Music," *Mind* 89 (1980): 67–86. Jenefer Robinson, "The Expression and Arousal of Emotion in Music," *Journal of Aesthetics and Art Criticism* 52, no. 1 (1994): 13–22. Jerrold Levinson, *Contemplating Art: Essays in Aesthetics* (Oxford: Oxford University Press, 2006).

49. Robert S. Hatten, *Interpreting Musical Gestures, Topics, and Tropes: Mozart, Beethoven, Schubert* (Bloomington: Indiana University Press, 2004). Hatten's analysis points to a circulation of information between a level of expressive cultural units (shared with literature) and a level of recognizable elements within a musical style. The interpretation of these elements is "an artistic process and not merely an identificational decoding" (from *Musical Meaning in Beethoven* [Bloomington: Indiana University Press, 2004], 269–270). The centripetal organization of aesthetic structure is the magnetic core around which nonmusical cultural units of expression align themselves in an expressive space. Beethoven worked in a period in which music and other arts had accumulated such a space outside themselves, to which to refer.

50. Arnold Schoenberg, *Letters*, ed. Erwin Stein (Berkeley: University of California Press, 1987), 47–48.

51. Jean-Paul Sartre, *Sketch for a Theory of the Emotions* (Hove: Psychology Press, 1962), 41.

52. Robin James, *The Conjectural Body: Gender, Race, and the Philosophy of Music* (Plymouth, UK: Lexington, 1978), 12.

53. James Currie, "Review of Andrew Bowie's *Music, Philosophy, and Modernity*," *Notre Dame Philosophical Reviews* (2008), http://ndpr.nd.edu/news/23563/?id=13328.

54. Albert Ayler; see cover notes for *The New Wave in Jazz*, CLP 1932, EMI Records, 1965.

13 Three Poietics of Contemporary Music

1. Huang-Po, *Doctrine of Universal Mind* (London: Buddhist Society of London, 1947), quoted in John Cage, "List No 2," in *John Cage: Documentary Monographs in Modern Art*, ed. Richard Kostelanetz (London: Allen Lane, 1971), 139.

2. Benjamin Piekut, *Experimentalism Otherwise: The New York Avant-Garde and Its Limits* (Berkeley: University of California Press, 2011), 149–176.

3. Michael Nyman, *Experimental Music; Cage and Beyond* (New York: Schirmer Books, 1974), 24–25.

4. Francisco López, "Profound Listening and Environmental Sound Matter," in *Audio Culture*, ed. Christopher Cox (New York: Continuum International, 2004), 82.

5. Fred Lonberg-Holm, interviewed in Charlie Wilmoth, "Scrapes and Hisses: Extended Techniques in Improvised Music," *Dusted Magazine* (2010), http://www.dustedmagazine.com/features/468.

6. John Cage, *Variations III Performance Instructions* (1962; New York: Henmar Press, 1963).

7. Pierre Schaeffer, *À la recherche d'une musique concrète* (Paris: Seuil, 1952).

8. Pierre Schaeffer, *Traité des objets musicaux* (Paris: Seuil, 1966), 349.

9. Ibid., 669, my translation.

10. Tim Hodgkinson, "An Interview with Pierre Schaeffer—Pioneer of Musique Concrète," *ReR Quarterly* 2, no. 1 (1987). Reprinted in *The Book of Music and Nature*, ed. David Rothenburg and Marta Ulvaeus (Middletown, CT: Wesleyan University Press, 2001).

11. John Cage, "On Earlier Pieces," in *John Cage: Documentary Monographs in Modern Art*, ed. Richard Kostelanetz (London: Allen Lane, 1971), 128.

12. François Nicolas, "Ècouter, lire et dire la musique (1) Théorie de l'écoute musicale," lecture notes (Paris: Ècole Normale Supérieure, Passerelle des Arts, Section de musicologie, 2004), 15–16, http://www.entretemps.asso.fr/Nicolas/BibNic.html; my translation. (Was Nono thinking of Venice?)

13. Schaeffer, *Traité des objets musicaux*, 271, my translation. "Écoutant l'objet sonore qui nous fournit une porte qui grince, nous pouvons bien nous désintéresser de la porte, pour ne nous intéresser qu'au grincement. Mais l'histoire de la porte et celle du grincement coïncide exactement dans le temps: la cohérence de l'objet sonore est celle de l'événement énergétique. Cette unité serait, dans le parlé, une unité de

respiration ou d'articulation: en musique, l'unité du geste instrumental. L'objet sonore est à la rencontre d'une action acoustique et d'une intention d'écoute."

14. Herbert Eimert, "What Is Electronic Music?" *Die Reihe*. Journal published in English as *Electronic Music* 1 (1957): 1–10.

15. Denis Smalley, "Spectromorphology: Explaining Sound-Shapes," *Organized Sound* 2, no. 2 (1997): 114.

16. Panel discussion, Kunstuniversität Graz, November 21, 2005, with Helmut Lachenmann; chairs: Clemens Gadenstätter and Christian Utz, "Sound, Magic, Structure: Aesthetical and Structural Dimensions in the Music of Helmut Lachenmann," English summary in *Musik Theorien der Gegenwart*, vol. 2, ed. Christian Utz and Clemens Gadenstätter (Saarbrücken: Pfau, 2008), 193.

17. Bryan Magee, *Wagner and Philosophy* (New York: Penguin, 2000), 206–207.

18. The difficulty is when the music most insists on making a point by using only extended techniques. Here the "familiarity factor" works against Lachenmann. In my own experience, once the sound-world of *Gran Torso*, a 1971 piece for string quartet that resolutely refuses to use the instruments in any familiar way, actually becomes familiar to me as a listener, its sound becomes an obstacle to finding out what else is going on below the surface of the music.

19. Lachenmann, panel discussion, Kunstuniversität Graz, 194.

20. Helmut Lachenmann, "On Structuralism," *Contemporary Music Review* 12, no. 1 (1995): 93.

21. Ola Stockfelt, "Adequate Modes of Listening," in *Audio Culture*, ed. Christopher Cox (New York: Continuum International, 2004), 88.

22. Helmut Lachenmann, 2008, quoted in Dominic Symonds and Pamela Karantonis, *The Legacy of Opera* (Amsterdam: Rodopi, 2013), 53.

23. Helmut Lachenmann, "Werkkommentar zu temA" (1983), in *Musik als existentielle Erfahrung: Schriften 1966–1995* (Wiesbaden: Breitkopf & Härtl, 2004), 378.

24. Chris Swithinbank, *A Structure of Physicalities* (2011), http://www.chrisswithinbank .net/2011/03/a-structure-of-physicalities-helmut-lachenmann-tema/.

25. Pierre Schaeffer, *Traité des objets musicaux* (Paris: Seuil, 1966), 475. My translation in text. "Nous l'avons vu, c'est le geste instrumental qui oriente notre redécouverte de la forme sonore. … Nous avons déjà insisté sur les liens primordiaux du faire et de l'entendre … dans le domaine des relations entre les fonctions auditives et les activités motrices."

26. Denis Smalley, "Spectromorphology: Explaining Sound-Shapes," *Organized Sound* 2, no. 2 (1997): 107–126.

27. Martin Kalteneker, panel discussion, Kunstuniversität Graz, 196.

28. That this is still problematic for musicology is surely a good thing. In *Helmut Lachenmann: Musik mit Bildern?* (Paderborn: Wilhelm Fink Verlag, 2012), Matteo Nanni and Matthias Schmidt discuss Lachenmann's "iconic turn"—which they see as problematizing the relationship between sound and image.

29. François Nicolas, "Ècouter, lire et dire la musique (1) Théorie de l'écoute musicale," 46–47.

30. Vittorio Gallese, "Embodied Simulation: From Neurons to Phenomenal Experience," *Phenomenology and the Cognitive Sciences* 4 (2005): 23–48.

31. John Willett, *The Theater of Bertolt Brecht* (London: Methuen, 1967), 185.

32. In discussion with Julian Anderson, in London, February 16, 2015, Lachenmann described "unobserved" listening as a "gastronomic experience": insofar as music could be an "existential experience," this was because "observed" listening leads to "self-observation."

33. Richard Steinitz, "The Inside-Out Concerto," *Guardian*, November 25, 2005. (Is he making a slight innuendo about workshop method?)

34. Jacques Rancière, *The Emancipated Spectator* (New York: Verso, 2011), 49.

14 Conclusion

1. Mikhail Bakhtin, "Content, Material and Form in Verbal Art," in *Art and Answerability*, ed. Michael Holquist and Vadim Liapunov (Austin: University of Texas Press, 1990), 259.

2. Raymond Williams, *Keywords* (London: Fontana, 1976), 32.

3. Theodore Levin, *Where Rivers and Mountains Sing* (Bloomington: Indiana University Press, 2006).

4. Zoia Kyrgys, *Pesennaia kultura Tuvinskova Naroda* (Kyzyl: Tuvinskoe Knizhnoe Izdatelstvo, 1992).

5. Tildy Bayar, "Music Inside Out: Spectral Music's Chords of Nature," in *Spectral World Musics*, ed. Robert Reigle and Paul Whitehead (Istanbul: Pan Yayincilik, 2003). Spectral music is music that elevates timbre—the spectrum of partials that give tones their sound quality—to a core principle of musical organization.

6. Valentina Suzukey, *The Drone-Overtone Basis of Tuvan Traditional Instrumental Music* (Kyzyl: Tuvan Scientific Research Institute for Language, Literature and Art, 1993).

7. Steven Feld, "Lift-Up-Over Sounding," in *The Book of Music and Nature*, ed. David Rothenburg and Marta Ulvaeus (Middletown, CT: Wesleyan University Press, 2001). Steven Feld, *Sound and Sentiment: Birds, Weeping, Poetics and Song in Kaluli Expression* (Philadelphia: University of Pennsylvania Press, 1982).

8. R. Murray Schafer, *The Tuning of the World* (New York: Random House, 1977).

9. Roy Rappaport, *Ecology, Meaning, and Religion* (Berkeley, CA: North Atlantic, 1979).

10. Feld, "Lift-Up-Over Sounding," 196.

11. Mark Johnson, *The Meaning of the Body: Aesthetics of Human Understanding* (Chicago: University of Chicago Press, 2007).

12. John Dewey, *Art as Experience* (New York: Putnam, 1934), 349.

13. Alfonsina Scarinzi, "Grounding Aesthetic Preference in the Bodily Conditions of Meaning Constitution: Towards an Enactive Approach," *Nordic Journal of Aesthetics* 43 (2012): 83–103.

14. Gianluca Consoli, "A Cognitive Theory of the Aesthetic Experience," *Contemporary Aesthetics* 10 (2012), http://www.contempaesthetics.org/newvolume/pages/article.php?articleID=657.

15. Alva Noë, *Action in Perception* (Cambridge, MA: MIT Press, 2004), 216.

16. Of course, in principle, interconnectedness and oppositional categories are not incompatible. But the enthusiasm of cognitive science for connectivity should not debar us from modeling the oppositions between different types of cognition associated with different types of information processing.

17. Martin Nowak, "Evolutionary Biology of Language," *Philosophical Transactions of the Royal Society of London, Series B, Biological Sciences* 355 (2000): 1615–1622.

18. Friedrich Nietzsche, *The Twilight of the Idols* (Oxford: Oxford University Press, 1998).

19. Kaadyr-ool Bicheldei, "Xoomei: The Tuvan Soul" in *Xoomei* (Kyzyl: Tuvan Ministry of Culture Publications, 1995).

Bibliography

Adorno, Theodor. *Introduction to the Sociology of Music*. New York: Continuum, 1988.

Adorno, Theodor. *Philosophy of Modern Music*. New York: Continuum, 2007.

Ahissar, Merav, Mor Nahum, Israel Nelken, and Shaul Hochstein. "Reverse Hierarchies and Sensory Learning." *Philosophical Transactions of the Royal Society B* 364 (2009): 285–299.

Alexander, Michelle. *The New Jim Crow: Mass Incarceration in the Age of Colorblindness*. New York: New Press, 2010.

Antufyev, Yevgeniy. "Shamanism: The Bear Spirit. Interview with Kara-ool Tyulyushevich." Center of Asia, May 26, 2008, translated by Heda Jindrak. http://www.centerasia.ru/issue/2008/20/1772-dukh-medvedya.html.

Aristoxenus. *Aristoxenou Harmonika stoicheia: The Harmonics of Aristoxenus*. Translated by H. S. Macran. Oxford: Clarendon, 1902.

Atlan, Henri. *À tort et à raison*. Paris: Seuil, 1986. Translated by L. Schramm as *Enlightenment to Enlightenment*. Albany, NY: SUNY Press, 1993.

Aubert, Laurent. *Les feux de la déesse*. Lausanne: Editions Payot, 2004.

Axelos, Kostas. "The World: Being Becoming Totality." *Environment and Planning D: Society and Space* 24 (2006): 643–651. Originally published 1984.

Ayler, Albert. *The New Wave in Jazz*, CLP 1932. EMI Records, 1965.

Bahro, Rudolph. "Interview with Fred Halliday." In *New Left Review*. Reprinted in Bahro, *From Red to Green*. New York: Verso, 1984.

Baily, John. "Music Performance, Motor Structure, and Cognitive Models." In *European Studies in Ethnomusicology: Historical Developments and Recent Trends*, edited by M. P. Baumann, A. Simon, and U. Wegner, 142–158. Wilhelmshaven: Florian Noetzel Verlag, 1992.

Bakhtin, Mikhail. "Author and Hero in Aesthetic Activity." In *Art and Answerability*, edited by M. Holquist and V. Liapunov. Austin: University of Texas Press, 1990.

Bakhtin, Mikhail. "Content, Material and Form in Verbal Art." In *Art and Answerability*, edited by M. Holquist and V. Liapunov. Austin: University of Texas Press, 1990.

Balch, Faith. "Examining Constraints and Feedback as System Regulators in a Combined Ecological and Cultural System Model." In *Cultural Analysis and the Navigation of Complexity: A Festschrift in Honor of Luther P. Gerlach*, edited by Lisa Kaye Brandt. Lanham, MD: Press of America, 2007.

Barba, Eugenio. *Anatomia del Teatro*. Florence: La casa Usher, 1983.

Barthes, Roland. *Elements of Semiology*. London: Cape, 1967.

Barthes, Roland. *Image, Music, Text*. London: Fontana Flamingo, 1977.

Bateson, Gregory. "Style, Grace, and Information in Primitive Art." In *Steps to an Ecology of Mind*. London: Granada Paladin, 1973.

Bayar, Tildy. "Music Inside Out: Spectral Music's Chords of Nature." In *Spectral World Musics*, edited by R. Reigle and P. Whitehead. Proceedings of the Istanbul Spectral Music Conference. Istanbul: Pan Yayincilik, 2003.

Becker, Judith. *Deep Listeners: Music, Emotion, and Trancing*. Bloomington: Indiana University Press, 2004.

Benioff, Paul. *Language Is Physical*. Argonne: Physics Division, Argonne National Laboratory, 2008.

Bicheldei, Kaadyr-ool. "Xoomei: The Tuvan Soul." In *Xoomei*. Kyzyl: Tuvan Ministry of Culture Publications, 1995.

Bickerton, Derek. "Syntax for Non-Syntacticians." In *Biological Foundations and Origin of Syntax*, edited by Derek Bickerton and Eörs Szathmàry. Cambridge, MA: MIT Press, 2009.

Bloch, Maurice. "Language, Anthropology, and Cognitive Science." *Man* 26, no. 2 (new series, 1991): 183–198.

Bloch, Maurice. "Symbols, Song, Dance, and Features of Articulation." *European Journal of Sociology* 15 (1974): 55–81.

Boethius. *The Consolation of Philosophy*. Book V. Translated by H. R. James. London: Elliot Stock, 1897.

Bourdieu, Pierre. *Les règles de l'art*. Paris: Seuil, 1992.

Bourguignon, Erika. *Possession*. San Francisco: Chandler & Sharp, 1976. Reprint, Waveland Press, 1991.

Broesch, James. *Signal Processing*. Burlington, MA: Newnes Instant Access, 2008.

Buck-Morss, Susan. "Visual Empire." *Diacritics* 37, nos. 2–3 (2007): 171–198.

Burckhardt, Carl Jacob. *Reflections on History*. Indianapolis: Liberty Classics, 1979.

Burridge, Kenelm. *New Heaven, New Earth*. Oxford: Blackwell, 1969.

Burrow, Colin. "Sudden Elevations of Mind." *London Review of Books*, February 17, 2011.

Cage, John. "On Earlier Pieces." In *John Cage: Documentary Monographs in Modern Art*, edited by Richard Kostelanetz. London: Allen Lane, 1971.

Cage, John. *Variations III Performance Instructions*. New York: Henmar Press, 1963.

Callahan, Roger J., and Joanne Callahan. *Thought Field Therapy and Trauma: Treatment and Theory*. Indian Wells, CA: Callahan Techniques, 1996.

Castillo, Richard. "Book Review Forum on Winkelman." *Journal of Ritual Studies* 18, no. 1 (2004): 96–108.

Castoriadis, Cornelius. *Les carrefours du labyrinthe V*. Paris: Seuil, 1997.

Castoriadis, Cornelius. *L'institution imaginaire de la société*. Paris: Seuil, 1975.

Cellini, Benvenuto. *The Autobiography of Benvenuto Cellini*. Translated by A. Macdonell. New York: Everyman, 2010.

Chauvet, Louis-Marie. *Symbol and Sacrament*. Translated by P. Madigan and M. Beaumont. Collegeville, MN: Liturgical Press, 1995.

Chrysostom, St. John. "Exposition of Psalm XLI." In *Source Readings in Music History from Classical Antiquity to the Romantic Era*, edited by O. Strunk. New York: W. W. Norton, 1950.

Clark, H. H., and W. G. Chase. "On the Process of Comparing Sentences with Pictures." *Cognitive Psychology* 3 (1972): 472–517.

Clarke, Eric F. *Ways of Listening: An Ecological Approach to the Perception of Musical Meaning*. Oxford: Oxford University Press, 2005.

Clastres, Pierre. *La société contre l'état*. Paris: Editions de Minuit, 1974.

Clastres, Pierre. "Les Marxistes et leur anthropologie." *Libre* 3 (1978): 135–149. Translated by Janine Herman in *The Archeology of Violence*, 128–130 (New York: Semiotext[e], 1994).

Cohen, Phil. *Sub-Cultural Conflict and Working Class Community*. Birmingham: University of Birmingham, 1972.

Conrad, Michael. "Statistical and Hierarchical Aspects of Biological Organization." In *Biological Processes in Living Systems: Toward a Theoretical Biology*, edited by C. H. Waddington. Edinburgh: Edinburgh University Press, 1972, and Chicago: Aldine, 2011.

Consoli, Gianluca. "A Cognitive Theory of the Aesthetic Experience." *Contemporary Aesthetics* 10 (2012). http://www.contempaesthetics.org/newvolume/pages/article .php?articleID=657.

Cook, Nicholas. *A Guide to Music Analysis*. London: Dent, 1987.

Cook, Nicholas. *Music, Imagination, and Culture*. Oxford: Clarendon Press, 1990.

Cook, Norman D. *Tone of Voice and Mind: The Connections between Intonation, Emotion, Cognition, and Consciousness*. Philadelphia: John Benjamins, 2002.

Cozens, Alexander. *A New Method of Assisting the Invention in Drawing Original Compositions of Landscape*. London: Paddington, 1977.

Cross, Ian. "Music Analysis and Music Perception." *Music Analysis* 17, no. 1 (1998): 3–20.

Cumming, Naomi. "Eugene Narmour's Theory of Melody." *Music Analysis* 11 (1992): 2–3.

Currie, James. "Review of Andrew Bowie's *Music, Philosophy, and Modernity*." *Notre Dame Philosophical Reviews* (2008). http://ndpr.nd.edu/news/23563/?id=13328.

Czaplicka, M. A. *Aboriginal Siberia: A Study in Social Anthropology*. Oxford: Oxford University Press, 1914.

Damasio, Antonio. *The Feeling of What Happens*. Portsmouth, NH: Heinemann, 2000.

Danto, Arthur. "The Artworld." *Journal of Philosophy* 61 (1964): 571–584.

Darwin, Charles. *The Expression of the Emotions in Man and Animals*. London: John Murray, 1872.

Davies, Stephen. "The Expression of Emotion in Music." *Mind* 89 (1980): 67–86.

Deacon, Terrence. *The Symbolic Species*. London: Penguin, 1997.

Debord, Guy. *The Society of the Spectacle*. New York: Zone Books, 1994.

Deleuze, Gilles, and Félix Guattari. *Anti-Oedipus: Capitalism and Schizophrenia*. New York: Viking, 1977.

de Man, Paul. *The Resistance to Theory*. Minneapolis: University of Minnesota Press, 1982.

Dennett, Daniel. *Consciousness Explained*. London: Penguin, 1993.

DeNora, Tia. "Musical Practice and Social Structure: A Toolkit." In *Empirical Musicology*, edited by Eric Clarke and Nicholas Cook. Oxford: Oxford University Press, 2004.

Dent, Edward J. *Mozart's Operas: A Critical Study*. New York: McBride, Nast, 1913.

Derrida, Jacques. "Interview with Julia Kristeva." Translated and annotated by Alan Bass. *Positions* (1982).

Derrida, Jacques. *Writing and Difference*. London: RKP, 1978.

Dewey, John. *Art as Experience*. New York: Putnam, 1934.

Diamond, Jared. *Guns, Germs, and Steel*. New York: W. W. Norton, 1997.

Doniger, Wendy. *Dreams, Illusion, and Other Realities*. Chicago: University of Chicago Press, 1984.

Doniger, Wendy, and Kelly Bulkley. "Why Study Dreams? A Religious Studies Perspective." *Dreaming* 3, no. 1 (1993): 69–73.

Dretske, Fred. *Knowledge and the Flow of Information*. Oxford: Blackwell, 1981.

Durkheim, Emile. *Elementary Forms of Religious Life*. New York: Free Press, 1965. Originally published as *Les formes élémentaires de la vie religieuse* (Paris: F. Alcan, 1912).

Durkheim, Emile. *The Rules of the Sociological Method*. Glencoe, IL: Free Press, 1938. Reprint, New York: Macmillan, 1982.

Edgar, Iain R. *The Dream in Islam: From Qur'anic Tradition to Jihadist Inspiration*. Oxford: Berghahn, 2011.

Eichenbaum, Boris. "The Theory of the Formal Method." In *Russian Formalist Criticism: Four Essays*, edited by T. Lemon and Marion J. Reis. Lincoln: University of Nebraska Press, 1965.

Eimert, Herbert. "What Is Electronic Music?" *Die Reihe*, journal published in English as *Electronic Music* 1 (1957): 1–10.

Eliade, Mircea. *Shamanism: Archaic Techniques of Ecstasy*. Princeton, NJ: Princeton University Press, 1951.

Elsea, Peter. *Basics of Digital Recording*. 1996. http://artsites.ucsc.edu/ems/music/tech_background/TE-16/teces_16.html.

Evans-Pritchard, Edward. *Theories of Primitive Religion*. Oxford: Oxford University Press, 1965.

Feld, Steven. "Lift-Up-Over Sounding." In *The Book of Music and Nature*, edited by David Rothenburg and Marta Ulvaeus, 193–206. Middletown, CT: Wesleyan University Press, 2001.

Feld, Steven. *Sound and Sentiment: Birds, Weeping, Poetics, and Song in Kaluli Expression*. Philadelphia: University of Pennsylvania Press, 1982.

Feldman, J., and S. Narayanan. "Embodied Meaning in a Neural Theory of Language." *Brain and Language* 89, no. 2 (2004): 385–392.

Fingelkurts, Andrew A., Alexander A. Fingelkurts, and Carlos F. H. Neves. "Natural World Physical, Brain Operational, and Mind Phenomenal Space-Time." *Physics of Life Reviews* 7, no. 2 (2010): 195–249.

Fodor, Jerry. *The Modularity of Mind.* Cambridge, MA: MIT Press, 1983.

Follin, Michel (dir.). *György Ligeti Un Portrait.* Film written by Arnaud de Mezamat, Judit Kele, and Michel Follin. Paris: Artline Films for Arte, 1993.

Foucault, Michel. *The Archaeology of Knowledge.* New York: Routledge, 2002. Originally published as *L'archéologie du savoir* (Paris: Gallimard, 1969).

Foucault, Michel. "The Subject and Power." *Critical Inquiry* 8, no. 4 (summer 1982): 777–795.

Freud, Sigmund. *The Interpretation of Dreams.* Leipzig: Franz Deuticke, 1899.

Gallese, Vittorio. "Embodied Simulation: From Neurons to Phenomenal Experience." *Phenomenology and the Cognitive Sciences* 4 (2005): 23–48.

Ganti, Tibor. *The Principles of Life.* Edited by Eörs Szathmary and James Griesemer. Oxford: Oxford University Press, 2003.

Geertz, Clifford. *The Interpretation of Cultures.* New York: Basic Books, 1973. Reprint, New York: HarperCollins, 1993.

Geertz, Clifford. "Religion as a Cultural System." In *Anthropological Approaches to the Study of Religion,* edited by Michael Banton, 1–46. London: Tavistock, 1966.

Geertz, Clifford. "The Transition to Humanity." In *Horizons of Anthropology,* edited by S. Tax, 42. London: Allen & Unwin, 1965.

Gell, Alfred. *Art and Agency: An Anthropological Theory.* Oxford: Clarendon Press, 1998.

Ghazala, Reed. *Circuit-Bending: Build Your Own Alien Instruments.* London: John Wiley, 2005.

Gibson, James. *The Ecological Approach to Visual Perception.* Boston: Houghton Mifflin, 1979.

Gibson, James. *The Senses Considered as Perceptual Systems.* Boston: Houghton Mifflin, 1966.

Ginzburg, Carlo. *Ecstasies: Deciphering the Witches' Sabbath.* Chicago: University of Chicago Press, 2004.

Ginzburg, Carlo. *The Enigma of Piero.* Translated by Kate Soper. New York: Verso, 1985. Revised edition, New York: Verso, 2000.

Glasersfeld, Ernst Von. "An Introduction to Radical Constructivism." In *The Invented Reality,* edited by Paul Watzvalik, 17–40. New York: Norton, 1984.

Gluckman, Max. *Politics, Law, and Ritual in Tribal Society*. Oxford: Blackwell, 1967.

Goffman, Erving. *The Presentation of Self in Everyday Life*. Edinburgh: University of Edinburgh, 1956.

González-Ruibal, Alfredo, Almudena Hernando, and Gustavo Politis. "Ontology of the Self and Material Culture: Arrow-Making among the Awa Hunter-Gatherers Brazil." *Journal of Anthropological Archaeology* 30 (2011): 1–6.

Guattari, Félix. *Chaosmose*. Paris: Galilée, 1992.

Habermas, Jürgen. "Excursus on Cornelius Castoriadis." In *The Philosophical Discourse of Modernity*, 327–335. Translated by Frederick G. Lawrence. Cambridge, MA: MIT Press, 1987.

Habermas, Jürgen. *Moral Consciousness and Communicative Action*. Translated C. Lenhardt and S. W. Nicholsen. Cambridge, MA: MIT Press, 1990.

Hamayon, Roberte. "Are 'Trance,' 'Ecstasy,' and Similar Concepts Appropriate in the Study of Shamanism?" *Shaman* 1, nos. 1–2 (1993): 3–25.

Hamayon, Roberte. *Taïga—Terre de Chamans*. Paris: Imprimerie Nationale, 1993. New ed., 1997.

Haraway, Donna. "Situated Knowledges: The Science Question in Feminism and the Privilege of Partial Perspective." *Feminist Studies* 14, no. 3 (autumn 1988): 575–599.

Hardin, Russell. *Indeterminacy and Society*. Princeton, NJ: Princeton University Press, 2005.

Hartmann, Ernest. "Why Do We Dream?" *Scientific American* (July 2006): 10.

Hatten, Robert S. *Interpreting Musical Gestures, Topics, and Tropes: Mozart, Beethoven, Schubert*. Bloomington: Indiana University Press, 2004.

Hatten, Robert S. *Musical Meaning in Beethoven*. Bloomington: Indiana University Press, 2004.

Hayek, Friedrich A. *The Sensory Order*. Chicago: University of Chicago Press, 1952.

Hayles, N. Katherine. *How We Became Posthuman: Virtual Bodies in Cybernetics, Literature, and Informatics*. Chicago: Chicago University Press, 1999.

Heidegger, Martin. *Being and Time*. Translated by J. Macquarrie and E. Robinson. Oxford: Blackwell, 1962.

Heidegger, Martin. *Introduction to Metaphysics*. Translated by Ralph Manheim. New Haven, CT: Yale University Press, 1959.

Heidegger, Martin. "The Origin of the Work of Art." In *Poetry, Language, Thought*, translated by A. Hofstadter, 17–87. New York: Harper & Row, 1971. Originally published 1935.

Helmholtz, Herman. *On the Sensations of Tone*. New York: Dover, 1954.

Hennion, Antoine. *La passion musicale*. Paris: Suites, 2007.

Hepokoski, James, and Warren Darcy. *Elements of Sonata Theory: Norms, Types, and Deformations in the Late Eighteenth Century Sonata*. Oxford: Oxford University Press, 2006.

Herder, Johann. *Ideen zu einer Philosophie der Geschichte der Menschheit*. Riga and Leipzig: J. F. Hartknoch, 1784–91.

Hodgkinson, Tim. "An Interview with Pierre Schaeffer—Pioneer of *Musique concrète*." *RēR Quarterly* 2, no. 1 (1987). Reprinted in *The Book of Music and Nature*, edited by David Rothenburg and Marta Ulvaeus. Middletown, CT: Wesleyan University Press, 2001.

Hodgkinson, Tim. "Musicians, Carvers, Shamans." *Cambridge Anthropology* 25, no. 3 (2005–2006): 1–16.

Hodgkinson, Tim. "Notes from the Underground: Interview with Iancu Dumitrescu." *Resonance* 6, no. 1 (1997).

Hodgkinson, Tim. "On Listening." *Perspectives of New Music* 48, no. 2 (summer 2010): 152–179.

Hodgkinson, Tim. "Transcultural Collisions; Music and Shamanism in Siberia." Essay published online by the School of Oriental and African Studies, London. September 2007. http://www.soas.ac.uk/musicanddance/projects/project6/essays/file45913.pdf.

Holmberg, David. *Order in Paradox: Myth and Ritual among Nepal's Tamang*. Ithaca, NY: Cornell University Press, 1992.

Huang-Po. *Doctrine of Universal Mind*. London: Buddhist Society of London, 1947. Reprinted in John Cage, "List No. 2," in *John Cage: Documentary Monographs in Modern Art*, edited by Richard Kostelanetz. London: Allen Lane, 1971.

Hughes, Jonathan. *Ecology and Historical Materialism*. Cambridge: Cambridge University Press, 2000.

Humphrey, Caroline. *Shamans and Elders*. Oxford: Oxford University Press, 1996.

Humphrey, Caroline, and David Sneath. *The End of Nomadism? Society, State, and the Environment in Inner Asia*. Durham, NC: Duke University Press, 1999.

Husser, Jean-Marie. "Songe." In *Supplément au dictionnaire de la Bible, XII*. Paris: Letouzey et Ané, 1996. Translated by by Jill Munro as *Dreams and Dream Narratives in the Biblical World*. Sheffield: Sheffield Academic Press, 1999.

Husserl, Edmund. *The Phenomenology of Internal Time-Consciousness*. Translated by J. S. Churchill. Bloomington: Indiana University Press, 1950.

Ikhtisamov, Khamza. "Notes on Two-Part Throat Singing of Turkic and Mongol Peoples." In *Music of Peoples of Africa and Asia*, vol. 4, edited by Viktor S. Vinogradov, 179–193. Moscow: Sovietskii Kompozitor, 1984.

Iribarne, Julia. "Contribution to the Phenomenology of Dreams." In *Essays in Celebration of the Founding of the Organization of Phenomenological Organizations*, edited by Chan-Fai Cheung, Ivan Chvatik, Ion Copoeru, Lester Embree, Julia Iribarne, and Hans Rainer. Sep. 2003. http://opo-phenomenology.org/essays/IribarneArticle.pdf.

Ives, Charles E. *Essays before a Sonata*. London: Calder & Boyars, 1969.

Ives, Charles E. *Memos*. Edited by John Kirkpatrick. London: Calder & Boyars, 1973.

Jackendoff, Ray. "Musical Parsing and Musical Affect." *Music Perception* 9, no. 2 (1991): 199–230.

Jakobson, Roman. "Préface." In *Théorie de la littérature: Textes des formalistes russes*, edited by Tzvetan Todorov. Paris: Seuil, 1965.

James, Robin. *The Conjectural Body: Gender, Race, and the Philosophy of Music*. Plymouth, UK: Lexington, 1978.

Jochelson, Waldemar. *The Koryak*. Leiden: E. J. Brill, 1908.

Johnson, Mark. *The Body in the Mind: The Bodily Basis of Meaning, Imagination, and Reason*. Chicago: University of Chicago Press, 1987.

Johnson, Mark. *The Meaning of the Body: Aesthetics of Human Understanding*. Chicago: University of Chicago Press, 2007.

Johnson, Samuel. *The Lives of the Poets*. Oxford: Oxford University Press, 2006.

Jousse, Marcel. *L'anthropologie du geste*. Paris: Editions Resma, 1969.

Kalteneker, Martin. "Panel Discussion with Helmut Lachenmann: Klang, Magie, Struktur." Kunstuniversität Graz, November 21, 2005. English summary in *Musik Theorien der Gegenwart*, vol. 2, edited by Christian Utz and Clemens Gadenstätter. Saarbrücken: Pfau, 2008.

Kandinsky, Wassily. "Reminiscences." In *Modern Artists on Art*, 2nd enl. ed., edited by Robert L. Herbert, 19–39. Chelmsford, MA: Courier Corporation, 2012.

Kant, Immanuel. *Critique of the Power of Judgement*. Cambridge: Cambridge University Press, 2000.

Kapferer, Bruce. "Introduction: Ritual Process and the Transformation of Context." *Social Analysis* 1 (1979): 3–19.

Katz, Fred E. *Structuralism in Sociology: An Approach to Knowledge*. Albany, NY: SUNY Press, 1976.

Keller, Hans, ed., with Gerold W. Gruber. *Functional Analysis: The Unity of Contrasting Themes*. New York: Lang, 2001.

Kenin-Lopsan, Mongush. *Shamanic Songs and Myths of Tuva*. Translated by Christiana Buckbee. Istor no. 7. Budapest: Akadémiai Kiadó, 1997.

Kent, Susan. "Cross-Cultural Perceptions of Farmers and the Value of Meat." In *Farmers as Hunters: The Implications of Sedentism*, edited by Susan Kent. Cambridge: Cambridge University Press, 1989.

Kitsoglou, Elisabeth. "Dreaming the Self: A Unified Approach towards Dreams, Subjectivity, and the Radical Imagination." *History and Anthropology* 21, no. 3 (2010): 321–355.

Kivy, Peter. *The Corded Shell: Reflections on Musical Expression*. Princeton, NJ: Princeton University Press, 1981.

Klee, Paul. *Artists on Art, from the 14th–20th Centuries*. Edited by Robert Goldwater and Marco Treves. London: Pantheon Books, 1972.

Knauft, Bruce. "Imagery, Pronouncement, and the Aesthetics of Reception in Gebusi Spirit Mediumship." In *The Religious Imagination in New Guinea*, edited by Gilbert Herdt and Michele Stephen. New Brunswick, NJ: Rutgers University Press, 1989.

Knight, Chris. *Blood Relations: Menstruation and the Origins of Culture*. New Haven, CT: Yale University Press, 1991.

Kolakowski, Leszek. *Main Currents of Marxism*. Oxford: Oxford University Press, 1978.

Kosslyn, Stephen. *Image and Mind*. Cambridge, MA: Harvard University Press, 1980.

Kosslyn, Stephen, and James Pomeranz. "Imagery, Propositions, and the Form of Internal Representations." *Cognitive Psychology* 9 (1977): 52–76.

Kramer, Lawrence. *Interpreting Music*. Berkeley: University of California Press, 2011.

Kramer, Lawrence. *Music as Cultural Practice, 1800–1900*. Berkeley: University of California Press, 1993.

Krippendorff, Klaus. "On the Cybernetics of Time." *Systemsletter* 7, no. 1 (1978): 1–2. http://repository.upenn.edu/asc_papers/228.

Kristeva, Julia. "Le sujet en procés." In *L'identité: Séminaire dirigé par Claude Lévi-Strauss*, 223–246. Paris: Quadrige/PUF, 1977.

Kulbin, Nikolai. "Svobodnaya Musika." In *Studiia impressionistov*, edited by Nikolai Kulbin, 15–26. St. Petersburg: Butovskoi, 1910.

Kurtág, György. *Portraitkonzert*. CD on Col Legno, WWE 31870, 1994.

Kyrgys, Zoia. *Pesennaia kultura Tuvinskova Naroda*. Kyzyl: Tuvinskoe Knizhnoe Izda-telstvo, 1992.

Labov, William. *Principles of Linguistic Change*, vol. 1: *Internal Factors*. Cambridge, MA: Blackwell, 1994.

Lachenmann, Helmut. "Musique Concrète Instrumentale: In Conversation with Gene Coleman." University of Pennsylvania, July 4, 2008. https://slought.org/resources/musique_concrete_instrumentale.

Lachenmann, Helmut. "On Structuralism." *Contemporary Music Review* 12, no. 1 (1995): 93–102.

Lachenmann, Helmut. "Sound, Magic, Structure: Aesthetical and Structural Dimensions in the Music of Helmut Lachenmann." In "Panel Discussion with Helmut Lachenmann," Kunstuniversität Graz, November 21, 2005. English summary in *Musik Theorien der Gegenwart*, vol. 2, edited by Christian Utz and Clemens Gadenstätter. Saarbrücken: Pfau, 2008.

Lachenmann, Helmut. "Werkkommentar zu temA." In *Musik als existentielle Erfahrung: Schriften 1966–1995*. Wiesbaden: Breitkopf & Härtl, 2004. Originally published 1983.

Lakoff, George. *Women, Fire, and Dangerous Things*. Chicago: University of Chicago Press, 1987.

Lakoff, George, and Mark Johnson. *Metaphors We Live By*. Chicago: University of Chicago Press, 1980.

Lakoff, George, and Mark Johnson. *Philosophy in the Flesh*. New York: Basic Books, 1999.

Landauer, Rolf. "Information Is a Physical Entity." *Physica A* 263, nos. 1–4 (1999): 63–67.

Lanternari, Vittorio. "Dreams as Charismatic Significants: Their Bearing on the Rise of New Religious Movements." In *Psychological Anthropology*, edited by T. R. Williams. Paris: Mouton, 1975.

Lapassade, Georges, with Patrick Boumard and Michel Lobrot. *Le mythe de l'identité, éloge de la dissociation*. Paris: Anthropos, 2006.

Lar, Leonid. *Shamani i Bogi*. Tyumen, Russian Federation: Institute Problemi Osvoyeniya Severa, 1998.

Larkin, Philip. "Letter to Monica 10/8/54." Quoted in Richard Bradford, *The Odd Couple: The Curious Friendship between Kingsley Amis and Philip Larkin*. London: Robson Press/Biteback, 2012.

Latour, Bruno. *We Have Never Been Modern.* Cambridge, MA: Harvard University Press, 1993.

Le Breton, David. *Anthropologie du corps et modernité.* Paris: Quadrige, 1990.

Lelas, Srdan. *Science and Modernity: Toward an Integral Theory of Science.* New York: Springer Science, 2001.

Lerdahl, Fred, and Ray Jackendoff. *A Generative Theory of Tonal Music.* Cambridge, MA: MIT Press, 1983.

Leroi-Gourhan, André. *Le geste et la parole.* Paris: Albin Michel, 1964.

Levin, Theodore. *Where Rivers and Mountains Sing.* Bloomington: Indiana University Press, 2006.

Levin, Theodore, and Michael E. Edgerton. "The Throat Singers of Tuva." *Scientific American* 281, no. 3 (1999): 80–87.

Levinson, Jerrold. *Contemplating Art: Essays in Aesthetics.* Oxford: Oxford University Press, 2006.

Lewin, Roger. "Stone Age Psychedelia." *New Scientist,* June 8, 1991, 30–34.

Lewis, Naphtali. *The Interpretation of Dreams and Portents.* Toronto: Samuel Stevens Hakkert, 1976.

Lindberg, David C. *Theories of Vision from al-Kindi to Kepler.* Chicago: University of Chicago Press, 1976.

Locke, John. *An Essay Concerning Human Understanding.* Menston, Yorkshire: Scolar Press, 1690.

Lonberg-Holm, Fred. "Scrapes and Hisses: Extended Techniques in Improvised Music" (interview with Charlie Wilmoth). *Dusted* (2010). http://www.dustedmagazine .com/features/468.

López, Francisco. "Profound Listening and Environmental Sound Matter." In *Audio Culture,* edited by Christopher Cox. New York: Continuum International, 2004.

Lorand, Sandor. "Dream Interpretation in the Talmud (Babylonian and Graeco-Roman Period)." *International Journal of Psycho-Analysis* 38 (1957): 92–97.

Lubbock, Tom. "The Early, Early Show." *Independent,* May 28, 2002.

Macke, August. "Brief an Eberhard Grisebach, März 20, 1913." In *Briefe an Elisabeth und die Freunde,* edited by Werner Frese and Ernst-Gerhard Güse, 300. Munich: Bruckmann, 1987. Quoted in English in Wolf-Dieter Dube, *The Expressionists,* 145 (London: Thames & Hudson, 1972).

Magee, Bryan. *Wagner and Philosophy.* London: Penguin, 2000.

Marcuse, Herbert. *One-Dimensional Man: Studies in the Ideology of Advanced Industrial Society*. London: Routledge, 2002.

Marwick, Max. "The Study of Witchcraft." In *The Craft of Social Anthropology*, ed. A. L. Epstein. London: Tavistock, 1967.

Mason, Charles Harrison. *Church of God in Christ: Official Manual*. Memphis, TN: Church of God in Christ Publishing Board, 1973.

Maturana, Humberto R., and Francisco J. Varela. *Autopoiesis and Cognition: The Realization of the Living*. Boston: Reidel, 1980.

Maus, Fred. "Concepts of Musical Unity." In *Rethinking Music*, edited by Nicholas Cook and Mark Everist. Oxford: Oxford University Press, 1999.

Mauss, Marcel. "Les techniques du corps." *Journal de Psychologie* 32 (1935): 271–293.

McDonough, Tom, ed. *Guy Debord and the Situationist International*. Cambridge, MA: MIT Press, 2002.

McDougall, W. *An Outline of Abnormal Psychology*. London: Methuen, 1926.

McLuhan, Marshall. *The Gutenburg Galaxy*. London: Routledge, 1962.

Medawar, Peter B., and J. S. Medawar. *The Life Science*. London: Granada Paladin, 1977.

Merleau-Ponty, Maurice. *Phenomenology of Perception*. New York: Routledge, 1962.

Miller, Andrew D., and Julian Tanner. *Essentials of Chemical Biology: Structure and Dynamics of Biological Macromolecules*. Hoboken, NJ: Wiley, 2013.

Moran, Seana, and Vera John-Steiner. "Creativity in the Making." In *Creativity and Development*, edited by R. Keith Sawyer. Oxford: Oxford University Press, 2003.

Morris, Brian. *Anthropological Studies of Religion*. Cambridge: Cambridge University Press, 1987.

Nancy, Jean-Luc. *Listening*. Translated by C. Mandell. New York: Fordham University Press, 2007.

Nanni, Matteo, and Matthias Schmidt. *Helmut Lachenmann: Musik mit Bildern?* Paderborn: Wilhelm Fink, 2012.

Narmour, Eugene. *The Analysis and Cognition of Basic Melodic Structures*. Chicago: University of Chicago Press, 1989.

Narmour, Eugene. *The Analysis and Cognition of Melodic Complexity*. Chicago: University of Chicago Press, 1992.

Nattiez, Jean-Jacques. *Music and Discourse: Toward a Semiology of Music*. Translated by Carolyn Abbate. Princeton, NJ: Princeton University Press, 1990. Originally published as *Musicologie générale et sémiologue* (Paris: C. Bourgois, 1987).

Nicholsen, Shierry. *Exact Imagination, Late Work: On Adorno's Aesthetics*. Cambridge, MA: MIT Press, 1999.

Nicolas, François. "Ècouter, lire et dire la musique (1) Théorie de l'ècoute musicale." Lecture notes. Paris: Ècole Normale Supérieure, Passerelle des Arts, Section de musicologie, 2004. http://www.entretemps.asso.fr/Nicolas/BibNic.html.

Nicolas, François. *Les moments favoris: Une problèmatique de l'écoute musicale*. Reims: Noria, 1997.

Nietzche, Friedrich. *The Twilight of the Idols*. Oxford: Oxford University Press, 1998.

Noë, Alva. *Action in Perception*. Cambridge, MA: MIT Press, 2004.

Noelle-Neumann, Elisabeth. "The Spiral of Silence: A Theory of Public Opinion." *Journal of Communication* 24, no. 2 (1974): 43–51.

Nowak, Martin. "Evolutionary Biology of Language." *Philosophical Transactions of the Royal Society of London, Series B, Biological Sciences* 355 (2000): 1615–1622.

Nyman, Michael. *Experimental Music: Cage and Beyond*. New York: Schirmer Books, 1974.

Oliveros, Pauline. "The Earthworm Also Sings—A Composer's Guide to Deep Listening." *Leonardo Music Journal* 3 (1993): 35–38.

Ornstein, Robert. *On the Experience of Time*. London: Penguin Books, 1969.

Ottaway, Hugh. "The Enlightenment and the Revolution." In *The Pelican History of Music*, vol. 3, edited by Alec Robertson and Denis Stevens. London: Penguin, 1968.

Pareyson, Luigi. *Estetica: Teoria della formatività*. Milan: Bompiani, 1988.

Pegg, Carole. *Mongolian Music, Dance, and Oral Narrative*. Seattle: University of Washington Press, 2001.

Peirce, Charles. "On a New List of Categories." In *The Writings of Charles S. Peirce: A Chronological Edition*, vols. 1–6, 8, pp. 49–58. Bloomington: Indiana University Press, 1982. Originally published 1867.

Penke, Mark Stephen. *The Vampire Survival Bible*, vol. 2. Lulu.com, 2012.

Pereira, Alfredo, Jr., and Dietrich Lehmann. *The Unity of Mind, Brain, and World: Current Perspectives on a Science of Consciousness*. Cambridge: Cambridge University Press, 2013.

Perniola, Mario. *L'Estetica Contemporanea*. Bologna: Il Mulino, 2011.

Piekut, Benjamin. *Experimentalism Otherwise: The New York Avant-Garde and Its Limits*. Berkeley: University of California Press, 2011.

Plant, Sadie. "An Interview with Sadie Plant." *Switch Interviews* 5, no. 1 (1999). http://switch.sjsu.edu:/web/v5n1/plant/.

Polanyi, Livia. *The Linguistic Structure of Discourse*. Stanford: CSLI Publications, 1995.

Prentoulis, Marina, and Lasse Thomassen. "Political Theory in the Square: Protest, Representation, and Subjectification." *Contemporary Political Theory* 12 (2013): 166–184. doi:10.1057/cpt.2012.26.

Price, Sally. *Paris Primitive*. Chicago: University of Chicago Press, 2007.

Pulvermüller, Friedemann. *The Neuroscience of Language: On Brain Circuits of Words and Serial Order*. Cambridge: Cambridge University Press, 2002.

Rączaszek-Leonardi, Joanna. "Multiple Systems and Multiple Time Scales of Language Dynamics: Coping with Complexity." *Cybernetics and Human Knowing* 21, nos. 1–2 (2014): 37–52.

Rancière, Jacques. *Disagreement: Politics and Philosophy*. Translated by J. Rose. Minneapolis: University of Minnesota Press, 1999.

Rancière, Jacques. *The Emancipated Spectator*. New York: Verso, 2011.

Rappaport, Roy. *Ecology, Meaning, and Religion*. Berkeley, CA: North Atlantic, 1979.

Réti, Rudolph. *Thematic Patterns in Sonatas of Beethoven*. London: Faber & Faber, 1967.

Réti, Rudolph. *The Thematic Process in Music*. New York: Macmillan, 1951.

Rich, Adrienne. *Blood, Bread, and Poetry: Selected Prose, 1979–1985*. New York: W. W. Norton, 1986.

Richter, Hans. *Dada, Art, and Anti-Art*. London: Thames & Hudson, 1965.

Robert, W. *Der Traum als Naturnotwendigkeit erklart*. Hamburg: Hermann Seippel, 1886.

Robertson, Alec. "Plainsong." In *The Pelican History of Music*, edited by Denis Stevens and Alec Robertson, vol. 1. London: Penguin, 1960.

Robertson, Ian. "Mental Imagery and Imagination." Abstract for Imaginative Minds: An Interdisciplinary Symposium. London: The British Academy, 2004.

Robinson, Jenefer. "The Expression and Arousal of Emotion in Music." *Journal of Aesthetics and Art Criticism* 52, no. 1 (1994): 13–22.

Roob, Alexander. *Alchemy and Mysticism*. Cologne: Taschen, 1996.

Ross, Alex. *The Rest Is Noise: Listening to the Twentieth Century*. New York: Picador, 2007.

Rouget, Gilbert. "Transe: Théâtre, émotion, neurosciences." In *Chamanisme et possession*, edited by Laurent Aubert, 211–220. Geneva: Ateliers de l'ethnomusicologie, 2006.

Sartre, Jean-Paul. *L'Imaginaire*. Paris: Gallimard, 1940.

Sartre, Jean-Paul. *Sketch for a Theory of the Emotions*. Hove: Psychology Press, 1962.

Sasso, Gennaro. *I corotii e gli inetti: Conversazioni su Machiavelli*. Milan: Bompiani, 2013.

Scarinzi, Alfonsina. "Grounding Aesthetic Preference in the Bodily Conditions of Meaning Constitution: Towards an Enactive Approach." *Nordic Journal of Aesthetics* 43 (2012): 83–103.

Schaeffer, Pierre. *À la recherche d'une musique concrète*. Paris: Seuil, 1952.

Schaeffer, Pierre. *Traité des objets musicaux*. Paris: Seuil, 1966.

Schafer, R. Murray. *The Tuning of the World*. New York: Random House, 1977.

Schenker, Heinrich. *The Masterwork*, vols. 1–3. Edited by W. Drabkin, translated by Ian Bent. New York: Dover, 2014.

Schieffelin, Edward. "Performance and the Cultural Construction of Reality." *American Ethnologist* 12, no. 4 (1985): 707–724.

Schneider, E. D., and J. J. Kay. "Order from Disorder: The Thermodynamics of Complexity in Biology." In *What Is Life: The Next Fifty Years: Reflections on the Future of Biology*, edited by Michael P. Murphy and Luke A. J. O'Neill, 161–172. Cambridge: Cambridge University Press, 1995.

Schoenberg, Arnold. *Letters*. Edited by Erwin Stein. Berkeley: University of California Press, 1987.

Schutz, Alfred. The Phenomenology of the Social World. Portsmouth, NH: Heinemann, 1972.

Schwartz, Eric. "A Generic Model for the Emergence and Evolution of Natural Systems toward Complexity and Autonomy." In *Proceedings of 36th Meeting of the International Society for the Systems Sciences*. Denver, CO: ISSS, 1992.

Severi, Carlo. "The Invisible Path: Ritual Representation of Suffering in Cuna Traditional Thought." *Res: Anthropology and Aesthetics* 14 (autumn 1987): 66–85.

Shannon, Claude, and Warren Weaver. *The Mathematical Theory of Communication*. Champaign: University of Illinois Press, 1949.

Shepard, Roger. "Externalization of Mental Images and the Act of Creation." In *Visual Learning, Thinking, and Communication*, edited by B. S. Randhawa and W. E. Coffman. New York: Academic Press, 1978.

Shklovsky, Victor. "Art as Technique." In *Russian Formalist Criticism: Four Essays*, edited by T. Lemon and Marion J. Reis. Lincoln: University of Nebraska Press, 1965.

Shuming, Liang. *Les cultures d'orient et d'occident et leurs philosophies*. Paris: PUF, 2000.

Simondon, Gilbert. "The Genesis of the Individual." In *Zone 6: Incorporations*, edited by Jonathan Crary and Sanford Kwinter, 297–319. New York: Zone Books, 1992. Originally published in *L'individuation à la lumière des notions de formes et d'information* (Jérôme Millon, 2005).

Sluyter, Andrew. "Neo-Environmental Determinism, Intellectual Damage Control, and Nature/Society Science." *Antipode* 4 (2003): 813–817.

Smalley, Denis. "Spectromorphology: Explaining Sound-Shapes." *Organized Sound* 2, no. 2 (1997): 107–126.

Smith, Jonathan. "Time in Biology and Physics." In *The Nature of Time: Geometry, Physics, and Perception*, edited by R. Buccheri, M. Saniga, and W. M. Stuckey, 145–152. Dordrecht: Kluwer, 2003.

Sperber, Dan. *Rethinking Symbolism*. Cambridge: Cambridge University Press, 1975.

Steiner, George. "The Retreat from the Word." In *Language and Silence*. London: Faber & Faber, 1967.

Steinitz, Richard. "The Inside-Out Concerto." *Guardian*, November 25, 2005.

Stephen, Michele. "Self, the Sacred Other, and Autonomous Imagination." In *The Religious Imagination in New Guinea*, edited by Gilbert Herdt and Michele Stephen. New Brunswick, NJ: Rutgers University Press, 1989.

Stockfelt, Ola. "Adequate Modes of Listening." In *Audio Culture*, edited by Christopher Cox. New York: Continuum International, 2004.

Strathern, Marilyn. *The Gender of the Gift: Problems with Women and Problems with Society in Melanesia*. Berkeley: University of California Press, 1988.

Strumpell, Ludwig. *Die Natur and Entstehung der Traume*. Leipzig, 1877.

Subotnik, Rose. "Towards a Deconstruction of Structural Listening: A Critique of Schoenberg, Adorno, and Stravinsky." In *Deconstructive Variations: Music and Reason in Western Society*. Minneapolis: University of Minnesota Press, 1996.

Suzukey, Valentina. *The Drone-Overtone Basis of Tuvan Traditional Instrumental Music*. Kyzyl: Tuvan Scientific Research Institute for Language, Literature and Art, 1993.

Swithinbank, Chris. "A Structure of Physicalities." 2011. http://www.chrisswithinbank.net/2011/03/a-structure-of-physicalities-helmut-lachenmann-tema/.

Symonds, Dominic, and Pamela Karantonis. *The Legacy of Opera*. Amsterdam: Rodopi, 2013.

Tagg, Philip. "Musicology and the Semiotics of Popular Music." *Semiotica* 66, nos. 1–3 (1987): 279–298.

Taussig, Michael. *The Nervous System*. New York: Routledge, 1992.

Taylor, Charles. *Philosophical Papers*, vol. 1: *Human Agency and Language*. Cambridge: Cambridge University Press, 1985.

Tett, Gillian. *Fool's Gold: How Unrestrained Greed Corrupted a Dream, Shattered Global Markets, and Unleashed a Catastrophe*. New York: Simon & Schuster, 2009.

Tongeren, Mark van. *Overtone Singing: Physics and Metaphysics of Harmonics in East and West*. Amsterdam: Fusica, 2002.

Tonkinson, Robert. "Aboriginal Dream-Spirit Beliefs in a Contact Situation: Jigalong, Western Australia." In *Australian Aboriginal Anthropology*, edited by Ronald M. Berndt. Crawley: University of Western Australia Press, 1970.

Tovey, Donald. *Essays in Musical Analysis*. Oxford: Oxford University Press, 1935.

Tran, Quang Hai, and Denis Guilou. "Original Research and Acoustical Analysis in Connection with the Xöömij Style of Biphonic Singing." In *Musical Voices of Asia*, edited by R. Emmert and Y. Minegushi, 162–173. Japan Foundation. Tokyo: Heibonsha, 1980.

Turner, Victor. "Aspects of Soara Ritual and Shamanism." In *The Craft of Social Anthropology*, edited by A. L. Epstein. London: Tavistock, 1967.

Turner, Victor. *Dramas, Fields, and Metaphors: Symbolic Action in Human Society*. Ithaca, NY: Cornell University Press, 1974.

Turner, Victor. *The Forest of Symbols: Aspects of Ndembu Ritual*. Ithaca, NY: Cornell University Press, 1967.

Turner, Victor. *From Ritual to Theatre: The Human Seriousness of Play*. New York: PAJ Publications, 1982.

Van Gennep, Arnold. *The Rites of Passage*. Florence, KY: Psychology Press, 1960. Translated from *Les rites de passage*, 1909.

Vattimo, Gianni. *Art's Claim to Truth*. New York: Columbia University Press, 2008.

Vendler, Helen. *The Art of Shakespeare's Sonnets*. Cambridge, MA: Harvard University Press, 1997.

Vendler, Helen. "Helen Vendler: The Art of Criticism, No. 3." Interview by Henri Cole. *Paris Review* 141 (winter 1996). http://www.theparisreview.org/interviews/1324/the-art-of-criticism-no-3-helen-vendler.

Volkov, Solomon, ed. *Testimony: The Memoirs of Dmitri Shostakovich.* New York: Harper & Row, 1979.

Vygotsky, Lev. "Imagination and Creativity in Childhood." *Journal of Russian and East European Psychology* 42, no. 1 (2004): 7–97. Originally published 1930.

Wagner, Roy. "The Fractal Person." In *Big Men and Great Men*, edited by M. Godelier and M. Strathern. Cambridge: Cambridge University Press, 1995.

Wallace, Anthony F. C. "Revitalization Movements." *American Anthropologist* 58 (1956): 264–281.

Warnock, Mary. *Imagination.* Berkeley: University of California Press, 1978.

Webern, Anton. *The Path to New Music.* Edited by Willi Reich, translated by Leo Black. Bryn Mawr, PA: Theodore Presser, 1963.

Weiss, Paul. *The Science of Life: The Living System—A System for Living.* Armonk, NY: Futura, 1973.

Wekker, Gloria. "One Finger Does Not Drink Okra Soup: Afro-Surinamese Women and Critical Agency." In *Feminist Genealogies, Colonial Legacies, Democratic Futures*, edited by M. Jacqui Alexander and Chandra Talpade Mohanty. New York: Routledge, 1997.

Whyte, L., ed. *Aspects of Form.* London: Lund Humphries, 1951.

Wiener, Norbert. *Cybernetics: Or Control and Communication in the Animal and the Machine.* Cambridge, MA: MIT Press, 1948.

Wiener, Norbert. "Time, Communication, and the Nervous System." In *Teleological Mechanisms*, vol. 50, edited by R. W. Miller, 197–219. New York: Annals of the New York Academy of Science, 1948.

Willett, John. *The Theatre of Bertolt Brecht.* London: Methuen, 1967.

Williams, Raymond. *Keywords.* London: Fontana, 1976.

Wilmoth, Charlie. "Scrapes and Hisses: Extended Techniques in Improvised Music." *Dusted* (2010). http://www.dustedmagazine.com/features/468.

Winkelman, Michael. *Shamanism: The Neural Ecology of Consciousness and Healing.* Westport, CT: Praeger, 2000.

Woolfson, Charles. *The Labour Theory of Culture.* London: RKP, 1982.

Wu, S., S. Amari, and H. Nakahara. "Population Coding and Decoding in a Neural Field: A Computational Study." *Neural Computation* 14, no. 5 (May 2002): 999–1026.

Yau, Jeffrey M., Anitha Pasupath, Paul J. Fitzgerald. Steven S. Hsiao, and Charles E. Connor. "Analogous Intermediate Shape Coding in Vision and Touch." *Proceedings of the National Academy of Sciences of the United States of America* 106, no. 38 (2009): 16457–16462.

Yu, Chai-shin, and R. Guisso, eds. *Shamanism: The Spirit World of Korea*. Berkeley: Asian Humanities Press, 1988.

Zarlino, Gioseffe. *Le Istitutione armoniche*. Venice, 1558.

Zepke, Stephen. *Deleuze, Guattari, and the Production of the New*. New York: Continuum, 2008.

Zwaan, Rolf A. "Embodied Cognition, Perceptual Symbols, and Situation Models." *Discourse Processes* 28 (1999): 81–88.

Index